Understanding International Art Markets and Management

Understanding International Art Markets and Management focuses on the visual art market – sculpture, paintings, drawings, prints – and examines the major transitions that have affected this market.

Exploring factors such as new tax initiatives, art being increasingly viewed as an alternative form of investment, the constraints placed on the market by public sector museums and galleries, and the huge amounts of money being spent on art, this text answers fundamental questions such as: Why is the art market dominated by America and Western Europe? Is art a good investment? In addition, it provides an insight into hot topics such as the illicit art trade, supply and demand in the Old Master picture market, and art crime.

This text takes an international perspective and merges theory with practice to enable the reader to understand the challenges and issues that those involved in art markets and management face today.

Analysing the decisions and actions of major art market 'players' – dealers, auctioneers, collectors, artists, investors – this text will be essential reading for all those studying and involved in art markets and management.

Iain Robertson is Senior Lecturer in Arts and Economics at City University School of Arts, London, Head of Art Business Studies at Sotheby's Institute of Art, London, Advisor to the Asia Art Archive, Hong Kong, and an Asia Correspondent for the International Edition of *The Art Newspaper*.

Understanding
International Art Markets
and Management

Edited by Iain Robertson

Routledge
Taylor & Francis Group

LONDON AND NEW YORK

First published 2005
by Routledge
2 Park Square, Milton Park, Abingdon, Oxon OX14 4RN

Simultaneously published in the USA and Canada
by Routledge
270 Madison Ave, New York, NY 10016

Routledge is an imprint of the Taylor & Francis Group

Transferred to Digital Printing 2010

Typeset in Sabon
by Keystroke, Jacaranda Lodge, Wolverhampton

British Library Cataloguing in Publication Data
A catalogue record for this book is available from the British Library

Library of Congress Cataloging in Publication Data
A catalog record for this book has been requested

ISBN 0–415–33956–1 (hbk)
ISBN 0–415–33957–X (pbk)

To my parents, Alec and Sylvia

Contents

Illustrations

Plates

Figures

Tables

Boxes

Contributors

Patrick Boylan is Emeritus Professor of Cultural Policy and Management, City University, London.

Derrick Chong is Senior Lecturer in Marketing, Royal Holloway University of London, Surrey.

Alexander Hope is Head of Old Master Pictures, Christie's, London.

Joan Jeffri is Director of the Research Center for Arts and Culture, Teachers College, Columbia University, New York.

Eric Moody is Professor of Arts Management, City University, London.

Renée Pfister is International Programme Registrar, The Tate Gallery, London.

Iain Robertson is Senior Lecturer in Arts and Economics at City University School of Arts, London, and Head of Art Business Studies at Sotheby's Institute of Art, London.

James Spencer is Director of The Chang Foundation, Taiwan.

Foreword

There have been many changes in art markets in the last two decades. Prices of many works of art have altered dramatically, but these are the stuff of headlines. Beyond the headlines there has been the appearance of a new generation of collectors, continuing sales by the inheritors of past collections, shifts in the commercial balance between sale-rooms and dealers, movements of trade to different countries as international demand or national taxation laws have exerted their influence, and long-running debates within government and museum circles about the role of museums in the management of their collections. It is therefore timely that a serious and authoritative book should appear dealing with these and other important themes.

Iain Robertson and his team of expert writers have compiled a text that will come to be considered a landmark in the field. I suspect that the book will be on the reading lists of all the arts management and business schools. Dealers, auctioneers, artists, museum professionals, private collectors and their agents will also want to study it.

The book aims to offer some refreshing and novel insights into the art market and its mechanisms. If, for example, you are interested in the debate about 'de-accessioning' by museums and whatever your views on the subject, you will want to read the discussion of it here. And is it always desirable that the governments of countries should actively prevent works of art from moving from one country to another, especially from richer countries to poorer ones? What is a reasonable position to take in this debate?

The book discusses at length the latest developments in art markets, such as the use of works of art as investment assets, new ways to tax works of art, and measures to combat the illicit trade in antiquities. The art trade emerges from the studies as a very complex market often driven by irrational decisions. It is a stimulating but risky market for its players, full of pleasing rewards and dangerous financial risks, and a potential minefield for amateurs.

Understanding International Art Markets and Management aims to unravel and de-mystify one of the last surviving unregulated international markets and to present a clear picture of its past and present state. I hope that readers will find it a valuable and stimulating source.

Sir Nicholas Goodison FBA, FSA

Acknowledgements

I have incurred many debts during the preparation, editing and writing of this book. I am especially grateful to the seven contributors: Professor Eric Moody, Professor Patrick Boylan, Professor Joan Jeffri, Dr Derrick Chong, James Spencer, Renée Pfister and Lord Hope. Without their sterling efforts this book would never have gone to press. I am also grateful to the multitudes of friends and colleagues who have helped me in the preparation of this volume: Chiang Ching-ling, Dr Paul Dawson, Johnson Chang, Kim In-hee, Chris Lumb, Li Yifei, Serghey Grishin, Andrew Mummery, Janet Oh, David Marks, Dr Brendon Howe, Jeremy Rex-Parkes and Colin Sheaf. Thanks also to my current art market students at City University and especially to Ho Meijing, Lei Zhao, Jeffrey Boloten, Stephania Portoghese, Elizabeth Molineux and Swati Bhalotia who helped by being critical.

I owe a special debt of thanks to Michael Quine Acting Head of the Department of Cultural Policy and Management, School of Arts, City University, who allowed me the time to research and write this book. My appreciation also goes to Francesca Heslop, the Commissioning Editor at Routledge, who saw the potential in such a book and guided me expertly through the publishing process. Thanks also to Sotheby's Press Office, Cass Business School library and the Bank of England for giving me all the information I needed.

1 Introduction

The economics of taste

Iain Robertson

No arts; no letters; no Society; and which is worst of all continual fear and danger of violent death; And the life of man, solitary, poor, nasty, brutish, and short.

(Thomas Hobbes, *Leviathan*, 1651, ch. 13, p. 62)

On 5 May 2004 at 7.25 p.m. New York time, in the space of five minutes Picasso's 'Boy with a Pipe' was hammered down to an anonymous bidder for $93 million, a price which rose to $104 million (£58 million) after Sotheby's added its colossal $11 million commission. A number of things can be said about this event. The first is that 'Boy with a Pipe' is now either the most or, in real terms, the third most expensive work of art ever sold at auction. The second is that the prices paid for art and antiques since the late 1980s are the highest ever. If the extravagant Duke of Saxony had been pitched against the Picasso buyer in a bidding battle of similar magnitude for Raphael's 'Sistine Madonna' (a painting the Duke acquired in 1754) he would have needed 163 times more cash. The third is that the capital returns on the Picasso have earned the vendor the equivalent of 64 per cent interest per annum over 54 years. The fourth is the morally suspect circumstances in which the work was sold, with the wife of its original owner, Mendelssohn-Barholdy, allegedly having sold the painting to a dealer against the wishes laid down by her deceased husband in his will. What does all this tell us about the art market, its past, present and future? Indeed, what is the art market? This book aims to give you the answers.

Art, some argue, stands between us and the bleak life vision encapsulated in Hobbes's epigraph to this chapter. Public sector curators, the descendants of Shaftesbury's leisured, landed class of gentlemen philosopher who achieved virtue through taste, are the self-appointed custodians of this 'treasure'. Yet, how disinterested, how unsullied by Hobbes's life are these connoisseurs of beauty? A profession by the early nineteenth century, connoisseurship imagined that it might reveal pictorial beauty through forensic analysis. Giovanni Morelli, the founding father, searched for the artist's signature brush mark in an inconsequential fragment or detail and his method informed

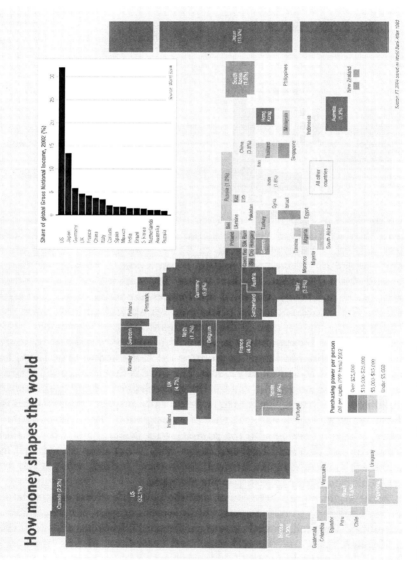

INTERNATIONAL ECONOMY THE FALLING DOLLAR

How money shapes the world

Plate 1.1 Economic world map (*Financial Times*, 2004 based on *World Bank Atlas*, 1998)

the processes by which the likes of Bernard Berenson and Max Friedlaender made their attributions. These pictorial flourishes are not always a cast iron guarantee of authorship, but as Peter Schatborn, who revised Benesch's list of Rembrandt drawings in the early 1990s, says the stylistic traits are the most important elements in determining authenticity. These people are important because the entire art market edifice rests on their pronouncements. The reduction of aesthetic judgement and valuation to a quasi-science is the reason that we have an art market, but how much of its credibility lies in the suspension of our disbelief? How much of the market is predicated on our desire for order and on our understanding that value today means money?

Art and money might still seem like uncomfortable bedmates, but in this book the relationship is sacrosanct. Art, here, is presented as a luxury commodity,[1] an 'experience good' that has to be tested or consumed before its true quality is revealed. It is also treated as an 'information good', since so much of its value is tied to an idea. The acquisition of art, a tangible 'consumption good' with 'social capital', is also seen as a positive addiction; the more that it is consumed, the more that it is desired. On the other hand, this book avoids any attempt to correlate monetary value with artistic quality or to express normative views on the quality of art. The great difficulty, however, is that so much of the value of art is tied to the 'judgements' of the commercial art establishment, that enjoy a monopoly of taste. The monopolists have access to privileged information that is not made universally available and so the market is drastically distorted in favour of the few. It is the élite nature of this market mechanism that maintains art's high unit value and encourages the perception that it is the ultimate consumer good.

This book examines art from a number of positions. The dominant one is economic and informed by Hobbes's vision of a bourgeois capitalist society in which perpetual motion, prompted by fear (the fear of death) leads to endless struggles for power. In this world, man is motivated by 'appetites' and 'aversions' and stimulated to act by the action of 'externall objects'. A crucial aspect of Hobbes's grand design is that 'appetites' continually change and are different in different men, and are incessant and of different strengths in different men. A man's power is relative to others and, 'The value, or WORTH of a man, is as of all things, his Price; that is to say, so much as would be given for the use of his Power' (*Leviathan*, Ch. 10, p. 42). Some men, Hobbes asserts, have unlimited desires, but all men seek to increase their power at the expense of others. The only society that can contain Hobbes's hungry creatures peacefully, is the Capitalist.

The international art market operates, with finesses, almost entirely on this model of bourgeois society laid out by Hobbes in *Leviathan*.

In affirmation of Hobbes, Bruno Frey declares that the economic approach to the study of art starts with the preferences or values of individuals whose views are shaped to a great extent by institutions (Frey, Peacock and Rizzo in Towse, 2003). This approach stops just short of saying what is and is not

art: 'As economists we have nothing to say on this subject; let the experts define the arts as they please, and then try to measure them economically' (Brosio, Peacock and Rizzo in Towse, 2003, p. 17). Art is thus defined by individual actors, determined by exogenous developments and subject to changes in value, correlated to changes in taste, over time (Brosio, Peacock and Rizzo in Towse, 2003). Taste is impossible to 'capture' economically, which makes the task of achieving price transparency all the harder. We argue, using Hobbes's resolutive-compositive method, that because art is determined by institutions with a monopoly of taste, art is only art when it has passed through certain mechanisms. Since money is the accepted medium of exchange for the transference of power, of which taste is one manifestation, art is only art when it has been exchanged for money. Transactions will, by definition, take place within the system. Art has by extension, therefore, latent art potential when it rests in a conduit before a sale, and is not art if it fails to appear in an art market conduit.

There is a growing body of literature dealing with the market for art. Most of it is focused on the role played by the public sector in capturing taste, arguing for or against the necessity of public arts subsidy. Frey, for example, argues sensibly for the need for the public sector to capture certain economic effects, such as public good. The Neo-Classical economist, Grampp, suggests that art should be treated like any other commodity. The Jonas Chuzzlewit school of economics – 'Do other men, for they would do you' (Dickens, *Martin Chuzzlewit*, Ch. 11) – is close to the reality of art market behaviour, but it has many detractors. Some writers believe that the instrumental-rational approach adopted by Neo-Classical economists in assessing the value of art to be fundamentally wrong. Those writers (Becker for example) might propose a sociological-economical network approach. Then there are the art historians, like Reitlinger, Wood and Cumming, who employ art-historical critiques alongside price histories.

The art that this book deals with is confined to the world of paintings, drawings sculptures (and their derivatives in the form of multiples), antiques and antiquities. All this art is purveyed through specialist retailers. The sales outlets are commercial galleries and the art fairs they attend, antique shops, auction houses, 'dirt' markets and commodities sold in so-called art ware-houses by independent specialist traders, in some department stores and the artist's studio. Two complications should be immediately evident. The first is the extreme difficulty of tracking even a small percentage of the trans-actions conducted daily on the international art market and the second is the implied ability of the retailers to determine what is art rather than leave it to the artist, traditional connoisseur or museum curator.

Economic determinism, which is based on the premise that economic growth promotes democratization, ensures re-election and is the key to international power, is, according to Niall Ferguson (2001), close to being conventional wisdom – particularly in the United States. Ferguson goes on to argue, persuasively, that the value of money is sustained by political

power and that power in turn is determined by societal demands which are often irrational. Culture is one of those irrational demands. We do not actually need it to survive, but it is certainly a strong want. The absorption, and later export, of their culture by powerful democratic governments helps define our world. Art and antiques are a sub-set of this broadest sense culture, and being commodities are particularly affected by money. The direct association between art and antiques and money elevates our commodity to the highest reaches of the capitalist tree. In short, art and antiques are the most easily translatable of the cultural commodities into the universally understood medium of exchange – money – and are consequently, on one level, the easiest to understand.

The art market is remarkable but not unique in having a substantial degree of ongoing support from the state in the form of grants to public museums and galleries. It is positively and negatively affected by pubic sector interventionism. Other commercial industries in Europe, if not in America, are also periodically subsidized: agriculture, car manufacture, the mining and steel industries to name four, but the arts are criticized because they are unproductive and appeal to a minority of the population. The counter arguments are that the marketplace is unable to capture all of art's value, and the pleasures and rewards of art should be accessible to all. The art that is supported by the public sector is of a particular type, and many practitioners and intermediaries argue that the vast range of production over the last hundred years or so is ignored in favour of a thin commercial cutting-edge. This has happened because public sector accession policies are opaque and undemocratic and fed by favoured networks. The fact that today's political élite is not necessarily its cultural élite might appear to challenge this assumption, but the arts establishment (an agenda-driven interest group) on both sides of the Atlantic is adept at presenting arguments to satisfy the paymaster. These arguments cover a range of effects that fall within the public interest. They permit a former director of the Arts Council, Luke Rittner, to say after the sale of Picasso's 'Boy with a Pipe' that 'It would be a tragedy if this wonderful picture were to be kept from public view' (Wapshott, 2004).

One is tempted to say the public couldn't care less, but then most governments squeal on the twin pikes of access and excellence. I am inclined to agree with Robert Hughes when he says that art, like war, is a minority taste.

The public sector performs a dual function. It validates the art made today and authenticates the art of the past. It prevents, through selection and in conjunction with commercial art dealers and brokers, the market from being over-loaded, a situation that would lead to a fall in art's unit value. But it hoards and fails to release works back onto the market. There are, for example, only three Rembrandts still in private hands (Alberge, 2003). The prevention of the movement of this portable asset from one set of collectors to another is justified by a series of public good and national pride arguments. There is also an art historical argument that maintains that public gallery collections add to the understanding of an artist or movement.

There are equally strong counter arguments. Many works of art, especially religious artefacts, are best seen in the churches, temples and grottoes from which they were appropriated. Special exhibitions are just as capable of bringing great works together as are permanent museum displays. A work of art, which is made for trade, loses much of its meaning when it is wrenched from the market and institutionalized. The real reasons for the restrictions placed on the flow of art owe more to political expediency, intellectual posturing and precedent than convincing argument.

The UK political arts establishment appears to group de-accessioning beside free admittance to public collections. I would agree that once a work 'rests' in a public institution the work is public property and admittance should be free. If, on the other hand, a museum decides to sell one of its assets it should be allowed to benefit financially from the transaction. The two views can co-exist quite happily. The preciousness with which we treat our art in times of peace is matched only by our total disregard for it in times of war. Iraq is simply the latest example.

The use of art for utilitarian purposes has formed an important part of public policy in the UK since the Myerscough report in 1987. Since then there have been other reports written on the economic benefit of the arts to the general economy. UNESCO produced a report on the cultural flows of selected cultural goods from 1980 to 1998 and the Department of Culture Media and Sport produced its second examination into the monetary value of the cultural industries in 2001. These enquiries and their findings are of little help to the trade. They are aimed at persuading Treasuries to continue to fund the public sector. It is fair to say that the market does not actually need the public sector but it would rather not have to do without it.

The efficient markets hypothesis (EMH) has governed the way we view financial markets since 1970 (Fama, 1972). An efficient market is one in which security prices always fully reflect the available information. Today, the idea that financial markets (arguably the world's most perfect) can be efficient has been strenuously challenged by behavioural finance and the concepts of limited arbitrage and investor sentiment. Behavioural finance maintains that the biased, the stupid and the confused operate in competitive markets in which at least some arbitrageurs are fully rational. These factors, combined with a haphazard knowledge on how real-world investors form their beliefs and valuations, lead to very low levels of price prediction (Shleifer, 1999). If these 'realities' are true of the financial markets how much truer are they of the art market where Baumol (1986) cited in Towse (2003, p. 58) has observed:

- On financial markets, a high number of homogeneous, substitutable stocks and shares are bought and sold, whereas the degree of substitutability is almost nil in the case of artistic products, given the fact that they are unique.

- The owner of a work of art enjoys a monopoly, whereas a stock is owned by a number of investors, who, theoretically, act independently of one another.
- The transactions relative to a particular stock or share take place in time almost continuously, whereas transactions concerning a particular work of art may be several decades apart.
- The fundamental value of a financial asset is known: it is the present value of the expected flow of income; on the contrary, the work of art has no long-term equilibrium price.
- The costs of holding and transacting are much higher for works of art than for stocks and shares: insurance costs are high, there are charges borne by the seller and the buyer at auction, although on the other hand the taxes incurred by these goods may be more advantageous.
- Finally, art, unlike stocks and shares, does not provide positive monetary dividends: its ownership may imply negative dividends in the form of insurance and restoration costs; it does, however, afford psychological dividends in the form of cultural consumption and services.

Part I of this book takes a topographical view of the art market, mapping its structure. It sees it within a global context and aligns it to other markets and takes into account human behaviour. In Chapters 2 and 3 I look first at the internal forces that drive today's art market locomotive and then at how these same forces have shaped past art markets. I use financial terms to give sense to the art market and break it down into category, sector, type and commodity. The art market is not global like the food and drinks market, but it is international and operates from select centres around the world. I show that without the wealth developed by bankers and accrued from global trade, the art market would have remained undeveloped. In Chapter 4, Eric Moody questions whether these forces are manageable, and whether the market is, as Adam Smith has it, guided by an invisible hand, or indeed significantly biased in favour of a self-appointed élite. Derrick Chong examines, in Chapter 5, the three prominent relationships in the contemporary art market; dealer–artist, dealer–collector and collector–artist and looks at the art market from the Classical economic perspective of production–distribution–consumption. In Chapter 6, Renée Pfister shows how the price of a picture depends on where it is sold. The cost of importing Rothko's painting, 'No. 9', to the EU would, she explains, add $458,722 to its $8.95 million sales price excluding national sales tax. The same work would attract $686,519 import duty in Switzerland but only $11,080 if consigned to the USA. Pfister considers whether these taxes as well as those invented specifically for art, namely *droit de suite*, are good for its health.

In Part II we examine some of the major market sectors and see how well they have fared over the last decade or so. Joan Jeffri draws distinctions between the American and European management of art in Chapter 7. She directs our attention to the pre-disposition of some American museums to

de-accession objects from their collections. She points also to a moral climate that permits public figures, like Mayor Giuliani of New York, to censor, on sacrilegious grounds, exhibitions such as Chris Ofili's in the Brooklyn Museum. The parallels between Jeffri's market for contemporary art in America with its tame critics and sharp dealers and the emerging art markets of East Asia are remarkable. In Chapter 8 I present the current state of development of these markets and, drawing on external 'realities' such as economic and political conditions as well as historical precedent, predict whether these markets have legs and where they are most likely to settle. I also show how great is the pricing gulf between the art of emerging and developed territories. James Spencer continues the Asia theme by introducing us to world taste in Chinese antiques in Chapter 9. It is clear from this chapter that Chinese, in particular, and Western taste for Chinese art have differed since the earliest days of the China Trade in the seventeenth century. It is also apparent that the recent economic booms in East Asia have drawn record prices from Asians for top works consigned by Western vendors. The alpha market has, significantly, also moved from London to Hong Kong and New York. If the world market for Chinese art is changing, then so is that of Old Masters. Alex Hope's observation in Chapter 10 that the price of alpha works has accelerated parallel to a huge increase in American museum endowments and a fall in the number of their acquisitions is compelling. The fact that these works, now that they have entered the institutional domain, are unlikely to re-appear onto the market has further inflated price and led to potential future supply problems. How different, Hope explains, from the days when even royal collections such as that of Charles I of England would be sure to re-appear onto the market. In Chapter 11 Patrick Boylan looks into the illegal market for antiquities and reveals a close association between the illicit traffic of works of art, drugs and guns. Plain old art theft has become a booming underground industry and governments and international agencies, perhaps because of stolen art's association with international crime, are taking preventative measures. Art is also used as a wealth-generating tool. In Chapter 12 I position art alongside other alternative investments and question the value of indices and a viable benchmark in order to establish an accurate value for this commodity. Time, place and particularly taste are the enemies of my attempts to rationalize this exotic market in which buyers often exceed their budgets and regret not this but the fact that the work of art got away. There is undoubtedly an 'X factor' to alpha art that drives buyers beyond their fiscal limits, and this makes estimates difficult to calculate. Conversely, unpopular work will regularly fail to make its reserve. Chapter 13 highlights the main themes in the book and asks fresh questions of its contents. In the final paragraph I imagine a dystopian art market, one which is efficient and autocratic.

Ultimately, the study of art markets is the study of the formation of taste informed by greed and made possible by opportunity. Those with sufficient

means at the right time, persuasive powers and the least scruples build up the greatest collections. This state of reality makes it hard for us to refute Hobbes's model of a cloak and dagger world in which 'words, not money, were the relevant currency, and selves the objects of exchange' (Thomas Hobbes, *Leviathan*, 1651, quoted in Solkin, 1992, p. 22).

Note

1 The notion of art as a commodity is challenged most effectively when reference is made to public sector art galleries and museums that store and display these 'unique' and unexchangeable or irreplaceable objects. More than unique, art, it is argued, is imbued with national, regional and, at its best, international cultural significance. This book argues, however, that cultural significance can and is, demonstrably, captured economically and art, although unique, is not the only commodity to enjoy such status.

Bibliography

Alberge, D. (2003) *The Times*, 11 July.
Bevers, H., Schatborn, P. and Welzel, B. (1991). *Rembrandt: the master and his workshop. Drawings and etchings.* New Haven, CT: Yale University Press.
Carey, J. (1999). *The Faber Book of Utopias.* London: Faber & Faber.
Fama, E. F. (1972). *The Theory of Finance.* New York and London: Holt, Reinhart & Winston.
Ferguson, N. (2001). *The Cash Nexus: money and power in the modern world 1700–2000.* London: Allen Lane, Penguin Press.
Hobbes, T. (1651). *Leviathan.* Reprinted Harmondsworth: Penguin (1985).
Hobbes, T. (1655). *Human Nature and De Corpore Politico.* Reprinted Oxford: Oxford University Press (1994).
Locke, J. (1689). *An Essay Concerning Human Understanding.* Reprinted Harmondsworth: Penguin (1997).
Marx, K. (1867). *Capital*, Vol. 1. Reprinted Harmondsworth: Penguin (1976).
Mill, J. S. (1859). *On Liberty.* Reprinted Harmondsworth: Penguin (1985).
Plato, *The Last Days of Socrates.* Reprinted Harmondsworth: Penguin (2003).
Schleifer, A. (1999). *Inefficient Markets.* Oxford: Clarendon Press.
Smith, A. (1776). *The Wealth of Nations.* Reprinted Harmondsworth: Penguin (1973).
Solkin, D. H. (1992). *Painting for Money: the visual arts and the public sphere in 18th century England.* New Haven, CT: Yale University Press.
Towse, R. (2003). *Handbook of Cultural Economics.* Cheltenham: Edward Elgar.
Wallerstein, I. (1979). *The Capitalist World Economy.* Cambridge: Cambridge University Press.
Wapshott, N. (2004). 'Last glimpse of boy with a $104m pipe', *The Times*, 7 May.
Wind, Edgar (1960). *Art and Anarchy*, The Reith Lecture. London: BBC.

Part I

The structure and mechanisms that fuel the art market

2 The international art market

Iain Robertson

For by Art is created that great Leviathan called a COMMON-WEALTH, or STATE, (in latine CIVITAS) which is but an Artificiall Man; though of greater stature and strength than the Naturall, for whose protection and defence it was intended; and in which, the Soveraingnty is an Artificiall Soul, as giving life and motion to the whole body; . . . The Wealth and Riches of all the particular members, are the Strength.

(Thomas Hobbes, Introduction to *Leviathan*, 1651)

We don't, in truth, need an art market anymore than we need art, but it is inevitable that when a desired commodity like art is created and made available, a distribution system forms around it. The system in this instance is replete with whispered half-truths and double talk, misinformed and misunderstood sound bites uttered by 'players' with strong vested interests, an extension of our imperfect selves, but it's all that we have and it's the best that we have. And this is how it works.

The international art market is the sole mechanism for conferring value onto art and antiques. It is also imperfect and difficult to access, consisting of thousands of élite, specialist retailers, a proportion of whom receive support from government. Government's support for parts of the art market is more subtle than the support it affords other industries, but it is no less effective. The art market, although dominated by two companies, Sotheby's and Christie's, by no means has the consumer at the mercy of a duopoly, nor is it dominated by an all-powerful, price-fixing cartel. It is perceived to be glamorous, exciting and engrossing and it carries the same allure as the fashion, film, media and sports industries. In truth, it has as much to do with entertainment as it has to the hard-headed world of global finance. Art market 'players' may appear to be aesthetes masquerading as financial traders but today the opposite is just as true – Christie's gentlemen pretending to be businessmen is a thing of the past. The sheer quantity of information that any business has to process, coupled with the international nature of art dealing, demands a greater professionalism and financial awareness from the art market's operators than at any time in its long history. This chapter

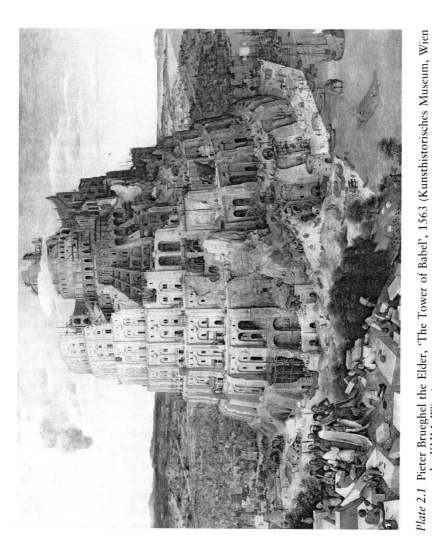

Plate 2.1 Pieter Brueghel the Elder, 'The Tower of Babel', 1563 (Kunsthistorisches Museum, Wien oder KHM, Wien)

will examine and comment on the structure of the art market, drawing out its peculiarities and particular characteristics.

The fact that art needs to be experienced and enjoyed means that prior knowledge of its quality is often unavailable, putting the ignorant consumer at a disadvantage. The opaque nature of art information means that the unwary consumer is left confused. Pignataro (Peacock and Rizzo in Towse, 2003) explains that imperfect information can cause 'producer inertia', but this does not appear to be the case in the art market, where consumers conceal their errors to protect their reputation. The cost to a buyer of acquiring the correct information on a work of art can be measured in the buyer's time and effort (opportunity costs) or the commission taken by a dealer or auction house at the point of sale. The penalties of not buying through traditional channels and going it alone can be high. A French couple bought £12.5 million of gems and Chinese artworks over a four-year period from a group of individuals in shopping-centre car parks and hotels in France and Spain. They were later found to have been dealing with an international group of gypsy con-men who had sold them, among other things, statues and vases made in Hong Kong and Taiwan in the 1950s (Samuel, 2003).

Information costs are only half the story; the seller has to consider the costs of making a transaction because buyers are, unfortunately, not drawn magnetically to the right art, they need to be introduced and then induced or persuaded to part with their money. These costs are made up of the promotion or marketing of artists and their work. Auction houses are compensated by the buyers' and sellers' commissions, charging sellers a fee even if the work is 'bought in'. Dealers pass these costs onto the buyer and dealers and brokers impound their commission into the sales price.

Market structure

Every art object or work of art has a 'source market', a point of origin, be it artists in their studios or grave goods buried deep beneath the ground. This item becomes a 'commodity' when it is traded in the art market. It can be traded 'locally', 'regionally' or 'internationally'. If it is a significant cultural artefact it will be traded internationally. A contemporary work of art is classified as either 'junk' (low unit and negative investment value), 'cutting-edge' or 'alternative'. 'Cutting-edge' work receives the support in the West of the publicly funded cultural sector and 'alternative' work does not. 'Cutting-edge' art is a legacy of the end of nineteenth-century Parisian dealer revolution and 'alternative' a derivative of the Academy system. Each one of these sectors determines the future value of the object (Robertson, 2000).

The stage of development of a country from which a cultural artefact originates has a strong bearing on that object's value. If the country or region is perceived to be transitional,[1] its culture is deemed primitive and its cultural artefacts of lesser value than those of a developing or developed country or region. The price of a work of art created by a contemporary artist is

also determined greatly by the environment in which it is created. If an artist from the Ivory Coast paints a painting in Abidjan it is highly likely that a similar work created at the same time by an artist in New York will have a greater value. This imbalance exists because transitional and developing economies have lesser art markets, producing lower levels of added value for their art. The only time a regional art market outperforms an international one is when there are particularly high levels of regional interest for a regional artist or object. There are examples of international art markets in developing economic regions. SAR Hong Kong, for example, is the international trading centre for Chinese art (see Chapter 9) and although not supported by an indigenous body of collectors prospers, as we see in Chapter 8, as an offshore, international art centre.

The correlation between economic, social and cultural capital is contentious. Goldstone (Towse, 2003, p. 180) talks of the supranational cultural body, UNESCO's 'strong wish' to construct a composite cultural index. The main objection to the proposal came from those who feared the establishment of a 'rich country cultural development index'. The same people also worried that it might be inappropriate to talk of culture in terms of one monolithic single cultural index.

Uncomfortable as it may be for market economies to accept that the rich nations are more cultured than the less rich and the poor, it is demonstrably true. As Goldstone explains:

> Because 'culture' as it is statistically defined is limited primarily to market activities and not life activities, people and countries that do not participate in the market are not considered 'cultured' from the point of view of the statistics that are currently available.
>
> (Towse, 2003, p. 180)

Common sense tells us that in a market economy, rich individuals and the citizens and subjects of wealthy countries can afford to travel, learn and experience commodified culture better than others. The depth of cultural understanding and experience for this culture is impossible to measure but an acquaintance with it is infinitely greater in the developed world than elsewhere. It can be measured by accumulating data on the imports of works of art in a country and surveying the state institutional and commercial provision for arts and culture.

The USA imported 43 per cent of the world's visual art culture in 1998, a pre-eminent position it has maintained since 1980, losing out briefly to Japan in 1990 when that nation experienced abnormally high levels of economic performance. The trading partners of the main exporters (the UK, the USA, Switzerland, France and Germany) of collectibles and antiques in 1998 were Japan, Hong Kong, Australia, the Netherlands, Canada, Italy, Belgium and Austria; all highly developed and therefore cultured states (UNESCO, 2000). We shall see that the status of the public sector cultural institutions in the countries that import and export the most art and antiques is unrivalled.

Gross Domestic Product (GDP) has a considerably greater impact on the import of works of art than on total trade. Variables that capture cultural proximity, distance and common language also exert a stronger influence on works of art than on total trade (Towse, 2003, p. 272), which adds substance to the view that the correlation between wealth and culture is strong. It follows, therefore, that city-states like Hong Kong and cities like New York, London, Paris and Basel are home to the highest premium art markets. Their success is dependent on key macroeconomic conditions: an internationally politically strong government, general economic prosperity, a soundly managed economy, a speculative environment and a high standard of living. Their respective markets must then demonstrate an ability to achieve international prices, attract indigenous or offshore demand and international competition, create benign business conditions and laws, provide public sector cultural investment and support and invest in the urban environment and in its community's cultural education (Robertson, 2000).

The 'core' capitalist societies of Western Europe, Japan and North America (Giddens, 1986, p. 151) attach the greatest premiums to their culture and the international art exchanges are established in their respective financial centres. (See Figure 2.1.)

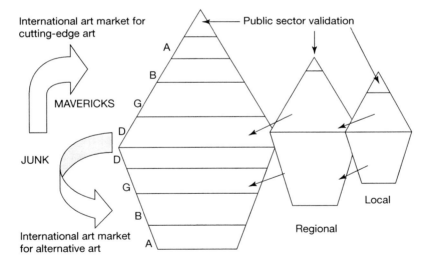

Figure 2.1 The markets for contemporary art

The international art market for cutting-edge art confers added value onto its art by ensuring that it is validated by the public sector. This value is represented by the apex to the triangles, an apex which is absent from the alternative market. Both markets have local and regional equivalents and Alpha to Delta dealers, but only the cutting-edge Alpha dealers have access to public sector validation which results in a significant price premium for the living artist and his/her dealer and secures the future of the work after the artist's death. Junk art remains outside the art market structure and valueless, but amongst the junk, mavericks hold out hope of inclusion in both, sometimes posthumously.

Primary, secondary and tertiary art markets

The art market is divided into three distinct trading levels: primary, secondary and tertiary (Singer and Lynch, 1994). There is a fourth, the illicit trade, which will be dealt with separately in Chapter 11. The primary market deals in work that appears on the open market for the first time. At this stage the works of art have not been bought or sold before and sales represent the first time artists discover that someone, often unknown to them, is prepared to exchange money for the benefits of ownership. A work of art by an 'undiscovered' deceased artist – a maverick – may also be traded on the primary market. An example would be the paintings of Van Gogh, sold after his premature death. The dealers in this market tend to be young and energetic, operating on very small margins with little or no stock. They are also more likely to act as brokers than dealers, lacking the funds to purchase the artist's output.

Ownership may be short-lived, especially in today's cutting-edge contemporary market, and the same work may soon re-appear with a different dealer on the secondary market. This middle market is characterized by established quasi-institutional galleries with significant cash and stock. The artists represented are either in late middle age (established contemporary),[2] dead (modern) or long dead (Old Master). At this point the work becomes more significant, and its price inevitably rises. It is a curious feature of the art market, and one that will be looked at in Chapter 12, that levels of demand do not impact on price as much as rarity and market approval. Once distinct, the tertiary or auction market is now indistinguishable from the secondary.

The market's composition

The art market offers many collecting opportunities that can be usefully divided into 'categories' such as furniture and decorative arts, 'sectors' such as rugs and carpets and 'types' such as Persian carpets. Almost every 'commodity' (a single Persian rug for example) within 'type' is heterogeneous with distinct characteristics (see Figure 2.2).

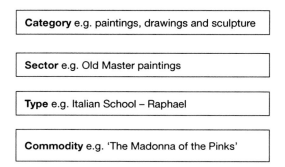

Category e.g. paintings, drawings and sculpture

Sector e.g. Old Master paintings

Type e.g. Italian School – Raphael

Commodity e.g. 'The Madonna of the Pinks'

Figure 2.2 The four components that make up the art market

The main temporal sectors within the paintings and drawings category, for example, are divided into the Old Masters, modern and contemporary markets. Old Masters start with Giotto and end with the early nineteenth century (Constable or Corot). The 'modern' market begins with the Impressionists and ends at the beginning of the Second World War. The 'contemporary' market comprises post-war art, but clearly its time lines will have to be reassessed as we move further into the twenty-first century. Asian art, which consists of all the creative arts from that continent, spans the earliest dynasties until the present day. Antiquaries are classified as works that predate the modern age or have been created by cultures that failed to modernize or modernized later than the core capitalist economies. It is worth saying at this stage that the Fine Art 'categories' and the dates that separate one 'sector' from another are often subjective and loosely interpreted. For example, at auctions in New York, Constable and Turner are considered to be Old Masters. Contemporary art is the most abused term in the art world, because it often used only for cutting-edge art. In this book it means work that is made by a living artist. (See Figure 2.3.)

Collecting 'types' within selected 'sectors'

Most 'types' within 'sectors' are made up of unique commodities but this distinction is often dependent on the object's condition where it is not unique, as is the case in many of the 'sectors' listed in Figure 2.4, with the possible exception of scientific instruments and furniture. These 'commodity' distinctions are related to value and will be dealt with in Chapter 12.

The role of the public and private sectors

The art market consists of institutional and commercial 'players'. The institutional players are supranational bodies such as UNESCO and Interpol. The national organizations are ministries of culture, agencies for the promotion of culture overseas, customs and excise, public museums and galleries and art schools. The world's five leading economies (the USA (Embassy), Japan (Japan Foundation), Germany (Goethe Institute), the UK (British Council), and France (Institut français)) actively promote their national culture overseas. The issue of a powerful ministry of culture is less significant, and apart from France the major industrial countries have relatively impotent ministries. Most countries have some form of customs and excise, public museums/ galleries and art schools, but the relative effectiveness of these entities varies from state to state. The commercial players are private/foundation collections, galleries and auction houses, specialist art magazines and dealers' societies. Most major cities have private museums and many developing and developed states have local and even international auction houses, dealers' societies and art magazines.

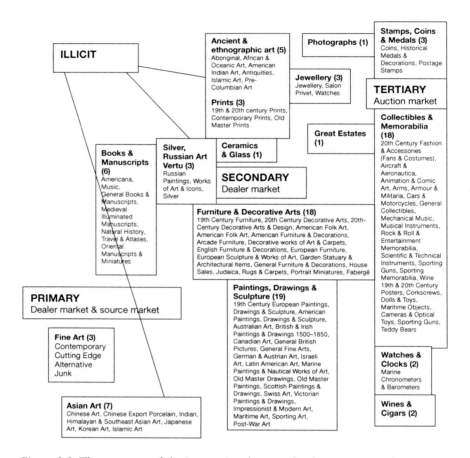

Figure 2.3 The structure of the international art market by category and sector

While it is probably safe to say that the market is dominated by the dealer trade, private buyers are becoming increasingly significant. The 15 separate categories that I have identified and drawn from Sotheby's and Christie's specialist departments (except for the contemporary art category which is my own invention), which in turn comprise almost 100 separate sectors, are presented in terms of their suitability or susceptibility to four markets: primary and secondary dealer markets, the tertiary auction market and the illicit market. This is not to say that Asian art, Antiquities and Russian icons are largely illicit, it is to say that a great quantity of art excavated, retrieved and sold appears on the market without regulation and is therefore prone to enter the illicit trade. Asian art and paintings, drawings and sculpture (Old Master drawings for example) are more suited to the secondary market because of the high levels of expertise required to authenticate and value the objects. The English silver market is dominated by the London trade and the wine business, because of the great difficulty in predicting successful growths, is controlled by a few agents. Motor cars and great estates are dealt with very effectively via mass marketing brokers, but at the top end appear in the tertiary market.

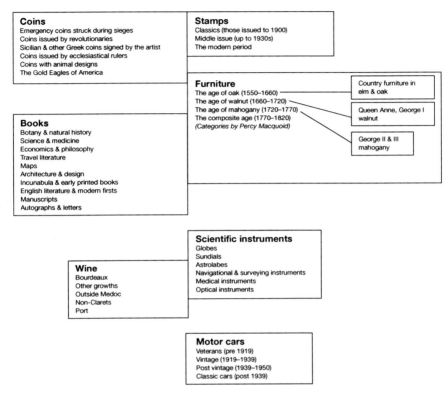

Figure 2.4 Sector and type components of the art market

 The institutional players construct a system of controls that restrict the entry of artists, art works, antiques and antiquities onto the art market. They do so in a number of ways. They prevent (see Italian *Testo Unico*, Chapter 6) or delay (see the UK government's stalling over the awarding of an export licence for Raphael's 'Madonna of the Pinks') works from leaving the country of ownership. They levy excessive import taxes (see Chapter 6) and they hoard. They act in this way for the 'public good' and to make money for their Treasuries. The result, however, is akin to over-fishing our seas – the number of works by 'dead' artists diminishes and the art gene pool contracts. Occasionally, the pubic sector intervenes in a positive manner by de- and re-attributing works to a famous artist.[3] This process of re-authentification is extremely important and dynamic, and it is doubtful whether it could be executed as convincingly by a private authority. Public exhibitions of the work of dead artists enhances the value of their work and the acquisition of contemporary art by our public art galleries validates an uncanonized commodity.

The commercial players have developed a pragmatic, if opaque, system of career development for artists in the contemporary art market. They consign most to a lifetime of the manufacture of junk, but admit a fraction of art school trained practitioners to one or the other of the mainstream markets and convert their creations into either cutting-edge or alternative art.

General price movements in the art market categories are determined by externalities, as is the case in the stock market, but 'sectoral' or art 'type' rises and falls are to a great extent manipulated by a consensus of opinion within art markets. The upward and downward shifts in the value of commodities are determined, therefore, by the commercial and public institutions represented by players working for these institutions. The art market is a restricted market with high barriers to entry, but, 'Unlike other restricted markets where barriers to entry benefit sellers at the expense of buyers; in art markets buyers and sellers are equally interested in restraining trade' (Singer, 1988, p. 34).

So, despite the great number of commercial sales outlets and public arts institutions, changes in value occur gradually and not always uniformly, but with the compliance of all the players. Taste is one of the important determinants of changing value in the art market and it is a condition that takes time to form and to alter, but power, which is closely related to taste, is turned into influence and thence value, and is conveyed according to the processes described in Figure 2.5.

Figure 2.5 shows that institutional power is most strongly felt in the antiques, antiquities and art of the past markets, through legal controls, import and export restrictions and authentification services. The contemporary art market is actually controlled discreetly at commercial player level. Dealers select art, then restrict supply onto the market and inform the public sector and critical worlds. The public sector museums and galleries and critics validate the commercial sector's decisions and convert, over time, cutting-edge contemporary art into the modern and Old Master work of the future. It is at this point that public sector attribution, scholarship and legal constraints begin to influence the market. We are left to conclude that the impetus and origin of much of our culture is commercially inspired and that commercial organizations feed the public institutions with the requisite information, expecting validation in return. This is the nature of the cultural contract. Art is made, in the main, of cheap raw materials and presented and sold in both public and private sectors by an underpaid workforce. It enjoys, in short, through the market's alchemy, extremely high levels of added value.

Government interference with the patterns of the art trade will be discussed in greater detail in Chapters 6 and 11, but it is worth recounting some of the legal constraints and stealth taxes in this chapter.

According to Article 36 of the Treaty of Rome, the EU member states have the right to protect their national patrimony through export restrictions, and they are free to define what they regard as national patrimony.

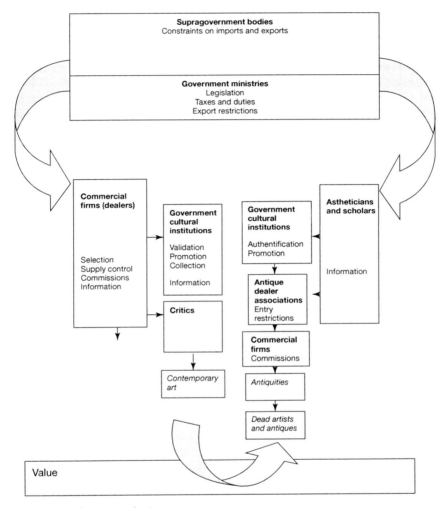

Figure 2.5 The art market's power structure

Value added tax (VAT), which varies from state to state further distorts the market. In the EU, for example, works of art are taxed at the margin (the difference between purchasing and selling price) according to the origin principle, which works against high VAT countries. *Droite de Suite* or the resale royalty right, which entitles artists and their heirs (70 years after their death) to a percentage of the profits from the resale, will now operate uniformly in the EU, with a five to ten year period of derogation for some countries. This leaves Switzerland and the USA (excluding California) as the only major markets without resale royalty rights. The costs of collecting this new tax will be high. The tax will benefit famous artists' families and depend

largely on blood ties (US Dept of Commerce, 1992). EU states, in particular, through tax incentives and export restrictions, are keen to prevent works of art from entering the bone fide art market. The UK has recently (Resource, Annual Report 2001/2) decreed that the Treasury will accept works of national and local importance in lieu of inheritance tax (IHT). The EU, in danger of being declared protectionist, is threatening to denude the British and Continental art markets, forcing commercial players to re-locate to Switzerland, Hong Kong, New York and, who knows, the Cayman and Channel Islands where the trading conditions are more favourable.

The players

While it is the aim of any trader, collector or dealer to corner the market this is, in truth, difficult to effect in the art market. There are just too many players and too much art for even a Saatchi, Richard Green or Larry Gagosian to own enough of the commodity to dictate prices and terms to others.

Dealers and brokers

What makes someone decide to become an art dealer or broker? Trimarchi (Towse, 2003) suggests that the motivation lies somewhere between altruistic mission and revenue maximization. Three of the most prominent incentives for dealing are the excitement of trading in a unique commodity, the intellectual appeal of art and the opportunity to be privy to privileged information. Super-dealers act as price stabilizers, but with greater numbers of small traders entering the market post art market recovery and the aggressive pursuit of record prices by auction houses, the market is volatile and the dealer-controlled art historical process harder to predict.

Dealers are as much collectors as traders, 'An art dealer is one who breaks even on the operation of his gallery from sales to the public, and may get very rich on what he does not sell to the public, but keeps for his own stock' (Ackerman, 1986, p. 27). Bone fide dealers are in a stronger position than brokers because, having acquired the work, a dealer can wait for the client. Brokers, in contrast, are under greater pressure to sell in order to realize their commissions. Some of the art market's super-dealers who have a great deal of information on emerging markets or certain categories of art might be considered jobbers because they are able to control supply and even set prices. But 'jobber' is an inappropriate term for art traders, because it suggests regulation and a central trading arena, which is absent from the art market.

When you buy works of art from traders you are buying into their reputation, taste and understanding of the market. You are buying into the trader as much as the artist and the work of art – the three are inseparable. In a sense you could say I have just acquired a Jopling, White Cube, Damien Hirst, Spot Painting, or a Kahnweiler, Picasso, Cubist, Still-Life.

Dealers and brokers, typically, operate out of street-front shops, or on the upper storeys of commercial premises, but also from home. In recent times, traditional avenues of sale have been circumvented with the appearance of artist-curated shows, inventory parties, at which people sell everything they own, and art parties, which mix a convivial occasion with art sales.

Super-dealers take as much as 90 per cent of the sale price of a work of art in commission and substantially discount work for public institutions and favoured clients, in order to enhance an artist's reputation. Dealers serve buyers and try always to stabilize prices by witholding or releasing supply onto the market. Brokers and auctioneers represent sellers seeking to maximize the sales price.

There are four distinct gallery trading levels and each can be risk-calibrated:[4]

1 Alpha – *gilts or treasury notes*, high quality art of dead artists. Old Master paintings, the best moderns and highest quality Asian art and antiques. Exclusively secondary market with considerable and certain resale and investment value.
Proprietors: Collector-connoisseurs, businessmen (former merchant-bankers or speculators) amateur dealers who may choose, for tax reasons, to operate at a loss.

2 Beta – *blue chip securities*, highest quality contemporary art, exclusively secondary market with highly likely potential resale and investment value.
Proprietors: Businessmen (financial services), amateur dealers who may choose, for tax reasons, to operate at a loss.

3 Gamma – *index-linked bonds and futures*, works of art that may prove worthless or ascend to the Beta level
Proprietors: Artist dealers and intellectuals.

4 Delta – *junk bonds*, i.e. worthless unit value art, with significant aggregate value but no resale value. Oil paintings, sculptures and low value (often damaged) antiques.
Proprietors: Souvenir merchants and tourist memorabilia sellers, park-railing merchants, art supermarket and warehouses salesmen.

Auction houses

There have been a spate of mergers in the art market in recent years. Bonhams (founded 1793) have acquired Phillips UK and Butterfields, the West Coast American auction house. Bernard Arnault, CEO of Louis Vuitton, Moët Hennessy (LVMH) sold his stake in Phillips, de Pury and Luxembourg to Simon de Pury and Daniella Luxembourg. Daniella Luxembourg has since left the partnership to establish a gallery in Zurich with Italian dealer Andrea Caratsch. Phillips, founded 1796, and for a long time the third largest house

in the world, is now a small specialist auctioneer operating out of offices in New York, Geneva, London, Munich, Paris and Zurich. In an interesting side-show to the art market, De Beers, the diamond company, are hoping to use LVMH stores in the US to penetrate the one market they have yet to conquer. In another French bid to control a British auction house the tycoon, François Pinault, head of Pinault-Printemps-Redoute, bought Christie's in 1998, but has since re-sold it. Sotheby's is in a period of transition. The American Ronald Baron owns a 41 per cent share and the incarcerated Alfred Taubman owns 26 per cent, but with former CEO Didi Brooks sentenced to house detention it has been left to William Ruprecht, the new Chief Executive, to steady the ship.

The French auction houses are, meanwhile, fighting a rearguard action against Christie's in particular, which is newly arrived along with Sotheby's in the French market. Still dominated by sales at Drouot, the French market is now headed by Christie's, with a 20 per cent share, having overtaken Tajan in 2002 (Melikian, 2004). The main French houses have, however, continued to perform well, with Tajan, Artcurial, Calmels Cohen and Piasa outperforming Sotheby's in France (Artdaily.com). Artcurial, which merged recently with Briest, has now bought Hervé Pulain and Remy le Fur, taking advantage of a new law that allows French houses to introduce outside investors. This newly formed French art business operates out of prestigious Paris premises close to Christie's and combines dealing with actioneering. Moves towards concentration have spread outside Paris, with a number of provincial houses, known as 'Ivoire', comprising more than ten auctioneers, aiming to set up an auction house conglomerate with national reach. The right of *commissaires prisseurs* to hold auctions ended on 10 July 2002, thereafter only companies have been allowed to hold auctions (Artprice Index, June 2002).

Auction houses[5] like dealers can be classified into four levels:

1 *Alpha 1* – Sotheby's and Christie's.
2 *Beta 1* – Those houses second in national markets to Sotheby's and Christie's but with international reach – such as Dorotheum, Finarte, Bonhams, Tajan.
3 *Gamma 1* – Those houses or consortia of houses that have national standing.
4 *Delta 1* – Regional and local auction houses.

Critics

Since the market is unable to disperse its information efficiently, critics, who serve little utilitarian market function, spread their normative judgements throughout the art world. Aesthetic judgements on art, however, depend on the dealers' actions, and are not spontaneous. It is the dealers and auction houses, responding to long-term changes in taste, that act as the real 'aes-

thetic risk arbitragists' (Gérard-Varet, 1995). Critics are the jackals of the art world, feeding off captured prey. They are active in all markets but less influential in the market for dead artists, antiques and alternative contemporary art and at their most potent and influential in the contemporary cutting-edge market. They are most effective in the market to which final value has yet to be awarded, and less effective in this market when the value criteria are dependent on skill, subject matter and technique.

David Lee's iconoclastic arts news sheet, *The Jackdaw*, demonstrated quite clearly that the link between the cutting-edge commercial and public sectors is reinforced by 'servile arts correspondents'. Lee's detective work con-firms what we have always suspected, that critics will review exhibitions in metropolitan art centres and wealthy arts foundations that are capable of extending them lavish hospitality, but rarely venture outside these enclaves. It all has very little to do with efficient or comprehensive reporting and much more to do with intellectual and physical indolence. (See Box 2.1.)

Box 2.1 The UK's top ten art galleries by newspaper coverage, 2001

Tate Britain
White Cube
Tate Modern
Serpentine Gallery
Royal Academy of Arts
National Gallery
Lisson Gallery
Anthony D'Offay
Saatchi Collection
ICA

Artists

'Artist as personality' stretches back to Michelangelo. Rembrandt was certainly outspoken and uncompromising, taking an active interest in promoting his reputation. Since the 1960s the star system has culminated in the 'artist as media star'. Andy Warhol is perhaps the best known, but there is also Jeff Koons, with his much publicized and media-ized marriage to La Cicciolina, and Julian Schnabel and Joseph Beuys, both of whom used the media to good effect. Quite how these self-promotional marketing practices are reflected in an enhanced reputation is impossible to gauge, and one is drawn to conclude that exposure without substance is, in the end, detrimental to an artist's reputation.

Since the demise of the art guild and Academy, artists have had an identity crisis. In the USA, an artist is defined according to his job in the previous week and dual careers and part-time employment are very common (Benhamou in Towse, 2003). I would agree with Benhamou's assertion that there are just too many of them: 'Since Diplomas have a low signalling capacity, people enjoy ease of entry to careers, especially those of the visual artists, this is a source of oversupply' (Benhamou in Towse, 2003).

Art schools do start the process, however loosely, of moulding the artist. The second stage of recognition is probably bestowed on apprentice artists by their peer group. If apprentices are able to attract the support of a Beta or Gamma dealer they can justifiably call themselves artists and they will start to conform to a gallery style. An alternative course of action is to present (and sell) work at an artist-curated show, raising the apprentice artist's status to senior apprentice. This method provides an opportunity for the artist to be 'spotted' by a dealer. Thereafter the fully fledged artists are as good as their last sale/exhibition, defined on the basis of their sales records. They stop being an artist if they fail to continue to sell their work, although, like Degas and Rembrandt, both of whom were rejected by the market at the end of their lives, the late work will command premium prices after the artists' death. This premium price is calculated on the basis of their earlier successful commercial reputation, aligned to the romantic notion that they rejected the market.

Artists rarely enjoy the luxury of a written contract with their dealer and exhibit and sell on the basis of a 'gentleman's agreement'. This situation, Velthuis suggests (Towse, 2003), is due to the fact that artists cannot be relied on to produce X number of paintings in blue and red every month. (See Figure 2.6.)

Benhamou (Towse, 2003) further argues that artists are irrational in their choice of profession, because of the low rates of success but, he points out, they are utility maximizers, seeking the optimal set of pecuniary and non-pecuniary rewards. High rewards for successful artists attract young risk-takers and contrary to popular belief artists are not significantly worse off, economically, than the rest of society (Benhamou in Towse, 2003, quoting Filer, 1989). Figure 2.6 shows how artists can scale the heights, but just as quickly sink without trace.

Collectors

The British art magazine *ArtReview* concluded in its December 2002 issue that Charles Saatchi, François Pinault (before he pulled out of Christie's) and Ronald Lauder (heir to the Estée Lauder empire) were the three most influential figures in the art world. Their elevated status had much to do with their day jobs, but nevertheless points to the value we place on the art market's consumers.

William Packer (2003), writing about the American early twentieth-century collector, Grenville L. Winthrop, describes collectors as: 'hoarders who are

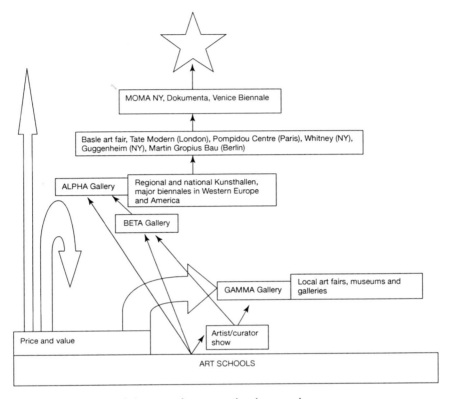

Figure 2.6 Progress of the artist from art school to stardom

sucked into their special subject – the stamp-collector–train-spotter type – and then there are the magpies, who pick up, with more or less discrimination, whatever catches their eye.' Stamp-collector and magpie are terms that accurately describe two types of collector, but there are also speculator collectors who attempt to make their collection work for them financially. At bottom all collectors seek access to the esoteric world of art with its sense of cultivation and shock of the new. The arrival of what Singer (1988, p. 36) has called the 'self-insured collectors' who cover and hedge themselves against mistakes by buying the entire oeuvre of a basket of artists and gain public sector validation soon afterwards, was the hallmark of 1990s cutting-edge collector tycoons.

The particular flavour of collectors is determined by what they did to make the money to start collecting in first place. Heinz Berggruen, a dealer who put together an Alpha collection of moderns was a stamp-collector. He collected in depth and with *verstandt* (Robertson, 1991). T. T. Tsui, who bought and sold a museum quality collection of Chinese art, was the classic self-insured collector. The steel baron, Thyssen, and his potpourri of Old Masters was

a magpie. Charles Saatchi, the advertising mogul is, like Berggruen, an astute speculator/collector de-accessioning when needs must. Frank Cohen, the discount wallpaper baron and self-styled northern Charles Saatchi, is quoted in the *Observer* as saying, 'I am a buyer. I was always a buyer, although I was in retail' (Thorpe, 2003). The act of buying and the thrill of the purchase at the right price lies at bottom behind many a collecting habit.

Public sector curators

I was ambivalent about curators in the second paragraph of my first chapter, saying that they were essential but not pre-eminent. They are the high priests of the art market and also its messengers, relaying information between agent and principal. Since most of this *ex ante* and *ex post* information is very variable and asymmetric, it often confuses the consumer. The moral hazard is compounded by the processes of selection which, contrary to Trimarchi (Towse, 2003, p. 347), are not, I believe, mitigated by a third party, the curator. The public sector does not cover all the risk that commercial institutions are unwilling to take on, but much of the market's disequilibrium is discounted by the institutional curator.

The degree of public sector disinterestedness in the value of art is debatable. Taylor (1999) has argued that the early twentieth-century mega-dealer, Joseph Duveen's, gift to the Tate of Impressionist paintings in 1918 underlined the dominant cultural position enjoyed subsequently and ever since by Impressionism. Hugh Lane, who acquired his collection of Impressionists through Durand-Ruel and donated this work to public collections, was one of many collectors who further determined the contents of our gallery collections and of art history. These collections are ably interpreted and preserved by our cultural civil servants but they are the fruits of the marketplace, handpicked by dealers.

The size of the market

The US and European art markets were estimated to have generated $20,053 million in 1999. The US market was worth $9,688.6 million (48 per cent) and the European market $10,365 million (52 per cent). The UK accounted for $5,242 (26 per cent) of European revenues, with a further $987 million spent on ancillary industries. French sales exceeded $3,000 million (15 per cent) for the first time. Germany was the only other European country to register sales in excess of $500 million. Germany was followed by Switzerland, Austria, Italy, the Netherlands and Sweden in 1998, but the total art sales of the German-speaking countries during this period was still under a third of France's (MTI, 2000). Artprice (2004) states that the US market in 2003 contracted in the wake of 9/11 to 42 per cent of global share, with the UK up to 28 per cent share and France down to 9 per cent. Europe now has a 54 per cent share of the global art market. Market share for 2003 was as shown in Table 2.1.

Table 2.1 The global art market share for 2003

	(%)
USA	42
UK	28
France	9
Italy	3.6
Germany	1.7
Netherlands	1.7
Australia	1.6
Switzerland	1.5
Sweden	1.3
Hong Kong	1.2
Others	6.8

Source: Artprice (2004).

The UK is home to approximately 750 auction houses, 9,600 dealers, employing over 37,000 people, but its galleries and auction houses are less efficient than its American and European equivalents (DCMS, 2001).

An obvious omission from the list of countries in Table 2.1 is Japan, which is after all the world's second economy. The reason lies in the inability of any of the art indices to capture tertiary market activity in that country, the absence of Sotheby's and Christie's, and the particularly secretive nature of the Japanese market.

The auction house records in Table 2.2, which lists the prices of the most expensive items sold across a range of categories and the eight most expensive paintings sold at auction, clearly show how highly we value paintings, drawings and sculpture. Within this category, modern and Impressionist art rules the roost. The top seventeen highest priced items are occupied by Van Gogh (4), Renoir (1), Cézanne (1) and Picasso (9). With the exception of one sale, Picasso's 'Les Noches de Pierette' ($51.6 million) at Drouot-Binoche & Godeau in 1989, and the alleged private treaty sale between Getty and the Louvre in 2004 for the Titian, all the top 16 lots were sold at Sotheby's (8) and Christie's (7). New York and London dominate the sale of top-priced lots, with New York holding sway in the modern market and London just pipping New York by five to four in the top ten highest priced Old Master paintings. One record breaking Old Master work was sold in Monaco. The top Old Master prices range from $12,656,000 to $76,730,700 and the four top priced Old Masters are Rubens and Titian (Table 2.2), Jacopo da Carucci, called Pontorno, 'Portrait of Duke Cosimo I de' Medici' ($33,002,500) and Rembrandt's 'Portrait of Lady, Aged 62' ($29,167,755). It is worth bearing in mind that the 'Portrait of Dr Gachet' by Van Gogh and Renoir's 'Au Moulin de la Galette' would, when inflation and the weak dollar are taken into account, today fetch approximately $133,370,000 and

Table 2.2 Selection of top auction house prices for a basket of art and antique commodities

Artist	Item	Price (million)	Category	Where sold	Date
Picasso	'Boy with a Pipe'	$104	PDS modern	Sotheby's (NY)	2004
Van Gogh	'Portrait of Dr Gachet'	$82.5	PDS modern	Christie's (NY)	1990
Renoir	'Au Moulin de la Galette'	$78.1	PDS modern	Sotheby's (NY)	1990
Rubens	'The Massacre of the Innocents'	$76.6	PDS Old Master	Sotheby's (Lon)	2002
Van Gogh	'Portrait de l'artist sans barbe'	$71.5	PDS modern	Christie's (NY)	1998
Titian	'Portrait of Alfonso d'Avalos'	$70	PDS Old Master	Private Treaty	2004
Cézanne	'Rideau, Cruchon et Compotier'	$60.5	PDS modern	Sotheby's (NY)	1999
Picasso	'Femme aux bras croises'	$55	PDS modern	Christie's (NY)	2000
X	The Badminton Cabinet	£19	Furniture and Decorative Arts	Christies (Lon)	2004
Simon Benning	The Rothschild Prayerbook	£8.6	Books and Manuscripts	Christie's (Lon)	1999
X	The Gospels of Henry the Lion	£8.1	Books and Manuscripts	Sotheby's (Lon)	1983
X	Barberini Venus	£7.9	Antiquities	Christie's (Lon)	2002
T. Germain	Louis XV Tureen etc. 1733–34	$10.3	Silver, Russian Art, Vertu	Sotheby's (NY)	1996
X	Bronze Ritual Wine Jar	$9.2	Asian Art (Shang/Zhou Dynasty)	Christie's (NY)	2001
X	Iron Decorated White Dragon Jar	$8.4	Asian Art (Choson Dynasty)	Christie's (NY)	1996
Ferrari	Ferrari 330 P3	$5.6	Collectibles and Memorabilia	Christie's (CA)	2000
X	3 Skilling, Swedish Yellow	$2.3	Stamps, Coins Medals	Christie's (NY)	1996
Stradivari	Violin, Cremona 1712, Le Brun	$1.2	Collectibles and Memorabilia	Sotheby's (NY)	1988
Girault de Prangey	Athenes	$0.9	Photographs (1842)	Christie's (Lon)	2003
J. Coney	American Silver Two Handle Cup, 1715	$0.8	Silver, Russian Art, Vertu	Sotheby's (NY)	2002
G. Lemonnier	Pearl and Diamond Tiara (T&T collec)	SF0.9	Jewellery	Sotheby's (Gen)	1992
Raden Sarief	'Deer Hunt' (Oil Painting)	S$3.1	Asian Art (1846)	Christie's (Sing)	1996

Sources: Sotheby's, Christie's and Artdaily.com

$126,556,000 respectively. It is also worth recording that the highest valued work by a living artist, Willem de Kooning's 'Interchange', which sold at Sotheby's, New York for $20,350,000 in 1990 would have fetched $33,265,000 today.

Sotheby's and Christie's have a share of all the significant art markets but there are important national auction houses operating in the top art market countries. (See Box 2.2.)

Box 2.2 Other significant auction houses by country

USA	Bonhams/Butterfields (SF), Swann Galleries (NY)
UK	Bonhams (London)
France	Tajan, Artcurial-Briest, Drouot (Paris)
Italy	Finarte (Milan)
Germany	Lempertz (Koln)
Australia	Lawsons (Sydney)
Switzerland	Galerie Koller (Zurich)
Sweden	Bukowskis (Stockholm)
Austria	Dorotheum (Wien)

The make-up of any single market according to Sagot-Duvauroux (Towse, 2003) is 25 per cent tertiary, and 75 per cent secondary and primary. Market Tracking International (now defunct) estimated that 44 per cent of the US market comprised dealers. My own experience based on a case study of the Taiwan art market was a half tertiary market share divided equally between Christie's and Sotheby's, while they were active on the island, and the remaining half split between three local houses. I further estimated the dealer/broker market to make up 50 per cent of the total market (Robertson, 2001). In Italy Christie's, Sotheby's and Finarte take equal shares of the Italian tertiary market and in France Christie's has outpaced Tajan (Melikian, 2004) leading one to conclude that there is no typical market.

The dealer/broker market consists of many sole traders and small and medium sized enterprises (SMEs) as well as the large auction houses. Dealers operate locally, regionally and internationally. The art market is, perhaps, unique in the international aspirations and conduct of its small traders. It is not unusual for a two or three person business to attend international art fairs and to court international clients. In an art market capital like London, for example, as many as 90 per cent of the client list of an Alpha or Beta gallery will be resident overseas. The top galleries will seek to enter significant art fairs (see Box 2.3) and these fairs in effect act as a dealer filter mechanism. Inclusion in a prestigious event like Basel, for example, acts as the market's stamp of approval. The proximity in time between the Venice

Box 2.3 International art fairs and biennales in order of importance

Art fairs

1	Basel	Switzerland
2	Basel/Miami Beach	USA
3	The Armory Show (NY)	USA
4	Frieze (London)	UK
5	Berlin	Germany

Biennales

1	Venice Biennale	Italy
2	Sao Paolo Biennale	Brazil
3	Dokumenta (Kassel)	Germany

Significant national fairs
ARCO (Madrid, Spain)
FIAC (Paris, France)
Cologne (Germany)
Arte Feira (Bologna, Italy)
Istanbul (Turkey)
Johannesburg (South Africa)
Shanghai Art Fair (China)

Biennale and the Basel art fair highlights the close relations between international curatorship and the super art fair.[6]

There are dozens of biennales and smaller art fairs serving different local and regional markets. The Guan-ju Biennale in South Korea, for example, showcases Asian art, although there is usually Western representation. Arte Fiera in Bologna is a strictly national art fair, although once again foreign dealers are represented. In London, two other fairs in Islington (London Art Fair) and Battersea (the Affordable Art Fair) appeal to the middle-market British consumer.

In conclusion

Maslow's hierachy of human wants reaches its apex with the consumption of art and antiques. When taste falls behind wealth creation, insecurity and over-indulgence elbow out stimulation and contentment. Elvis Presley ate increasing amounts of fast food as he became richer, rather than choosing to eat smaller amounts of better quality food, and this helped bring about his untimely death. Rather than spending leisure time pursuing the same pleasures more often, it is probably more rewarding to discover 'higher' pleasures to enjoy less frequently. By way of demonstration, I have witnessed wealthy ex-patriots beginning their stay in their country of domicile as ignorant amateurs and leaving after three years with a considerable understanding of the art and culture of that country, as well as a substantial art collection.

Finally, it is worth emphasizing that the art market is linked not only to consumer behaviour but to world economic and political events. If a trillion butterflies flutter their wings simultaneously this may result in floods in coffee producing Colombia, which may precipitate a bloody civil war. The global economic effects of events in Colombia will be felt on the stock market and on the price of coffee. Somewhere down the line this will affect the market for art and antiques and the price of a Persian carpet.

Notes

1 'Transitional' is the term used to describe the poorest countries in the world (Williams, 2004).
2 The notion of age has been overturned in recent years particularly with the great and early success of the young British artists (YBAs).
3 See Rembrandt Research Project (RRP) and its Codex. The RRP successfully inflated Rembrandt's reputation and that of his pupils by demonstrating that the Master could not paint less than a masterpiece, and his students' works of art had for a long time been thought worthy of the Master.
4 For a full explanation of the methodology behind gallery grading see Robertson (2000). Galleries are judged across four criteria according to whether they (1) set trends, (2) achieve top prices, (3) promote their artists sophisticatedly, and (4) organize museum quality exhibitions. Each criterion attracts a maximum of 5 marks and a minimum of 0 marks.
5 Auction house grading is based purely on the annual sales results.
6 The order of the list in Box 2.3 was developed in consultation with a cross-section of dealers who regularly attended the fairs.

Bibliography

Ackerman, M. S. (1986). *Smart Money and Art: investing in fine art*. New York: Station Hill Press.
Artdaily.com website.
Art Newspaper, The, International edition.
Artprice (2004). Data from http://web.artprice.com/tour/aspx?t=5
Becker, S. H. (1982). *Art Worlds*. Berkeley: University of California Press.
Bongard, W. (1982–). 'Kunst Kompass', published annually in *Capitol*.
Bowness, A. (1989). *The Conditions of Success*. London: Thames & Hudson.
Buck, L. and Dodd, P. (1985). *Relative Values or What's Art Worth*. London: Hamish Hamilton.
Department for Culture, Media and Sport (DCMS) (2001). 'Creative industries mapping document 2001', City University, Department of Arts Policy and Management, for DCMS.
Duthy, R. (1978). *Alternative Investments*. London: Michael Joseph.
Fukuyama, F. (1992). *The End of History and the Last Man*. Harmondsworth: Penguin.
Gérard-Varet, L.-A. (1995). 'On pricing the priceless: comments on the economics of the visual art market', *European Economic Review*, 39, pp. 509–18.
Giddens, A. (1986). *Sociology*. London: Macmillan.
Giddens, A. (1999). *Runaway World*. London: Profile Books.
Hobbes, T. (1651). *Leviathan*. Reprinted Harmondsworth: Penguin (1985).
Market Tracking International (MTI) (2000). Art data collected for 2000, MTI, London.
Melikian, S. (2004). *International Herald Tribune*, 17–18 January.
Montias, J. M. (1979). 'Microeconomics of the art market', *Journal of Cultural Economics*, 3 (1), pp. 1–29.
Moulin, R. (1987). *The French Art Market: a sociological view*. New Brunswick, NJ: Rutgers.
Packer, W. (2003) 'At last the wraps come off', *Financial Times*, 16 July.

Robertson, I. A. (1991). 'Berggruen collection: welcomed addition', *Art Monthly*, September.

Robertson, I. A. (2000). 'The emerging art markets of greater China 1990–1999', unpublished PhD, City University, London.

Robertson, I. A. (2001). 'Auction houses expand into China', *Art Newspaper*, February.

Samuel, H. (2003). 'Millionaires caught in gypsy art sting buy £12.m fakes', *Daily Telegraph*, 31 July.

Singer, L. P. (1978). 'Microeconomics of the art market', *Journal of Cultural Economics*, 2(1), pp. 21–40.

Singer, L. P. (1988). 'Phenomenology and economics of art markets: an art historical perspective', *Journal of Cultural Economics*, 12(1), pp. 27–40.

Singer, L. P. and Lynch, G. (1994). 'Public choice in the tertiary art market', *Journal of Cultural Economics*, 18(3), pp. 199–216.

Taylor, B. (1999). *Art for the Nation: exhibitions and the London public, 1745–2001.* Manchester: Manchester University Press.

Thorpe, V. (2003). *The Observer*, 23 February.

Towse, R. (2003). *Handbook of Cultural Economics.* Cheltenham: Edward Elgar.

UNESCO (2000). 'International flows of selected cultural goods 1980–98', Report prepared by P. Ramsdale, UNESCO Institute for Statistics, UNESCO Culture Sector.

US Department of Commerce (1992). Droit de Suite, *The Artist's Resale Royalty.* Washington, DC: US Department of Commerce.

Watson, P. (1992). *From Manet to Manhatten. The Rise of the Modern Art Market* Hutchinson: London.

Watson, P. (1997). *Sotheby's the Inside Story.* London: Bloomsbury.

Williams, F. (2004). *Financial Times*, 25 February.

Wullschlager, J. (1989). 'Alternative investments', *Financial Times Business Information.*

3 Art, religion, history, money

Iain Robertson

Fall down and worship of the Golden Image.

(Revelations 1.12)

We start our history at the beginning of the West's (uninterrupted) global ascendancy. For that reason this chapter will not deal with the art markets of the Classical and Ancient worlds. Why then have the wealthy Tuscan city states, the Flemish and Dutch trading entrepôts and the financial power-houses of London and New York nurtured the most expensive and enduring art? It can be explained as a happy conflation of Hobbes's 'Naturall' and 'instrumentall' powers, a fully functional Leviathan (1651, Ch. 10), a coming together at a particular time in a particular place of educational attainment, artistic skill, entrepreneurship, conceptual money, probability and international trade and empire. The story of the art market is one of the eventual triumph of commerce over the spirit and over craft.

The unique relationship between money and art

The Italian Renaissance was made possible by the bankers of Lombardy and Florence, the Medici *et al.*, and the Northern Renaissance by the great banking families, the Fuggers, Welschers and Hochstetters. These dynasties bankrolled the greatest patrons of the age, the Pope and the Holy Roman Emperor.

Italian art is littered with references to money and religion. In the Chapel of San Francisco in Prato, money-changers are shown behind their counter or 'banco' (bank), and Quentin Metsys's 'The Money Changer' (1514) is one of the most literal and negative depictions of money in art. The conflation of the *intellectus* (spiritual) and *res* (material) (see Shell, 1995) has defined notions of value in the West since the Renaissance. Images of money and art appear throughout the Western art canon. Titian's 'Danae' is impregnated with Zeus' gold-coined semen in what amounts, with the arrival of Perseus, to an immaculate conception. Early coins stamped with Christ's image and disc-shaped communion wafers, Shell argues, have blurred the boundaries between *intellectus* and *res*, and point to the consumption of a

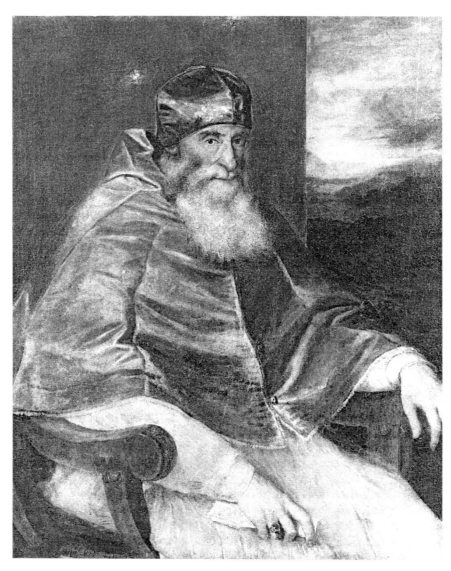

Plate 3.1 Titian, 'Pope Paul III', 1543 (Museo Nazionale di Capodimonte, Naples, Italy) (Courtesy of Fototeca della Soprintendenza Speciale per il Polo Museale napoletano)

tangible spirit during transubstantiation. The transference of spiritual value to coin and its internalization became important to money when value was no longer expressed in terms of the material – gold, silver or bronze. Money became even more significant after the introduction of bills of paper. The contradiction between face value and substantial value is one we tolerate easily today, but it met with opposition in the past. It is a dichotomy that allows us to accept that a work of art can have a great deal more value than the cost of its materials, labour, information and transaction costs.

It is natural, therefore, that the first truly professional art market should grow up in the 1480s out of churchyard booths in commerce-inspired Antwerp. The art market reached a height in that city in the 1540s, by which time a permanent salesroom had been created in the new commodities market. The northern art trade had been buoyant since the 1440s, notably in illuminated manuscripts. At that time, and until mid-century, the Burgundian court in Paris was its centre. By mid-century the Flemish illuminators out-shone the Parisians and developed an export market for their work, shifting the centre of the trade to the Netherlands.

Conceptual money, in the form of banknotes, invented by the London goldsmiths in the seventeenth century, was a response to Europe's growing industrial populations. The appearance of central banks during the same period (the Dutch *Wisselbank* was formed in 1609) raised capital for government and identified the need for the regulation of Adam Smith's invisible market hand. Artists like Titian and Rembrandt were quick to learn the new financial lessons. They could now claim substantial slices of this capital for their paintings, over and above the material and craft-made qualities of the work. Two and half centuries later Whistler would defend the value of his seemingly unskilled and ill-finished painting by pointing to the years of human capital investment.

This was the age of 'trading in the wind' (*windei handel*), of the tulip mania (*bloemenspeculatie*) and of stock markets. The Dutch exchange, Europe's oldest, 'the Wall Street of the 17th century' (Aymard, 1982, p. 111) opened in 1611 and brought respectability to what had amounted to licensed gambling. In London, New Jonathan's coffee house was converted into a stock exchange in 1773 and in 1792 dealers in stock met at 22 Wall Street, New York. The first joint stock East and West India companies were formed in the first decade of the seventeenth century, and the art market with its charity auctions, on-spec markets and full-time dealers conformed to the age of conceptual value and the measurement of chance.

The final development crucial to the formation of 'modern' societies was the introduction of the concept of underwritten risk. Edward Lloyd's coffee house was first mentioned in 1688 and the Lloyd's list appeared in 1734. The Dutch, through the VOC (*Verenigde Oostindische Compagnie*), were the first to underwrite through shareholders the great risks undertaken by their *supercargoes* (merchant ships) in the trilateral trade between Batavia (Indonesia) China and the mother country (Jörg, 1982). The concept of

sharing in and speculating on risk permeated European societies, and together with global expansion and trade wars set the West on an upward trajectory. Art became something on which to risk capital, just as a joint stock debenture for a plot of land in Mississippi (the great mirror folly – *Het Groote Tafereel der Dwaasheid* of the 1720s) was considered, foolishly, to be a risk worth taking. Hans Floerke writing 100 years ago noted (1905, p. 164): 'The Dutch carry out a kind of trade with it [art] they only invest so much into it in order to make something out of it.'

The real breakthrough on risk had come a century earlier when merchants were perceived not as usurers but as do-gooders because they increased the wealth of nations and avoided war. Under the *periculum sortis* (the danger of chance), merchants who lent money were permitted reasonable compensation for other lost opportunities. Philip Melanchton and Thomas Hobbes (*De Corpore Politico*) argued that civil and Christian law, although not mutually exclusive, could be separated, and that the strict ethical codes that had governed Christians could be set aside in the conducting of business. A clear indication that one should give unto Caesar what is Caesar's and unto God what is God's.

In *Leviathan* (1651), Hobbes likens money to blood circulating around the commonwealth as blood courses around the body, and although the philosopher's work appeared late in the seventeenth century, Dutch artists already intuitively understood the importance of liquidity. Both Rembrandt and Jan de Bray used paintings to clear property debt and as a downpayment on a house, respectively, in the second and third quarters of the century. Rembrandt's great 'Juno' was given in lieu of a debt to the Riga merchant, Harman Becker, on 24 July 1668, the artist agreeing to pay the merchant two-thirds in cash, one-third in pictures 'by his own hand' (Held, 1969, p. 88).

The protean nature of art, particularly portable easel paintings, bamboozled the seventeenth-century Dutch artist, dealer and collector. The collapse of the Dutch art market in the 1680s, deregulated after the demise of the guilds in mid-century, mirrored the decline of the country's economy, and a surfeit of art and artists reduced the value of low and medium value art below the cost of production. Faith in the value of paintings diminished and the market contracted severely. To borrow a thought from James Buchan's (1994) book, *Money*: 'The price of objects as expressed in money fell; the price of money, as expressed in objects or in the rate of interest, rose' (p. 101). The unique artistic partnership of *intellectus* and *res* thus fell apart. In his book Shell (1995) asserts that lucre began its career as electrum (in a reference to the first coins minted in Lydia) and ended as electricity. Art also started life as a set of valuable materials and concluded as a thought, from Quentin Metsys's lucid solidity to Yves Klein's transient gold leaf floating down the River Seine.

Gold underpinned capital in the Renaissance. Spain controlled its supply throughout the sixteenth and seventeenth centuries and Britain from 1816

until 1948, at which point the Bretton Woods scheme replaced the mineral with a floating exchange rate. In the main, and with the notable exception of seventeenth-century Netherlands, the Art Academy gave the same universal guarantee to art that gold did to money, a guarantee that was undermined by the French avant-garde dealers and reclaimed by the Museum of Modern Art, New York and its 'unofficial' franchises (Tate, Pompidou, etc.) in the 1930s.

The history of the trade

With the exception of England in the nineteenth century, the major collectors, artists and dealers tended to gravitate towards or live in the art market centre(s) of their age. It also seems that these collectors were excited by the prospect of buying into the *zeitgeist*. The relationship between the church, the donor and the artist until the sixteenth century favoured the church. In a sense, there was an imbalance in favour of the spiritual over the material (client and money) and conceptual (artist and thought).

With the formation of Academies (Accademia di San Luca of Rome 1593, Académie Royale de Peinture et de Sculpture in Paris 1648, The Royal Academy in London 1768) and the ascendancy of the lay patron, the material and the conceptual started to dominate the spiritual; although the spirit was never dismissed. It is disappointing to relate that after about 1350, the dissemination of painting among a broad section of the population was replaced by exchanges between small élites, only briefly reversed in seventeenth-century Netherlands and nineteenth-century Britain. Both painter guilds and Academies fostered a strict professional and social hierarchy among artists and the first Royal Academy exhibition in London employed rigorous selection criteria and showed only 136 works (Wedd *et al.*, 2001). The development of élites and the de-professionalism of artists, with the demise of these regulatory bodies, and the rise of lay collectors, has given today's market its current complexion: originality, autonomy, excellence and individuality. Dealers, critics and curators have arisen to interpret the new meanings.

The Italian states, 1250–1350: the Mendicant orders, direct commissions and a dominant patron

The importance of patronage in Europe from the Renaissance to the early years of the twentieth century has as much to do with taste as it does with finance. Patronage in Italy moved from the Mendicant orders and city communes to the merchant families and princely courts (Kempers, 1994).

The patronage of the Mendicant orders in Rome and Assisi, in particular, was financed by the Papacy through the sale of indulgences. In 1253, Innocent IV (1243–54) issued a Bull enabling friars to decorate their churches and the result was a neat division of the 'exhibition' space into monks choir,

lay choir, woman's church and side chapels for private patrons. This allowed for a hierarchy of subject matter, ultimately determined by the friar/curator. Gradually, the feudal élites demanded private altarpieces for their homes, and a new professional artist responded, disciplined by the restrained taste of the Mendicant orders. The city-states, such as Siena, continued to patronize restraint and promote civic value. The results are such wonders as Duccio's Byzantine 34-image, double-sided altarpiece of the Virgin, 'Maesta', for Siena's cathedral, for which the artist received two and a half florins an image and a 50 florin advance.

The fame of artists of immense stature reached beyond their city: 'Cimabue and Duccio were Tuscan painters; Giotto and Simone Martini were Italian, even Western, painters. Giotto worked at Padua and at Naples, Simone at Naples and at Avignon' (Chastel, 1972, p. 130).

Siena and Florence, 1350–1500: civic commissions, the rise of the city-state and the merchant princes

The skills of altarpiece making (specifically the Sienese polyptych) combined with the cheapness, in terms of time and material cost, of panel painting allowed for the dissemination of a style of art throughout the Italian city-states. An international artistic élite, an intermediate tier and a lower level developed. Fifteenth-century Italian guilds such as the *Medici e speziali* were strict, only admitting apprentices from 14 to 24 years old and then without pay. This hierarchy was mirrored in the north of Europe, with the *Kladschilder* (rough painter) and *fijnschilder* (fine painter) distinction. Workshops, according to Thomas (1995), provided the necessary security for Italian artists up until the fifteenth century, because of the wide range of commissions undertaken simultaneously.

Mid-fifteenth-century Florence offered a new generation of artists even more challenging commissions than Siena and the *sacre conversazione* replaced the multiple panels of old. This reflected the desire of bankers and warlords, rather than friars or civic communes, to wash away their guilt. As Kempers (1994, p. 186) explains: 'Exchange relations between monks and merchants sanctioned acquired wealth because part of that wealth was transferred to church ownership'.

The Papacy returned to Rome for good at the end of the Great Schism in 1417 and the restoration of the city undertaken by Nicolas V culminated in the jubilee of 1450. Cosimo de Medici returned from exile to Florence in 1434 and in 1447 the Sforza *condottiere* ousted the Visconti from Milan. Under the D'Este and Borso, Ferrara became an artistic centre. The House of Aragon established itself in Naples and Venice expanded its empire to Crete and Cyprus.

This situation suited church and merchant alike and the subtle pictorial reference to the patron, in the form of the family's patron saint, announced the arrival of serious lay capital. Federico da Montefeltro (*condottieri*), who

ruled the roost in Urbino in the third quarter of the fifteenth century, created a great library and commissioned work from, among others, Piero della Francesca and Justus of Ghent. In Piero's 'Brera Madonna' Federico is shown kneeling before the Virgin and saints. He appears again as the soldier of Christ in Piero's 'Flagellation'. The appearance of donors in paintings suggests a more self-confident patron asserting his role in the *intellectus/res* debate. The stress on material finery was transferred to Italy from Flanders, demonstrating that the art market was no longer localized. Painters, too, like the internationally acclaimed Justus of Ghent, grew rich, and both he and Piero enjoyed property and position. Finally, the efforts of *Quattroccento* Italian and particularly Florentine artists were immortalized by Vasari, through his *Vite* ('*Lives*', 1568).

Pan-European kings and princes, 1500–1600: the art academy and superstar artists

The geopolitical stage changed with the French invasion of the Italian peninsular in 1494. Henceforth the world would be dominated by European super-states. It was in this pan-European theatre that Michelangelo and Raphael achieved international fame through the intervention of the Pope and that Titian and Rubens rose to greatness with the patronage of Charles V, the Holy Roman Emperor. It was through a network of international patrons (and the writings of Pietro Aretino, which appeared in 1557), beginning with Federico Gonzaga of Mantua and thence to his brother-in-law, Francesco Maria della Rovere, the Duke of Urbino that Titian's reputation spread, initially, beyond Venice. In 1542, he was contracted to paint for the Farnese, the family of Pope Paul III, and it was at this point that he was introduced to Charles V. From 1548 onwards he was effectively the court painter to the Hapsburgs (Hope, 2003). The abolition of the Pragmatic Sanction in 1516 (which had given more power to the General Council than to the Pope) heralded the age of the glorification of the Pope by Raphael in particular. The same artist also developed the easel painting and the archetypal portrait for reigning princes. Cosimo de Medici and his exploits, for example, became the central feature in a series of frescos and paintings in the renamed town hall – the Palazzo Vecchio. In 1563 an *Academia del Disegno* was established in Florence and further ones were founded shortly afterwards in Rome, Bologna, Paris and Antwerp.

Painting, like sculpture and architecture, began to move away from craft. In Northern Europe, the guilds held sway for longer, but by the mid-1650s most of the Dutch towns had replaced the Guild of St Luke with *confreries* or brotherhoods. The Italian workshops and Dutch guild artists catered to the client's needs, but style and fashion became extremely important to Renaissance patrons and the styles leaked down into the multiple market for terracotta tabernacles (Thomas, 1995, p. 135): 'Such negotiations have the flavour of the market place. The artwork was considered as a commodity

to be bought at "buon prezzo", but was subsequently presented to the world as a high quality artefact.'

The impact of the intellectualization of paintings had two effects. It separated 'great' artists from 'good' and 'good' artists from 'craftsmen'. In 1602 the Academy in Florence drew up a list of artists whose work could not be exported: Michelangelo, Raphael, Leonardo, Andrea del Sarto, Titian, Correggio, Parmigianino and Perugino. Their reputation and value remain intact to this day.

The Dutch art market, 1620–80

The Dutch Vasari, Karel van Mander, wrote *Het Schilderboek* ('The Painters Book') in 1604 and modelled it on *Lives*, recording the first extensive accounts of the lives of major North European artists. The extent to which the third part of his book, 'The Fundamentals of the Noble and Free Art of Painting', 'liberated' artists like Rembrandt from the notions of craft, is contentious (see Alpers, 1988). There is little doubt, however, that this work and Arnold Houbraken's *De Groote Schouburgh* (1718–21) formed the canon of Flemish and Dutch artists during this period.

In the Netherlands in the first half of the seventeenth century, the guild system allowed for a measure of social distinction between painters and other crafts and professions, which in turn shaped the economic fate of artists. The marine painter Hendrick Vroom charged the Dutch admiralty 6,000 guilders for 'The Battle of Gibralter' in 1622 and when Rembrandt applied for a *Cessio Bonorum* in July 1656 he had debts of 13,000 guilders and owed his son, Titus, 20,000 guilders, a measure of his credit lines. Art dealers were particularly successful. Abraham de Cooge bought a 6,000 guilder house in 1644 at a time when a house on the fashionable Lange Vijverberg in the capital would cost 15,000 guilders and houses on the Prinsengracht would rent out for between 1,200 and 1,500 guilders a year. Life was less rosy for the rough house painters. At the bottom of the scale a *kladschilder* like Pieter van der Vin died bankrupt, his *desolate boedel* (chattels of the bankrupt) making just over 192 guilders (Robertson, 1992).

Seventeenth-century Dutch dealers were today's precursors. At the bottom (Delta level) lay the short-term contractors like Leendart Hendricksz Volmarijn. Volmarijn was an itinerant dealer who travelled throughout the United Provinces to trade in all manner of paintings, and was often hauled up before local magistrates for trading in the works of professional artists who were not the member of that town's guild. Many of these traders were also suppliers to artists of paints and boards or *doeken* (canvases) in set sizes. Local, dual contract (Gamma) dealers such as Vermeer's father, Reynier, trained as a weaver, and ran an inn (a common outlet for sales at this level). He had a wide range of contacts with local Delft artists who specialized in set genres, like still-lifes, Vanitas and flower painting (see Montias, 1982). Fully fledged *kunstverkopers*, dealers in Beta art, were less common in the

United Provinces during this period. Abraham De Cooge was one of the few. He traded throughout the Netherlands as well as in Flanders and in local and foreign artists. At the very top of the dealer tree we find men like Amsterdam-based De Renialme, an Alpha dealer whose inventory at his death comprised works by the top Dutch artists of the day. De Renialme dealt in Rembrandts in markets as diverse as Amsterdam, Leiden, Antwerp and Paris. The extended clan of influential Dutchmen who patronized Rembrandt were the indirect result of the influence enjoyed by his first wife's family, Alpha dealers the Uylenburghs.

The beginnings of the global market under the Dutch and English, 1602–1760

Although exotic goods first appeared on the Renaissance art markets of Italy and Flanders, it was the Dutch who took the trade to a new level. By the second decade of the seventeenth century the Dutch East India Company (*Verenigde Oostindische Compagnie*) was committed to the China Trade. From 1602 to the mid-eighteenth century, Dutch supercargoes bought and sold precious Chinese artefacts in the markets of Southeast Asia and Europe. Between 1730 and 1789, the Dutch shipped 42.5 million pieces of porcelain to Europe from China (Jörg, 1982). By this time, other European states had joined the Dutch in the scramble for influence in the China market.

The Dutch cultural commodity market centred in Amsterdam was, for much of the seventeenth century, the centre of an international art trade. By the 1680s it was in decline, and a surfeit of paintings had severely depressed prices. It was then that London, for so long isolated from main-stream European taste, began to establish itself as the centre of a new art market.

It was no coincidence that Gerrit Uylenburgh (Rembrandt's dealer) ended up painting backgrounds to Lely's paintings, because there was an exodus of Dutch artists to England after the collapse of that market around 1680. Gerrit was bankrupted in 1671 when he refused to accept the conclusion of two independent juries that the Italian paintings he was attempting to sell to the Kürfurst von Brandenburg, were the work of pupils (see Floerke, 1905).

Willem van de Velde arrived in 1675 and started a seascape tradition in England. He was followed Van Dyck, Lely and Kneller. Until that time art dealing had not featured substantially in the English market. This might explain John Evelyn's astonishment at an art fair in Rotterdam in 1641:

> We arrived late at Rotterdam, where was an annual marte or faire, so furnished with pictures (especially landscapes and Drolleries as they call those clownish representations) that I was amaz'd. Some I bought and sent into England, the reason of this store of pictures and their cheapness proceedes from their want of land to employ their stock, so that it is an

ordinary thing to find a common farmer lay out two or £3,000 in this com'odity. Their houses are full of them and they vend them at their fairs to very great gaines.

(from John Evelyn's diaries, in Martin, 1907, p. 369)

London artists' fortunes were linked to those of printmakers from the late seventeenth century until the late nineteenth century. Printmaking kept them in the public eye, even when they weren't exhibiting. Like the Dutch merchants, the late seventeenth-century English patron wanted to be painted, and in contemporary clothes, highlighting not lineage but commercial achievement. Artists such as Hayman, Streeter, Lely, Kneller and Thornhill all moved into the newly fashionable area of Covent Garden where they painted portraits. Others, such as the emigrée Dutch artist Willem van de Velde the Younger and the Englishman Samuel Scott, also took houses in the area and specialized in shipping and sea scenes. The market took on much of the character of the Amsterdam market of 50 years before. Artists chose to live in the heart of Covent Garden so that they could invite important patrons to respectable surroundings.

Within a few years of the first artists arriving in Covent Garden, and within a few streets of the Piazza, could be found everything – auctioneers, colourmen, framers, engravers and printsellers – needed to create, exhibit and sell paintings new and old.

(Wedd *et al.*, 2001, p. 31)

By the early eighteenth century there were half a dozen good shop dealers in London and between fifteen and twenty-five auctions a year (Pears in Watson, 1992) and a few who based their businesses in Italy to profit from the Grand Tour.

The Grand Tour and the development of a thriving print market combined with the country's growing prosperity to broaden the collecting base and result in the establishment of great private collections such as those of Sir Robert Walpole, Sir John Soane, Lord Cavendish, the Duke of Devonshire and Lord Burlington and a return to the patronage of British artists like Reynolds and Hogarth.

Hogarth spoke for the new commercial age ushered in by Dutch a century earlier when he said: 'We cannot vie with these Italian and Gothic theatres of art, and to enter into competition with them is ridiculous; we are a commercial people, and can purchase their curiosities ready-made, as in fact we do' (Foss, 1971, p. 204).

France and England, 1760–92

Europe was beguiled by Italy, and as late as 1820 Shelley was able to write:

From Aeaean
To the cold Alps, eternal Italy
Starts to hear thine! The sea
Which paves the desert streets of Venice laughs
In light and music; widowed Genoa wan
By moonlight spells ancestral epitaphs,
Murmuring, where is Doria? Fair Milan,
Within whose veins long ran
The Viper's palsying venom, lifts her heel
To bruise his head . . .

Florence! beneath the sun,
Of cities fairest one,
Blushes within her bower for Freedom's expectation:
From eyes of quenchless hope
Rome tears the priestly cope
As ruling once by power, so now by admiration.'
 (Percy Bysshe Shelley, 'Ode to Naples',
 September 1820)

The British (as they became known in 1707) were the most populous travellers on the Grand Tour, closely followed by the French. These two nations were emerging at the beginning of the eighteenth century as the great art buyers. Venice, and particularly Canaletto and Guardi, English and French favourites, benefited from this new international patronage. The Grand Tour and the growth of London into Europe's art market capital are synonymous with, and closely correlated to, the broadening and seriousness of scholarship among a wealthy aristocracy and its mentors (Grand Tour, Cesare de Seta). Reitlinger (1961) asserts that Raphael, Leonardo and Correggio were the favoured artists. (See Table 3.1.)

Italy became an increasingly secularized source market for London and Paris. Such market as there was in Rome was controlled by two British dealers, Thomas Jenkins and James Byres, who dominated the scene for 50 years to such an extent that Tobias Smollett warned travellers in 1767: 'to be on their guard against a set of sharpers (some of them from our own country) who deal in pictures and antiques' (Wilton and Bignamini, 1996, p. 28).

James Byres acquired the Portland Vase for Sir William Hamilton from Cordelia Barberini-Colonna, Princess of Palestrina in 1780 and Poussin's first set of 'Seven Sacraments' from the Boccapaduli family which he sold to the fourth Duke of Rutland in 1785 (Wilton and Bignamini, 1996). Gavin Hamilton was another notable emigré dealer who bought and sold Raphael's 'Ansidei Madonna' and Leonardo's 'Virgin of the Rocks' to Britain (Watson,

Table 3.1 Record prices from the past

Artist	Title	Sale	Price	Today's value	Buyer
Giovanni Bellini (1427–1516)	'Holy Family'	Houghton Hall Sale 1779	£60	£3,600	Empress Catherine
Antonio Canaletto (1697–1768)	'Two Views of Verona'	Fleming, London 1771	£260 10s each	£15,777	
Annibale Carracci (1560–1609)	'Toilet of Venus'	Orleans Sale 1798	£840	£33,600	Earl of Berwick
Correggio (1494–1534)	'Magdalen Reading'	1746	£6,500	£533,000	King of Saxony
Correggio	'Venus Cupid and Satyr'	1771	£3,000	£182,040	William Hamilton
Aelbert Cuyp (1620–91)	'Cattle Watering'	1795	£147	£7,350	C.-A. de Calonne
Gerrit Dou (1613–75)	'Tryptich (Lost at Sea)'	Braamkamp, Amsterdam 1778	£1,410	£84,600	Empress Catherine
Meindert Hobbema (1638–1709)	'Watermill Landscape'	1776	£5,914	£354,840	Lord Montford
Michelangelo Buonarrotti (1475–1564)	'Holy Family'	Orleans Sale 1798	£420	£16,800	Thomas Hope
Raphael (1483–1520)	'Sistine Madonna'	1754	£8,500	£637,500	King of Saxony
Guido Reni (1575–1642)	'Immaculate Conception'	Houghton Hall Sale 1779	£3,500	£210,000	Empress Catherine
Sir Peter Paul Rubens (1577–1640)	'Magdalene at the Feet of Christ'	Houghton Hall Sale 1779	£1,600	£96,000	Empress Catherine
Titian (1487–1576)	'Diana and Actaeon'	Orleans Sale 1798	£2,625	£105,000	Duke of Bridgewater

Source: Reitlinger (1961).

1992). Sotheby's and Christie's grew up in response to the increase in size of the British market, opening for business in 1744 and 1766 respectively. The London trade also benefited, after an initial downturn from the effects of the French Revolution (1789), from a great selection of Alpha works from Paris appearing in the London sale rooms (Watson, 1992), enabling the city to develop a commercial expertise in Old Masters in the early part of the nineteenth century. London dealers, such as William Buchanan (Italian pictures) and John Smith (Flemish and Dutch), appeared and Thomas Agnew (still trading today) opened his doors in 1817. In 1785, Paul Colnaghi joined forces with Giovanni Battista Torres to open a London dealership specializing in topical prints such as 'Cries of London'.

The British and French did not have it all their own way. The wealthy Romanovs, and particularly Catherine the Great during her reign (1763–1796), were, along with the extravagant King of Saxony, the greatest collectors of the eighteenth century. Catherine took advantage of the bankrupt European princes and aristocrats at the end of the Seven Years War. Her agents scoured Europe, buying at auction and from dealers such as Berlin-based J. E. Gotzkowsky from whom she bought the paintings belonging to an impoverished Frederick the Great of Prussia. She gravitated towards France in the 1770s as revolution approached, buying from an equally impoverished aristocracy.

Dutch seventeenth-century paintings, which had suffered in comparison to Italian, received a boost along with the London market after the French invasion of Holland in 1795, and the arrival of many Dutch collections in England: 'At this time the Dutch paintings had become something more than substitutes for good examples of the Italian school that were unobtainable. They had become a form of political taste, a Whig taste' (Reitlinger, 1961, p. 13). Meanwhile in France, speculators, who had made fortunes collecting on commission France's unstable revenues, replaced the aristocracy by the time of the Houghton Sale in Paris in 1779 (Reitlinger, 1961). The Orleans Sales from 1792 to 1800, however, sealed the fate of the Paris market and moved its centre to London. Reitlinger describes the distinctive nature of the British buyers' backgrounds – nobility, painters, art dealers, bankers, gentlemen amateurs and merchants. He notes that a number of the merchants appeared to be speculators rather than collectors, dispersing of their purchases soon after the sales. The pictures were sold at two separate galleries in the Strand and Pall Mall, but even after six months of continuous bidding some works remained unsold (Reitlinger, 1961).

Britain and the industrialists, 1816–82

Britain enjoyed stable prices from 1816, the date when Britain re-introduced the gold standard, until its suspension at the outbreak of the First World War in 1914. France, on the contrary, endured a series of revolutions that adversely affected its art market.

Britain's nineteenth-century market was dominated by the great Royal Academicians, who were patronized by the wealthy aristocrats and, increasingly, great industrialists. The country was awash with liquid capital and this allowed the iron baron, Bolckow, and the Wigan cotton magnet, Thomas Taylor, to pay huge sums for paintings. Even the Pre-Raphaelites, such as Holman Hunt, sold well. The core of the market lay not in paintings, however, but in the rights to steel engravings and in ticket sales to private exhibitions. The dealer Gambart made £4,000 (today: £164,000) in shilling exhibition fees and £5,000 (today: £205,000) from the sale of prints from Holman Hunt's 'The Finding of the Saviour in the Temple'. He later sold the work for £1,500 (today: £61,500). The market was thus dual layered, with wealthy clients taking the advice of their dealer and spending vast sums on 'something very large and showy that was expected to enhance their status' (Reitlinger, 1961, p. 151), and at the bottom lay two- or three-shilling steel print engravings, later replaced by chrome lithographs, which popularized the mother images.

The 1882 Settled Lands Act, which permitted landowners to break the terms of the trust in which collections were held, signalled the end of the British era. The Act was passed in order to compensate big estates for falling grain prices and the loss of rental value with the exodus of labour to the city. It resulted in sales such as the disastrous Julius Angerstein sale of 1883 and Blenheim, 1884–85, and a collapse in the prices of English painters, saved from total collapse by the intervention of Agnew's and the acquisition of art from British collections by wealthy Americans and Europeans. Less than a decade earlier, in 1874, the Impressionists had held their first group exhibition, and the age of English patronage for mainstream contemporary art drew slowly to a close. (See Table 3.2.)

Paris – capital for contemporary art, 1880–1929; London – centre for Old Masters and British contemporaries, 1882–1914

Two further factors resulted in the contemporary art market shift from London to Paris. Haussmann rebuilt and improved Paris, turning it into a fashionable modern city, and the London trade failed to embrace the art of the future, Impressionism.

The Paris dealers of the late nineteenth century were tenacious. Paul Durand-Ruel had been a supporter of Monet since 1874, and nearly went bankrupt twice. Vollard backed Cézanne, Picasso and Braque and Daniel-Henri Kahnweiler (who loaned his stock to dealers in Eastern Europe, Switzerland and Germany) supported the Cubists, Vlaminck and van Dongen. These three dealers' support of the avant-garde and their identification of Russian and American clients gave us the modern art legacy.

There were French collectors for the new art, such as the composer, Jean Baptiste Fauré and Victor Chocquet, whose collection, among which were thirty Cézannes, ten Monets and ten Renoirs, was auctioned after his wife's death in 1899 at Galerie Georges Petit, making 452,635 francs (equivalent

Table 3.2 A comparison of prices for British Victorian artists and the French Impressionists between 1860 and 1912

Date	Artist	Title	Buyer	Price	Today's value
1887	John Everett Millais	'Over the Hills and Far Away'	Bolckow	£5,250	£294,000
1860	William Holman Hunt	'Finding Christ in the Temple'	Gambart	£5,775	£236,775
1903	Sir Lawrence Alma-Tadema	'Dedication to Bacchus'	Gambart	£5,880	£317,520
1873	Sir Edwin Landseer	'The Otter Hunt'	Baron Grant	£10,000	£380,000
1893	Frederick Lord Leighton	'Daphnephoria'	Lord Revelstoke	£3,937	£232,283
1910	Henri Matisse	'Still Life with Fruit and Coffee Pot', 1899	Druet, Morozov	700 FF	£1,482
1911	Henri Matisse	'Bottle of Schiedam', 1896	Bernheim-Jeune, Morozov	1,500 FF	£3,300
1912	Paul Cézanne	'Blue Landscape'	Vollard, Morozov	35,000 FF	£75,600

to £18,105, today: £1,013,902). It was Choquet's 'Au Moulin de la Galette' that was auctioned at Sotheby's in 1990 for $78.1 million (approx: $114.34 million). There were German collectors like Hugo von Tschudi, Director of the National Gallery in Berlin, and Count Harry Kessler (Watson, 1992) but trading was initially conducted in that country through art unions, which bought for public collections, although by the 1870s there was competition between the unions and the trade (Watson, 1992).

A vast exhibition held in Paris in 1900, in the Grand Palais, highlighted the tensions of a market in transition. Alongside the 'Pompiers' like Bouguereau, Leighton and Alma-Tadema, were hung old works by the new artists, Monet and Renoir. Outside, Durand-Ruel organized a show of the newest of the new such as Monet's twenty-six views of water lilies. The clash in ideology between the Academy, in France in particular, and the commercial status of art was fought in the last quarter of the nineteenth century, and by the end of the First World War commerce had won over academicism: 'Instead of applauding commercial success, the French Academy went so far as to dismiss it as harmful to the intellectual stature of art' (FitzGerald, 1995, p. 6). The Impressionist (Modernist) ideology succeeded over that of the Academy, 'By coupling their new aesthetic with the establishment of a commercial and critical system to support their art' (FitzGerald, 1995, p. 7).

The Salon d'Automme, which was created in 1903, started the process of selection of Impressionist art by 'expert' jury, supplanting the role of the Academy. It was this nascent validating structure that a French businessman, André Level, and a group of dealers projected so effectively on 2 March 1914. On that day the collection of La Peau de l'Ours was sold at Drouot at great financial success. The collection had been assembled over the previous decade by a consortium of thirteen men (speculators) led by Level (FitzGerald, 1995): 'Economic success stood as a powerful demonstration of the aesthetic quality that many had doubted' (p. 38). It was Level who introduced Picasso to collector Léonce Rosenberg in the same year. When Léonce's brother, Paul, entered the Picasso market in 1919 backed up by his prestigious gallery on La Boétie, Picasso's success was assured. While holidaying in Biarritz, shortly before the end of the war, Picasso had cemented relations with Georges Wildenstein and thereby gained the support of the other great dealer of the day. Rosenberg's strategy was always to develop Picasso's prices on the back of rapidly rising Impressionist values.

London may not have been the driving force behind the avant-garde but it was home to the highest prices paid for living artists, most of them Academic British. Gambart, the city's premiere dealer, had succeeded in inflating the prices of the Pre-Raphaelites. London also achieved top prices for early nineteenth-century work such as Turner's 'Grand Canal and Rialto' and Gainsborough's 'Duchess of Devonshire', for which Agnew's paid £7,350 (today: £301,350) and £10,605 (today: £417,837), respectively, in 1875 and 1876. Old Masters, particularly the Dutch and Flemish School, also commanded high prices in London.

For a brief period between 1900 and 1918 the Russian *intelligentsia* was rich enough to speculate on the emerging art of Impressionsim: 'Apollinaire contended that the Russians and the Americans understood French art much better than did the French' (Whitney Kean, 1994, p. 138). The Morozov brothers, Mikhail and Ivan (scions of wealthy clothes manufacturers), were great patrons of French Impressionist painting. In 1907, Ivan purchased Monet's 'Landscape with Haystacks' (1889) from Durand-Ruel, paying 8,000 francs (£314) (today: £16,487) for it. The next year he bought Gauguin's 'Café Arles' (1888) from Vollard. Druet, a Paris dealer who conducted much business with the Russians, sold regularly to the other great Russian collector, Sergey Shchukin, and in 1909 sold Ivan Morozov a grey and bathetic work by Van Gogh, 'Prisoners' Round'. Druet paid 5,865 francs (£234) (today: £11,964) on behalf of Morozov for 'Cottage at Auvers' (1890) at the Hôtel Drouot in 1908. The market for Van Gogh's paintings, tragically for the artist, was established less than two decades after his death in 1890, demonstrating that he was a 'fold' member and that his work always held latent financial potential. Ivan Morozov bought from Durand-Ruel Renoir's 'Under the Arbour at the Moulin Galette' (1875) and 'Young Woman with a Fan' (1881) for 25,000 francs (£1,000) each in 1907 (today: £52,000 and £54,000 respectively). He paid Vollard 42,000 francs (£1,643) (today: £87,079) in 1913 for Renoir's, 'Girl with a Whip' (1885), which shows how that artist's artistic capital had increased, and how Van Gogh would have prospered had he lived longer.

It was left to Serghey Shchukin (descendent of a textile baron) and the German emigré dealer, Kahnweiler, to support Cubism in the early days. Morozov, Leo and Gertrude Stein, and Ambroise Vollard rejected the style. Practically as a sweetner, Vollard sold Picasso's self-portrait of him to Morozov for 3,000 francs (£120) (today: £6,480). Serghey was an objective, jig-saw puzzle collector, finding the intellectual reordering of space by the Cubists stimulating. He averaged ten Picasso purchases a year, often buying irrationally and at the highest prices of the day.

The Armory Show in New York in 1913, which was held the year that import tariffs were repealed in the USA for the work of living artists, was the first sign that the Impressionist market could expand beyond Europe, although Americans were still reluctant to pay European prices for the new art.

The inter-war world was remarkable for its levels of economic uncertainty. This uncertainty in general had a de-stabilizing effect on the art market. Between 4 September 1929 and the summer of 1932, the Dow lost 89 per cent of its value, erasing every gain since 1897. It would be 30 years before the market returned to its 1929 high. Whereas returns from the Dow averaged nearly 15 per cent annually throughout the 1920s, they fell to −0.63 per cent per annum throughout the 1930s (Bull Investors.com). The greatest bull markets of the 1920s were to be found in Germany followed by France, Belgium and the USA. The bear market of 1929–32 hit Germany and those

economies tied to Germany, such as France's, worst. German stocks lost 97 per cent of value and the country endured hyper-inflation. The UK saw limited and measured growth and limited falls throughout this period. The London market's collecting base broadened as a result and, coupled with such developments as the establishment of the Oriental Ceramic Society in 1921 and the growth in antiques shops, led to study and later collecting interest in new fields.

Despite the massive devaluation of the franc between 1925 and 1930, the Paris-based French School market continued to expand throughout the 1920s with new dealers appearing on the Rive Gauche so that they and l'Hôtel Drouot were seen as the measure for contemporary art value (Moulin, 1987). By 1925 Modern art was firmly established in the USA and Europe and even a few Japanese collectors had entered the market (FitzGerald, 1995). The Paris market peaked in 1929 and crashed with Wall Street in October. The German market also boomed until that market's high point in June 1928. Both markets collapsed for the duration of the bear market 1929–34. In Germany a number of buyers deferred payment on art purchases as the mark continued to depreciate against other major currencies. This would push many dealers to the wall. Paris never fully recovered its premier position even as American, British and German buyers returned.

American buying power during and after the bear market, 1929–36

During the bear market there was a period of dislocation and opportunist American buying, especially in the Old Master sector. London dealers like Joseph Duveen: 'Noticed that Europe had plenty of art and America had plenty of money, and his entire astonishing career was the product of that simple observation' (Behrman, 1953, p. 1). Duveen gained the confidences of the great American industrialists J. P. Morgan, Henry Clay Frick and Paul Mellon. Duveen, like Gambart, had hyped the market in the heady days of rising stock markets by buying for top prices. On 19 February 1926 he bought Rembrandt's 'Watchmaker' for $410,000 (today: $4.46 million) from Count Carl Wachtmeister. On 18 July the next year he bought the entire 120 work collection of Robert H. Benson for $3 million (today: $18.1 million). He sold to Andrew Mellon Raphael's 'Cowper Madonna' for $970,000 (today: $10.9 million) on 7 January 1929.

Duveen was fortunate that his American clients rode out the stock market storm. In 1936 he rented an apartment below Mellon's in Washington, filled it with Old Masters, and went on vacation, leaving his key to the collector. A few months later Mellon paid $21 million (today: $277 million) for fifty-five masterpieces. Nearly half of the 115 pictures, excluding American portraits, in the Mellon collection now in the National Gallery in Washington, came to Mellon from Duveen. Duveen realized that the key to success lay in persuading the American billionaires to buy into the idea of

assembling collections and he was also not averse to purchasing authentification from a tame scholar, Bernard Berenson (Behrman, 1953). Duveen was also fortunate that the Lloyd George government of the 1920s had increased death duties, forcing the British aristocracy to sell off its art holdings.

The other advantage enjoyed by the main European Old Master players was the economic plight in the newly formed Soviet Union. The sale of the Morozov and Shchukin moderns by the cash-starved Soviet state in the 1920s was prevented because of low estimates ($6,500–$50,000 a piece) and clouded legal titles, but Old Masters flooded out of Russia throughout this period. Andrew Mellon bought Raphael's 'Alba Madonna' through M. Knoedler and Co. in 1931 for between $1.6 and $1.7 million (today: approx. $20.2 million). The painting had originally been purchased by Tsar Alexander's son Nicholas in 1836 from Dutch banker M. G. Coesvelt in London for £14,000 (today: £663,040).

The dealers who unlocked American capital by identifying the right European art, Joseph Duveen of London, Charles Henschel of Knoedler, New York and Germain Seligmann of Paris, all made fortunes from the transatlantic Old Masters trade. Knoedler's ventures involved complex oligopolistic relations. Henschel's fountain of information was the head of Matthiesen in Berlin, who had a representative in Moscow and who used to contact Knoedler through Colnaghi in London. Henschel then used another retainee in the USA to intercede between him and Andrew Mellon.

Russian raw material exports were insufficient to match the country's 'need' for American industrial hardware, and so in 1928 the Soviet government initiated a policy to sell specifically Old Master paintings abroad for hard currency. Many of the trades took place in Berlin because the USA did not recognize the Bolshevik government until 1933 and feared ownership suits from the disposessed Russian emigrés.

The Soviet sales from 1928 to 1933 amassed as much as $72 million (today: $2.19 billion) but suffered from depressed prices because of the 1930s economic collapse. In a 1931 sale the entire contents of the Stroganov palace sold through Lepke in Berlin made only $613,000 (today: $7.8 million). The crucial go-between role played by the Matthiesen Gallery came to an abrupt end in 1933 with the election of Adolf Hitler as Chancellor. His ascendancy prevented the American, Albert C. Barnes, from adding French Impressionist paintings from Russia to his collection.

It wasn't all one way, and an American art dealer/writer called Christian Brinton, together with the Director of the Brooklyn Museum, William Fox, and patroness, Katherine Dreier, started to show and sell Russian avant-garde art in New York. Dreier had set up the Societé Anonyme with Man Ray and Marcel Duchamp. The triumverate secured exhibitions for their artists at Knoedler's in New York and the Soviet government sponsored the Van Diemen Gallery in Germany, which showed, among others, Malevich, Gabo and Archipenko.

New York, London, Paris and Berlin revivals, 1932–39

By 1934, the pound stood at an all time high of $5.041. It would remain at a high level until 1939, and at over $4 until 1948. The French franc rallied from 1932 to 1936 and the new Reichsmark remained stable from 1924 to 1938. Stronger European economies meant that the art business recovered much of its lustre in London, Paris and Berlin while a weak dollar stunted New York growth. Prices and turnover were still considerably down on the pre-1929 period. Exhibitions of the French School at the Galeries Georges Petit and the Zurich Kunsthaus in 1932 and a later Picasso retrospective at the Wandsworth Atheneum (1934) and Museum of Modern Art in New York in 1939–40 rejuvenated the art market. The false European dawn was brought to a close by Hitler's *Entartete Kunst* exhibition in June 1939, while in America Alfred Barr began his quest to institutionalize the new art and wrest the initiative from the dealers, securing for it a place in history and boosting its price. Barr's greatest coup was undoubtedly the purchase of Picasso's 'Demoiselles' from Seligmann in April 1939 for $28,000 (today: $361,614). Doucet had paid either 25,000 francs (£294) (today: £8,232) or 30,000 francs (£352) (today: £9,882) for the painting from the artist's own collection in February 1924.

New York, Paris, London, 1943–62

During the Second World War, when most of Europe was ravished, New York grew exponentially. Peggy Guggenheim, who had acquired much art from Paris at knock-down prices in advance of the German army, now put her reputation behind new American artists such as Jackson Pollock, Clyfford Still and Robert Motherwell. She also worked with displaced European artists such as Piet Mondrian, Salvador Dali and Ferdinand Léger. Peggy Guggenheim's 'Art of this Century' gallery showed the new work from 1943 until 1947, announcing the arrival of New York as the contemporary art market capital of the world.

Post-war revival in the London market was stunted by currency restrictions that stayed until 1954. Reitlinger refers to the post war market as one 'created by inflated currency, topsy-turvey financial controls and topsy-turvey systems of taxation, the market of the declining Roman Empire of Western man' (Reitlinger, 1961, p. 228). The updated 1895 Act on death duties, Reitlinger (1961) suggests perversely, encouraged the 'insecure and the overtaxed' (p. 228) to participate in the market, because art could be substituted for money in lieu of tax.

The American auction house Parke-Bernet outperformed Sotheby's in the 1946–47 season and Peter Wilson, Sotheby's CEO, decided that Old Master sales could be successfully conducted across the Atlantic. Meanwhile, New York dealers like Leo Castelli and Betty Parsons led the way in the contemporary field.

Hong Kong, 1949–today

The Asian antiques market grew in size with the disembarkement of great numbers of Chinese dealers and artefacts from China after the revolution in 1949. There had been a market for Chinese art since the seventeenth century, but never an international Asian entrepôt like Hong Kong. Dealers such as Shanghai-born Edward Chow sold to Percival David, Barbara Hutton and King Gustav of Sweden. Most of the best dealers, T. Y. King, Joseph Chan, Edward Chow and Robert Chang, who sought sanctuary from the Communists, came from Shanghai as Hong Kong began to rival London as the international centre for Asian art

The rise and fall of Paris, 1945–62

The Paris market rose gradually from 1945 to 1950, rapidly from 1954 to 1956, and boomed in 1959–60 before crashing in 1962.

The French stock market had recovered its value quicker than the other industrialized countries. From 1941 to 1962 it enjoyed a steady increase, whereas Britain and America had to wait until 1954, but the country endured a bear market from 1962 to 1965 and in 1959 the franc was devalued (Global Financial Data). The art market in France, which saw the arrival of Aime Maeght, Heinz Berggruen and Galerie de France in the 1950s, had been commandeered by speculators who had enjoyed an average annual return of 19.28 per cent throughout the 1950s (Bull Investors.com). As they withdrew, prices fell and confidence waned, especially in the new and 'challenging' abstract work (Moulin, 1987).

New York and London, 1962–73

Mid-1960s New York on the other hand was now the centre of major Sotheby's and Parke-Bernet Impressionists sales, as well as home to a new Montmartre located in Soho. A strong Wall Street led to healthy prices across all markets.

London was slow to recover but the arrival of Leslie Waddington and Marlborough Fine Art helped boost confidence. Marlborough, in particular, turned itself into a super-gallery, with branches in New York, Liechtenstein, Zurich, Rome, Tokyo and Montreal. The necessity to have international outlets, particularly in New York, characterized the behaviour of the major galleries and auction houses from this period onwards.

Blow out, 1971–73

Britain's greatest ever stock market crash sent the London art market into a tail-spin. Annual stock market returns in the 1970s fell to 5.82 per cent, but Britain's devalued currency (1967), high inflation and interest rates in the

1970s actually encouraged a perception that art would make a good alternative investment. As a result, the art market was not affected until 1974 and recovered in the same season early in 1975. Frank Hermann explains this in Christie's *End of Year Report* (1974, p. 10):

> However, in all areas of collecting interest, with the possible exception of Chinese works of art, the decline did not parallel anything like the fall of capital values in purely monetary areas and, as we shall see, it recovered much more rapidly.

London retained its premiere market position for Old Masters, Asian antiques, English and French eighteenth-century art and the Victorians. New York took control of the French nineteenth-century *pompiers*, twentieth-century South Americans, the Impressionists and post-Impressionists and contemporary art. The market boomed and busted across most sectors. Chinese ceramics (particularly Ming) had been bid up by Japanese buyers from 1969 to 1973 as they switched out of an inflation affected yen. London dealers had meanwhile sold at inflated prices to speculators (particularly the Portuguese). When oil prices quadrupled in late 1973, Japanese corporate collecting stalled and a *coup d'état* in Portugal in 1974 took out major collectors for Chinese ceramics from that country. Prices dropped dramatically in response. The rare book market (graphics, maps and atlases) also suffered greatly from Japan's departure from the market.

Boom and crash, 1980–90

World-wide economic prosperity in the 1980s (stock market returns averaged 17.57 per cent annually) until the New York crash of October 1987 and Black Monday in London in October 1988, resulted in a growth in global art centres. The growth of established markets and the global expansion of firms like Sotheby's and Christie's added to the power of the market. Prices remained high until the bitter end in both contemporary and modern sectors, culminating in the Christie's sale of Van Gogh's 'Portrait of Dr Gachet' in New York on 15 May 1990 for $82.5 million (today: approx. $120.79 million) and 'Au Moulin de la Galette' at Sotheby's, New York, two days later for $78.1 million (today: $114.34 million). (See Box 3.1.)

The late 1980s were characterized by a number of things: the world's highest ever auction prices (half the top prices ever paid at auction were paid between 1987 and 1990), the dominance of New York in the price game (out of the 23 top prices, 15 were achieved in New York, 7 in London and 1 in Paris), and the exorbitant prices paid for modern art. Another legacy of the 1980s was the tertiary market contemporary sales that are now a permanent feature. Just like the crashes in the 1960s and 1970s, a time lag of a few years separated the stock from art market collapses. The reason is that, as in Paris in 1959–62 (and arguably in London from 1971 to 1973), speculators

Box 3.1 The price of today's contemporaries

Baselitz, Georg (1938–) 'Ludwig Richterauf dem Weg zur Arbeit', Sotheby's NY, 8 Nov 1991 ($1 million) (£1.38 million)

Twombly, Cy (1928–) 'Untitled', Sotheby's NY, 8 May 1990 ($5 million) ($7.3 million)

Johns, Jasper (1930–) 'False Start', Sotheby's NY, 10 Nov 1988 ($15.5 million) (today: $25 million)

Rauschenberg, Robert (1925–) 'Rebus', Sotheby's NY, 30 April 1991 ($6.6 million) (today: $9.2 million)

Hockney, David (1937–) 'Grand procession of dignitaries in the semi-Egyptian style', Sotheby's NY, 2 May 1989 ($2 million) (today: $3.52 million)

Hirst, Damien (1965–) 'Hymn' ($2 million) Gagosian 2000, NY

Hirst, Damien, 'Charity' ($2.4 million) White Cube, 10 September 2003, London

had entered the market and as dividends dwindled on the stock market, investors sought short-term returns from rapid turnover in the art market. Irresponsible bank lending exacerbated an already volatile situation.

The extraordinary nature of the boom of 1987–91 received added zest from the actions of the Japanese. The post-Plaza and Baker/Miyazawa Agreements of 1985 and 1986 respectively had raised the value of the yen dramatically against the dollar but failed to stem the high levels of Japanese exports. As a result, Japan was awash with money that was invested in real estate and stocks – much of it overseas. Banks like Sumitomo lent money to companies like the Osaka-based Itoman Corporation on the basis of a $521 million valued art collection. An interest rate hike at the end of 1989 and again in August 1990 and a tightening of the money supply failed to prevent the bursting of the asset bubble in Japan. Art had been one of the most frequently traded assets, along with golf club memberships and real-estate, and the banks had backed dealerships such as Gallery Urban and the Aoyama Gallery on the basis that these assets could be sold on indefinitely, and at higher prices.

New York and London in the 1990s

From a 1991 low, the art market index has climbed steadily until 2004, with a brief negative tremor following 11 September 2001. Since the height of the boom in 1989 by far the greatest number of top painting prices have been

achieved in New York (mainly for 'moderns' and Impressionists) although London retains its dominance in the Old Master market, sealed by the sale of 'The Massacre of the Innocents', at Sotheby's of London on 10 July 2002 for $76,600,000. Growth across the major sectors has been fuelled by the highest ever annual stock dividends (18.17 per cent). The market has witnessed the development of strong emerging markets in the Chinese world and Russia. It has seen the failure of aspirant art markets in South America and Eastern Europe. Firmly rooted in New York (Impressionists, moderns, contemporary) and London (Old Masters), the market has seen Hong Kong cement its position as the leading international market in Asia as well as the international centre for Oriental art. The market for the Alpha works of dead artists is diminishing (although this is often overstated) and a greater number of collecting categories exist now to compensate for the dearth of the best art. Christopher Wood spoke of 1980s/1990s taste, which favoured decorative imagery over great work, and Reitlinger of the vulgar and frilly taste of men of low origin (*Intendents Généraux* and *fermiers généraux*). They should know that a society gets the art that it deserves and the market simply converts taste into value.

Bibliography

Alpers, S. (1988). *Rembrandt's Enterprise: the studio and the market.* Chicago: University of Chicago Press.

Aymard, M. (1982). *Dutch Capitalism and World Capitalism.* Cambridge: Cambridge University Press.

Behrman, S. N. (1953). *Duveen.* London: Readers Union, Hamish Hamilton.

Brown, C., Kelch, J. and Van Thiel, P. (1991). *Rembrandt: the master and his workshop.* New Haven, CT: Yale University Press in association with National Gallery publications.

Buchan, J. (1994). *Money: the psychology of money.* Harmondsworth: Granta Publications.

Chastel, A. (1972). *Italian Art.* London: Faber & Faber.

FitzGerald, M. C. (1995). *Making Modernism: Picasso and the creation of the market for twentieth century art.* New York: HarperCollins.

Floerke, H. (1905). *Studien Zur Niederlandischen Kunst und Kulturgeschichte.* Munich and Leipzig: Georg Muller.

Foss, M. (1971). *Man of Wit to Man of Business: the arts and changing patronage 1660–1750.* London: Hamish Hamilton.

Gimpel, R. (1963). *Diary of an Art Dealer.* London: Hamish Hamilton.

Haak, B. (1984). *The Golden Age: Dutch painters of the seventeenth century.* London: Thames & Hudson.

Held, J. S. (1969). *Jung: Rembrandt's Aristotle and other Rembrandt essays.* Princeton, NJ: Princeton University Press.

Hobbes, T. (1651). *Leviathan.* Reprinted Harmondsworth: Penguin Classics (1985).

Hope, C. (2003). *Titan,* edited by D. Jaffe. London: The National Gallery.

Jardine, L. (1996). *Wordly Goods: a new history of the Renaissance.* Basingstoke: Macmillan.

Jörg, C. J. A. (1982). *Porcelain and the Dutch China Trade*. The Hague: Martinus Nijhoff.

Kempers, B. (1994). *Painting, Power and Patronage: the rise of the professional artist in Renaissance Italy*. Harmondsworth: Penguin.

Martin, W. (1907). 'The life of a Dutch artist in the seventeenth century', *Burlington Magazine*, xi (April–Sept), p. 369.

Montias, J. M. (1982). *Artists and Artisans in Delft: a socio-economic study*. Princeton, NJ: Princeton University Press.

Moulin, R. (1987). *The French Art Market: a sociological view*. New Brunswick, NJ: Rutgers University Press.

Reitlinger, G. (1961). *The Economics of Taste, 1760–1960*. London: Barrie Books Ltd.

Robertson, I. A. (1992). *Apollo Magazine*, October.

Rosenblum, R. (2000). *1900. Art at the Crossroads*. London: Royal Academy of Arts.

Schama, S. (1987). *The Embarrassment of Riches: an interpretation of Dutch culture in the golden age*. London: William Collins and Sons Ltd.

Shell, M. (1995). *Art and Money*. Chicago: University of Chicago Press.

Thomas, A. (1995). *The Painter's Practice in Renaissance Tuscany*. Cambridge: Cambridge University Press.

Trevor-Roper, H. (1976). *Princes and Artists, Patronage and Ideology at Four Habsburg Courts 1517–1633*. London: Thames & Hudson.

Vasari, G. (1550–68). *Vite dé più eccelenti pittori, scultorie e architetti* [*Lives of the Most Eminent Italian Architects, Painters and Sculptures*]. Reprinted Harmondsworth: Penguin (1987).

Watson, P. (1992). *From Manet to Manhattan. The Rise of the Modern Art Market*. London: Random House.

Wedd, K., Peltz, L. and Ross, C. (2001). *Creative Quarters: the art world in London 1700–2000*. London: Museum of London.

Whitney Kean, B. (1994). *French Painters, Russian Collectors. Shchukin, Morozov and Modern French Art 1890–1914*. London: Hodder & Stoughton.

Williams, R. C. (1980). *Russian Art and American Money 1900–1940*. Cambridge, MA: Harvard University Press.

Wilson, S., de Chassey, E., Fabre, G., Fraquelli, S., Hewitt, N., Murawska-Muthesius, K. and Silver, K. (2002). *Paris, Capital of the Arts 1900–1968*. London: Royal Academy of Arts.

Wilton, A. and Bignamini, I. (1996). *Grand Tour: the lure of Italy in the eighteenth century*. London: Tate Gallery Publishing.

Wood, C. (1997). *The Great Art Boom, 1970–1997*. Weybridge: Art Sales Index.

4 The success and failure of international arts management

The profitable evolution of a hybrid discipline

Eric Moody

This is about creating the arts leaders of tomorrow. The Clore Cultural Leadership Programme is an investment in the future of the performing arts, of museums, art galleries and all cultural venues.

(Press Release: Clore Duffield Foundation, 2003)

A culture of complaint

The first years of the twenty-first century see arts management firmly established internationally as a profession deserving of criticism for its failure to meet the expectations of those with a vested interest. A search for new leaders in the cultural sector is not new. Alfred H. Barr Jr, the prototype director of the world's first museum of modern art, was effectively relieved of his post in 1943 by his trustees, four years after the opening of the Museum of Modern Art (MOMA) at its purpose-built home in New York. Barr's role had been relieved of 'niggling detail' and this allowed him to realize 'the one great mission as yet undone' to develop a collection 'which would coherently – and exquisitely – illustrate the gospel of modern art according to Barr' (Marquis, 1989: 210).

Over the years Barr and his 'gospel' have received some robust criticism, but his career provides a start for an account of the role of arts management in international art markets. A culture of complaint, often triggered by Barr's museological legacy, provides an opportunity to audit the profession and its contribution to the market economy of the arts and the broader creative and cultural industries, of which the international art market is a key component. Government encourages and business aspires to add aesthetic value to its products. Britain's first full Secretary of State for Culture, Media and Sport (DCMS), Chris Smith, published his vision of a *Creative Britain* in which he expressed his belief in a 'synergy' between the cultural and creative sectors. The book is protected by a jacket featuring paintings by Damien Hirst, the archetypal young British artist (Smith, 1998).

Arts management, at best a hybrid discipline of public and business administration, operational and strategic management, and practical and theoretical criticism, now has a professional identity, political attention and academic

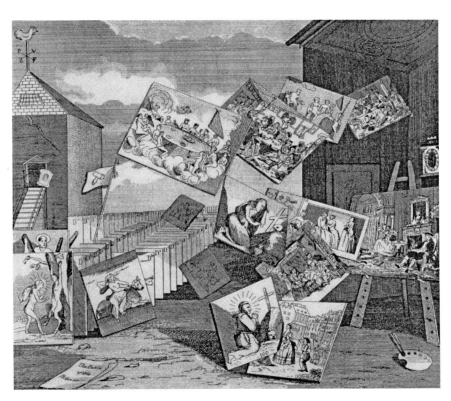

Plate 4.1 William Hogarth, 'The Battle of the Pictures', Engraving, 1744/45
(Kupferstichkabinett, SMPK, Berlin) (By permission of the Mary Evans
Picture Library)

mass. We can safely appraise individuals and audit art management's corporate effectiveness against expectations, which may or may not be realistic, secure in the knowledge of an effective vocabulary and discourse about art and management. We know expressions such as 'art world' refer to the dominant system of production, distribution and utilization of art but should also allow for other art worlds and markets. We are aware that 'culture' may simply be a set of shared 'attitudes and beliefs' as well as, on occasions, an inspirational high art culture. In this respect we are practised at lifting and dropping the heavy baggage of Matthew Arnold with his 'pursuit of perfection' against 'anarchy' (Arnold, 1869: 59). We are aware that we live in a globalized market economy and in our dealings with institutions we experience the difference between effective management and ineffective managerialism. We rejoice in efficient administration, when we meet it.

A culture of audit and appraisal

If we are in employment, we will know of personal appraisal and corporate audit. In both it is usual to address what a profession claims to do against evidence of performance. Here we can be brief – most arts managers claim to promote artistic or aesthetic quality and thereby, through fractured logic, the general welfare of the arts. History tells another story. Quality is hotly contested while the generality of art goes unseen and the majority of artists remain unknown and thereby economically dormant. As artists they don't contribute to a 'creative economy' but they do as consumers and, as we will see, they are a major source of hidden subsidy for the market and art's institutions. As Robert Hughes observed of the USA in an article called 'Art and money':

> Today, according to the best statistics I can find, 35,000 painters, sculptors, potters, art historians and so forth graduate from the art schools of America every year. This means that every two years this culture produces as many art related professionals as there were people in Florence at the end of the Quattrocento.
>
> (Hughes, 1990: 401)

The consequences of such an apparent over-supply of producers and product under prevailing market conditions, are spelt out by Hughes: 'It means that we have a severe unemployment problem at the bottom and an exaggerated star-system at the top of the artist population' (Hughes, 1990: 401).

A report commissioned by the Australia Council anticipates Hughes and suggests an international problem: 'Although they are highly trained and make a major contribution to society, artists' status in the community is not high, partly because of the low income-earning potential of their profession' (Australia Council, 1983: 1). This lengthy report goes on to quote the Canadian Federal Cultural Policy Review Committee and in so doing

provides a new insight into cultural subsidy: 'Too many artists, dancers, singers, writers and others are being asked, in effect, to give a personal financial subsidy to Canadian cultural activity – through their acceptance of low financial rewards for their efforts' (Ottawa Review Committee, 1980: 10, cited in Australia Council, 1983).

Carol Duncan in her essay, 'Who rules the arts world?', provides a convincing explanation for a cultural paradox (or sweat-shop reality) of general producer poverty and extensive institutional growth: 'Artists make works, but they do not have the power to make their work visible as art in the high art world. Their work becomes high art when someone with authority in that world treats it as art' (Duncan, 1993: 171). Those 'with authority', the arts managers, support an even more privileged caste within their profession, charged with deciding what is art and where it can be acquired. The sociologist Howard S. Becker calls them 'gate keepers' but we know them as artistic directors or curators (Becker, 1982).

In order to understand the role of arts managers and their role in the international art market we are going to concentrate on the art of the living, since the past is dealt with in great detail in the preceding chapters.

The contemporary art market operates in the same way as other markets and, with careful management, it provides the blue-chip stock of the future. Closer inspection of this market, however, reveals an identity, policy and ethical deficit which has a huge impact on its scale and strength nationally and internationally. It is even possible to consider the lack of a diverse contemporary market as a contributory factor in periodic art market recession and possibly in the broader creative economy.

When the British DCMS reported on the economic importance of the *Creative Industries* in 2001 it failed to differentiate contemporary art from the broader art and antique market. The European Symposium on the *Status of the Artist*, held in Finland in 1992, likewise made no mention of policies for market development:

> We have traditionally had arts policies or cultural policies in Europe, but seldom have we talked of artist policies. What we do have is art policies for public cultural institutions, policies to promote participation in cultural life and artist policies pertaining to grants to artists.
>
> (Mitchell, 1992: 41)

This is a strange omission in a global market economy where income confers status. It is, therefore, important to continue to ask and answer the following questions:

- What is arts management and where is the profit in the not-for-profit world it manages?
- Who complains and about what in the management of the visual arts?
- Who are the arts managers and what are their roles?

- Where is the success and failure of arts management?
- What recommendations can be made for market development and economic growth?

What is arts management and where is the profit in not-for-profit?

A bit of canvas with a few dollars worth of paint – provided that the brush was wielded by a Cézanne or a Renoir – can bring greater capital gains than glamour stocks or a corner lot on Wall Street.

(Meyer, 1973: 18)

Without provenance art can appear as so much 'junk' worthy of target practice, if we recollect the mythologized tale of Vincent Van Gogh. There is, of course, a happier, though posthumous story of Van Gogh's art. At Christie's in March 1987 his 'Sunflowers' sold for £24.75 million: 'This land-mark sale heralded both the beginning of the auction house boom and the conspicuous emergence of the Japanese corporate collector and the two have continued to be bracketed together' (Buck and Dodd, 1991: 79). In their televised *Relative Values or What's Art Worth* neither Buck nor Dodd was able to anticipate the bursting of the Japanese Bubble Economy in the early 1990s.

In the developed world, willing and able to embrace a globalized generic brand called Art, visual arts management flourishes to serve an expanding institutional framework for validation and promotion of the Van Gogh condition. Although it is obviously good for business to locate the work of living artists and their markets within the even greater dead artist brand, it is important to understand the difference. In order to function in the living artists' market, art objects need to have a demonstrable connection with their producer (the artist) and he or she needs to establish and maintain a repu-tation for producing a particular quality brand of high art. These unique objects are made or conceived by a producer who is primarily engaged in the therapeutic process of self-expression. They may be batch produced or sub-contracted but they are not, like some other arts or crafts, mass produced but nor are they bespoke. The activities of the late Willi Bongard, editor and publisher of the Cologne based newsletter *Art Actuel*, demonstrated the way reputation is maintained and value attributed. Bongard provided a value-index based on points awarded for exposure within overlapping systems of validation and valuation. Exhibitions in major art museums and galleries, themselves of international repute, and critical coverage in international publications scored highly (Nairne, 1987: 60–1).

Combining Meyer's insight with Bongard's index identifies the inestimable service provided by an international community of arts managers with a shared taste in arts and artists. These institutions appear to have no com-

mercial interest but they increase market value through their cultural interest. Once started the reputation process cannot stop even after the death of the artist. Promotional systems supported by nation states have led some commentators to observe the existence of state art and artists even in liberal democracies like Britain (Lee, *The Jackdaw*, 2002). While undoubtedly true, and Lee goes into great detail in his magazine, *The Jackdaw* (see issue 16, March 2002 for example), the real imperative is to transcend a local, regional, national reputation for a state of grace – an international artist. This requires a major investment beyond the scope of even rich artists and dealers.

Roger Berthoud, biographer of Britain's most celebrated sculptor, Henry Moore, illustrates the necessity of state investment and the Meyer/Bongard principle in action when speaking of the activities of the British Council:

> The Henry Moore exhibition which the Council showed on the continent from May 1960 was the biggest to-date with fifty-five sculptures and sixty-two drawings. It was to visit Hamburg, Essen, Zurich, Munich, Rome, Paris, Amsterdam, Berlin, Vienna and Copenhagen. Moore and British prestige were not the only beneficiaries. In the British Council, Marlborough Fine Art had a state-supported public-relations operation on behalf of their client which the largest multi-national corporation might have indeed envied.
>
> (Berthoud, 1987: 284)

Throughout the 1960s and for most of his life, the British Council marketed the Moore sub-brand of the great Art brand. In the world of international cultural diplomacy this was and remains a way of demonstrating to the world Britain's continued presence, influence and modernity. Other 'powers' are doing the same with their national and international artists and commercial representatives through similar agencies and with similar positive consequences. In 1964, for instance, the United States Information Agency was entrusted with the task of organizing the exhibition of Robert Rauschenberg at the Venice Biennale and his dealer, Leo Castelli, threw several victory parties when his artist won the painting prize (Tomkins, 1980).

From hamlet to city-state

The international art world of the 1960s and 1970s was a mere 'hamlet' of '10,000 souls' devoted to modern art as Tom Wolfe claimed in his infamous and entertaining debunk, *The Painted Word* (Wolfe, 1976: 26). It has grown beyond recognition (from hamlet to city-state) as the respected international art journal *Art in America* documents:

> In a single summer, Germany added three new museums of contemporary art to a landscape thickly sown with similar institutions. Each of

the newcomers – Bremen's Westerberg, Frankfurt's Museum of Modern Art and Aachen's Ludwig Forum – reflects the passion of the private collector and highlights the cultural rivalries encouraged by the country's federalized structure.

(Jan Galloway, 1992, in *Art in America*)

Throughout the 1990s the art world continued to expand. New signature buildings (by signature architects for signature artists) appeared in the world's art market capitals. Biennales appeared in just about every city in the world. All these rehabilitated urban centres pushed the brand of contemporary art known as Modern. By December 1995 reports from nations in *Art in America* were joined by Robert Alkin's report on 'the year the art world went online' (Alkin, December 1995, in *Art in America*). The colonization of cyberspace as well as real space continues as we settle nervously into the twenty-first century.

The 1990s also saw the progressive colonization of the institutions and the symbolic spaces of the past. National and local heritage museums hosted installations of contemporary modern art or allowed re-hangs of their collections to tell stories other than their own. Other disciplines and their institutions, such as religion, science, education and healthcare, were annexed to provide opportunity for artists and marketing for collaborators. Cheap labour in the name of 'regeneration', 'education' and 'out-reach' for major and minor installations was procured by 'agents' in local and far-flung communities – from primary schools to peasant villages. Arguably the most emblematic of colonial victories was the siting of contemporary modern art on the fourth plinth of Trafalgar Square in central London. The 'cutting-edge' in the heart of Empire.

Among all this growth and activity we can recollect two things; an art market recession and the failure of arts managers to address the welfare of the practitioner, to represent culturally diverse communities and to develop 'new' markets. We might easily conclude: 'It is useless to consider a larger place for art in the life of a nation without first securing the livelihood of the artist' (Anon, 1946: 13).

How public service became a service to private enterprise

As John Pick (1998) points out in his seminal work, *Arts Administration*, what we today call arts management has a long history and can be applied to the 'middlemen in a three-way transaction between artists, audience and the state' (Pick, 1988: 2). The efficient administration of resources requires the techniques of administration to be developed into skills in a context where the goals of the institution are articulated and shared by all. Unfortunately, although it is clear that business is driven towards maximizing profits, it is less clear what the world's art institutions are administered to achieve beyond sustaining their own existence, programmes and expansion.

As a consequence titular vacillation is commonplace in academic circles. Intriguingly, we are introduced to John Pick as 'Director of Arts Administration Studies' in the first edition of his book but in the second he is 'Emeritus Professor of Arts Policy and Management' and 'founding Professor of Arts Management'. His changing title reveals an evolution of the academic discipline which is not, as we will see, evident in the profession.

If we look back to the early days of arts administration it is easy to see how the special status of public institutions (improved by better administration) encouraged the building of elaborate national frameworks on top of bequeathed buildings and collections. This process was itself underpinned by philanthropic traditions, which already provided free or inexpensive access to museums, arts galleries and libraries as public resources for education and self-improvements. In time this solid late nineteenth-century foundation allowed the development of now publicly funded institutions for contemporary art and artists to replace the loss of refined aristocratic and educational patronage. It also allowed it to supersede private self-help and educational establishments such as the salons, academies and exhibition societies of the nineteenth and early twentieth century. By the mid-twentieth century these artists-led institutions were considered at best old fashioned and at worst reactionary. Some were considered crudely commercial and, what's more, patronized by arrivists with too much money and too little taste for international modern art.

It is ironic that whatever the political ideology of a national institutional framework, attitudes towards effective management remain remarkably similar. As Christine Lindsey's *Art in the Cold War* (1990) demonstrates, national systems administer the prerogative of controlling and protecting the quality of art and the selective participation of artists (Lindsey, 1990). They decide what is 'high art' (Duncan, 1993: 171). These self-important and modernizing systems are by their nature expensive to run. Even before the global oil crisis of the early 1970s governments with higher priorities discovered they couldn't afford to adequately fund their high art institutions.

A cultural revolution in funding

Since the mid-1970s a growing challenge for those quietly administering the self-arrogated right to play God with high art is a cultural revolution in funding. Some ill-suited, like fish out of water, and others, like ducks to the same, have been obliged to negotiate a complex and fluid fiscal culture of public/private partnerships which are inevitably driven by business and political imperatives rather than by laudable but vague notions of public service. The challenge for institutions is survival with the prerogative of choosing high art intact. The solution has been managerial, not simply administrative but certainly not a managed response to environmental challenges. The paradox is that leaders of cultural institutions are not expected to manage for the general good of art. This accounts for the nomenclature problems faced by

trainers and educators and the thwarted ambitions of the talented. It may well be the cause of the paucity of 'leaders for tomorrow' (Clore Duffield Foundation, Press Release, 2003). The educators know the sector needs policy to contextualize resources management, but the sectors' senior managers need efficient and obedient administrators to protect the prerogative of choice as they, the leaders, navigate the new and dangerous fiscal waters in bigger and safer institutions.

Privatizing culture?

A nostalgia for a reliable welfare state including adequate provision for art permeates Wu Chin-tao's (2002) exhaustive catalogue of cultural change in the USA and the UK since the 1980s. Her sentiment for recently lost conditions in Britain are privately echoed by arts managers even as they seek to play their part in negotiating new deals with politicians and the corporate sector. A contemporary review featured on the jacket of Wu's book, *Privatising Culture: Corporate Art Intervention since the 1980s*, summarizes her contribution to an important debate about a radical change in the management of culture which is not exclusive to the USA and the UK:

> The (corporate) patrons of postmodernity are not white patriarchs or the haute bourgeoisie, aiming to bolster their privilege by imposing timeless, conservative verities on the masses. Instead they transmit their values by sponsoring art which is disorientating, shocking, rebellious and cool. If anyone still wants to criticize the morality of the market place, they must also develop a critique of this commercial aesthetic.
>
> (*Times Literary Supplement*, 2002)

What this endorsement encapsulates, and Wu explores, is the new and enhanced power of a globalized, plurally funded, state-endorsed cultural sector. It is then the morality of the cultural sector rather than the marketplace which should be the concern. What we are witnessing is more than just another corporate intervention. This is recognition by the corporate sector of a new or a revival of an old but highly successful imperial business paradigm. Institutionalized high art advertised as culture has been commodified and bought into by business. In the visual arts, an older model of art objects sold through the orthodox market of dealers and auction houses, which are filtered for quality and gradually absorbed into the art museums of high culture, is being superseded by the institutions' own cultural product. The production line shows signs of being a closed, anti-competitive system with international aspirations. It is a model more like trade within an empire than free-market capitalism. The moral question for culture and business has already been addressed by Naomi Klein (2000) in her investigation of global super brands in business. The full title of her study, *No Space,*

No Choice, No Jobs, No Logo. Taking Aim at the Brand Bullies, reveals a similar agenda for culture, which claims to be different (Klein, 2000).

The paradox of the cold war years of 1945–62 where ideological differences produced similar institutions for different high art serves to underline global conformity today. Although there are often higher social and political priorities in countries emerging from political or economic isolation, modest government investment in a biennale of contemporary modern art or a similar event provides an effective symbol of a commitment to personal freedom and a willingness to be a player in global market capitalism. A similar service is available for governments of post-industrial/colonial nations in need of a makeover as a creative, regenerated, socially inclusive, educated nation. Symbols are cheaper than real political and financial investment in an effective infrastructure designed to sustain a creative environment and economy. Today, symbols of 'creativity' can be bought by simply spending taxpayers' money on the refurbishment and expansion of a nation's institutional framework for contemporary modern art.

Who complains about the management of contemporary modern culture?

Those who do not benefit financially, socially or professionally from modern culture are the complainants. With a few notable exceptions vehemence varies from the privately strident to public whispers. Laws of libel properly prevent overly specific allegations and vested interest usually de-motivates whistle-blowers. No one wants to offend the goose that might just lay the golden egg of opportunity. Understandably, dissent also derives from the public/private nature of the institutions and their claim to represent 'excellent', 'serious', 'innovative', 'cutting-edge', 'challenging', 'difficult', contemporary but 'modern' art. A prerogative and outcome easily contested by those with experience and a memory.

Dealing with dissent: artists and philistines

Dissenters are assumed to have similar personal and peculiar reasons for complaint inevitably seasoned with 'sour grapes'. For the champions of culture dissent falls into two easily dismissed categories – artists and philistines. Both groups are inevitably excluded from active participation because the generality of artists are judged to be unable to produce 'serious' work and the philistine, is by definition, unable to recognize the same. This patronizing rejection, almost by constitution, requires a more strategic and collective response from the artist and a more detailed response from the philistine. To be effective protest needs to be attached to bigger issues such as the politics of identity, disadvantage and exclusion or to a detailed knowledge of operations and inequity. The following examples serve to illustrate a more strategic and effective challenge to the considerable defences of contemporary modern

art, which include a highly effective propaganda machine and the savagery of sycophants.

Getting included

In 1984 the Museum of Modern Art in New York presented an international painting and sculpture show of 166 artists. The fact that there were 'about 16 women' in the show triggered the formation of the *Guerrilla Girls*. Their highly effective and much cited agit-prop campaign allowed them to claim success after less than ten years of international activity. The artist Romaine Brook reported in an interview with Suzie Gablik: 'The 1993 Whitney Biennal in New York was 40% women and about 35% artists of color, and we take full credit for that.' Male artists 'of color' might wish to contest the accuracy of this claim since globally there has been wave after wave of protest orchestrated around race, ethnicity, nationality, sexuality, region, locality – the so called Other demanding inclusion. Of course there remain other Others to be identified and organized but arguably the most significant Other in the twenty-first century is the excluded aged (over 50). The abiding example of the *Guerrilla Girls* has been to claim endemic disadvantage as their own while remaining anonymous and, therefore, protected from reprisal. According to Brook: 'The whole point of our anonymity is that we don't use the Guerrilla Girls to further our own careers' (Brook, 1993, cited in Gablik, 1997: 209).

Substituting the word 'damage' in this statement for 'further' might be closer to the truth. These proudly feminist artists, using, 'their other great tactic of Report Cards which evaluate specific members of the art world on their performance in relation to the under-representation of women', the Guerilla Girls want access to the system which has the power to give them financial independence in a market economy (Gablik, 1997: 203). They are happy to identify 'critics, artists, curators and dealers' (some of whom were women) as the cause of 'the under-representation of women' but they don't want to be identified themselves. They don't want to be patronized but they need patronage – the opportunity to have their work selected, validated and ultimately bought and sold in the market for contemporary modern art. Such ghettoization may be a short-term necessity but once institutionalized it perpetrates disadvantage and exclusion by type-casting beneficiaries and those who are excluded from new special provision. Many artists and even some arts managers protest against exclusion and impoverishment caused by special provision while others use it as a step towards personal international success detached from particular identity politics. The director of inIVA (Institute of International Visual Arts), 'Britain's only nationally funded arts organisation with a specific brief to promote international artists from diverse cultural backgrounds which take(s) risks on young, unknown artists and those who have not yet been validated by the mainstream art world', reveals a real problem of perception which is hard to dispel. Gilane Tawadros confirms:

One of the misconceptions about inIVA is that it is an organisation that works only with artists who are not white. But inIVA has consistently rejected the idea of developing projects around essentialist notions of race and ethnicity. That means being inclusive; it doesn't mean being exclusive which is often an assumption made about the organisation.

(Tawadros, 2002: 14)

Such emphatic rejection 'of an assumption' doesn't fit comfortably with 'a specific brief' which uses the term 'international artist' to identify artists who may not, in the usual sense, be of international repute but who are 'international' as opposed to an assumed essentialist notion of national.

A culture of complaint in 'culture'

To complain about public misconceptions or public hostility is an integral part of the belief system of publicly funded institutions of contemporary modern art. They see themselves as guardians of an international avant-garde (in a national context) whose function is to challenge rather than serve a general public or private markets. Similarly, rich and famous international artists, usually on the occasion of their latest retrospective in the not-for-profit sector, complain of their country of origin or domicile and its 'philistine' inability to sufficiently recognize and reward their talent. An assumed lack of sympathy and opportunity which caused them to migrate in the first place (like Picasso and Brancusi to Paris and Duchamp *et al.* to New York). This posturing overlooks what Alan Bowness, former director of the Tate Gallery, London, calls *The Condition of Success*. Bowness (1989: 11) identifies:

> Four successive [essentially national] circles of recognition through which the exceptional artist passes on his path to fame. I will call them peer recognition, critical recognition, patronage by dealers and collectors and finally public acclaim.

Represented graphically in Figure 4.1, we are able to compare Bowness's account with the Guerrilla Girls' *Report Cards* on 'critics, artists, curators and dealers'. In 2004 we might contest and enhance Bowness's order and duration (he reckoned 25 years to success) but his model holds true although he omits international promotion and acclaim.

We might also consider Bowness somewhat modest in not revealing the importance of himself and his institution. Then, as now, the Tate Gallery in Britain is the centre of a network of public galleries which provide exposure for artists deemed, in Bowness's word, 'exceptional'.

A certain sort of political disingenuousness appears to be an important part of the culture of high culture. Highly successful institutions with politically astute leaders, just like the highly successful artists that depend on them, claim there is under-funding from non-governmental organizations

Conditions of success

Peer
Critical
Market
Public

Personal
Peers
Curatorial
Market
Public
International

Bowness Bowness Plus

Figure 4.1 The conditions of success for the contemporary artist

responsible for arts funding as they vacuum up public and private resources for contemporary arts and, even, those intended for other purposes like regeneration or education. A carefully orchestrated protest against the injustice of 'instrumental agendas', after the money with these conditions has been used, provides a defensive smokescreen.

Philistines from within

In 2003 the former director of Glasgow Museums and Galleries, Julian Spalding, published *The Eclipse of Art* as a sequel to his *The Poetic Museum: Reviving Historic Collections*. His introduction to the *Eclipse of Art* reassures his reader, 'you are right not to like modern art'. This provocative opener might easily be dismissed as philistine reassurance for a philistine readership published by a philistine publisher if it were not for the track record of both. Spalding was an innovative museum and gallery executive in a European City of Culture and Prestel's reputation as a publisher of high quality art books, often in collaboration with museums and galleries, is irrefutable. Their book, which has its metaphor an 'eclipse' of nothing less than 'language, learning, content and judgement', is a rigorous if sometimes indirect indictment of those who control the British art world. In his concluding chapter, 'The passing of the eclipse', where Spalding seems to be arguing for a more catholic patronage, exhibitions and acquisitions policy, he cites the example of the executors of an artists' estate offering, as a gift, seven small paintings to the Tate Gallery. The gift was declined since, by Spalding's account, the paintings were judged to be only of 'provincial interest' (Spalding, 2003: 9, 10).

As Spalding will know and the Tate's official history reveals, this recent example is just one in a long line of 'bargains' declined by the Tate. Spalding opens his challenge to the British art world by recollecting that the Tate acquired from an edition of ninety 'a tin of shit' by the Italian artist Piero Manzoni for the sum of £22,300. Whatever we might make of Spalding's and the Tate's judgement is less important than a serious argument about effective resource management towards a more inclusive and diverse visual culture as represented in a national museum of modern art. Through Spalding's account we also recollect the ingenuity of the art market, literally selling shit to museums (not just the Tate), and the perspicacity of the anonymous executors who recognize the relationship between the museums and markets. Had they succeeded they would have enhanced the posthumous reputation of their artist and thereby the value of the artist's estate. With a similar mix of emotion we might recall the words of Sebastian Peake: 'Humiliated and heartbroken by the Tate's offer of £1,500 for my father's [Mervyn Peake] whole artistic output she [his mother, Maeve Gilmore] walked home in tears' (Peake, 1999: 9).

Alternatively we might share Jim Ede's delight at being able to pick up for a song what remained of Henri Guadier Breziska's estate after the Tate's modest purchase. Happily for the University of Cambridge these became the basis of Ede's bequest now in Kettles Yard Gallery, Cambridge. From the twenty-first century these examples of lost or gained opportunity are not primarily about an 'eclipse of judgement' (hindsight is indeed a wonderful thing) but rather an 'eclipse' of policy, in the absence of which there persists an anachronistic conceit of presuming to make private deals on behalf of a nation. The impossibility of collecting the best of the 'cutting-edge' of contemporary art should require museums of modern art to consider how art enters and is retained by art museums. They should acknowledge the filtration provided by a viable existence for artists and art outside the museum and the importance of independent commercial galleries in providing patronage. Protesting against the high cost of the market and poor acquisitions budgets is hardly creative.

The dilemma of museums of modern art

On the face of it Nicholas Serota, director of the Tate in Britain, offers the solution to the challenge of acquiring the avant-garde – cut out the middlemen. His re-published *Experience or Interpretation: The Dilemma of Museums of Modern Art* (2000), coinciding with the launch of Tate Modern in 2001, sets out what the international art world would recognize as a Kunsthalle agenda for museums of modern art – an ongoing programme of temporary exhibitions of contemporary modern art with the existing collections being used as resources for parallel programmes of re-hangs and re-configurations. In the case of the Tates we are able to observe a related strategy of using one national museum, Tate Britain, along with a handful

of smaller temporary exhibition spaces for contemporary modern art in London, as a talent test-bed. A transfer to Tate Modern (from national to international) is the ultimate goal and reward with the endorsement of the Turner Prize (for artists under 50). Tate Modern is the new and separate home of international modern art in Britain – connected to Tate Britain by Damien Hirst's 'Tate to Tate boat' which also services the Saatchi Gallery.

The short history of the Tate Modern reveals a programme of temporary exhibitions and installations of international modern and contemporary art imported from abroad and a permanent collection displayed around 'four separate themes that cut right through history' (Nittve, 2000: 11).

Nittve, and other spokespersons for the Tate, echo in their contributions to Tate Modern: The Handbook the view of Serota in his exploration of 'the dilemma':

> Our aim must be to generate a condition in which visitors can experience a sense of discovery in looking at particular paintings sculpture or installations in a particular room at a particular moment, rather than finding themselves standing on the conveyor belt of history.
>
> (Serota, 2000: 55)

Although it easy to be seduced by the 'innovative' displays of an expanded museum empire we might also observe that contemporary audiences are capable of experiencing 'a sense of discovery' unaided, provided they have the courtesy of optimum conditions. Arguably less decorous than 'Monet's Water lilies next to a stone circle by Richard Long of 1991' a chronological hang can be as efficient as a good cataloguing system in a public library in allowing users the creative opportunity to provide their own juxtaposition, interpretations and meanings.

In the context of a consideration of art markets it is necessary to argue for greater attention to the needs of users and a more democratic acquisitions and exhibitions policy designed to develop new and independent canons of 'excellence'.

Commercial galleries dealing in contemporary art

In the autumn of 2002 the Royal Academy in London created an opportunity for thirty-three commercial galleries dealing in contemporary art to exhibit their wares. The introduction to an accompanying publication called The Galleries Book succinctly identifies the role of all commercial galleries in 'the process of evaluating, sifting and disseminating the virtually endless production of art around the world'. The concluding paragraph reveals a focus on those 'sustaining serious, international, contemporary programmes of individual character'.

This group of galleries is not the sum total of commercial operatives in Britain, merely a sample of cutting-edge London, validated by the not-for-profit sector. Almost incidentally their achievements as commercial art

managers are easily denigrated 'many people think that galleries exist merely to make profit at the expense of artists' (Rosenthal and Wigram, 2002: 1–2). The majority of commercial galleries in Britain are obliged to cultivate unaided their own markets.

'High art lite' and the question of quality

In 1999 Julian Stallabrass acknowledged financial assistance from his employer the Courtauld Institute along with the usual expressions of gratitude to his colleagues and students. He was also driven to publish 'anti-acknowledgements' for those with financial interest in the art he criticized who had refused to illustrate his criticism. Alone the title of his book, *High Art Lite: British Art in the 1990s*, justifies their reluctance and provides a withering criticism of an aspect of British art that had come to prominence in the 1990s:

> My term, 'high art lite', has the virtue of being descriptive: I hope that it captures the idea of what I describe, an art that looks like but is not quite art, that acts as a substitute for art. It also suggests that the phenomenon is not confined to Britain, though the particular form that it has taken here will be the focus of this book.
>
> (Stallabrass, 1999: 2)

Stallabrass's detailed account of the rise and rise of young British artists (YBAs) shouldn't distract us from his observation that the phenomenon of 'high art lite' is not confined to Britain or, indeed, to a particular modernist period. Thoughtout art history, demand, whether from the state, bourgeois markets or even the church, can cause the artist to respond with a familiar portfolio of short cuts – deception, sub-contracting, repetition and exploitation. This is a resource management strategy not exclusive to artists but familiar to all those seeking goods and services from over-marketed suppliers.

What is intriguing is the way the successful contemporary modern artist is drawn deeper into marketing rather than making. She or he is required to perform 'the boho-dance' (Wolfe, 1976) more often as a way of paying back the marketing machine of public and private galleries, museums and projects. These artists become arts managers (curators, trustees, educators, community liaison officers and general friend of the art world system). The process of creating the YBAs has by now been turned into an urban myth of self-help combined with careful manipulation of the artworld. The exhibition, 'Brilliant! New Art from London', at the New York Walker Art Center that then went to the Contemporary Arts Museum, Houston in 1996 demonstrates how YBAs were adopted by American institutions, to their mutual advantage. The enterprise, unsurprisingly, received 'enormous co-operation from the artists, dealers and agents' (Flood, 1996). Unlike Stallabrass, in Flood's acknowledgments, there is no need of 'anti-

acknowledgements' – everyone thinks the project is 'brilliant', even the critics employed to comment in the exhibition catalogue.

The silence of the critics

Traditionally, critics provide dissent, alternative interpretation or, indeed, justified praise but as Stallabrass alleges in a chapter called 'The decline and fall of art criticism' there are no contemporary critics in Britain of the calibre of 'Roger Fry, Herbert Read, Adrian Stokes, John Berger and even Peter Fuller' (Stallabrass, 1999: 259). Stallabrass speculates on the cause but underestimates the obvious – today's critics are employed by the system they might, as independent voices, be expected to criticize. Even those employed as academics and, therefore, economically independent require the validation of the system to maintain their personal research profile. Research funds, distributed through arts funding bodies or through research boards influenced by the system, understandably prefer 'songs of praise' for the art they choose to support, rather than objective criticism of institutional products.

An examination of conveniently provided biographies like those in *Art in Europe: 1990–2000* edited by Gianfranco Maraniello (2002) provides evidence of what Charles Handy calls 'portfolio careers' – where a combination of curator, critic, reviewer, art manager and academic is not uncommon. Maraniello acknowledges: 'the fruit of the generous collaboration of critics, artists, collectors, photographers, gallery directors, institutions and all those who have offered the materials presented here' (Maraniello, 2002: 181–3). Again, like Stallabrass he has no need of 'anti-acknowledgements'. Taken collectively the critical essays in *Art in Europe: 1990–2000* reveal a familiar set of challenges for readers – translation, assumptions of fore-knowledge, experimentation with the form (as an art form?) and discovering a sensible connection between images and text. This may be a collection of essays by 'some of today's most aware art critics' but its intended readership is those, and their like, cited in the editor's acknowledgements – those already inhabiting the international city state of contemporary modern art. With the prospect of such a habitat the independent critic is obliged to migrate to broader cultural criticism or art history. Consequently, for the professional galleryist, art dealer and commercial agent there is little in the way of objective critical comment or even a rating system similar to film or, even, restaurants in most market centres.

Dissenting voices in distant lands

Kazuo Yamawaki, Chief Curator of Nagoya City Art Museum, provided an essay entitled 'Regionalism and internationalism of Japanese contemporary art' for the catalogue of an exhibition of Japanese contemporary art held at the Korean National Museum of Contemporary Art in 1997. In his essay

Yamawaki expresses his misgivings about globalization, 'modern Western civilisation has proven its limitations and there are efforts to compensate its deficiency through new methods'. His preference, making common cause with his Korean hosts, is a return to 'values and methods of the East which have been treated as out-dated and insignificant are now being evaluated as something mysterious and full of new possibilities'. He acknowledges that 'the foundations of Modern Art in Japan and Korea are rooted in Western Art' but 'there are movements rising to seek cultural routes of one's own' (Yamawaki, 1997: 59).

The exhibition catalogue by universal convention contains the biographies of the sixteen participating artists who, to a person, were born and trained in Japan but exhibited throughout the world. Yamawaki, as a senior arts manager, is expressing concern about Western cultural hegemony but is also involved in a strategy to seek greater representation for selected Japanese artists within a globalized contemporary modern art culture which isn't really international but rather Western by definition and management – a culture which is managed to control and exclude and, in response to a fiscal culture of plural funding, to produce and market its own product designed to attract diverse funding.

Although legitimate and expressed with conviction, Kazuo Yamawaki's complaint is like so much from within the international arts world muted by a desire to participate more fully. Nonetheless, his contribution to the pattern of protest emphasizes, as a necessary antidote to hegemony, a national, regional, local, race, gender, sexual identity, but fails to explore alternative policy and management.

A foreign visitor to modern and contemporary art galleries and museums in East Asia will notice, by virtue of what's on display, a tolerance of diversity which accepts that contemporary practice might include Western and Eastern practices and traditions which are given exhibition space and critical attention.

The former Eastern bloc (well represented in *Art in Europe: 1990–2000*; Maraniello, 2002) and the Far East now have an art infrastructure which includes modest markets in desperate need of marketing and maintenance and which are driven to seek inclusion in the international artworld. These nations are also supporting the development of arts management as a profession. Looking at a particular national context also rehearses universal management problems that need to be addressed. These are neatly if indirectly identified by Joan Stanley-Baker, former director of the National Tsing Hua University Arts Centre and Professor of Chinese History, in her essay 'Painting in Taiwan today':

> The traditionally revered giants of Chinese painting after the Sung dynasty were rarely professional painters, being usually of the official or gentry class, who indulged in art as a spare-time hobby for private enjoyment and were never concerned over 'markets' for their work.

Today's artists are following the western model of trying to make a living selling their works in the open market place. But the Taiwanese clients to whom they sell their works do not always appreciate their special qualities. More often than not they are happy to pay high prices – but only for works by an artist who has managed to acquire fame.

(Stanley-Baker, 1995: 86)

Conclusion: an eco-system for enterprise in art and everything, or learning to digest sour grapes

Democratic governments in a global market economy seeking the development of the 'creative and cultural industries' must provide political leadership with policy and practice towards this end. They must recognize as a political priority the important of maintaining a public infrastructure for civilized life and enterprise in general rather than symbolic support for 'creative' and 'cultural' enterprise as a substitute for the complex business of supporting a civil society. The maintenance of a safe and efficient environment is of paramount importance to all legal enterprises. No amount of 'new technology' or further privatization can compensate for an inefficient postal, transport, banking and taxation system. This is environmental degradation which enervates enterprise and creates opportunity for crime. A plurally funded arts/cultural sector raises ethical and resource management issues that need to be identified and addressed. Accepting the criticism of the disaffected is the best way to start.

Leadership in the not-for-profit cultural sector

Leaders in the cultural sector need to recollect that not-for-profit status linked to direct and indirect public support confers responsibilities as well as privileges. Rather than protesting about the unfairness of 'instrumental agendas' it would be more useful to debate with governments what these requirements might be for the cultural sector and, in the context of the visual arts, for museums and galleries of contemporary art.

In the visual arts the extraordinary success of the institutions of international contemporary modern art needs to be contrasted with the abiding poverty of individual artists and the limited scale of national markets for contemporary art. The marketing service provided for a minority by the museums, galleries and other support agencies needs to be expanded by using the proven abilities of an international community of highly motivated and well qualified arts managers capable of managing resources for public purposes. This community requires leaders able to articulate public service as well as estate development goals. These new goals are to make facilities available to those who need them – artists, their audiences and entrepreneurs prepared to develop new national and international markets for contemporary art. Public institutions can no longer be seen as instruments of serial

private patronage for selected artists and their dealers nor as a means of personal professional advancement within an international community of curators who appear to have broken away from other resource managers in the cultural sector. Curators need to be re-incorporated into the profession of arts management.

Digesting sour grapes

Although it was fashionable in the late twentieth century to criticize Alfred Barr, we need to recollect his achievement in creating a prototype museum of modern art which defined and developed a field of creative and commercial enterprise while continuing a public service tradition. Barr was able to embrace American modern as well as the international modern art favoured by his trustees (Marquis, 1989).

In general curator/critics of Barr fail to recognize their own role in creating an international mono-culture which encourages the culture of complaint. Token inclusion and strategic funding of the disadvantaged isn't a long-term solution. What we need is the creation of a bio-diverse eco-system for a variety of art worlds and a variety of art markets. We do not need more opportunities for the few.

A lesson from China for the art worlds of the world

The journal *Cultural Exchange: China and the World* devoted much if its July 2003 issue to a discussion of the progress of 'Chinese contemporary art: between local and global dynamics'. A time-line provided by Fan Dian demonstrates a rapid 14-year growth from zero with an impressive infrastructure for contemporary art. His response to a question on the new art market of China focused on exhibitions and provides guidance on market development:

> China's art exhibitions are now presented through three major channels. First, large-scale exhibitions held by the government bodies such as the Chinese Ministry of Culture and artists' associations promote mainstream ideologies. Second, exhibitions organised by art colleges, critics and professional presenters focus on scholarship and experiment. Third, galleries, auctions, and art expos addressing the market and, therefore, facilitate production and circulation of art works.
> (Fan Dian, quoted by Wang Keng, 2003, in *Cultural Exchange: China and the World*)

We need hardly remind ourselves that China is the largest transitional market in the world for all commodities and services including art. If a nation aspires to be a player in global markets it needs a level playing field on which a diversity of talent can be identified and developed. Arts managers (including

curators) are the 'middlemen' who can make this happen. There will be no further need for 'The Battle of the Pictures' (Hogarth, 1744) when all are well represented.

Bibliography (except magazines where full bibliographic details are provided in the text)

Anon (1946) *The Arts Enquiry: the visual arts*. London: Oxford University Press.

Arnold, M. (1869) 'Sweetness and Light', in S. Collini (1993) *Arnold: culture and anarchy and other writings*. Cambridge: Cambridge University Press.

Australia Council (1983) *The Artist in Australia*. Sydney: Australia Council.

Becker, H.S. (1982) *Arts Worlds*. Berkeley: University of California Press.

Berthoud, R. (1987) *The Life of Henry Moore*. London: Faber & Faber.

Bowness, A. (1989) *The Conditions of Success. How the Modern Artist Rises to Fame*. London: Thames & Hudson.

Buck, S. and Dodd, P. (1991) *Relative Values and What's Art Worth*. London: BBC Books.

Collini, S. (1993) *Arnold: culture and anarchy and other writings*. Cambridge: Cambridge University Press.

Duncan, C. (1993) *The Aesthetics of Power Essays in Critical Art History*. Cambridge: Cambridge University Press.

Flood, R. (1996) *Brilliant! New Art from London*. New York: Walker Art Center Publication.

Gablik, S. (1997) *Conversations Before the End of Time*. London: Thames & Hudson.

Hughes, R. (1990) 'Art and Money', in *Nothing if Not Critical: selected essays on art and artists*. London: Collins Harvill.

Klein, N. (2000) *No Logo*. London: Flamingo.

Lindsey, C. (1990) *Art in the Cold War: from Vladivostok to Kalamazoo, 1945–1962*. London: The Herbert Press.

Maraniello, G. (ed.) (2002) *Art in Europe, 1990–2000*. Milan: Skira.

Marquis, A.G. (1989) *Alfred H. Barr Jr. Missionary for the Modern*. Chicago: Contemporary Books.

Martin, S. and Thomas, E. (eds) (2002) *Baltic: the art factory*. Gateshead: Baltic.

Meyer, K.E. (1977) *The Plundered Past. The Traffic in Art Treasures*. London: Penguin.

Mitchell, R. (1992) 'Conclusion', in A. Irjala (ed.) *European Symposium on the Status of the Artist*. Helsinki: Finnish Commission for UNESCO.

Nairne, S. (1987) *State of the Art: ideas and images in the 1980s*. London: Chatto & Windus/Channel Four.

Nittve, L. (2000) in I. Blazwick and S. Wilson (eds) *Tate Modern: the handbook*. London: Tate Publishing.

Ottawa Review Committee (1980) *Speaking of our Culture*. Ottawa: Federal Cultural Policy Review Committee.

Peake, S. (1999) *Mervyn Peake: two lives*. London: Vintage.

Pick, J. (1998) *Arts Administration*. London: E. and F.N. Spon.

Rosenthal, N. and Wigram, M. (eds) (2002) *The Balleries Book*. London: Royal Academy Publications.

Serota, N. (2000) *Experience or Interpretation: the dilemma of museums of modern art*. London: Thames & Hudson (first published 1996).

Smith, C. (1998) *Creative Britain*. London: Faber & Faber.

Spalding, J. (2003) *The Eclipse of Art: tackling the crisis in art today*. London: Prestel.

Stallabras, J. (1999) *High Art Lite: British art in the 1990s*. London: Verso.

Stanley-Baker, J. (1995) 'Painting in Taiwan Today' in N. Jose and Y. Wen-I (eds) *Art Taiwan: the contemporary art of Taiwan*, Sydney: Museum of Contemporary Art and G+B Arts International.

Tawadros, G. (2002) in S. Hillier and S. Martin (eds) *The Producers: contemporary curators in conversation*. Gateshead: Baltic/University of Newcastle.

Tomkins, C. (1980) *Off the Wall. Robert Rauschenberg and the Art World of Our Time*. New York: Penguin.

Wolfe, T. (1976) *The Painted Word*. London: Bantam Books.

Wu, Chin-tao (2002) *Privatising Culture: corporate art intervention since the 1980s*. London: Verso.

Yamayaki, K. (1997) 'Regionalism and Internationalism of Japanese Contemporary Art' in *Japanese Contemporary Art Exhibition*. Seoul: National Museum of Contemporary Art, Korea.

5 Stakeholder relationships in the market for contemporary art

Derrick Chong

Business art is the step that comes after Art . . . good business is the best art.
(Andy Warhol, 1975: 92)

Introduction

A classical view of the industrial economy as 'production–distribution–consumption' is not unhelpful in appreciating the world of so-called high art. Marcel Duchamp (1973: 47), as much as any informed commentator, recognized that the artist (creator) and spectator (consumer) were embedded as part of a circular process:

> In the final analysis, the artist may shout from all the rooftops that he is a genius; he will have to wait for the verdict of the spectator in order that his declarations take a social value and that, finally, posterity includes him in the primers of art history.

Complementing this 'flow-of-exchanges' outlook, one can turn to the role of relationships, as artist and critic Martha Rosler (1997: 20–1, n. 1) does, in articulating the various stakeholders (also called actors or players) constituting the '*high* art world':

> I am taking the art world as the changing international group of commercial and nonprofit galleries, museums, study centers, and associated venues and the individuals who own, run, direct, and toil in them; the critics, reviewers, and historians, and their publications, who supply the studies, rationales, publicity, and explanations; the connoisseurs and collectors who form the nucleus of sales and appreciation; plus the artists living and recently dead who supply the goods.

Within this system, several points can be noted. First, there are indications that networks of cooperation exist such that works of art are joint products

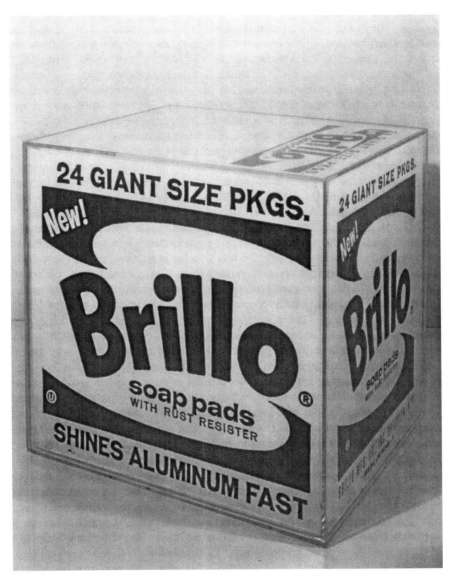

Plate 5.1 Andy Warhol, 'Brillo Box', 1964 (© The Andy Warhol Foundation for the
Visual Arts, Inc./ARS, NY and DACS, London 2004)

of all stakeholders who cooperate; of course, this emphasis on a complex set of relationships, and runs counter to the dominant tradition of emphasizing the individual artist as unique creator of a work (Becker, 1982; Wolff, 1981).[1] Second, the marketing effects of intermediaries help to refine market taste. Systems vary in the kind of intermediaries such as curators, critics, dealers, and arts institutions, who handle the movement of work and money between artist and audiences (of spectators and collectors), and in the immediacy of the communication and influence between the two groups (Becker, 1982). These intermediary stakeholders play a role in the cross-valuation and certification of works of art. Third, economies of agglomeration are important. A threshold market size is necessary. A core–periphery relationship structure is created with an identifiable acme of success. City centres can represent geographical clustering of productive activity. New York has grown in stature since the end of the Second World War, with European entrepôts located in Paris, London and Berlin. Clusters form and change within cities. During the 1990s New York's SoHo gave way to Chelsea; and in London, Hoxton emerged as an alternative to London's West End dealers with Cork Street falling even further behind.[2] The influence of dealers, curators and critics is subject to varying life cycles.[3] The aesthetic ranking of museums of modern art may be less volatile compared to the reputation of individual contemporary arts venues (like ICAs, kunsthalles, or artist-run centres) that rely on programming temporary exhibitions.[4] Large-scale, international art fairs like the Venice Biennale and Dokumenta afford high visibility to artists and are complemented by an increasing global list (e.g. Sao Paolo, Prague, Toronto, Shanghai, Lisbon, Istanbul and Chicago). Fourth, there is a blurring of private–public relationships in the way stakeholders manage their networks. Numerous relationships operate at the same time.[5] Contemporary artists seek to exhibit at state-funded institutions as a means to validate their work, which can lead to higher prices charged by their commercial dealers. Dealers sell to private clients (individuals and corporation) and public institutions – indeed one might argue that large-scale conceptual art is only suited to public collections. Individuals working freelance find that they can wear different hats spanning the private–public divide: curating a temporary exhibition at a public institution, writing reviews for an arts magazine, and offering advice to buyers as a consultant to a commercial dealer. Each can raise ethical issues for the individual actors. Fifth, a hierarchy of effects is discernible: high, middle and low art is a common tripartite classification system to indicate the existence of markers of taste (e.g. Bourdieu, 1984; Wolff, 1981), and linked sub-markets (e.g. Throsby, 1994).[6] Indeed the 'pyramid' structure represents an important way to represent facets of the art world. Sixth, contemporary art relies, by definition, on a temporal marker. Many art museums, for example, classify art works created within the last 30 years as 'contemporary'. The best of contemporary art, then, enters the canon as 'modern' art. Seventh, there is an unlimited supply of contemporary art of varying 'quality'. This invites

change within the system, which is to suggest that entrepreneurial activity can allow neophyte players of artists, dealers, critics and collectors to take root and prosper; moreover, change means that new core players can displace over time some established players falling from power.

In teasing out implications that flow from the citations of Duchamp and Rosler, this chapter seeks to examine the networks and institutional structures as posited by prominent commentators from two strands of writing: sociology of the arts (e.g. Bourdieu, 1984; Becker, 1982; Moulin, 1987; Wolff, 1981) and cultural economics (e.g. Frey and Pommerehne, 1989; Grampp, 1989; Throsby, 1994; Frey, 2000; Towse, 2000). A central interest is to reflect the relationships between the various stakeholders and their role in helping us to better understand forces shaping the contemporary art world.

The next two sections review literature from the sociology of the arts and cultural economics to better understand the contemporary art world: the former section, on the consumption of the arts, including collecting art, focuses on Pierre Bourdieu's research from a sociological perspective; the latter section, on the value of the arts, including art as an investment, emphasizes the cultural economics work of the likes of William Baumol. The fourth section investigates various stakeholders from the 'production–distribution–consumption' exchange system, with a particular reference to the art world system that that allowed particular British artists to gain prominence in the 1990s. The fifth section addresses three power relations among key stakeholders: dealer–artist, dealer–collector and collector–artist.

Consuming art: addiction or cultivation of taste

Cultural economists use 'addiction'; sociologists working in the arts – which dominates the field – prefer 'cultivation of taste'. The arts are 'addictive in the sense that an increase in an individual's present consumption of the arts will increase future consumption' (Throsby, 1994: 3). The cultural economist continues that 'the relative consumption of the arts will rise over time, not because of a shift in tastes, but because the shadow price of the arts falls as experience, understanding and other human capital attributes associated with the arts are acquired' (Throsby, 1994: 3). The more you know, the more you appreciate it. This is to say that a self-reinforcing system exists: arts consumption increases with the ability to appreciate art, which is a function of past arts consumption. *Satisfaction* from arts consumption rises over time.

The sociological approach to understanding the predisposition to arts consumption, as advanced by Pierre Bourdieu, is at odds with the standard Kantian view in which the purity of aesthetic contemplation derives from disinterested pleasure. Bourdieu's pioneering investigations challenged the myth of innate taste: it set out to define the social conditions which made Kant's experience – the beautiful is that which pleases without concept – and

the people for whom it is possible (namely art lovers and so-called people of taste). Arts consumption – visiting art museums let alone buying 'original' art – is closely linked to level of education (whether measured by qualifications or length of schooling) and social origins.[7] Thus, according to Bourdieu, a work of art has meaning and interest only for someone who possesses the requisite cultural competence.

Successful mastery of the code to gain artistic competence requires the use of scarce resource time. First, the economic means to invest in educational time must exist. Second, as the development of cultural practice and artistic production has become more complex in its coding, there is the requirement that one is competent with a wider and wider range of cultural references. Much contemporary art is self-referential so that one needs to devote more and more time to it in order to remain competent. For example, how does one separates a work of art from non-art, the ready-made from commodity? Arthur Danto's analysis of Andy Warhol's 'Brillo Boxes' (1964) is an instructive reminder:

> What in the end makes the difference between a Brillo box and a work of art consisting of a Brillo box is a certain theory of art. It is the theory that takes it up into the world of art, and keeps it from collapsing into the real object which it is (in a sense of *is* other than that of artistic identification). Of course, without the theory, one is unlikely to see it as art, and in order to see it as part of the artworld, and one must have mastered a good deal of the artistic theory as well as a considerable amount of the history of recent New York painting.
>
> (Danto, 1964: 581; italics in the original)

He continues, 'It is the role of artistic theories, these days as always, to make the artworld, and art, possible' (Danto, 1964: 581). The atmosphere of interpretation, according to Danto, is needed. Knowledge of the history of art serves to help make conceptual links to objects already deemed art. Aesthetic theory is needed to justify such a linkage. Moreover, the art world stands at the ready with a willingness to shift with the times to accommodate new languages and ideas.

Gaining cultural competence also can be achieved by using money to recruit advisors who can supplement one's own taste and time constraints. This echoes a cultural economics position: 'One of the reasons why an interest in the arts is limited to a relatively few people is that only a few have made the investment in taste or learning which the interest requires, and that is because the investment is worthwhile to only a few' (Grampp, 1989: 58). The few who do make an investment may enjoy a flow of social dividends:

> Any work of art 'quoted' by publicity serves two purposes. Art is a sign of affluence; it belongs to the good life; it is part of the furnishings which the world gives to the rich and beautiful.

But a work also suggests a cultural authority, a form of dignity, even of wisdom, which is superior to any vulgar material interest; an oil painting belongs to cultural heritage; it is a reminder of what it means to be a cultivated European.

(Berger, 1972: 135)

A 'high' art object offers a gloss that glitters. It remains a superb symbolic good.

The value of art

Art provides satisfaction – utility in the case of economists – in the same sense that any object that is desired provides it:

Works of art are economic goods, their value can be measured by the market, and the sellers and buyers of art – the people who create and benefit from it – are people who try to get as much as they can from what they have. In a word or two, the activity of art is a maximizing activity. Without that assumption, economics has no place in the study of art or of anything else.

(Grampp, 1989: 8)

This is to suggest the transformation of aesthetic value into economic value. At one level, the artist is integrated into society's economy (Moulin, 1987). Moreover, cultural economists view fine art as offering two types of value: art as investment, and art as consumption good. In the former, art is viewed in terms of a financial rate of return; in the latter, art offers an aesthetic yield (or psychic return). Most collectors seek to balance satisfaction on both fronts. Art can appreciate in monetary value, while it is enjoyed from an aesthetic perspective:

Part of the pleasure of collecting lies in risk and competition. Collectors gamble on paintings and artists the way racing enthusiasts gamble on horses or market enthusiasts or stocks. . . . It is an elite recreation, a game in which the losers are presumably those without culture or artistic flair.

(Moulin, 1987: 82)

Speculators represent an interesting category of collector: they highlight some of the nuances of art collecting. First, pure speculators have an 'aesthetic yield' of zero as they receive no pleasure from holding art. 'The financial rate of return on art object should, in equilibrium, be *lower* than that in other markets with similar risk' (Frey, 2000: 166; italics in the original). Second, the successful speculator needs to know something of the value of works

of art: 'Speculation, whatever its objects, is amusing. Because good taste and good investment go hand in hand, the speculator qualifies as a connoisseur by the profit he earns' (Moulin, 1987: 99).

But is art as investment superior to other investments? Is there sufficient information about the rate of return? Economist William Baumol (1986: 10) suggests the answer is no to such questions: 'There are several distinctions between the workings of the securities and arts markets, all of which suggest that an equilibration mechanism is likely to be more feeble in the latter'.[8] Baumol (1986: 10–11) identifies key factors differentiating financial securities as investments from works of art:

- The inventory of a particular stock is made up of a large number of homogeneous securities, all perfect substitutes for one another. Works of art even by the same artist are imperfect substitutes.
- A given stock is held by many shareholders, who can act as independent traders in a competitive stock exchange. The owner of a work of art has a monopoly on that work of art.
- Transactions in a given stock take place frequently – almost continuously. However, the resale of a work of art may be infrequent.
- The price at which a stock is exchanged is public information. Works of art may be exchanged without the terms of sale being disclosed to outside parties.
- In principle, based on efficient markets, the equilibrium price of a stock is known; no comparable assumption can be made of a work of art.

From this Baumol (1986: 13) draws two conclusions: rates of return on painting as an investment were remarkably low – 'the rate of return on a median painting was about one-third as high as that on a government security, and the average return was only about one-sixth of the latter' – and rates of return were remarkably dispersed, 'meaning that this form of investment was quite risky.'

Baumol examined rates of return on dead artists and their long-term reputations.[9] The short-term market for contemporary art may present different opportunities. Contemporary art markets can be likened to an ongoing boom market (i.e. initial public offerings or IPOs of high-tech firms during the late 1990s). There are real winners out there, but how to decide? It is not easy to find the artist who will grow from US$10,000 to US$100,000 in just a few years. 'To make huge profits as a speculator requires taking major risks, and this usually means investing in contemporary art' (Moulin, 1987: 97). Diversifying one's holding – do not put all your eggs in one basket – is conventional finance wisdom. Of course, it requires a sizeable amount of capital for investment. A tracker fund helps smaller investors to diversify: in an ideal world, one could track a successful collector's moves of purchases *and* sales (which might be akin to following Warren Buffet's Berkshire Hathaway).[10] If one believes that perfect information does not exist in contemporary art

markets, it may be worthwhile to think about tapping the private telephone lines of leading dealers (bearing in mind that this is illegal).

Works of art, not unlike investing in theatrical productions, cannot guarantee capital gains.[11] There is an inherent degree of risk. Attribution matters in the sense that one of the chief uncertainties about art – though not often associated with contemporary works of art sold on the primary market – is its authorship. Attribution may not affect the beauty of the work, however it does have a material impact on collectors and consequently values. Transaction costs (e.g. sales commissions, insurance, conservation, transportation, etc.) need to be included in any investment calculation, as they can 'significantly influence the calculated rates of return' (Frey, 2000: 160). Indeed the transaction costs associated with art investments are much larger than for other investment markets.

Stakeholders

'The art market is the place where, by some secret alchemy, the cultural good becomes a commodity' (Moulin, 1987: 3). The institutional approach views the art world as a social and economic network, with more incentives to be connected to the network than disincentives to remain disconnected (Becker, 1989). Artists serve as producers; collectors and spectators serve as consumers. From the exchange process of 'production–distribution–consumption', 'today's contemporary art scene places marketing and distribution at the forefront' (Cowen, 1998: 121). This means that players in the contemporary art market, operating as dealers, critics or curators, have significant roles as intermediaries; moreover, institutions displaying contemporary art also influence taste among non-specialist audiences.

Artists

So-called 'Young British Artists' (YBAs) of the 1990s, centred in London, offer some instructive pointers.[12] Gilbert and George, from an earlier generation of British artists, served as role models. Goldsmiths College, University of London, served as a prominent training ground for some of the lead YBAs. The influence of Michael Craig-Martin, a conceptual artist who has served as a trustee of the Tate Gallery, is viewed as crucial; Craig-Martin and Jon Thompson, another educator at Goldsmiths, are often cited as progenitors to the YBAs. Attention is devoted to the now-famous 'Freeze' exhibition of 1988, organized by the then Goldsmiths student Damien Hirst.

With the marketing potential associated with 'celebrity', fame and money can accrue to successful creators earlier in their careers. (This is not unlike the situation in popular music and mass spectator sports.) The case of Hirst is illustrative of entrepreneurial qualities. For a brief period during the late 1990s, he was involved with a fashionable restaurant venture called Pharmacy – situated in an old chemist's shop in London's Notting Hill – that

was designed to exploit references to the artist's work. Artists are shrewder in exploiting marketing segmentation and price discrimination, not unlike the owners of luxury brands (e.g. Prada, Gucci, etc.) by creating separate bodies of work that can be sold at lower prices to the less wealthy. Hirst's spin paintings represent a recent example of product line extension. At the bottom of the 'fine' art market, there are firms that publish 'limited edition prints' by recognizable contemporary artists.

Spectators/collectors

Should the artist be leading the spectator? Audience reception to 'new' art can be one of bafflement and bewilderment; one may even be troubled by certain shifts – the destruction of values one still cherishes – as they occur in contemporary art. Who is the intended spectator? There is a case that as art turns in on itself, the audience becomes more specialized even if occasional 'blockbusters' of contemporary art invite the curious. For example, does the large scale of some contemporary works of art seek the approval of institutional collectors like museums and corporations?

The individual collector might be viewed as an engaged and sophisticated spectator, someone situated at an advanced level of arts consumption. The individual collector serves as buyer and seller of art. An important duality exists for such art connoisseurs: 'The same person cannot be an ignorant buyer and a shrewd seller' (Grampp, 1989: 28–9). Charles Saatchi, adman *par excellence*, has served as an entrepreneurial collector of contemporary art, including an appetite for work by British artists. (His collecting activity is pronounced given that it takes place in a country where the state has become the chief patron.) In interview with Lisa Jardine, she notes the relationship between Saatchi's career in advertising and his taste in contemporary art:

> From the beginning he 'felt' pretty confident with visual images and their manipulation and that made him relaxed about saying what he liked and following that up with purchasing. He acknowledges that some people consider his advertising man's eyes a weakness. It is true that he instinctively picks the kind of work that plays vigorously on rapid audience reception, and that he has a preference for artists who are likely aware about the interaction between themselves, their work and the gallery goer.
>
> (Jardine, 1997)

In this way, Saatchi is not unlike other collectors, who desire to differentiate themselves from peers (Moulin, 1987: 85). Moreover, the establishment of the Saatchi Gallery at County Hall – a private museum of indeterminate tenancy situated near Tate Modern – is an indication of a serious preoccupation with collecting contemporary art (approaching what Peggy Guggenheim achieved in Venice).

Collectors with the money and acquired esoteric taste of contemporary art necessary to be enlightened in how to spend it (Becker, 1982: 104) have come under the critical gaze of cultural commentators:

> Today, an increasing large fraction of owners and upper management throughout the world graduate from the best schools. Although they may not be great intellectuals, those who dominate the economic world, the owners of industry and commerce, are no longer the narrow-minded bourgeois of the nineteenth century. In the nineteenth century, artists such as Baudelaire and Flaubert could oppose the 'bourgeois' as ignorant or dim-witted philistines. Today's owners are, often, very refined people, at least in terms of social strategies of manipulation, but also in the realm of art, which easily becomes part of the bourgeois style of life, even if it is a product of the heretical raptures and veritable symbols revolutions.
>
> (Bourdieu and Haacke, 1995: 41)

In extreme cases, a major collector of art can be likened to the fat boy in a canoe: when he moves, all the others need to change their position.

Institutional exhibition venues

The Royal Academy, a temporary exhibition venue in London under the curatorial direction of its exhibitions secretary, Norman Rosenthal, has hosted a trio of shows – 'Sensation: young British artists from the Saatchi Collection' (1997), 'Apocalypse: beauty and horror in contemporary art' (2000), and 'The Galleries Show' (2002) – that were interpreted as promoting a particular perspective of contemporary art practice.[13] In some respects, Rosenthal represents the role of the curator as the *creator* of the exhibition, that is on par with the artists on display.

Dominant members of the 'Sensation' exhibition can, as they approach early middle age, be viewed entering the canon of British art. That (Sir) Nicholas Serota, director of the Tate since 1988, has been an ardent supporter of YBAs is of interest, particularly as he views taste formation as an essential role of the national collections:

> I think that the collections, if they are doing their job, will establish taste. There are plenty of examples going back to the nineteenth century that demonstrate how the National Gallery established taste, particularly in terms of collecting early quattrocento painting. You could say the same is true of the Tate at certain moments, for example when it collected minimal art in the 1970s. This was regarded as an affront by some parts of the popular press at the time, but I don't think there is any doubt that it was the right thing for the Tate to bring that work into this collection.
>
> (Serota, 2003: 52)[14]

One can see that Serota associates YBAs of the 1990s with minimalist art production of the 1970s. He continues on the role of making critical judgements:

> Museums have to make selections. Choices are made all the time, and you can't duck those choices. They establish the frame through which we look at the very recent past. Later generations can make corrections, and that may be more or less expensive to do; generally more expensive, because we have failed to collect some of those things that have become regarded as important. But you can't evade the responsibility of taking a view.
>
> (Serota, 2003: 52)

Dealers

A shift away from traditional forms of patronage (e.g. church, royalty and aristocrats) to the public sale of works by contemporary artists to members of the well-to-do or affluent middle classes helps to account for the rise of commercial art dealers (Alsop, 1982; Becker, 1982; Shubik in Towse, 2000).[15] Art dealing remains an unregulated market – vis-à-vis other occupations or the selling of financial instruments – such that art dealers are self-selected. The current period is marked by dealers behaving as entrepreneurs, which is to suggest that self-promotion and innovation are important in being a successful market agent (Moulin, 1987; Cowen, 1998). Yet the social cachet associated with art means that there are class differences from other types of selling. Even in contemporary art, it is not uncommon to meet dealers from 'privileged' backgrounds (including sources of private wealth as a form of income support). Dealers can make direct acquisitions of art, or sell works on consignment by artists. The former requires capital outlay to buy works (on the primary or secondary markets) and managing risk, but all capital gains accrue to the dealer. The latter operates on a commission basis (50–50 is not untypical) between the dealer and artist based on the sales price. Such (primary market) dealers enter into contracts with artists (producers of works), which the dealer turns into commercial properties. Leading dealers like Jay Jopling (White Cube), Sadie Coles (Sadie Coles HQ), Anthony D'Offay, or Nicholas Logsdail (Lisson) can become as well known as the artists they exhibit.

Critics

The critic serves as a communications link between artist and public. Critics come in different forms, including those with training such as art historians, curators and artists. Journals like *Artforum* and *October* represent one end of the field, writing in a specialist language to a restricted coterie who can understand it. The most common category, focusing on the wider general

audience, is the newspaper journalist, who can be viewed as a 'poor relation' of the family of art (Moulin, 1987: 69). Indeed one might argue that too often the journalist-as-critic serves a public relations role, with limited critical reviewing, which has devalued criticism and robbed it of its usefulness. It is suggested that a gap exists in the middle ground.[16]

Of course, there are critics who view the contemporary situation as one of declining morals. Moreover, they protest that an insular contemporary art system exists that exploits public funding: a handful of dealers represent featured artists at leading publicly funded venues of contemporary art in London (e.g. ICA, Serpentine, Whitechapel and Hayward) and others within the UK (e.g. Modern Art Oxford, Cornerhouse (Manchester), Baltic (Gateshead–Newcastle), Arnolfini (Bristol), and Ikon (Birmingham)).[17] These critics contend that there is a presumed bias in favour of institutionalized conceptual art. In particular, the shortlist for the Turner Prize, established in 1984 by the Tate as an annual prize to recognize a contemporary British artist, is scrutinized for representation. What artistic styles are on display? Who are the dealers of the artists? Where did the artists study?

Power relations

'Exchanges in the arts sector form a complex network that can be interpreted as a combination of different principal–agent relationships' (Trimarchi in Towse, 2000: 373). Cooperation is emphasized in art-world networks (Becker, 1982). In an ideal network situation, maximizing the overall value of the relationship would be a key objective. Yet competition is an economic reality as differing interests and conflicting goals can be observed among the various stakeholders. Three prominent relationships are examined: dealer–artist; dealer–collector; and collector–artist. What these relationships share in common is an emphasis on 'face-to-face' exchanges, which is a direct acknowledgment of an art scene, namely the 'performance' elements of the art world (Rosler, 1997).

Dealer–artist relations

It has been suggested that the dealer–artist relationship always involves a struggle for power (Moulin, 1987: 60). Loyalty is possible if their careers advance together. However, there is the common perception that relationships between dealers and artists, apart from the case of 'superstar' artists, tend to tip the balance of power to the dealer, who acts as an important gatekeeper (by selecting, representing and promoting artists in his 'stable').

In the early 1970s, New York lawyer Bob Projansky drafted a three-page agreement based on Seth Siegelaub's discussions and correspondence with people involved in the day-to-day workings of the international art market. 'The artist's reserved rights to transfer and sale request agreement' was designed to offer the artist certain economic benefits and aesthetic control:

- 15 per cent of any increase in the value of each work each time it is transferred in the future;
- a record of who owns each work at any given time;
- the right to be notified when the work is to be exhibited, so the artist can advise on or veto the proposed exhibition of his/her work;
- the right to borrow the work for exhibition two months every five years (at no cost to the owner);
- the right to be consulted if repairs become necessary;
- half of any rental income to be paid to the owner for the use of the work at exhibitions, if there is any;
- all reproduction rights in the work; and
- the economic benefits to accrue to the artist for life, plus the life of the surviving spouse (if any) plus 21 years (Projansky and Siegelaub, 1971).

The role of the dealer is acknowledged to be central to the success of the agreement as 'he is going to be very important in getting people to sign the contract when he sells your work' because 'your dealer knows all the ins and outs that go down in the business of the art world'. This emphasizes the 'gatekeeper' role of the dealer. However, it is less clear what incentives exist to encourage dealers to participate, as Projansky and Siegelaub's proposed agreement would be viewed by many prospective buyers as an additional transaction cost.

Projansky and Siegelaub acknowledged that the proposed agreement would alter the existing relationship between artist and dealer. The agreement would start with primary market transactions and then carry over to all subsequent secondary market transactions. Owners of art would face new obligations. Projansky and Siegelaub's lead point – 15 per cent of any increase in the value of each work each time it is transferred in the future – serves as a form of capital gains tax payable to the artist by the seller. Enforcement is a major obstacle in secondary markets without a regulated system of collecting royalties like *droit de suite* in France. Buyers might well ask for a reduced purchase price to account for a prospective capital gains tax when the work is resold.

Re-reading Projansky and Siegelaub's agreement three decades later, it is still the case that (visual) artists do not recoup all the intellectual property rights due to them. Yet there are means that artists have adopted, using their artistic output, in the absence of royalties from secondary market transactions. Retain a small portion of one's own output throughout different stages of an artistic career – these works would enter the marketplace as primary sales – in order to derive the full economic value as other works trade in secondary markets at higher prices. Reciprocal trading of works of art with peer artists would enable a 'diversified' portfolio (collection) to be established.

Dealer–collector relations

Contemporary art dealers, it is suggested, can take an attitude that the dealer makes the customer-as-collector (Moulin, 1987: 63). This assumes that certain conditions exist in the primary market for contemporary art. Customers are engaged in ambiguous purchase decisions and do not have adequate information; at the same time, the buying task is complex and repeat business is possible. The dealer has the resources (e.g. personal qualities, product alternatives, and negotiable terms of sale) to engage in adaptive sales behaviour. The dealer has an incentive to adapt his or her behaviour to better present his or her products as a solution to the buyer's problems. As such, the level of conflict can be low as the dealer anticipates future relationships with the buyer. Moreover, a collector may seek to forge special relationship with 'in-demand' dealers to gain access to popular artists and potential discounts.

A more competitive dynamic is present if the balance of negotiating power shifts. A powerful dealer can tie up the work of art of a particular artist, essentially acting as a monopsonist in dealing with the artist and as a monopolist in dealing with buyers (Throsby, 1994: 5). This works best under certain conditions: a successful artist who produces few works each year; and a (restrictive) resale agreement that a dealer can persuade buyers to sign. In the resale agreement the buyer agrees to offer the work back to the dealer when he or she wants to sell it. It is difficult to enforce the agreement, but a dealer can blacklist a buyer who breaks it.

Collector–artist relations

There is a strong case that 'distribution has a crucial effect on reputation' (Becker, 1982: 95). Artists who are not distributed are not known to audiences. At the same time, an artist without a good reputation will not be distributed. This circular argument replicates the exchange process as it operates in the contemporary art market. As such, what is the value of the dealer-as-intermediary? Projansky and Siegelaub (1971) were supportive of the dealer's role in strengthening collector–artist relationships. Dealers can articulate benefits to art owners: chief was 'a certified history and provenance of the work'; the others, such as the establishment of 'a non-exploitative, one-to-one relationship' and 'recognition that the artist maintains a moral relationship to the work' appear more idealistic.

Disintermediation questions the costs associated with intermediaries vis-à-vis the value they provide to the overall exchange relationship.[18] The so-called direct selling model bypasses intermediaries between producer (artist) and end consumer (collector). How would exchange relationships establish and develop between artist and collector in the absence of a dealer? An artist would need to have acquired a sufficient reputation not to require the promotional value afforded by a dealer. The artist would be saving the cost

of the commission paid to the dealer. A collector would need strong access networks to works of art comparable to the wares offered by a good dealer. Degree shows at leading art schools allow a unique opportunity for artists to sell direct to collectors and for collectors to buy direct from artists: relationships may be established. Dealers are absent from the buying–selling exchange, yet their presence is noticeable as they scout for new artistic talent.

There are cases of collectors gaining potential market power over contemporary artists. For example, a collector can gain significant market share by buying the entire degree show (i.e. primary market) output of selected artists. Any collector with a significant share of an artist's output can influence the artist's reputation. Subsequent works of the artist may attract a premium to recognize inclusion in a major private collection. Market power can also operate in the opposite way. A collector 'off-loading' works of an artist (in the secondary market) can damage the artist's reputation; of course, the collector is also cognizant not to indicate that particular artists are no longer favoured, as this would have a depressing impact on the collector's sales prices.

Concluding remarks

The sociological and economic approaches can be viewed as complementary in helping one to better appreciate the contemporary art world. In examining stakeholder relationships in contemporary art, aesthetic concerns are of secondary significance. Social conditions, such as education and social class, which help to explain the consumption of the arts are prime concerns for sociologists of the arts. A great deal of research on understanding how one gains cultural competence follows the work of Bourdieu. At the same time, cultural economists, by applying economic thinking to the arts, are better at articulating the value of art, namely assessing art as an investment vehicle (offering a financial return and aesthetic yield). Investing in contemporary art, which can represent a more speculative market (than for Old Masters), as reputations and prices are subject to fluctuation, remains under-researched.

Cooperation is highlighted as crucial to network systems in the contemporary art world, from production (artists) to consumption (spectators and collectors) with intermediaries (critics, curators, collectors) playing a role in valuating and certificating works of art. Competition, the flip side of cooperation, also makes an appearance: economic spoils accrue to some stakeholders more than others. A pyramid system exists with 'talent' and 'celebrity' (or the cult of personality) being important not just for artists – as one might assume – but also for other stakeholders such as curators, critics, dealers and collectors.

The relative bargaining power of stakeholders in what can be described as one-to-one relationships (artist–dealer, dealer–collector, or collector–artist)

can lead to varying levels of cooperation and competition. The role of the dealer, as an important intermediary between artists and collectors, is exposed. What value does the dealer offer? This needs to be viewed in terms of what artists and collectors can do on their own. At the same time, there is inter-firm rivalry among contemporary art dealers: competitive positioning occurs as dealers seek to be viewed as more innovative than rivals; and securing attractive resources in the form of artists and collector networks is necessary if the dealer is to be a successful market agent.

Within a relatively short period of time, namely 20–30 years, contemporary art becomes 'modern' or fades from art historical significance. As YBAs of the 1990s start to enter permanent collections of museums of modern art, it will be interesting to assess the impact of the 'Sensation' exhibition in 2012. In doing so, we may also be evaluating Charles Saatchi's 'eye' on the permanent collections of Tate Modern and Tate Britain. Collectors of contemporary art, who are buying on personal taste, can have an impact on shaping the permanent collections of museums of modern art, which may represent national views of taste through donations of art works.

Notes

1 Becker (1982: xi) casts his study as a 'sociology of occupations applied to the artistic work'. That so-called superstars (Rosen, 1981; Schulze in Towse, 2000) exist in the contemporary art world is an indication that economic profits are not distributed to all stakeholders in an equal manner. Small differences in talent can translate into large earnings. The demythologizing of artists by sociologists and art historians has yet to impact on the economic marketplace. 'As for super-prices, there is no escape from them in any art market, as soon as large numbers of sufficiently well heeled collectors begin to compete ferociously for a limited number of prizes' (Alsop, 1982: 162).

2 At the same time, the West End's Heddon Street has established itself as fashionable with top contemporary art galleries, Sadie Coles HQ and Gagosian, alongside restaurant-club Momo.

3 For example, the influence of critic Clement Greenberg is an interesting case. Attention to flatness and two-dimensionality was advocated by Greenberg as part of developing the self-identity of modernist painting: painting as painting. In particular, Greenberg helped to shape taste in the reception of American art – he was a champion of Jackson Pollock and the work of Abstract Expressionists working in New York – in America and elsewhere. As another case of prolonged influence, the case of New York-based dealer Leo Castelli can be cited. Such examples of individual influence may be less common with much shorter life cycles for actors at the top end of art criticism, commercial dealing, or curating.

4 The remaking of the Tate Gallery with two locations in London is a notable exception. From its inception, Tate Modern had New York's MoMA and the Pompidou Centre in Paris as competitor museums of modern art. Allowing Tate Britain to remain housed at the original Millbank site has been beneficial to Tate Modern. Even the blurring of responsibility for contemporary British artists (i.e. both sites can claim some curatorial responsibility) has been less problematic in practice than first perceived by commentators.

5 For example, Becker (1982) had in mind that some artists could access a mixture of self-support (e.g. private income, wealthier spouse, or other occupational income), patronage (e.g. public and private) and public sale.

6 Bourdieu identifies a social hierarchy of cultural taste with three zones: legitimate, middle brow, and popular (i.e. devoid of artistic ambition). Wolff sees the question of aesthetic value along additional 'levels': avant-garde versus popular; traditional versus new; and restricted versus mass reception. Throsby looks at linked sub-markets: the lowest level of the market (primary) is marked by unorganized structures; significant entrepôts serve as sites for the secondary level with living artists (i.e. those who have established themselves with key players making a successful transition from the primary level) and 'works of dead artists whose names are still recognizable'; and, at the highest level, 'an international art market exists where the auction houses are the main players, and where works of artist of the highest reputation are traded prices that frequently make headline news'. It is worthwhile to distinguish Throsby's use of 'primary' and 'secondary' from the more conventional sense in art markets: the primary market represents first-time sales of a work of art; the secondary market represents resales.

7 A cultural economist would argue that sociologists are 'almost exclusively concerned with the demand side [effects of education and income on arts consumption], and tends to neglect [monetary and non-monetary] cost factors' (Frey and Pommerehne, 1989: 12).

8 It is instructive to highlight that Baumol's data consisted of 'several centuries of price data in the market for visual arts [1652–1961], particularly the works of noted *creators who are no longer living*' (my italics).

9 In reviewing research on auction prices, Ashenfelter and Graddy (2002: especially pp. 13–19) see a case for the inclusion of art in a diversified portfolio (given a weak correlation between art asset returns with other asset returns), and note that 'masterpieces' under-perform the market.

10 Various art funds have been established by dealers. Contemporary art funds for neophytes can start with a minimum investment of US$5,000 per year, with an added bonus that investors can take turns displaying the works in their homes. At the other extreme, wealth private investors, often advised by investment banks, may be interested in joining art funds that look at high-end works of art (i.e. US$100,000 to $15 million) where the rates of return can surpass the central portions.

11 So-called 'angel' investors, who provide private equity to finance theatrical productions, are investing in a highly speculative financial instrument. How to review competing theatrical productions? How does one separate the shoddy, third-rate and over-priced from genuinely attractive vehicles? How to compare the goods at all the stalls? Moreover, it is important to recognize that there is no market for the transfer of investments in theatrical productions.

12 The case of the YBAs has been recounted in various publications: Matthew Collings, *Blimey! from Bohemia to Britpop: the London art world from Francis Bacon to Damien Hirst* (Cambridge University Press, 1997); Louisa Buck, *Moving Targets: a user's guide to British art now* (Tate Publishing, 1997); Julian Stallabrass, *High Art Lite: British art in the 1990s* (Verso, 2001); Rosie Millard, *The Tastemakers: UK art now* (Scribner, 2002); and Virgina Button, *The Turner Prize Twenty Years* (Tate Publishing, 2003). Lead artists include Damien Hirst, Tracey Emin, Sarah Lucas, Rachel Whiteread, Gillian Wearing, Jake and Dinos Chapman, Angus Fairhurst, Marc Quinn, Mark Wallinger, Richard Billingham, Gavin Turk, Douglas Gordon, Gary Hume, Chris Ofili and Sam Taylor-Wood.

13 For example, 'Sensation' faced dual criticisms. First, it was viewed as Saatchi aggrandizement. Second, it was a form of 'Cool Britannia' boosterism to promote

British art and notify London's challenge to New York as the centre for contemporary art. 'Apocalypse' was viewed as a thematic successor to 'Sensation' with some of Saatchi's YBAs appearing alongside international artists. 'The Galleries Show' was interpreted by some as an uncritical in its curatorial mandate, operating as a trade show publicizing London's 20 leading commercial dealers of contemporary art (with the notable absence of White Cube).

14 For example, Serota curated an exhibition on Donald Judd, one of the key exponents of Minimalism, at Tate Modern in 2004.

15 A notable exception is the rise of government patronage, particularly following the end of the Second World War. On a more limited scale, impresarios (or producers) such as Artangel can support artists for particular projects and assemble an audience.

16 A new prize for writing on the visual arts has been established by *Modern Painters* and the *Guardian* newspaper, in memory of Richard Wollheim, to address this gap.

17 David Lee, as editor of *Art Review* until 1999, was a notable critic. The 'Stuckist' group is 'against conceptualism, hedonism and the cult of the ego-artist'; moreover, 'Artists who don't paint aren't artists' (www.stuckism.com).

18 For example, an author may decide to bypass an established publishing house by self-publishing and then selling on consignment to bookshops and direct to readers.

Bibliography

Alsop, J. (1982). *The Rare Art Traditions: the history of art collecting and its linked phenomenon*. Bollinger Series 27. New York: Harper and Row.

Ashenfelter, O. and Graddy, K. (2002). 'Art auctions: a survey of empirical studies', NBER Working Paper No. 8997.

Baumol, W. (1986). 'Unnatural value: or art investment as floating crap game', *American Economic Review* 76 (May): 10–14.

Becker, H. (1982). *Art Worlds*. Berkeley: University of California Press.

Berger, J. (1972). *Ways of Seeing*. London: BBC and Harmondsworth: Penguin Books.

Bourdieu, P. (1984 [1979]). *Distinction: a social critique of the judgement of taste*. Richard Nice, trans. London: Routledge & Kegan Paul.

Bourdieu, P. and Haacke, H. (1995). *Free Exchange*. Richard Johnson, trans. Cambridge: Polity.

Cowen, T. (1998). *In Praise of Commercial Culture*. Cambridge, MA and London: Harvard University Press.

Danto, A. (1964). 'The artworld', *Journal of Philosophy* 61 (October): 571–84.

Duchamp, Marcel (1973 [1957]). 'The creative act', reprinted in Gregory Battcok, (ed.) *The New Art*. New York: E.P. Dutton, pp. 46–8.

Frey, B. (2000). *Arts and Economics: analysis and cultural policy*. Berlin: Springer-Verlag.

Frey, B. and Pommerehne, W. (1989). *Muses and Markets: explorations in the economics of art*. Oxford and New York: Basil Blackwell.

Grampp, W. (1989). *Pricing the Priceless: art, artists and economics*. New York: Basic Books.

Jardine, L. (1997). 'How one man decides what is good art', interview with Charles Saatchi, *Daily Telegraph*, 19 November.

Moulin, R. (1987 [1967]). *The French Art Market: a sociological view*. Arthur Goldhammer, trans. New Brunswick and London: Rutgers University Press.

Projansky, B. and Siegelaub, S. (1971). 'The artist's reserved rights transfer and sale agreement', Mimeograph copy.

Rosen, S. (1981). 'The economics of superstars', *American Economic Review* 71 (December): 845–58.

Rosler, M. (1997). 'Money, power and contemporary art', *Art Bulletin* LXXIX (March): 20–4.

Serota, N. (2003). 'The way forward', in *Art Nation: celebrating 100 years of the National Art Collections Fund*. London: Cultureshock Media and NACF, pp. 52–7.

Throsby, D. (1994). 'The production and consumption of the arts: a view of cultural economics', *Journal of Economic Literature* 32 (March): 1–29.

Towse, R. (ed.) (2000). *A Handbook of Cultural Economics*. Cheltenham and Northampton, MA: Edward Elgar.

Warhol, A. (1975). *The Philosophy of Andy Warhol from A to B and Back Again*. London: Michael Dempsey in association with Cassell.

Wolff, J. (1981). *The Social Production of Art*. London: Macmillan.

6 Tax matters

Renée Pfister

In our state no duties will have to be paid by anyone on either imports or exports. No one must import frankincense and similar foreign fragrant stuff used in religious ritual, or purple and similar dyes not native to the country, or materials for any other process which only needs imports from abroad for inessential purposes; nor, on the other hand, is anyone to export anything that it is essential to keep in the state.

(Plato, 1970, p. 350)

Winston Churchill's 1946 Zürich University address led, indirectly, to the formation of the United Europe Movement. At the Europe Congress in The Hague in May the following year, delegates recommended the political and economic integration of Europe. Central to this approach was the ideal that democratic Europeans could live and work together in harmony. It was also, clearly, an attempt to prevent a reoccurance of the atrocities and the destruction of the two world wars. The vision became a political reality when the Council of Europe held its first assembly in Strasbourg in August 1949.

In May 1950 the French Foreign Minister, Robert Schuman, invited Germany and other European countries to share their coal and steel resources with France. The Treaty of Paris signed by the six founder members: Belgium, Germany, France, Italy, Luxembourg and the Netherlands in April 1951, led to the formation of the European Coal and Steel Community. In 1953 five institutions were envisaged in a draft treaty safeguarding the aims of a political European Community and a Common Market. Today, the European Parliament, Council of the European Union, European Commission, Court of Justice and Court of Auditors are the manifestations of this intent. The success of the six led to the authorization of the Treaty of Rome in March 1957, the main legislative building brick of the European Economic Community (EEC), an area free of worker, goods and services restrictions. Three working groups, subsequently, worked towards the eradication of customs duties and the harmonization of indirect levy legislation. Customs duties on manufactured goods were abolished and by the end of the decade common policies on agriculture and commerce were in place.

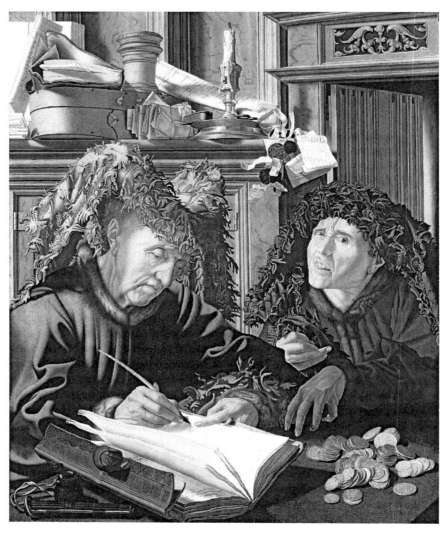

Plate 6.1 Marinus van Reymerswaele, 'The Two Tax Gatherers', 1526 (© The
National Gallery, London)

Denmark, Ireland and the United Kingdom (UK) were finally admitted into the EEC in 1973. The expansion from six to nine member states necessitated further investigation into regional, social and environmental issues. In addition, Council members proposed a strengthening of international cooperation and suggested a continuation of the extensive liberalization of world trade. The grim and gloomy economic climate and monetary instability of the 1970s brought about by the oil price hikes of 1973 and 1978, forced member states to defer their ambitious plans for market liberalization and focus on their domestic economic problems. These major set backs aside, a first convention was signed in Lorme between the Community and forty-six African states, the Caribbean and the Pacific in February 1975. Economic stabilization brought about by the European Monetary System helped to reassure member states of the benefits of strictly imposed economic policies.

The economic recovery of the 1980s revived the pursuit of economic integration, with the aim of creating a Single European Market. The Community continued to expand. Greece joined in 1986, followed by Portugal and Spain. The political structure of Europe was further transformed by the collapse of the Eastern bloc and the fall of the Berlin Wall. These events led, indirectly, to the negotiation of the Maastricht Treaty and its ratification in 1991. Finally, in 1995, Sweden, Finland and Austria entered the Euro club. Seven years later the euro was born. The biggest accession in euroland's short history is taking place at the time of writing, with ten new countries joining the Union in 2004.

Single European Market

The Treaty of Rome's attempt to establish a truly integrated market slowly began to materialize in the 1990s. On 1 January 1993, 35 years after the Treaty of Rome was signed, the Single European Act finally accomplished market unification, transforming a common market into a Single European Market (SEM).

The SEM is defined as a region without internal boundaries that ensures the free movement of goods, persons, services and capital and requires the removal of all barriers to trade and commodities, services and factors of production. The implementation of an effective policy on competition supported by common regulations is fundamental. In spite of developments since the founding of the community in 1958, especially in liberalizing commodity trade between member states and the adoption of a common system of tariffs on external trade, a number of original non-tariff barriers have remained, and some new ones have sprung up.

Harmonization

There are still existing barriers in the SEM as far as differences in indirect taxation, tax rates affecting the trade between member states and non-EU

countries are concerned. The fragmentation of the SEM operates along national lines. Obstacles arise when member states fail to agree on a common fiscal and legal approach. The treaties agreed for the unified European market inevitably affected member countries' internal art markets.

National taxation peculiarities were largely overcome in 1994 with an agreement by the Seventh Directive on the harmonization of value added tax (VAT) within the EU. It legislated that VAT on profit margins (VAT to be paid on the difference between buying and selling price) should be made payable throughout the EU. Concurrently, the Seventh Directive decided on the harmonization of import VAT and attuned the levels of import VAT throughout the EU to a calculated minimum rate of 5 per cent. In both instances individual member states were allowed to determine their own rates. The various rates applied are shown in Table 6.1.

Table 6.1 Import VAT rates and VAT rates as applied to fine art

Country	Standard rate (%)	Rate applying to works of art (%)
Austria	20	10
Belgium	21	21
Denmark	25	25
Finland	22	22
France	19.6	5.5
Germany	16	7
UK	17.5	5
Greece	18	18
Ireland	21	10.5
Italy	20	10
Luxembourg	15	6
Netherlands, the	19	6
Portugal	19	19
Spain	16	7
Sweden	25	12

Source: European Commission, BAMF (1997, p. 7). Please note some rates may have changed in the meantime.

Note: This table demonstrates the complexities the EU faces in the realization of the SEM. The difficulty is finding a formula to overcome national obstacles in an attempt to enter the super-highway of globalization and create a strong competitive unified European market.

Preliminaries

Art markets are governed like any other commodity market by economic principles, although the performance of art is harder to predict than stocks and shares. The supply of works of art and the process by which artists make their creative capital, that is, paintings, sculptures, collages, photographs and time-based media installations, are the subjects of this chapter. These commodities can be either commissioned or made speculatively.

Commissioned works are those specifically requested by a client, and speculative works are those the artist produces without a guarantee of sale. There are three levels to the market: the primary, secondary and tertiary. The primary market is distinguished by first-time sales of original works of art. This market trades in both the works of new artists and the works of the more established. Purchasing works of art on the primary market can involve a significant amount of risk for the buyers, such as uncertain intellectual appeal, quality and expenditure. In contrast, the secondary market consists of the exchange of existing works of art. It is a market in which buyers are more likely to possess good information about the artists and their works. On the primary market, the reserve price reflects the minimum the artist is willing to accept to bring a work to the market. The difficulty lies in setting the price; it should exceed the reserve without being too high for the purchaser. Prices reflected in the secondary market are defined by gallery and auction sales and the attributes of both intellectual appeal and decorativeness. The 'posted' gallery prices include the dealer's mark-up, in contrast to the auction houses whose prices depend on the amounts that are bid and a commission added to the hammer price. In the secondary market supply and demand are determined by factors other than the output and turnover of creative capital. This market's well-being and growth is hugely dependent on domestic tax regulations, as the following chapter will demonstrate. For reasons of clarity the harmonization of VAT payable on the profit margin, margin schemes for second-hand goods, works of art and antiques, including global accounting and bonded warehousing for importing works of art and antiques, are not dealt with in this chapter. I am sure that certain laws and regulations may change between the time of writing and the book's publication.

In 1992, following the introduction of the SEM, member states were supposed to harmonize their levels of import VAT. The Seventh EC Directive stipulated an effective minimum rate of 5 per cent. The forthcoming pages draw attention to the import regulations of the EU, Switzerland and the USA. In order to characterize the various rates of import duty and their practical application, the following assumptions are made. In each case, the costs for packing, transport and insurance are based on a painting by Mark Rothko, 'No. 9 (White and Black on Wine)', 1958, sold at Sotheby's or Christie's on 16 May 2003 for $16,359,500. All figures presented are listed in GBP. The emphasis is focussed on the drastically different costs created by various import VAT rates.

Imports into the European Union

In the EU the current regulations for importing works of art from overseas are dealt with by the following methods. All goods hold an *HS-Code* (product numbers based on the international harmonized system), for example 9701 1000 000 for paintings, 9702 0000 00 for original prints, 4911 9100 90 for

photographs and 9703 0000 000 for sculptures. Furthermore, for these articles the customs clearance code is zero, which means for imports from any EU country the customs clearance duty and import VAT are not levied.

Temporary import relief is constituted when an item is imported for a temporary period, such as for a loan to an exhibition or when an item is brought in with the purpose of exhibition with a view to a possible sale. In this case the customs authorities recommend the use of the international customs document *Carnet-ATA*. ATA stands for the combined French and English words Admission Temporaire – Temporary Admission.

For imports of paintings and sculptures from overseas no payment for customs clearance is required, but the minimum rate 5 per cent import VAT is applicable. The estimated value of the work of art and the costs of packing, transport and insurance, added together provide the axiom for the calculation of the import VAT. The cost of import into the UK is shown in Table 6.2.

Since 1 January 2004, the customs clearance duty on imports of photographs (photographs taken by artists or under their supervision, up to 30 copies, numbered and signed by the artist) has been negated. But, whether the duty is levied in full or at a reduced rate depends on the individual member state. In the UK a minimum 5 per cent is levied and in Germany the maximum of 16 per cent is brought to bear for photographs but not other works of art which attract only 7 per cent. Time-based media works (videos, films, audios, slides and computer-based elements) are often imported as sculptures and the minimum 5 per cent import VAT is levied in these cases. The import of display equipment associated with time-based media installations, players, projectors, screens and other forms of hardware, differs slightly. These items attract a customs clearance duty (depending on item, e.g. players 14 per cent) and the full rate of 17.5 per cent import VAT.

At the point of resale, depending on the national VAT legislation of the member states, either the full rate or the reduced rate of VAT is charged. For

Table 6.2 Import of Rothko's 'No. 9 (Black and White on Wine)', 1958, into the UK

Sold at auction	$16,359,500.00[1]	£8,955,277.00
Packing and transport		£3,686.00[2]
Insurance		£6,750.00[3]
Customs value		£8,965,713.00
Import VAT 5 per cent		£448,285.65
Total costs of import		£458,721.65

Notes:
1 *Art Newspaper*, June 2003, Art market section, auction reports, p. 38. US dollars were converted at a rate of £1.82680, 25 January 2004).
2 Dinah Pyatt, Constantine, London, 2004.
3 Robert Graham, Blackwall Green, London, 2004.

instance, if a London gallery buys a painting from a Swiss dealer it is liable to a 5 per cent import VAT. If the same gallery is able to resell that painting within the UK, the full VAT rate of 17.5 per cent is levied. If, however, the gallery sells the painting without it entering the UK to a Greek collector and he or she is VAT registered in Greece, the VAT can be deferred and the reduced Greek rate of only 8 per cent VAT made payable on the work. Overseas buyers are exempted from VAT, regardless of the type of work purchased, but proof of export is required.

Federal Swiss laws for imports and VAT

Each Swiss citizen, foreign visitors and the international art trade are allowed to import and export works of art and antiques into and out of Switzerland. For temporary imports the importer can apply for a *Freipassabfertigung* or *Carnet ATA*, including a list (in triplicate) with information such as title of the work, name of the artist, date, media, size/dimension and value. These procedures allow items to enter and leave Switzerland without the obligation to pay import VAT.

For works of art and antiques imported for sale, the CIF value (costs for work of art/antiquity, insurance and freight, meaning all charges levied by the transport/shipping agent) is the basis for the calculation of the 7.6 per cent import VAT. Normally, the forwarding transport/shipping agency secures the import VAT payment through a bond. In the case of any unsold imported items the total import VAT from sales (sales documents acting as proof) is deducted from the total estimated monetary value of the whole consignment. The difference between both sums constitutes the outstanding import VAT. In any case the Swiss customs authority wants to be informed if the commercial invoice includes insurance and transport charges, especially if there isn't an indication of an approximate charge. For any art sales the VAT rate of 7.6 per cent is imposed on buyers from Switzerland and the EU. VAT exemption is given to clients from overseas with the appropriate documents of export. (See Table 6.3.)

Imports into the USA

One of main the reasons the USA is the leading international art market lies in the duty free status of imported and exported original works of art and antiques. For articles one might regard as works of art such as furniture, silver, jewellery, watches, Fabergé and sculptures after the first twelve casts, provided they are less than 20 years old, a rate of 9 per cent is applied.

According to US law, American vendors do not pay a customs fee or sales tax, but overseas vendors are levied with a customs user fee or merchandise processing fee (MPF) of 0.21 per cent on the total entry value of works of art and antiques. This means a minimum of $25 up to a maximum of $485 is charged. Moreover, works of art and antiques arriving under a temporary

Table 6.3 Import of Rothko's 'No. 9 (Black and White on Wine)', 1958, into Switzerland

Sold at auction	$16,359,500.00[1]	£8,955,277.00
Packing, transport		£2,250.00[2]
Insurance		£3,250.00[3]
Customs value		£8,960,777.00
Import VAT, 7.6 per cent		£681,019.05
Total costs of import		£686,519.05

Notes:
1 *Art Newspaper*, June 2003, Art market section, auction reports, p. 38. US dollars were converted at a rate of £1.82680, 25 January 2004.
2 Dinah Pyatt, Constantine, London, 2004.
3 Robert Graham, Blackwall Green, London, 2004.

exhibition licence at a non-profit institution are not liable and therefore exempt from the MPF.

The US Customs authorities require a bond for an entry above $1,250. For this reason, bond fees are applicable on almost all consignments and are normally calculated at $1.00 to $5.00 per $1,000. Despite this regulation, concessions can be independently negotiated from broker to broker. Bonds are provided by surety companies and the amount of the bond depends on the type of entry, entered value, potential risk and potential duty. After the initial entry is made and estimated duties are paid the customs entry continues to stay open up to at least one year after the entry date, allowing US Customs to review the entry and change the status if necessary. The bond acts as a warranty, enabling US Customs when necessary to collect additional duties due at a higher rate.

The US sales tax rates (equivalent to VAT in Europe) differ from state to state, and vary between 4 per cent and 11 per cent. When American buyers purchase works of art, they are liable to the state's legitimate sales tax. Paying this tax is far more complicated and payment may be due in the state where the art work is domiciled if the vendor has a company in the state of use or actually bought the work in that state. In addition, foreign buyers are not charged sales tax, as long as the items are shipped by a licensed carrier and a bill of lading is issued for export. Sales tax lawyers can provide advice on correct sales tax payments. (See Table 6.4.)

Export regulations in the EU, Switzerland and the USA

Presently, exports of cultural goods are dealt with in the following manner: that is, either under the EU regulation or under the national export controls of each EU member state, and no export duties are levied. Exporters from an EU member state must, therefore, obtain an EU licence from their appropriate authority where one is required, and/or comply with their national

Table 6.4 Import of Rothko's 'No. 9 (Black and White on Wine)', 1958, into the USA

Sold at auction	$16,359,500.00[1]	£8,955,277.00
Packing and transport London, Luxembourg to NY		£4,065.00[2]
Insurance		£6,750.00[3]
Customs user fee	$485.00	£265.49[4]
Bond fee minimum rate of $1.00 per $1000	$16,359.50	£8,955.28
Total costs of import		£20,035.77

Notes:
1 *Art Newspaper*, June 2003, Art market section, auction reports, p. 38. US dollars were converted at a rate of £1.82680, 25 January 2004.
2 Dinah Pyatt, Constantine, London, 2004.
3 Robert Graham, Blackwall Green, London, 2004.
4 The $210 customs user fee was converted at the rate of £1.82680, 25 January 2004.

export controls. These formal requirements control the traffic of cultural goods and are protective measures enabling member states to guard their national patrimony.

For exports from the EU into a country overseas the standardized EU threshold values apply, for example:

€150,000 (£91,200) for paintings, €30,000 (£18,200) for watercolours, gouaches and pastels. Archaeological objects and materials excavated or found on EU member states and any other countries land or under water, archaeological sites and archaeological collections more than 100 years old are zero rated.

(Export Licensing Unit, Guidance to Exporter
of Cultural Goods, March 2003)

Regulations differ from one member state to another. For instance, in Germany about 650 works of art and antique are classified as national patrimony. These cultural objects are catalogued and can only be temporarily exported for exhibitions in the EU or overseas with permission from the Institute of Kultur and Medien in Berlin. Though for any other cultural objects no export licences are necessary for movement within the EU licences are required for exports overseas and are issued by the appropriate regional office. In Italy all cultural objects require an export licence; conditions of export are outlined in the 1999 *Testo Unico* document available from the Ministry of Cultural Affairs. In that country, export licences are authorized through twenty regional offices and are valid up to one year only for works of art and antiques over 50 years old.

The UK legislation stipulates that exports of works of art and antiques over 50 years old from the UK into a European member state or a country overseas require a licence from the Department for Culture, Media and Sport. However, an Open General Export Licence (OGEL) permits the export of works of art and antiques with a value at or below, for example:

> £180,000 for paintings in oil, tempera, £10,000 for a portrait of a British Historical Person and a zero rate for archaeological objects/material, excavated or found in UK soil, territorial waters and sites.
>
> (Export Licensing Unit, Guidance to Exporter
> of Cultural Goods, 3 March 2003)

An Open Individual Export Licence (OIEL) can be granted to national museums, companies and named individuals to allow either the permanent or temporary export of cultural goods and is valid for three years and can be renewed thereafter. However, no OIEL licence is approved by the DCMS without the recommendation of a relevant expert adviser from a national museum or gallery.

Neither the OGEL nor an OIEL can remove the need to obtain an export licence under the EU regulation where one is required. Export licences will not be granted to objects which, in the view of the Reviewing Committee for the Export of Works of Art, fulfil one or more of the three 'Waverly Criteria', provided a British institution or a private person (in certain circumstances) is able to meet the purchase price:

> Is the object so closely connected with our history and national life that its departure would be a misfortune; is it of outstanding aesthetic importance; is it of outstanding significance for the study of some particular branch of art, learning or history.
>
> (Annual Report of the Reviewing Committee for the
> exports of works of art, 1988–89: 3)

To combat the illicit trade and the laundering of cultural property, the international community closely collaborates. The 1995 *Unidroit* Convention, the 1970 UNESCO Convention and Council of Europe conventions achieved significant steps forward in the foundation of an international law protecting cultural property, namely that of national interest and national identity, from being illegally interchanged. Two additional control mechanisms were launched to undermine the movement of works within the EU for onward export out of the Community. These measures are the regulation on the export of cultural goods and the directive on the return of cultural objects unlawfully removed from a European member state. Recently, under the provision of Cultural Object (Offences) Act 2003 any person deceitfully dealing with a cultural object that is tainted commits an offence and can be prosecuted.

Export regulations in Switzerland and the USA

In Switzerland no restrictions are made and no taxes or duties are levied with regard to the export of art and antiques. Some *Kantons* (regions), however, hold export regulations, but these are frequently ignored due to deficient federal statutory mechanisms for export controls. As a consequence the protection for the transfer of cultural objects is insufficient. So far the only permits required are CITES permits (International Convention on Trade of Endangered Species) which must be obtained from the Swiss government before importing/exporting works of art and antiques (works containing ivory, stuffed animals, snake or crocodile skin) for sale or temporary loans to exhibitions.

Since 1996 Switzerland has become a signatory to the 1995 *Unidroit* Convention but the country has not ratified this agreement. In contrast, on 1 October 2003, Switzerland approved the 1970 UNESCO Convention. This requires that certain obligations be implemented under Swiss federal law, establishing, for example, an inventory of national cultural goods, maintaining, as a dealer, a provenance register and informing buyers of probable export prohibitions.

The *Kulturgüter Transfer Gesetz* (Cultural Property Transfer Act) was ratified after a referendum with implementation in 2005. This law regulates the import of cultural goods into Switzerland, as well as their transit, export and, when appropriate, return to the rightful Swiss owners.

Like Switzerland the USA does not impose major restrictions on the export of works of art/antiques. However, the US Customs authorities are responsible for ensuring that all goods entering and exiting the USA do so in accordance with all applicable US laws and regulations. It is a requirement of the exporter, for example for certain cultural objects depending on their provenance and age (for example Native American or Pre-Columbian artefacts), to provide documents proving the legitimacy of the purchase. They may require a shipper's export declaration (SED) in order to obtain approval of export by the US Customs authorities. A special Art Recovery Team (ART) is working for the US Customs authorities investigating cases in which individuals have smuggled or attempted to smuggle cultural property, stolen art and forgeries into the country. Over the past several years more than $30 million (http://www.cbp.gov/custoday/apr2000/phiale2.htm) worth of art and antiques were seized by the US Customs authorities and returned to their rightful owners. The USA also complies with the CITES Convention.

Droit de suite – a community-wide artist's resale royalty right

The idea of *droit de suite* developed originally in Europe and was first codified in France, on 20 May 1920, to protect the works of visual artists. Through the adoption of articles based on the revised Berne Convention of 2 July 1948,

droit de suite entered the international convention: 'The special feature of article 14bis is that it allows the Member States to make the observance of droit de suite by foreigners dependent on the prerequisite of reciprocity' (Pfennig, 1996: 1). Furthermore, article 14bis states that the resale royalty right is a matter of national legislation. *Droit de suite* has been adopted in 47 countries, including 11 from the EU, but only a few of them have fully implemented this levy.

Droit de suite constitutes the right of visual artists to a percentage share of the earnings from the resale of their works of art on the art market. The beneficiaries are the creators of original works or their heirs, since the right lasts for 70 years after the creator's death. People from other creative professions, it is argued, already have the opportunity within the framework of the statutory concept of copyright to earn income in this way. *Droit de suite* would similarly allow visual artists to participate in the financial exploitation of their works, through sales of art on the secondary market. It would also fulfil the copyright legislation, which ensures that artists receive earnings through the utilization of their works.

The following two case studies in Tables 6.5 and 6.6 demonstrate the monetary effect of *droit de suite* and reveal additional charges when a work of art is sold through an auction. The works compared are the 'spin painting' – 'Beautiful, Abstract, Whirlwind, Cosmic, Comic, Expanding, Scatalogical' – by Damien Hirst and the 'No. 9 (Black and White on Wine)' by Mark Rothko. *Droit de suite* payments are calculated after the proposed Directive 2001/84EC.

Droit de suite in Switzerland and the USA

In 1993, the legislative process to introduce *droit de suite* in Switzerland as federal law failed. The issue received a great deal of support from artists and opposition from the art trade, further underlining its economic significance. The Swiss are still actively discussing *droit de suite*, but finalization is a long way off.

California is the only state in America to grant its artists a 5 per cent resale royalty right. It has done so since 1977. In order to attract the tax the work

Table 6.5 Damien Hirst's spin painting

Sold at auction	£36,700.00*
+ *Droit de suite* 3 per cent*	£1,101.00
+ VAT 17.5 per cent	£6,422.50
+ Sales commission 15 per cent, paid by seller	£5,505.00
+ Sales commission 15 per cent, paid by buyer	£5,505.00
Real term price/value	£55,233.50

* *Art Monthly*, February 1998, p. 40.

Table 6.6 Rothko's 'No. 9 (Black and White on Wine)', 1958

Sold at auction	£8,955,277.00[1]
+ *Droit de suite*, maximum rate of €12,500, converted into GBP[2]	£8,342.30
+ VAT 17.5 per cent	£1,567,173.48
+ Sales commission 15 per cent, to seller	£1,343,291.55
+ Sales commission 15 per cent, to buyer	£1,343,291.55
Real term price/value	£13,217,375.88

Notes:
1 *Art Newspaper*, June 2003, Art market section, auction reports, p. 38. US dollars were converted at a rate of £1.82680, 25 January 2004.
2 €12,500 converted into US dollars at a rate of $1.23547 and to GBP at a rate £0.667459, 8 March 2004.

Tables 6.5 and 6.6 reflect the proposed rate under Directive 2001/84EC of the European Parliament and the Council on the Resale Right adopted in September 2001. It reveals that the demand of an artist for participation in any profits arising from further trade of his/her work has a comparatively small economic impact on the original price when set against the punitive penalties imposed by VAT and the commission.

has to be resold in California or resold elsewhere by a California resident. Furthermore, at the time of the resale the royalty can only be collected if the artist has been a citizen for a minimum of two years. The California right applies to works of fine art created during the artists' life-time, until 50 years after their death. The minimum price threshold is $1,000. In 1982, through the modification of the Resale Royalty Act, the waiver has been prohibited and the California Arts Council (CAC) was established as the collecting institution. Artists are now able to transfer the collecting process to a lawfully recognized body. However, if the resale takes place within ten years of the initial sale, no royalty payment is required, provided all the resales are intra-trade. In order for the seller to satisfy the royalty payment he or she has to locate the artist. If the seller is unable to find the artist, the CAC acts as the collecting institution. As a result, the payment must be transferred to the CAC, where the premium is deposited in the artist's name for seven years. If a seller fails to fulfil his or her commitment to the right, then an action for damages is brought, either by the artist or by the CAC. The discovery of breach has to be within three years after the date of sale or one year after the finding of sale. The artist resale right has been introduced into eleven American states, including Connecticut, Florida, Illinois, Michigan and New York. But, up until now, none of these states have ratified the right as state law. The attempt to legislate *droit de suite* throughout the USA was supported by various federal proposals, such as the 1977 Henry Waxman Bill and 1986 Kennedy and Markey Proposal. The bill introduced by Kennedy and Markey in the 100th Congress included a royalty provision, but this matter was put aside in order to get the main body of information passed. The proposed bill already represented a significant improvement on earlier versions and led to a study of resale royalty rights and other alternative solutions.

The USA joined the Berne Convention in March 1989. Thereafter, the works of American writers and visual artists were protected automatically in all member states of the Berne Union and reciprocally works of foreign artists of Berne Union countries were protected in the USA. In 1990, under the Visual Rights Act, the Registrar of Copyright was obliged to compile a study on the introduction of *droit de suite* and this was presented to the US Senate in December 1992. The paper included public hearings in New York and San Francisco. The majority of well-known artists spoke out in favour of this right, and for the first time the report cited a majority of witnesses who voted for the right's introduction. In spite of these endeavours the US Senate once again rejected the law.

In March 1996, the SEM Commissioner, Mario Monti, proposed a Directive to harmonize *droit de suite* throughout the EU. Mr Monti's proposition is an attempt to support the visual arts in the EU and to resolve distortions in the marketplace. Again, there are various national inconsistencies: different rates, different threshold prices of right collection and different levels of applicability. Eleven out of fifteen member states in the EU have already provided artists with the royalty right. The exceptions are Austria, the UK, Ireland and the Netherlands. It is, however, very likely that this legislation will become part of EU law and that *droit de suite* will soon be implemented in every country in the Union.

Resale right defined

According to the European Commission, Directive 2001/84EC applies only to works created by artists who are nationals of the European Economic Area: the EU, Norway, Iceland and Lichtenstein. The directive only covers works in the following media: paintings, collages, drawings, engravings, prints, lithographs, sculptures, tapestries, ceramics, glassware, photographs and copies of works of art. Under this directive copies are included provided they are made in sufficiently limited numbers by artists or under their direct supervision. It is not mandatory for the works to be numbered, signed and authorized by the artist.

The artist's resale right can be defined as the right of an author to receive a percentage of the price of the work when resold on the secondary market either directly between a buyer and seller or indirectly through an intermediary. Excluded are works sold between private individuals and works sold by art market professionals within three years and for a resale price below €10,000. The right does not apply to the artist's first transaction. Member states must levy a royalty of 4 per cent, or if they so wish, 5 per cent, for a sale value up to €50,000. They may also determine the minimum threshold above which the resale royalty starts to apply of below €3,000. Member states are obliged to charge at least 4 per cent royalty of the sale price and the total amount of the royalty may not exceed €12,500. It is left to the member states to decide who is liable for the royalty payment; that is,

vendor, buyer, gallery, auction house or a combination of all three. The rates applied are structured in cumulative bands depending on sale price, and apply throughout the life of the artist and for 70 years after his or her death.

Under the newly negotiated terms of the Directive 2001/84EC the right will come into force for living artists on 1 January 2006. For those entitled to the royalty following the artist's death, the right will be applicable on 1 January 2010. In member states for which the right had not been introduced by 27 September 2001 when the directive came into force, there is a requirement to commence the deceased artist derogation no later than 1 January 2012. Artists have the right to knowledge of sale, to enable them to collect the royalty, for up to three years following the resale. *Droit de suite* is inalienable and can not be waived by the artist. Member states may provide for compulsory or the optional collective management of the royalty.

Revision clause

> The Commission shall submit to the European Parliament, the Council and the Economic and Social Committee not later than January 1, 2009 and every four years thereafter a report on the implementation and the effect of this Directive, paying particular attention to the competitiveness of the market in modern and contemporary art in the Community, especially as regards the position of the Community in relation to and the management procedures in the Member States. It shall examine in particular its impact on the internal market and the effect of the introduction of the resale right in those Member States that did not apply the right in national law prior to entry into force adapting the minimum threshold and the rates of royalty to take account of changes in the sector, proposals relating to the maximum amount laid down in article 4 (1) and any other proposal it may deem necessary in order to enhance the effectiveness of this Directive.
>
> (Official Journal of the European Commission, L 272, 32, Directive 2001/84 of the European Parliament and of the Council, 27 September 2001)

Concluding thoughts

The preceding pages have surveyed the import and export regulations for works of art and antiques entering the EU, Switzerland and the USA, reflecting the problems to which their markets are exposed. Since July 1999, the harmonized minimum rate of 5 per cent import VAT has been applicable throughout the EU but member states are allowed to set their own rates above this – for example Germany 7 per cent, France 5.5 per cent, Italy 10 per cent, Ireland 8 per cent. The UK government and its art trade had to accept the fact that the 5 per cent import VAT was now payable on works of art and antiques entering the country from outside the EU. As a result, some

Table 6.7 Proposed rates of *droit de suite* under Directive 2001/84EC of the European Parliament and the Council on the Resale Right adopted in September 2001

European euro €	US dollars $	Pounds sterling £	Rate (%)
Up to 50,000	Up to 60,326.50	Up to 33,238.85	4
50,000–200,000	60,326.51–241,306.00	33,238.86–132,955.40	3
200,000–350,000	241,306.01–422,285.50	132,955.41–232,671.95	1
350,000–500,000	422,285.51–603,265.00	232,671.96–332,388.50	0.5
Over 500,000	Over 603,265.00	Over 332,388.51	0.25

Source: www.patent.gov.uk/copy/notice/2001/resale.htm

Notes:
Euros were converted at a rate of €1 = $1.20653, 14 June 2004 for the US dollar calculation and at a rate of €1 = £0.664777, 14 June 2004 for the pound sterling calculation.
The conversions into US dollars and pounds sterling were made for two case studies on the calculations of *droit de suite*, presented later in this chapter.

distortions of the SEM have been removed and some new ones have emerged. Consequently, member states with a higher national import VAT rate are disadvantaged compared to those applying the minimum rate of 5 per cent import VAT only, and the USA and Switzerland stand by to profit from a playing field that favours them.

Until 1995 the UK was the only member state in the EU with a zero rate of VAT on imported works of art and antiquities, both from within and outside the EU The reduced tariff of 2.5 per cent import VAT was only relevant for the following imports: 'Works of art pre-1st of April 1973, re-imported works of art under some conditions, antiquities items over 100 years old at date of import and collectors pieces of certain types' (Knowles, 1998: 3). In contrast, the UK's blue chip and contemporary sector were greatly debilitated by the post-1973 rule and the 17.5 per cent VAT. With the introduction of the harmonized import VAT of 5 per cent in July 1999 the UK government abolished the post-1973 rule. In the hope of market expansion and consolidation of current import levels, European art market representatives agreed with their British counterparts and proposed that the EC Directive should lower the 5 per cent minimum rate to 2.5 per cent. This did not happen. The harmonized 5 per cent EU import duty, however, may encourage sellers to auction or sell their works of art and antiques particularly in New York or Switzerland, which has an import duty of 7.6 per cent.

According to Market Tracking International (MTI), 'Imports to the UK have already fallen by 40% since 1995, following the introduction of the 2.5% import VAT', with the result of affecting the supply of foreign works of art and antiques. (See Table 6.8.)

Table 6.8 UK imports from non-EU countries, 1994–96

£m	1994	1995	1996	% change 1994
USA	342	339	283	–17.3
Switzerland	246	221	87	–64.6
Japan	30	18	11	–63.3
Israel	9	–	8	–11.1
Australia	–	6	6	–
Hong Kong	28	12	5	–82.1
Mexico	13	4	–	–
Others	445	324	265	–40.5
Total	1113	924	665	–40.3

Source: DTI-derived Overseas Statistics.

Other than the UK, France, Germany, Italy and Benelux, the smothering of the trade through taxation does not raise the same concerns throughout Europe. The UK has the most to lose, with many secondary London dealers fearing that *droit de suite* will disadvantage them compared with their New York and Swiss counterparts.

The recently dissolved Market Tracking International (MTI) puts it this way:

> that the UK art market has a turnover of £2 billion a year, comprises of 10,200 businesses, contributing to the employment of 40,000 people. In 1996 the Exchequer and HM Customs and Excise have benefited from estimated corporation tax, income tax and VAT of nearly £500 million, resulting from sales of art and antiquities.
>
> (Knowles, 1998: 2)

As Table 6.9 shows, the US art market overwhelmingly demonstrates its leading position, mainly driven by its advantageous tax legislation. The Swiss and the US art trade is likely to profit from relocation of sales for modern and contemporary art, but not to such a high proportion as costs for transport and insurance have to be taken into account and European artists are presented by American galleries with sales conducted in the US primary market. Second in position is the UK, the foremost art exchange in the EU, in contrast to Germany, France and Italy.

The aspiration of a common unified European market is a painstakingly slow process and the proposed implementation of *droit de suite* throughout the EU may have a positive effect on the art trade of other EU member states by taking business away from dominant London. One market distortion would have been abolished, but other significant and far-reaching ones would remain.

Table 6.9 Analysis of art auction markets by countries

	2001/2002 turnover in GBP	2001/2002 number sold	2001/2002 average price
Country of sale			
France	118,300,502	19,266	6,153
Germany	42,352,375	9,746	4,346
Great Britain	526,532,975	30,016	17,542
Italy	38,949,303	6,656	5,852
Switzerland	28,185,279	4,630	6,088
USA	712,825,515	19,908	35,806
Total	1,467,145,949	90,222	–

Source: Hislop, 2002, http://www.art-sales-index.com./country.html

If *droit de suite* legislation were to be passed in 2006 or latest in 2010, the Design and Artist Copyright Society (DACS) would be the UK collecting body, acting on behalf of the artists and their heirs. Through collaboration with their European counterparts, international government officials and other important individuals, UK artists' societies and groups aim to see the implementation *droit de suite* in Europe's largest market.

The EU Directive 2001/84EC on resale right is regarded as a major part of the EU intellectual property law. This proposed complex directive, with its various exemptions and the absence of an efficient collecting society and standardized collection procedures is in danger of doing more harm than good. Ever since the concept of *droit de suite* was formulated, it has aroused controversy. There is a strong sense that it is an inefficient way to support artists – a much better solution being for dealers and auction houses to pay a percentage of their annual turnover to an artists' benevolent fund, administered by a registered charity. Other measures are already being considered, for instance an exhibition fee, whereby artists are paid a sum each time their work is exhibited.

It is the responsibility of government to find money for our cultural sector, not to bite the hand that feeds it – the trade. Part of the new Greater European political mood can be seen in rules governing the import and export of works of art and antiques and the laws safeguarding the criminal exploitation of a country's cultural patrimony. *Droit de suite* is both an attempt to regulate and make 'fairer' this untidy market as well as a supra-government initiative to control a market it hardly understands.

Bibliography

Annual Report (1988/1989). Reviewing Committee for Exports of Works of Art.
Bence-Fritzsche, R. (1993) 'Was bringt Europa den Künstlern?', *Atelier*, 1/93.
Bischoff, F. (1996). 'Der lange Marsch durch die Gremien von Brüssel', *Die Welt*, 13 June.

Bischoff, F. (1996). 'Wettbewerbschancengleichheit in der Europäischen Union und Liberalität im Kulturgüterverkehr', *Arbeitskreis Deutscher Kunsthandelsverbände*, August.

Bischoff, F. (1997). 'Die Harmonisierung des Folgerechts in der Europäischen Union', *Arbeitskreis Deutscher Galerien*, September.

Buck, L. and Dodd, P. (1991). *Relative Values or What's Art Worth?*, London: BBC Books.

Buckley, R. (1996). *Understanding Global Issues. Fairer Global Trade? The Challenge for the WTO*. Cheltenham: Buxton Press.

Cook, D. (1989). 'Adorno on late capitalism: totalitarianism and the welfare state', *Radical Philosophy* 89, May/June.

Copyright Office Report (1992). *Droit de Suite: Artist's Resale Royalty*. Washington, DC: Library of Congress.

Frey, Bruno and Pommerehne, W. (1989). *Muses and Markets. Explorations in the Economics of Art*. Oxford: Basil Blackwell.

Heathcoat-Amory, D. (1998). *A Market under Threat*. London: Centre for Policy Studies.

Heathcoat-Amory, D. (1998). 'UK Minister opposes droit de suite', *The Art Newspaper*, July/August.

Heilbrun, J. and Gray, C. M. (1993). *The Economics of Art and Culture*. Cambridge: Cambridge University Press.

Hitiris, Theo (1998). *European Union Economics*, 4th edn, London: Prentice Hall.

HM Customs and Excise, Notice 718 (1995) *Value Added Tax: margin scheme for second-hand goods, works of art, antiquities and collectors' items*. London: HMSO.

HM Customs and Excise, Notice 703 (1996). *Exports and Removals of Goods from the United Kingdom*. London: HMSO.

Knowles, K. (1998). 'The British art market 1997', *Society of London Art Dealers Newsletter*, January.

Louis, Peters (1995). 'Das Folgerecht', *Atelier* 4/95.

Lydiate, Henry (1996). 'Royalties, *droit de suite*', *Art Monthly*, April.

Market Tracking International (1998). 'The British Art Market 1997', British Art Market Federation, February.

Moncrieff, Elspeth (1997). 'VAT and *Droit de Suite* potentially deadly', *The Art Newspaper*, February.

Pfennig, Gerhard (1996). *Artists Resale Remuneration, Droit de Suite*. Bonn: Verwertungsgesellschaft VG Bild-Kunst.

Plato (1970) *The Laws*. Trans. Trevor J. Saunders, Harmondsworth: Penguin Classics.

Tarlant, Eric (1998). 'Brussels-imposed VAT threatens the European art market', *The Art Newspaper*, May.

Wilson, Andrew (1998). 'Salerooms: sales, resales no sales', *Art Monthly*, February.

Zimmermann, Olaf (1996). 'Die Zukunft des Urheberrechts', *Ateliers* 5/96.

Internet sources

http://www.europa.eu.int
http://www.art-sales-index.com

http://www.bildkunst.de/rechte/folgerecht.html
http://www.culture.gov.uk
http://www.taxadmin.org
http://www.ial.uk.com
http://www.hmce.gov.uk
http://www.customs.org
http://www.patent.gov.uk/copy/notices/2001/resale.htm
http://www.liaison-vat.co.uk/vatinfo/eu€vat€rates.html

Part II

The behaviour and performance of the main markets for art

7 Managing uncertainty

The visual art market for contemporary art in the United States

Joan Jeffri

> In the future everybody will be world-famous for 15 minutes.
>
> (Attributed to Andy Warhol)

A single event in 1970 changed the contemporary American art market forever: the sale of the private collection of American taxi fleet owner Robert Scull and his wife, Ethel, which grossed $2,242,290. At this sale at New York's Park-Bernet auction house, a Robert Rauschenberg painting originally bought by the Sculls for $900 was sold for $85,000, a Jasper Johns painting for $250,000 and a Johns bronze sculpture of beer cans for $90,000. Riding the coat-tails of the Abstract Expressionists, which in New York consisted of immigrants like Mark Rothko and Willem De Kooning, the Scull sale exploded the traditional art market for work by contemporary artists. The sale also gave rise to the frequent expression by critics that 'My kid could paint better than that!' Both the Scull sale and, a decade later, the growth of the Pop Art Movement in which artists appropriated everyday objects were largely responsible for the current climate in which anything can be designated as art, especially if it can be sold.

The art market in the second half of the twentieth century could be described loosely by decade as follows: in the 1950s, the Abstract Expressionists convened in the Cedar Bar in downtown New York City as part of a community of artists. Art historian Dore Ashton claims that the first time American artists forged such an 'artistic milieu' was the PWAP (Public Works of Art Project) and its extension, the WPA (Works Progress Administration), in the 1930s when US president Franklin Delano Roosevelt created welfare relief programmes for artists. From 1935 to 1938, artists received training, status and payment as they painted murals for public buildings and other government-sanctioned art. The WPA's Federal Art Project employed close to 5,500 painters, craftspeople, designers and art teachers (Burton 1993: xxiii). Painters were paid $85–$100 per month for working either in central workshops or at home to produce one canvas for every 96 hours of work or one oil every six weeks and one watercolor every three weeks (Burton 1993: xxiv).

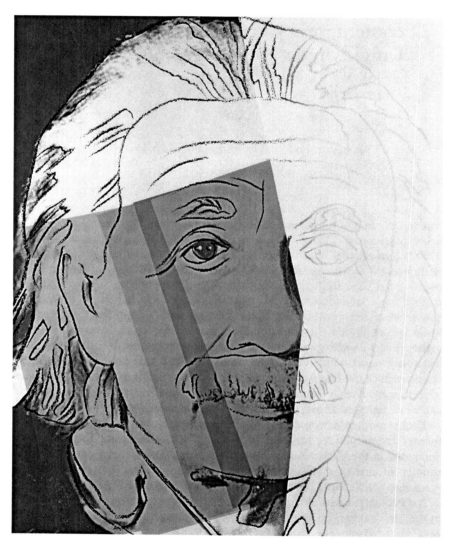

Plate 7.1 Andy Warhol, 'Albert Einstein', 1980, from Andy Warhol, 'Ten Portraits of Jews in the Twentieth Century', 1980, silkscreen, 40 × 32 inches (Courtesy Ronald Feldman Fine Arts, New York. © 2004 Andy Warhol Foundation for the Visual Arts/Artist Rights Society (ARS) New York)

After the Second World War the US arts community was held together by aesthetic matters. Aside from the Abstract Expressionists who met regularly in the Cedar Bar in Greenwich Village, artists like Robert Motherwell joined together in cooperative galleries on New York's 10th Street and worked with a group of colleagues to share gallery duties, enjoying a professional camaraderie not usually afforded the solo artist.

The permissive 1960s made 'stars' of Pop artists like Andy Warhol and marked the point at which the traditionally accepted body of knowledge about art was questioned and challenged. The subject matter for art changed with critics declaring that almost anything could be called art. This was also the decade that saw the founding of state arts councils across the USA and of the National Endowment for the Arts (NEA) in 1965, whose original mandate was to provide for both excellence and access in the arts – a mandate that would come to haunt it in the 1990s.

Corporations became arts conscious in the 1960s. In 1967 David Rockefeller, president of Chase Manhattan Bank, founded the Business Committee for the Arts (BCA), an organization intended to publicize the good works of business in and for the arts.

Although corporations had been involved in art from the early twentieth century, one of the earliest supporters was the Atchison, Topeka and Santa Fe Railroad (which paid artists to design everything from train décor to dining car place mats in an attempt to encourage train travel). In the 1930s and 1940s corporations were forming substantial art collections. IBM, the former Container Corporation of America and Steinway & Sons started art collections and used artists and designers to promote their products. By the 1950s and 1960s they were joined by Chase Manhattan Bank and Philip Morris. The motivation for corporations ranged from being perceived as doing good while promoting their company's image and visibility to the predilections of the CEO's wife. The Arts and Business Council followed on the heels of the BCA and began a national programme called Business Volunteers for the Arts that matched corporate executives as volunteers with arts and cultural organizations.

By the 1970s the co-op galleries of the 1950s re-emerged, complete with a New York agency for arts advocacy called the Association of Artist-Run Galleries (AARG) which served as their advocate. They were soon joined by re-emerging 'alternative spaces' (now called 'artists' spaces'). In New York these alternatives included The Kitchen and Artists Space and in San Francisco, Real Art Ways. When they first re-emerged, co-ops and alternative spaces sought nonprofit status and public funding but were perceived as vanity operations, since most of their boards consisted of artist-members. It took them several years to justify their missions to the NEA and the state arts councils in order to be eligible for funding.

The 1980s and 1990s acted as a hypodermic to the status and prestige of the visual arts. The East Village, a formerly seedy area of New York's down-town, spawned numerous galleries. Reminiscent of the 1960s but without

the social conscience, anything could become an art space. Gallerists were renting out their apartments and showing art in their bathrooms. Jeff Koons gave up his job as a trader of cotton futures on Wall Street to become an artist. Sales increased and prices escalated rapidly as the bull market works of art were hoovered up.

By the start of the 1990s, the National Endowment for the Arts (NEA) came under scrutiny – particularly from the religious right – for its financial participation in exhibitions of 'indecent art'. In June 1990 performance artists Karen Finley, John Fleck, Tim Miller and Holly Hughes were turned down for fellowships by the NEA. They sued the NEA (and lost in 1998), claiming the decision had been made on political, not artistic, grounds; and challenged the NEA's constitutional right to demand 'general standards of decency' from the individuals and organizations it funded.

In 1990 Dennie Barrie, executive director of the Cincinnati Contemporary Art Center (CCAC), was tried and acquitted for obscenity for CCAC's having shown the travelling exhibition of the photographic works of the recently deceased photographer Robert Mapplethorpe, ironically titled *The Perfect Moment*. The decade that began with scandal ended with scandal when, in 1999, the mayor of New York, Rudy Guiliani, tried and failed to impose his taste on the Brooklyn Museum of Art – a recipient of city funding with a building on city-owned land – for an exhibition called 'Sensation!' Financed largely by British advertising mogul and private art collector Charles Saatchi, the exhibition included a Madonna made by artist Chris Ofili that included elephant dung.

The new millennium has seen the New York arts community decentralize to the outer boroughs as the Lower Manhattan Development Council begins a $750 million cleanup of the World Trade Center site. Artist Michael Richards died in his studio on a top floor of one of the towers, and important works were lost in the assault.

While the blue-chip art market did not suffer greatly from the event of September 11, 2001, nonprofit art institutions did. The arts funding community rallied to give support; rents remained high and a mini recession ensued that affected artists' welfare dramatically (Slaff and Sévos 2002). According to a New York Foundation for the Arts survey, after 9/11, 66 per cent of artists lost sales or income, 69 per cent lost business, and 20 per cent were left unemployed. Many artists felt more marginalized than they had before the event, experiencing eviction from their spaces and studios and homelessness as a result of 9/11. In addition, the manifestation of visual representation was everywhere – homemade shrines, sidewalk vigils complete with photographs, collages, and the emergence of an instant nonprofit gallery where photographs and drawings representing the event were hung on indoor clotheslines and added to daily.

Some museums, including the Guggenheim's New York flagship and the Whitney, cancelled expansion plans. According to the Association of Art Museum Directors (AAMD), visitor numbers actually increased following

9/11 with museums that did experience a drop in visitor numbers rebounding fairly quickly.

On the auction house scene, it was not until the start of 2002 that collectors launched into lively bidding, but only the finest works could be certain to find buyers. By the first anniversary of 9/11, sellers seemed reluctant to put their works on the market. Buyers sat back, and prices softened, although as 2002 closed the art market ended on a high note – with contemporary art sales in New York giving the first encouraging signs of a market rebound. In the commercial gallery world, some dealers had the reverse experience: clients became acutely aware of their own mortality, adopted a *carpe diem* philosophy, and actually bought more art.

Museums

If juried exhibitions, galleries, artists' spaces and cooperative galleries 'discover' artists, then museums select and validate their work. Able to scan the art environment for trends, to research exhibitions and solo shows worldwide, US museums – of which 1,200 are art museums, according to the American Association of Museums (AAM) – often offer no written contract and no fee and hone their selection function through academically trained curators. They also have an increasingly ageing audience, a good proportion of whom are rich enough to allow them to make philanthropic contributions to the museum and to buy art. Some of these individuals are board members who, although bound by law to eschew conflicts of interest, can obtain a great deal of market information that spills over into their collecting decisions.

How the museum treats its objects and how it represents objects within its collection has an impact on the object's condition and price. How it treats those objects as part of the collection does also. There is heated debate in the US museum community regarding the de-accessioning of objects from a collection. Professional organizations like the AAMD and the AAM strongly oppose de-accessioning to fund operating costs and support the use of all funds from the sale of an object for purchase of another. Economists are horrified by such behaviour, since it does not allow the museum to maximize its assets. For years museums have resisted the suggestion of the Financial Accounting and Standards Board to list their collections as an asset on the museum's balance sheet – a sure signal to any funder that the museum has no need of philanthropy because it can just sell a painting to pay the bills.

The relationship between museums and commercial galleries is symbiotic, but the economic benefit to dealer and artist of a contemporary artist show in a major museum is clear to all. Artists' value in general rises after such an event and increases at a faster rate if further works are purchased for the museum's permanent collection.

From 1989 to 1991 a national battle between politicians and artists over the reauthorization of the National Endowment for the Arts resulted in a

nationwide debate over morality and American society. In these so-called Culture Wars of the 1990s, the Cincinnati Contemporary Art Museum and its director, Dennis Barrie, stood trial for showing the photographs of Robert Mapplethorpe, and the Southeastern Center for Contemporary Art (SECCA) came under fire for regranting money to show the work of photographer Andres Serrano. Finally, in 1999, as already noted, the mayor of New York, Rudy Giuliani, tried and failed to deny subsidy to the Brooklyn Museum of Art for showing a Madonna painted by Chris Ofili. In each of these examples the artists worked with themes of sex and death, bodily fluids, religious content or fecal matter; and each of these artists and his works were lambasted by the religious right. It would take another essay to explore the issues surrounding works of art that are difficult to understand, work in which artists push the envelope and work that is created by so-called minorities – women, homosexuals, Latinos, African Americans. Censorship became the buzzword, and while none of these institutions received formal legal sanctions, each was affected financially.

Whereas Cincinnati and SECCA suffered future setbacks in funding, the Brooklyn Museum of Art turned the 'Sensation!' show into one of the most highly attended, highly publicized shows in its recent history. And collector Charles Saatchi, whose paintings were on display, stood to benefit greatly from his artists' success. The fact that Saatchi was also a financial supporter of the Brooklyn show made American museums think long and hard about conflicts of interest between collectors and a museum's mission, and the AAM came out with guidelines for future exhibition support.

Price

Price is directly related to the desire and demand for a work of art, its condition, its provenance or history, its size, and the artist's reputation. Indeed, price is the one feature of art that continually makes the front page of the *New York Times*, especially when an escalation in price can be documented. In 1980 Jasper Johns' 'Three Flags' was touted for its sale to the Whitney Museum for $1 million compared with its initial sale from the Leo Castelli Gallery in 1959 for $900 plus a $15 delivery charge.

But for curators and connoisseurs, the intrinsic or aesthetic value of art is often not reflected in its price. Museum scholar, attorney and administrator Stephen Weil notes that the more functional an object, the lower its price. Conversely, high art serves no useful function, so prices would appear to escalate for completely different reasons. In contemporary art this is even more problematic, since it is virtually impossible to predict the long-term success of a living artist, even though what Robert Hughes called 'the shock of the new' confers the title of genius on much new art that is shocking, untraditional, different or difficult to categorize. Such art is often political, public and controversial. For example, performance art, while often categorized by public funding agencies under the visual arts, has elements of

theatre, film, media and literature. The artist William Pope L. creates art that is largely performance-based, evoking themes of slavery and submission or sexual ambiguity. Since 1978 he has done over 40 'crawls' including 'The Great White Way', a five-year, 22-mile performance art piece in New York's five boroughs and a walk around New York City wearing an extendible (to 14 feet) white cardboard penis as a commentary on the pervasiveness of the white phallus. Ricardo Dominguez, co-founder of the Electronic Disturbance Theater that exists in cyberspace, uses the Internet to revolutionize activism and has been particularly involved with the Mexican Zapatistas.

Artists often have problems thinking about their work in terms of price, in part because many are experimenting and making art for themselves and their peers, not, they believe, for the market. The market is a reality they end up confronting with great reluctance. Even well-known artists have problems in this area. In an interview I conducted with Chuck Close in the early 1990s, he said he tried never to think about price or the astronomical amounts people paid for his work. After all, if artists were interested primarily in money, they would simply use the standard format of work that sold best, and indeed some do. Many artists, however, continue to experiment, and resist a dealer's admonition to 'make five more paintings like the last one since they're selling like hot cakes'. Thinking of art as a saleable commodity is also complicated by new forms of art that cannot be 'owned' in traditional ways. Robert Smithson's 'Spiral Jetty' is an environmental, public work of art of which only photographs can be owned, since the actual work can only be appreciated from the air.

Price is also an imponderable in the art world. It is well known that works are priced generally by size, medium, materials and other quantifiable factors, but pricing is one of the dealer's innate skills. Leo Castelli was known for making his clients buy their way up the ladder, telling them they might not be 'ready' for certain paintings. He was also reputed to have placed secret bids at auctions in various cities to keep his artists' prices up.

While dealers often raise the price of an artist's work as an indication to the art world that the artist is succeeding, the cardinal sin is to raise the price too high, meaning the work does not find a buyer. Price, as with any other commodity, depends on supply and demand. The demand for a unique work by a painter who has just died and whose supply is, therefore, limited will be greater than that for a painter of similar reputation who is alive and still producing – but will be affected by factors such as the painter's reputation and the provenance of the work, including whether it has been owned previously, has appeared in museum exhibitions and museum catalogues, artists' reviews and any other documentation. Unlike other economic goods, lowering the price is not an option, since it signals failure. To avoid advertising such failure, auction houses generally do not list works that have been 'bought-in', which means those that have not met their reserve price. Dealers rely on offering deep discounts to long-time collectors or taking the work off the market and returning it only after the public forgets.

Artists have become so frustrated by seemingly arbitrary pricing policies that one decided, in a one-woman show at a cooperative gallery in New York in the 1970s, to price each of her 15 sculptures at $600. The relief sculptures, all made with the same material, ranged from 15 in × 6 in × 6 in (38.1 × 15.24 × 15.24 cm) to 6 ft × 3 ft × 2 ft (182.88 × 91.44 × 60.96 cm). There may have been many reasons for all the works being unsold, but one was certainly the confusion people felt regarding size and price.

Conversely, price for some is an indication of value. Publicity, controversy and, even better, scandal can affect the perception of value. The prices of works by Mapplethorpe and Ofili after the scandals of the 1990s are a case in point. Robert Mapplethorpe, as a photographer, dealt in multiple images, so the value of his work was affected by whether the work was a unique image or, if not, by the number of photographs in an edition, the exact medium (whether they were gelatin, silver prints, etc.) and whether they were signed or stamped as authentic. While subject matter is often an area where buyers play it safe (a landscape is easier to sell than a crucifixion), the controversy generated by 'The Perfect Moment' became a world-wide media frenzy by 1990. The fact that Mapplethorpe died of AIDS added to the controversy, and the fact that he was dead limited the supply of his work on the market. Only one piece sold above the $10,000 mark in 1988, but two years later thirty-nine sold for that amount.[1]

For artist Chris Ofili, it may be too soon to predict his rise or fall on the art market. Nevertheless, sales figures are startling. On 8 December 1998, Christie's London sold two of Ofili's works made in 1995 and similar in material and size to his controversial 'The Holy Virgin Mary' in the 'Sensation!' show: 'Homage' went for the premium price of £19,550 (US$32,335) and 'Them Bones' for the premium price of £21,850 (US$36,139). (Buyers' premiums are charges, usually a small percentage over the buying price, assessed to cover the auction house's costs.)

The 'Sensation!' exhibition took place in October 1999. On 16 November 2000, 'Popcorn' (1995), again of similar size and materials to 'The Holy Virgin Mary' – roughly 72 × 48 inches (182.8 × 121.9 cm) and acrylic on canvas or linen with oil, resin, map pins and elephant dung – sold for the premium price of $121,000 at Christie's New York. On 27 June 2001, 'Blind Popcorn' (1996) was sold by Christie's London for £113,750 (US$160,937). Clearly, the controversy at the Brooklyn Museum of Art was good for Charles Saatchi's investment and Ofili's career. At the 2003 Venice Biennale, Ofili represented Britain; ironically, he was sponsored by Bloomberg LP, the company owned by Rudy Guiliani's successor, current New York City mayor, Michael Bloomberg.

Legal regulation, restriction and manipulation

New York's Truth in Pricing Law, created by the Department of Consumer Affairs, requires sellers to list the prices of works for sale. There is no

restriction against a dealer selling a work for a higher price than that stated, but it is not normal practice. In California, the California Resale Royalties Act of 1976 was created on the European model of *droit de suite* and allows artists who resell their work (anything after the initial sale) in the state of California to obtain a 5 per cent royalty from these subsequent sales with gains valued at over $1,000. Seen initially as an incentive, the Act's limitations are considered an encumbrance on the work's title; buyers and sellers can (and do) retreat across the border to an adjoining state to make a sale, and there is no agency to monitor such transactions.

Artists' legal rights over their work

Prior to 1990, US artists (with a few exceptions) had no way to protect their work from mutilation, misattribution or destruction. In 1990 the Visual Artists Rights Act was passed, based on the European model of *droit moral*, protecting limited rights of attribution and integrity for single copies in drawing, painting and sculpture or for signed and numbered limited editions of 200 prints or still photographs produced for exhibition. Nine states passed moral rights statutes, spurred by initial statutes in California (the 1979 California Art Preservation Act, broadened in 1982) and New York, which passed its Artists' Authorship Rights Act in 1983. New York state law also gives artists a kind of default right.

Auction houses

Over 15 years ago Sotheby's auctioneer Hugh Hildesley, at a conference sponsored by the art magazine *Art News*, gave his ten review points for works of art in order of weighting. Although quality is listed last, it can override all other characteristics.

 1 authenticity
 2 condition
 3 rarity
 4 historical importance
 5 provenance
 6 size
 7 medium
 8 subject matter
 9 fashion
10 quality

Auctions deal in the tertiary market, in other words in the sale of items after the initial and subsequent sales. Buyers are likely to have better information in this market, since the work has already been sold once and there is likely to be documentation, critical reviews, dealers' knowledge, information on the

Internet and a variety of other sources. It is interesting that an auction house only guarantees information about a work to the best of its ability, so buyers spend substantial time researching information on potential purchases.

In 1999 the international auction houses Sotheby's and Christie's were accused of price fixing in a civil suit brought by former customers. They agreed to split the cost of a $537 million settlement, with Sotheby's paying an additional $45 million and Sotheby's Chairman Alfred Taubman serving a prison sentence.

In early 2002, according to Artprice 2003, the American market share shrank by over 6 per cent to 42 per cent of the total world market, but New York auctions in November 2002 helped the USA regain its leading position. It swapped positions with Europe, whose market share for 2002 was 53 per cent – ranking it number one in the world. In contemporary art (artists born after 1940), the USA was down to 56.3 per cent of the contemporary market from 64.2 per cent in 2001. (See Boxes 7.1 and 7.2.)

Galleries and dealers

New York continues its rivalry with Paris (and now London) as the capital of the art world, a title conferred on it in the 1960s with the geographic shift of the avant-garde and the collapse of the Parisian art market. This was also the time that at least some galleries began to think of themselves as businesses, and ideas like promoting and advertising artists began to take hold (Bystryn 1989: 179).This was also the time when a gallery hierarchy became evident – there were galleries that discovered new artists, gave them an initial show and provided early media coverage. A second group of galleries reviewed the artists being shown at the first group of galleries and drew off those with the greatest market potential. The first group of galleries was seen as a stepping stone to the second group. While this may serve the market as a successful screening device, dealers who invest time, energy and

Box 7.1 Top eight contemporary art prices in the USA, 2002

Jean-Michel Basquiat	'Profit 1', $5 million
Jean-Michel Basquiat	'Untitled', $1.9 million
Jean-Michel Basquiat	A mixed media work, $1.5 million
Jean-Michel Basquiat	'In this case', $900,000
Jeff Koons	'Self-portrait', $1.85 million
Jeff Koons	A bronze, $1.6 million
Jeff Koons	'Buster Keaton', $1million
Miquel Barcelo	'Autour de lac noir', $1.28 million

Source: Artprice (2003).

Box 7.2 Artists' incomes, numbers and exhibitions in the USA, 1990–2003

In 1991 63 per cent male artists and 65 per cent female artists earned $7,000 or less from their work as artists. Of those, 26 per cent earned most of their money from art and 14 per cent supported themselves totally from their art.

Artists' median total personal income according to the US census in 1989 was $17,116. (For other professional and technical workers it was $25,000.)

In 1999 the average income of artists in New York was $31,190.

In 2001 255,000 painters, sculptors and craft artists lived in the USA, with 100,000 artists in New York.

In 2003 there were:
2,500 exhibitions in New York of which 544 were in Manhattan;
83 exhibitions in Chicago out of 240 galleries and museums;
73 exhibitions in LA out of 238 galleries and museums.

In 2003:
100,000 artists were living in New York;
Average mean income of artists in New York was $31,190.

Source: Jeffri *et al.* (1991) and phone interview 2003.

resources often feel exploited when an artist they have 'discovered' moves on to a more prestigious gallery the minute he or she gets critical and media attention.

The prototypes for commercial dealers in New York were Sir Joseph Duveen and Daniel Henry Kahnweiler. Duveen's style manifested itself in Manhattan's high-end galleries, complete with liveried doormen. Kahnweiler's legacy was felt in the artist/dealer partnership (the dealer befriended, supported and groomed Picasso, Braque and Moore, among others).

In contemporary art, Duveen and Kahnweiler gave way to Alfred Stieglitz, Sydney Janis and Leo Castelli, the last being perhaps the most visible contemporary art dealer in the second half of the twentieth century – his 'offspring' Ivan Karp (who opened O.K. Harris Gallery), Mary Boone (first in partnership and then on her own as the Mary Boone Gallery), and current gallerists Larry Gagosian who has galleries in New York and Los Angeles as well as London and Arne Glimcher of Pace Wildenstein (an example of a contemporary gallery merging with a traditional one). Competition was fierce; for every 5,000 artists who sent or brought slides, Karp would select just one.

There is no certifying agency for dealers in the USA. In fact, a criticism is that a dealer can just 'hang out a shingle'. Because of this, the Art Dealers Association of America (ADAA) (founded in 1962) was set up to 'promote the highest standards of connoisseurship, scholarship and ethical practice within the profession' (see www.artdealers.org/who.html). Membership is by invitation and open only to those who 'have a reputation for honesty and integrity in relations with the public, museums, artists and other dealers; have expert knowledge of the works of the artists or periods in which he or she specializes'; and 'make a substantial contribution to the cultural life of the community by offering works of high aesthetic quality, presenting worthwhile exhibitions, or publishing scholarly catalogues or other documentary materials' (ibid.). Some have extensive Codes of Ethics (Boston) that detail pledges of authenticity for works members sell and for truth in advertising. And some quite well-known dealers such as Ivan Karp refuse to join.

The dealer's relationship with the living artist is sometimes a struggle for power – the less well-known the artist, the more powerful the dealer. As and if the artist gains in reputation and sales, he or she begins to equalize and sometimes surpass the dealer's power and reputation. This is a direct legacy of the steep price rises of the 1960s. And it is likely that, for the most part, history will remember artists before it records the accomplishments of dealers.

In dealing with the market for original (not multiple) art, dealers try to control the artist's work by employing two basic strategies: sell or hold. They can sell the artist's work to another dealer, a museum, a private collector or a corporation; they can sell it at auction; or, if they feel the market is too soft, they can hold the work back for a period of time in the hope that the price escalates. This is much more difficult in the case of a living artist, since there is no way of knowing whether the artist has created his or her finest work. With dead artists the supply is limited, so the 'holding' strategy is more effective. If demand for the artist' work turns into a 'fad', the dealer may try to sell many works quickly to drive prices up.

Economist William Grampp makes the case (Grampp 1989: 137) that success comes to those artists who promote themselves or who have professional representation, Appearances at upscale art fairs like Dokumenta and Basel and reviews in major art publications are essential. It is well-known in the art world that galleries that do not advertise in major art publications (*ArtNews*, *Art in America*, *ArtForum*) will probably fail to have their artists reviewed in those publications. Placement or buyer selection is essentially another kind of marketing, and the collections in which a work is placed affect its price.

Dealers have been known to be unscrupulous – for example, Frank Lloyd of Marlborough Fine Arts retreated to the Bahamas after absconding with a good deal of Mark Rothko's fortune. Dealers have also been known to report their earnings irregularly to artists so the artist has a hard time telling which work sold for what price. Even though the New York State Artist/Dealer

Consignment Law enacted in 1966 states that 'the dealer becomes your agent, the art work trust property; and the proceeds from the sale of the work, trust funds held for your benefit', some artists still fail to get receipts for works they consign to a gallery.

But dealers often have to care for their artists in lean as well as good times. Leo Castelli was one of the few dealers to offer his artists stipends. Sculptor Richard Serra felt the faith Castelli showed in him as well as the financial support money enabled him to pursue his art (Columbia University, New York City, lecture, 1975). From 1920 to 1926, Parisian dealer Daniel-Henry Kahnweiler tried to take care of his stable of poorer artists by setting up a mutual aid society in which investors contributed a sum of money each month that was distributed equally to the painters. At year's end each contributor was compensated in paintings according to their level of investment.

In the USA, dealers try to monitor artists' donations as well as sales. A donation to a major museum is worth a great deal more for the artist than a donation to a fund-raising event or a hospital. A contentious area for US artists, a 1969 law allows collectors to deduct the fair market value of a donation of a work of art from their taxes while the artist who made the work can only claim the cost of materials on his tax return. While some art world experts, including Maxwell Anderson who, as director of the Whitney Museum of American Art in New York, lobbied in Washington DC to change this law, it remains firmly in place.

Many dealers in contemporary art have a back room–front room situation. New York dealer Ronald Feldman is able to exhibit installations of Ida Applebroog because he has a lucrative business in Andy Warhol paintings, drawings and silk screens. The dealer is often responsible for educating his buyer – providing reviews, articles and information about the commodity's provenance, condition and maintenance. This is even more crucial for works made of materials that are likely to deteriorate.

Collectors

There are no typical collectors, but contemporary art collectors share a thirst for information and competition, and a desire to differentiate themselves from other collectors (Moulin 1987: 85). Collectors rely on dealers, and not always a single dealer, to supply them with information on the artists whose work they wish to collect or are considering to buy. They are often as well informed as their dealers: attending international fairs; subscribing to art magazines, newspapers, journals and auction catalogues; following critical reviews; meeting with artists; and trying to keep abreast of the latest trends.

Of the various contemporary art collectors who have spoken to my students at Columbia University, five will serve to illustrate some of the basic types. Vera List saw herself as the 'caretaker' of her collection, something she would enjoy during her lifetime but that she would make a bequest. A patron of Lincoln Center and the Metropolitan Opera and a former board

member of the New Museum, when she died in 2002 List had already sold much of her collection to support various causes. Centurion Roy Neuberger immortalized himself and his collection by first donating it and then by building the Neuberger Museum of Art at the State University at Purchase, New York. Agnes Gund, the founder of a stellar arts education organiza- tion, Studio in a School, and for many years the president of the Museum of Modern Art, has always been seen as a 'philanthropic leader'. Elaine Dannheisser was a collector hooked on the acquisition and the chase and also the status collecting brought her. In her obituary, art critic Deborah Solomon pointed out that Dannheisser recalled her days as a housewife with 'so little social standing that dealers like Mary Boone refused to sell her a paint- ing' (*New York Times*, 30 December 2001). She bought and stored art in an enormous warehouse in New York and used her collection to broker membership on the board of the Whitney Museum. She fell out with the museum and defected to the board of the Museum of Modern Art (MoMA). In 1996 she and her husband, Werner, donated seventy-five works to MoMA, the largest group of contemporary art ever given to a US museum at the time. Eighty more works were bequeathed to MoMA at her death. Other col- lectors, like Joel and Sherry Mallin, have a realistic market view of their collection. They expect when they die it will be sold on the market for someone else to enjoy it. In the meantime, they, like many collectors, are involved in acquiring more art and building special storage and exhibition facilities for it, and they can recall the circumstances in which they acquired each piece in their collection. The Mallins, unlike some collectors, enjoy sharing this knowledge with the public through tours.

Critics

Traditionally, critics have validated or excoriated artists, but recently their role has been substantially compromised.

The French critic, Denis Diderot, active from 1759 to 1781, was perhaps responsible for the distinction between aesthetics and art criticism. And it is in Diderot's time that the ambivalence surrounding criticism, which main- tains that it is both necessary and contemptible – was fixed (Moulin 1987: 67). The critic's role in giving a work of art legitimacy is used as an economic tool whereby good reviews translate to higher prices.

In a 2002 study of over 100 art critics at daily and weekly newspapers in cities across the USA, the National Arts Journalism Program (NAJP) at Columbia University found that about two-thirds of those critics write positively about art, many eschewing negative criticism. Art critic Peter Frank, speaking in a class at Columbia University in the mid-1980s, confessed that he would not give a newly emerging artist's first show a bad review, since he was well aware what that would do to the artist's market and future chances. Another critic in the NAJP study remarked, 'We live in Iowa – anyone doing anything here has to be encouraged' (Szanto 2002: 32).

It is also interesting that art critics, at least in the Columbia survey, are actively involved in other areas of the art world. Four out of five art critics collect art, two of the five make art, and half of those who make art actively exhibit their work. Still, they are only moderately excited about the current accomplishments in visual art (Szanto 2002: 8–9).

According to the NAJP, art critics generate about five visual arts stories a month, split between reported and critical pieces. At mainstream publications they focus primarily on contemporary art and living artists (Szanto 2002: 25). Almost 60 per cent never write about art, artists and exhibitions abroad, even with an art world that is clearly international (Szanto 2002). Art critics do, however, write frequently about 'the commercial, ethical, political and institutional dynamics of the art world' (Szanto 2002: 26). Seventy-seven per cent like to write most about painting, and over half like to write least about online art (Szanto 2002: 34).[2]

Artists' spaces, co-ops and alternatives

In the 1970s, artists' spaces and cooperative galleries were created as alternatives to the traditional marketplace. Cooperatives were funded initially by the artists themselves, whereas artists' spaces attracted public funding. The New York State Council on the Arts was instrumental in the founding of Artists Space, and alternatives like Franklin Furnace and Exit Art were later joined by Art in General and White Columns. For many of these spaces, artists were concerned with showing rather than selling work and with ridding themselves of the decision-making control of the traditional dealer. Artists often made up the board of these organizations, causing the NEA to deem them vanity operations until they could prove they were acting in the public interest.

From 1973 to 1982, many of these spaces found seed money from a US Department of Labor initiative to help increase employment. The Comprehensive Employment and Training Act (CETA) was a scheme co-opted by some savvy artists and administrators. For some, like the Randolph Street Gallery in Chicago – open from 1979 to 1998 – CETA provided important support to launch artist-friendly alternatives.

Over the next 20 years some of these spaces became institutions. Franklin Furnace amassed one of the best collections of artists' books in the world; it donated them to MoMA and was simultaneously criticized for selling out and praised for increasing the reputation of and market for its artists. In 1996 Franklin Furnace cast itself as an online institution without a walk-in space. In 2002, through the Franklin Furnace Fund for Performance Art, it offered an honorarium open to any artist of $5,000 and a two to four month residency in a physical venue. Creative Time, which began in 1974 without a space and with the purpose of turning found spaces into art venues, was responsible as an anchor institution for organizing the Tribute in Light memorial in the sky over Manhattan to commemorate 9/11. Exit Art

developed earned income strategies with its own interpretation of an 'art store'.

Most dealers would deny that these alternative spaces and venues had any influence on the art market or over artists in the market simply because, they might say, these artists are not in the market, but in some cases artists used these spaces as stepping stones to commercial galleries where they could find colleagiality and feedback for their work as well as being allowed to experiment and fail. As real estate became more expensive and Soho, Noho and Tribeca gentrified, it became harder and harder to tell which galleries were commercial and which cooperative. When rents became prohibitive, artists moved to Hoboken, New Jersey, to DUMBO in Brooklyn, and to other areas in which they could afford to create and show their art.

At the same time, institutes of contemporary art (ICAs) developed in Chicago, Boston, Philadelphia and other cities. These were organizations committed to cutting-edge art – not always with permanent collections – that began as institutions, perhaps stealing some of the thunder from the alternatives.

Then there were the hybrid organizations like the New Museum for Contemporary Art – committed to the scholarship and documentation of a museum but created with a ten-year-only collection policy, after which artists' works were de-accessioned – and PS 1, an alternative space the size of a city block in a former school in Queens, which rented out artists' studios, had no permanent collection and sold a portfolio collection of artists' works donated by well-known artists such as Christo to earn income.

The other/subsidy market

With the founding of the National Endowment for the Arts in 1965, the USA began to get a taste for another kind of visual art market. Not since the WPA in the 1930s (mentioned earlier) had substantial monies been directed at artists and their institutions, save for the US Department of State-sponsored exhibitions abroad and various ambassadorial residences. Now, in addition to substantial support to nonprofit arts institutions, including museums and cooperative galleries and artists' spaces, individual visual artists (and for a time art critics) were eligible for fellowships. Yet although the odds were not quite as bad as they were for Ivan Karp's gallery, for every 5,000 fellowship applications, the NEA would select approximately 100 recipients (Brenson 2001: 132).

Since 1996 the NEA has been prohibited by Congress from dispensing grants to almost all individual artists. One new organization, called Creative Capital and funded by upward of twenty-five private foundations, seeks to take up where the NEA leaves off. Other organizations, like the New York Foundation for the Arts, still give individual artist grants, but do not come close to replacing the cuts in artist resources that came with the cessation of the NEA's artist grants.

Corporations

In the 1980s, when the economy was buoyant, corporations were touted as the new Medicis, challenged to fill the gap left when federal public funding levelled off and then declined, and as budgets tightened these corporations turned away from philanthropy towards sponsorship.

European countries have a more direct relationship to sponsorship. In the USA, the line between the two has become increasingly blurred. Corporations ultimately behave as strategically in the art world as they do in business, choosing certain kinds of art and venues for building collections that reflect their own business purposes. They became major sponsors of museum exhibitions, primarily for publicity and public relations, for 'self-promotion and high-style decoration' (Wu 2002: 269). While their sponsorship dollars have tended to favour large, treasure-oriented shows, they have also funded contemporary artists, but usually those who already have established reputations (Alexander 1996: 25).

The relationship between museums and corporations also affects art's market price, especially when corporations determine, through substantial funding, the kinds of shows that will be exhibited and when, through sponsorship, they support blockbuster exhibitions that are intended to draw crowds and notoriety. Victoria Alexander's study of temporary, changing, special exhibitions in thirty large American museums from 1960 to 1986 found that while the number of museum exhibits almost doubled during this period, corporations tended to sponsor blockbuster and non-canonical, accessible and often American art shows in order to reach broad audiences (ibid.: 60–1). For museums, corporate funding has meant a new revenue stream to supplement admission charges for visitors (for example, Revlon underwrote a free evening at the Whitney Museum), generating income for the use of museum spaces (it is rumoured that for $35,000 you can have a bar mitzvah party in the Temple of Dendur at New York's Metropolitan Museum). Some would say it has also compromised the sanctity of curatorial decision-making. And this funding has also brought museums uncomfortably close to the market, since the production of exhibitions sanctions the art museums' display.

Philip Morris Inc (PMI; now called Altria) former CEO George Weissman used modern art to position his company on the cutting edge and to deflect people away from the fact that PMI made cigarettes. The company's logo for almost 25 years was 'It takes art to make a company great'. Weissman's foresightedness became the model for what is now considered routine marketing.

Some corporations – IBM, Chase, PMI and First Banks in Minneapolis – have collected stellar collections of contemporary art, complete with documentation. Lynne Sowder, a curator of the First Banks programme for ten years, built up just such a first-rate collection which also allowed employees to deflect their frustration with the corporation onto the collec-

tion. Sowder created exemplary art education programmes and her corporate budget enabled First Banks to be a major player in the marketplace.

Artists

Artists' career trajectories are neither linear nor predictable. Even the 'household names' have had periods of great fame followed by fallow periods. The notion of 'career' is a late twentieth-century concept. Pre-war artists did not speak in terms of careers; they were simply painters.

The USA is known for the pre-eminence of its entrepreneurs and risk takers in all walks of life, and American artists are no exception. Artists seek validation for their work as artists and recognition that they are, in fact, artists. In a study of 1,000 US painters in 1989 (the Artists Training and Career Project, or ATC), the Research Center for Arts and Culture at Columbia University found that, in their early careers, 61 per cent of painters received validation from teachers and 50 per cent from peers (Jeffri *et al.* 1991: 20). Validation in the initial stage of an artist's career usually includes some kind of representation – a jury selection, an agent or a gallery. This stage has certain markers. Mihaly Cziksentmihaly conducted a longitudinal study of arts students from the Art Institute of Chicago in the 1960s and found that what represented career entry for many of them was getting a loft apartment/studio. For ATC artists over 25 years later, clearly the cachet of a loft did not signal 'arrival' as a professional. Thirty-four per cent identified their first professional recognition as a gallery show, another 33 per cent as an honour or award, 17 per cent as winning a competition and 28 per cent as the first sale of their work. (Some respondents chose more than one answer.) Thirty-six per cent were first represented in the market between ages 18 and 25 and 32 per cent between ages 26 and 35 (Jeffri *et al.* 1991: 16–17). In the previous 12 months, 65 per cent of the respondents had participated in group-invited exhibitions, 52 per cent had been involved in group competition exhibitions, 50 per cent had one-person shows and 49 per cent had participated in juried events (Jeffri *et al.* 1991: 22).

Unlike artists in Europe, American artists do not have access to significant subsidies. In the ATC, less than a third of respondents had received art-related grants or fellowships; the most frequently cited amount being $500. After securing some kind of representation, artists reside, perhaps for the remainder of their lifetimes, in the developmental stage of their career. The 'paying one's dues' stage can be an isolated experience; and the artist may join an artists' space, a cooperative gallery or some other group to have regular interaction with colleagues. In addition to interaction, the opinion of an artist's peers is significant.[3]

Artists today are adept at self-promotion. Many major cities including Boston and Minneapolis have regular seasonal tours of artists' studios. Even a smaller town like Ithaca, New York, organizes a 51-artist studio tour for two weekends in October. The Internet has been a useful medium for artists

to supplement creativity but also to communicate ideas. Artists have begun to form collectives, like the online collective in Canada, where there is no interest in selling. Online art (as well as online selling of art) is another alternative to traditional media and channels. Web sources like Artist Registry. com, Guild.com, fine-art.com and iTheo.com provide artists with a database to display images of their work as well as documentation and reviews. ArtQuest and eBay bring artists and buyers together and eliminate the dealer and the commission. Agencies like the New York Foundation for the Arts offer credit, loans and tips for artists creating their own web pages. And instead of slides, many artists are send their work by e-mail and create CD-ROMs that contain everything from works of art to performances.

Almost half of the ATC painters chose themselves as their most important critics. This self-evaluation is sometimes frustrating and maybe seen as prima donna behaviour by the people who manage artists, although it is often this self-criticism that keeps artists' work alive. And since there is no official academy to regulate admission, anyone can call him or herself an artist. Indeed, when artists were asked what definitions marked them out as professionals out of thirteen possible choices, 40 per cent chose inner drive to make art as their first choice; and even though 43 per cent had graduate degrees, 61 per cent said they were self-taught (Jeffri *et al*. 1991: 21). Indeed, the market often capitalizes on this phenomenon, as it has done in recent years by promoting outsider art, asylum inmates, prisoners, Primitives, Naifs and others. The 'discovery' of some of these artists has resulted in a large annual Outsider Art Fair at the prestigious Puck Building in downtown Manhattan.

The third stage, only entered by the few, allows artists control over their own destiny. This is the stage at which galleries and dealers seek out the artists, when collectors vie for the artist's next work and when museums jockey for the right to accession the artist's work. Very few artists reach this stage, and the ones who do are afforded yet another career level, albeit a posthumous one. Famous artists can leave their work to a museum. They, or the executors of their estate, can request that the works be shown together and cared for in certain ways. Mark Rothko's paintings in the Menil Chapel in Houston, Texas, are the result of just such an action. The Warhol Museum in Pittsburgh houses a large portion of Andy Warhol's output. Museums, however, especially in times of limited resources, are skittish about accepting restricted collections, no matter how eminent the artist.

With artists' perception of the market as unfair and highly competitive, it is perhaps surprising that 52 per cent said they were satisfied or very satisfied with their careers, and 87 per cent that they would choose the same career if they had it to do over again (Jeffri *et al*. 1991: 24).

Conclusion

The one thing this chapter has not mentioned is the public. Satirist Tom Wolfe titled a chapter in *The Painted Word* 'The public is not invited (and never has been)'. He makes the point that:

> [t]he notion that the public accepts or rejects anything in Modern Art, the notion that the public scorns, ignores, fails to comprehend, allows to wither, crushes the spirit of, or commits any other crime against Art or any individual artists is merely a romantic fiction, a bittersweet Trilby sentiment. The game is completed and the trophies distributed long before the public knows what has happened.
>
> (Wolfe 1976: 26)

The art market is a small, incestuous family, inaccessible to the general public, and kept alive by groups of tightly connected insiders. This tiny band, for reasons of status, prestige, knowledge, enlightenment, conquest, posterity, greed, personal pleasure as well as notions of investment or philanthropy, keeps itself thoroughly informed on the buying, selling and managing of what is at best an uncertain prospect.

Notes

1 Mapplethorpe's first work to be sold at auction in Sotheby's New York was a 38.9 cm × 38.9 cm 1982 signed photograph, 'Lisa with a gun', on 8 May 1987, which made $2,090. On 2 Nov 1989 the artist's signed silver prints, self-portrait in drag and self-portrait in leather jacket, both 34.9 cm × 35.6 cm, were sold at Sotheby's New York for $37,750 each. On 9 October 1991, his 1980 signed photograph measuring 45.5 cm × 35.3 cm, 'Man in polyester suit' sold above Sotheby's New York's high estimate for $6,050. A year later on 14 April 1992, the same photograph made $9,000. On 8 October 1993 Christie's New York sold the second of 15 Mapplethorpe signed 1980s gelatine silver prints of a similar size, 'Self-portrait with a cigarette', for $13,225. The highest price for the artist's work to date is $76,650. Mapplethorpe dealer, Harley Baldwin, sells rare images of flowers by the artist in his gallery for $150,000 and a five calla lily image for $350,000. But, according to New York Mapplethorpe dealer Howard Read of Cheim & Read, the artist's career is slow and measured and it is a fact that he had to wait until 1985 and 'The Black Male Nude' exhibition, before he was able to make a living from his art.

2 At least three or four critics such as Jasper Johns, Roberts Rauschenberg, Claes Oldenburg, Maya Lin, Louise Bourgeois, Chuck Close, Ed Ruscha, Gerhard Richter, Cindy Sherman, Frank Stella (Szanto 2002: 38). Critics over 46 like these artists more than critics under 46: Karen Finley, Dale Chihuly, David Salle, Chuck Close, Sol Le Wit, Pepon Osorio, Wayne Thiebaud, William Wegman, Elizabeth Murray and Martin Puryear. Seventy three per cent of artists felt that critical approval had helped their work (Jeffri *et al.* 1991: 24).

3 In the ATC 28 per cent of artists rely on peer group validation, 47 per cent on critical review. In 1991 33 per cent of male and 46 per cent female artists in the US had college degrees and 46 per cent of male and 40 per cent of females had

graduate degrees. Alarmingly, 52 per cent of artists failed to make art for the market, 39 per cent did so sometimes and 9 per cent did so regularly (Jeffri *et al.* 1991: 13).

Bibliography

Abbing, H. (2002). *Why are Artists Poor?* Amsterdam: Amsterdam University Press.
Alexander, V. (1996). *Museums and Money*. Bloomington: Indiana University Press.
Artprice (2003). Lyon, France: Artprice.
Baumol, W. J. (1985). 'Unnatural value: or art investment as floating crap game', *Journal of Arts Management and Law*, 25(3): 47–60.
Brenson, M. (2001). *Visionaries and Outcasts*. New York: New Press.
Burton, J. M. (1993). 'Introduction', in J. Jeffri (ed.) *The Painter Speaks*. Westport, CT: Greenwood Press, pp. xiii–xxxi.
Bystryn, M. (1989). 'Art galleries as gatekeepers: the case of the Abstract Expressionists', in A. W. Foster and J. R. Blau (eds) *Art and Society*. Albany: State University of New York Press, pp. 177–89.
Csikszentmihaly, M. (1996). *Creativity, Flow and the Psychology of Discovery and Invention*. New York: Harper Collins.
Dannheisser, E. (2001). Obituary, *New York Times*, 30 December.
Grampp, W. D. (1989). *Pricing the Priceless: art, artists and economics*. New York: Basic Books.
Hughes, R. (1981). *The Shock of the New*. New York: Alfred A. Knopf.
Jeffri, J., Greenblatt, R, Friedman, Z. and Greeley, M. (1991). *The Artists Training and Career Project: painters*. New York: Columbia University Research Center for Arts and Culture.
Moulin, R. (1987). *The French Art Market*. New Brunswick, NJ: Rutgers University Press.
National Endowment for the Arts (2002). Research Division note No. 80: *Artist Employment in 2001*. Washington, DC: National Endowment for the Arts.
Slaff, J. and Sévos, C. (2002). 'Summary of findings. Artists one year later: survey of 9/11's economic impact on individual artists in New York City, October 2002', htttp://www.jsnyc.com/case_studies.htm
Szanto, A. (2002). *The Visual Art Critic*. New York: National Arts Journalism Program.
Wolfe, T. (1976). *The Painted Word*. New York: Bantam.
Wu, C.-T. (2002). *Privatising Culture: corporate art intervention since the 1980s*. New York: Verso.
Zolberg, V. and Cherbo, J. M. (eds) (1997). *Outsider Art: contesting boundaries in contemporary culture*. Cambridge: Cambridge University Press.

Internet sources

http://www.arts.gov
http://www.artdealers.org/who.html
http://www.dcita.gov.au/Article/0,01-21415599,00
http://www.galleryguide.org

8 The emerging art markets for contemporary art in East Asia

Iain Robertson

> There are some sketchy kinds of landscapes in high repute among the natives at Canton, who consider them quite masterpieces. They are very scarce, and consist of rough outlines of trees, rocks, waterfalls, etc., painted with a brush dipped in a single pot of colour. Although to our eye these performances have no merit whatever.
>
> (Toogood Downing, *c.* 1835 in Sullivan, 1973, p. 89)

New art doesn't have to originate in Western Europe or America. Today, it is as likely to be 'discovered' in the developing world as the developed. Travellers to Africa will buy contemporary carvings and paintings for a song. Cultural tourists to South America and Southeast Asia will pick up paintings and drawings from highly respected local artists for tens of dollars and believe they have a bargain. Visitors to the Russian Federation, China and East Asia will pay considerably more for local art, but still feel confident that they have something better, or at least more exotic, and cheaper than a Western European or American equivalent. Are these new art buyers successful arbitragists, enlightened collectors or just deluded cultural tourists? Are they panning successfully for gold or just trading in the wind?

In the mainstream markets for contemporary art there is, in theory, no such thing as an undervalued asset because the markets are regulated and anything you buy for very little has no resale value. In the non-contemporary Western markets asymmetrical information benefits both sellers and buyers and bargains can be had. In the transitional economies of Africa, devoid of a sophisticated art market, the work can only have decorative appeal and is, to all intents and purposes, Delta quality art. The South American economies have, as yet, failed to realize their economic potential and, except for a few blue-chip names, trade largely in Delta quality art. The areas of the world which show the greatest artistic promise are located in the fast developing regions of Southeast Asia, the Russian Federation and Eastern Europe. One area in particular has demonstrated the potential for long-term cultural sustenance, and that is East Asia, a part of the world which will be the focus of this chapter.

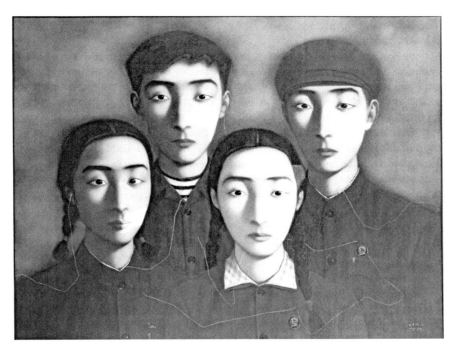

Plate 8.1 Zhang Xiaogang, 'Big Family', 2000 (Hanart TZ Gallery Ltd, Hong Kong)

East Asia's regional art markets

Four years ago I argued (Robertson, 2000) that Taipei would be the regional art centre for contemporary Chinese and Taiwanese art. I based my prognosis on the current political realities: post-Asian flu, pre-SARS and before a concerted political demonstration of Taiwanese nationalism. Back then, Taiwan had just become a democracy, had the unequivocal military support of the USA and a free press. It had plans to be the centre for high technology – almost fulfilled, a healthy speculative environment (a NASDAQ style stock market opened in 1998) and GDP per capita that was higher than any of its Asian neighbours barring the city-states of Hong Kong and Singapore. The World Economic Analysis of 1997 weighted the territory's political and country risk as less than Hong Kong and China's.

Taipei scored highly across a number of specific art market systematic criteria (Robertson, 2000). The city scored top marks for achieving international art prices, the size of its indigenous market, the public support for its art and for its cultural education system. It also scored highly for its laws facilitating the art trade and its cultural and urban infrastructure. It scored less well on its desire to encourage international competition but overall pipped Hong Kong to be the most likely East Asian art market capital. Shanghai and Beijing languished far behind.

Since that time the region's, and indeed international, politics has changed dramatically and with it the relative art market merits of these cities. My current assessment, which now includes Seoul and uses London as a benchmark, presents a different picture. (See Table 8.1.)

International prices

The recent devaluation of the NT$ and Won have dragged prices for Taiwanese and Korean art down. The RMB, still fixed at an artificially low rate against the dollar, has had less impact on indigenous demand for Chinese contemporary art since most business in this commodity is conducted in US and HK dollars. There is considerable disparity between auction house and dealer prices in mainland China and in the case of the 'romantic realist', alternative art market star, Chen Yifei, the prices are 'fixed' by Marlborough Fine Art. Prices are on average 25 per cent higher in London and Hong Kong than either Shanghai or Beijing although these differences will flatten as the China market develops. Certainly the presence of Sotheby's and Christie's (1992–99) helped Taipei achieve record prices for Taiwanese contemporary artists – notably Ju Min and Chang Huang-ming, coming off the back of records for Taiwanese and Chinese first-generation oil painters such as Chen Cheng-bo and Chang Yu. The market, buoyed by escalating land prices, also propelled the value of many mainland contemporary, alternative oil painters to high values. Hong Kong is still the benchmark for pricing Chinese contemporary art and the sole serious market for indigenous talent.

Its pioneering galleries, notably Hanart TZ, Alisan, Shoeni and Plum Blossoms operate in a mature art market. Prices for first-generation Korean oil painters are as high as those for other East Asian art, but, in common with most modern and contemporary art from the region, few artists have international reputations. Korean modern and contemporary art is not traded in Hong Kong, the region's international art exchange, and only occasional works by first generation moderns, like Park Soo-keun, are auctioned in New York, although this does not appear to depress prices in relation to Chinese and Taiwanese equivalents.

Indigenous commercial art market

Despite rapid development in the Beijing and Shanghai art markets, China's indigenous markets are small and their tone set by foreign dealers. The main auction house, China Guardian, is modelled on Sotheby's and boasts a collector's club in Shanghai. There are other houses, the most significant being Beijing Hanhai Art Auction Corp, Rong Bao Zhai Art Auction Co Ltd and Duo Yun Xuan, but none operate internationally. The majority of Beijing and Shanghai art galleries deal in alternative oil paintings, and with the exception of the foreign owned, ShanghART, Courtyard, Red Gate, Shoeni and Japanese owned J Gallery, none could be described as appealing to international buyers or to have Alpha status. A new generation of Shanghai dealerships, like Shanghai Yibo Gallery Ltd and Longrun, have profited from the financial and residential developments in Pudong and Gubei respectively. Although there are signs of a Chinese middle class, evidenced by the appearance of traders on Shanghai's new stock market and new department stores in Beijing and Shanghai, most buyers of cutting-edge Chinese contemporary art are still made up of foreign visitors and the expatriate community. The most noteworthy collector, the former Swiss ambassador Uli Sigg, has amassed the world's largest collection of cutting-edge Chinese contemporary art, acquiring most of the work directly from artists' studios and art academies. Even established artists can be persuaded to sell from the art academies where they often maintain studios into middle life, and Beijing, Chengdu and Zhejiang (Hangzhou) art academies are excellent art conduits, each specializing in a different type of commodity. The Central Academy of Fine Art in Beijing is notable for the quality of its alternative oil painters, Chengdu for the work of its cutting-edge artists and Zhejiang for new brush painting artists (*guohua*).

Taipei is home to over 200 galleries, the largest concentration in East Asia outside Japan. The quality of these outlets varies considerably, but there are a number of first-rate dealerships: Dimensions, Caves and Lung Men.[1] The vast majority of Taiwan's galleries focus on the local art market, although some like Soka Art Centre trade in modern and contemporary Chinese artists out of franchises in Beijing and Seoul as well as Taipei. Many of Taiwan's commercial dealers are located in a single building – the Apollo

Table 8.1 The contemporary art markets of London, Hong Kong, Taipei, Shanghai, Seoul and Beijing measured across seven principal criteria, April 2004

Criteria	London	HK	Taipei	Seoul	Shanghai	Beijing
International prices	A	A	C	C	C	C
Indigenous art market	A	C	A	C	C	E
International competition encouraged	A	A	C	E	B	B
Facilitating laws	C	A	B	C	D	D
Public support for the arts	A	C	C	D	D	D
Cultural and urban infrastructure	A	B	B	D	C	E
Cultural education	A	B	A	D	D	D
Total	34	29	27	18	16	15

Broad areas sustaining an art market

Government: levels of democracy	A	C	C*	A	E	E
High standard of living (per capita income)	A ($25,000+)	A ($25,000+)	C ($15,000–25,000)	C ($15,000–25,000)	E (under $5,000)**	E (under $5000)***
Sovereign credit rating (S&P, July 2002)	A (AAA)	C (A+)	B (AA)	D (BBB+)	E (BBB)	E (BBB)
Investor-friendly environment; year end market values of listed (stock-market) companies	A	C	D	E	E	E
Grand total	53	43	39	29	20	19
Maximum	55	55	55	55	55	55
Effectiveness (%)	96.3	78.2	70.9	52.7	36.4	34.5

Notes:
A is worth 10 points and E, 1 and the higher the score the more competitive the market. See Chapter 6 on taxation for down-grading of London from A to B on facilitating laws.

* Taiwan is a democracy but there are international political restraints placed on its de facto government

** In 1999, Shanghai's average per capita GDP was about $4,400 on a par with Slovakia. China's average GDP per capita was slightly over $2,400 in 2001. In certain provinces such as Gansu it falls to around $600 per head, the same as India (DTI, PRC–UK Trade and Investment figures).

*** Beijingers purchased over $40 billion worth of commodities in 2001, up 8.1 per cent on 2000 (DTI, PRC–UK Trade and Investment figures).

– in the centre of the city, but the vast majority are spread throughout Taipei. There are a few experimental commercial art spaces such as ITPark and Space II, as well as galleries like Han Mo Xuan, and Snow Falcon that concentrate on a dying art form, contemporary *guohua* art. Chinese cutting-edge contemporary art is not sold in Taipei, but the alternative oil painting variety is ubiquitous. The better galleries, like Galerie Elegance, will offset the often loss-making part of their business – Taiwanese cutting-edge art – by trading in the work of established contemporary Chinese masters like Zao Wou-ki. The retreat into private dealing of Hanart Taipei (now under different ownership and renamed MOMA!) a market maker for the Taiwanese cutting-edge stars like Chen Tsai-tung and Yu Peng, seems to herald a new stage in the former owner's (Johnson Chang) special relationship with the internationally renowned sculptor Ju Min. Ju, who recently established his own open-air museum, is rumoured to be trading through his family, a situation which mirrors that of his teacher and mentor, the late Yu Yu Yang. The consequences of suppliers side-stepping professional intermediaries are as damaging as buyers circumventing dealers and going directly to source. It works in both cases at the market's inception, but reduces confidence in the commodity in a mature market. The collapse of the market for Yu Yu Yang sculptures following family rivalry and mis-management should be evidence enough for Ju Min that this is a mistake.

The $18.2 million auction market in Taiwan was, until 2001, vibrant and mature. It divided up fairly evenly into quarter shares between Christie's, Ching Shiun, Unique and Ravenel. Christie's have since followed Sotheby's suit and left Taipei. Two local houses sensing the decline in Taipei's tertiary market prospects, and the great potential across the Straits, have taken advantage of the recent trade rapprochement between Taipei and Beijing to open up trading arms in China. Unique now owns the Jenya gallery in Beijing and is in joint partnership with Rongbau.

Practically all Hong Kong's galleries can be considered to be international. Some, such as Hanart and Alisan, have being trading for over 25 years and spearheaded the Chinese cutting-edge movement, known as Political Pop. Both galleries actively advise public sector curators world-wide. Alisan assisted the Guggenheim with its 'China-5000 years' exhibition six years ago, while Hanart is practically the sole representative of Chinese artists at the San Paolo and Venice biennales. Recently, Hanart has set up in partnership with the Paris dealer Enrico Navarra, while Sotheby's and Christie's have made Hong Kong the centre for their Asian operations. Political Pop art from China and subsequent Chinese cutting-edge art is patronized by one of the territory's foremost collectors, David Tang, owner of the China Club and Shanghai Tang Department stores.

Despite its great number of dealers (almost 150) the Seoul market is provincial. There are Alpha dealers in the South Korean capital, CAIS and PKM, but the other top dealers, Hyundai, Kukje and IHN, fail to lead taste. Few South Korean artists find regional or international approval and most

Table 8.2 International traders in East Asian art, with art form

Alpha East Asian dealers			Overseas equivalents		
Hanart TZ (HK)*	20	CE	Marlborough FA (London/global)	20	AAM
Dimensions (Taipei)	20	CE	Michael Goedhuis (NY)*	20	CE
PKM (Seoul)	20	CE	Enrico Navarra (Paris)	20	CE
Pierre (Taichung)	19	CE	Galerie de France (Paris)	19	CE
CAIS (Seoul)	18	CE	Chinese Contemporary (London)	18	CE
Caves (Taipei)	18	CE	Eaothen Cohen (NY)	18	CE
Martini (HK)	18	CE			
Lung Men (Taipei)	18	CE			
Lin & Ken (Taipei)	18	CE			
Shoeni (HK)	17	AAM			
Plum Blossoms (HK)	17	CE			
Elegance (Taipei)	17	CE/AAM			
Kukje (Seoul)	17	CE			
Red Gate (Beijing)	17	CE			
Alisan (HK)	16	CE			
Hyundai (Seoul)	16	CE			
Han Mo Xuan (Taipei)*	16	AAM			
Modern (Taichung)	16	CE			
Courtyard (Beijing)	16	CE			
Hwa's (Shanghai)	16	AAM			
Shanghai Yibo (Shanghai)	16	AAM			
ShanghART (Shanghai)	16	CE			
Gate (Taipei)	16	CE			
IHN (Seoul)	16	CE			

Notes:
The gallery scores were reached after consideration of trend-setting, pricing, promotion and presentation. A total of five marks were awarded per category, making a maximum score of 20. Galleries that scored 16–20 points were awarded Alpha gallery status (Robertson, 2000/2002).

* Three galleries deal in a new *guohua* art which, if it departs dramatically from tradition, is seen as cutting-edge.

AAM = alternative art market/academic realism.
 CE = cutting-edge.

buying is local, with great support from the chaebols, Samsung, Dongyang and Daewoo. The professionally run Seoul Auction House attracts few foreign bidders. (See Table 8.2.)

International competition encouraged

China is prostrating itself in its efforts to attract foreign investment and competition. It is, however, still extremely difficult for a foreigner to establish a street-front gallery in either Shanghai or Beijing that is not part of a larger joint venture. The art fairs, China Art Exposition, Shanghai Art Fair and the ROC Art Fair, have all singularly failed to attract significant numbers of foreign dealers. The 2002 Beijing event was the region's nadir with even the

local Western-owned galleries staying away and the event dominated by artist-owned stands. The year 2004 promised more with a number of Korean and Taiwanese galleries, but few Western galleries, agreeing to participate. Taiwan's Ministry of Culture has promised to support a 'super' Taipei fair but at the moment there is no clear regional leader. Hong Kong perhaps feels it does not need the added impetus of an international art fair after the demise of Art Asia some years ago. Seoul, meanwhile, has no visible commercial opportunities for foreign dealers or auctioneers outside oligopolistic ventures with the top galleries, which are willing to exhibit and sell foreign blue-chip cutting-edge contemporary work. The Korea international art fair (2003), however, attracted twenty-nine overseas galleries making it one of the more internationally successful in Asia.

Facilitating laws

There are legal reasons why there are more foreign commercial galleries based in China than in Taiwan and there are further reasons why these dealers prefer Hong Kong to either Shanghai, Beijing or Seoul.

The various forms of joint venture do not suit small foreign businesses wishing to trade in China, favouring large multinationals. Those few foreign dealers who have established themselves transact a proportion of their business under a licensed company in Hong Kong or other offshore haven in order to avoid Chinese tax penalties. The key in determining where profits arise is where the taxpayer's contracts of purchase and sale are 'effected'. Copyright law in China, meanwhile, is in its infancy and does not extend to art. The infringement of intellectual copyright is a massive problem and affects all goods, especially the luxury commodity sector. Royal Doulton (the British pottery) found that many of its designs had been appropriated by Chinese manufacturers in 2004 and sold at a fraction of the price of the originals – a corrupted extension of the China Trade. The Public Security Bureau is still very wary of politically or socially charged work that might be critical of government. China charges 12 per cent import duty on works of art and levies a 17.5 per cent sales tax in addition to a 5 per cent business tax. As in Taiwan, antiques and early works of art (pre-1795) are prohibited from export.

Taiwan's business environment is benevolent compared to China's, with no special restrictions placed on foreign companies unless they are from Hong Kong or Japan. Any amount of foreign currency can be transferred in or out of the country and joint ventures remain private affairs. The problem facing foreign dealers in Taiwan is not red tape but the unreliability of the private partnership and the great difficulty in gaining the confidence of Taiwanese collectors. Paintings, drawings and pastels executed entirely by hand are import and tariff free, but if the work is a reproduction or a print the tax is levied at 7.5 per cent. There is a sales tax of 5 per cent on invoice value and a business tax of 25 per cent.

Hong Kong is one of the most open and business friendly environments in the world according to the DTI (HK, UK Trade and Investment, 2004). It is a free port, does not operate any tariffs. There is no sales tax on art. Company registration is straightforward and company laws allow a wide range of commercial activity. An added advantage is that English is the chosen language for contracts. Hong Kong does not, as a rule, censor works of art imported and exported from the territory.

International business in South Korea is usually conducted in US dollars and payment often made in 100 per cent Confirmed Irrevocable Letters of Credit. An organization like the Small and Medium Industry Promotion Corporation (SMIPC) established by the Korean government in 1979, with offices in the USA, Europe, Japan and China, offering a range of business services, is testimony to the internationalization of the Korean economy. Import tariffs on art into South Korea are zero rated.

Public support for the arts

China's Ministry of Culture is a hindrance rather than a validatory mechanism to the development of cutting-edge art. With the exception of North Korea, China is the only state that officially supports a derivative of Socialist Realism. But there are at least signs of political ambivalence towards the selection of works in auction and art fairs, and to *huaxiao* or emigrant cutting-edge artists, as the government relaxes its hard-line approach to censorship.

Rather like the UK, Taiwan does not have a minister for culture, but instead implements policy through an 'arms-length' Council for Cultural Planning and Development (CCPD) with access to a sizeable art fund. Despite the recent art fair initiative the practice of arts policy is in the hands of museum directors, notably that of the Taipei Fine Arts, National History and National Palace Museums. There is, currently, political and professional discord between all three directors, but the cultural direction is Taiwanese and cutting-edge, endorsing the decisions of the Alpha galleries. Taiwan's de facto statehood make the acceptance of its culture on the international stage problematic. Yet, Taiwan, largely through the intercession of its top galleries, has introduced its artists to the outside world and Hung Tung and Ju Min while not being household names are internationally successful and distinctively Taiwanese.

The Hong Kong Arts Development Council (HKADC), an independent statutory body, has done little to promote the Hong Kong visual arts scene beyond small gestures such as the funding of experimental spaces like Videotage, and the financial support for Hong Kong artists to participate in the Sao Paolo and Venice biennales.

Seoul's city government worked furiously to prepare the city for the World Cup in 2002, bankrolling, among other projects, the establishment of Media City, a cutting-edge technological arts think tank. The Guan-ju Biennale has

also established itself on the East Asian cultural road map with support of the city's government, but in both instances budgets have been severely cut, suggesting that the political will is lacking.

Cultural and urban infrastructure

It is much easier for government to demonstrate its support for the arts through museum and gallery building programmes and city 'improvement' schemes than through creative and sensitive policy. The news that Mayor Wang Qishan is committed to building twenty new museums in Beijing in time for the 2008 Olympics[2] and that Shanghai is to construct ten a year over the next decade is superficially impressive. It mirrors the behaviour of South Korea prior to the World Cup, when the Museum of History and Museum of Art opened simultaneously in the capital. Both countries should beware the consequences of building museums and galleries before deciding on their content. Taiwan went through its only museum building boom in the 1990s and most recently opened the Museum of Contemporary Art (MOCA), but for years the visitor was presented with empty showcases. The overall impact of these institutions is a force for cultural good perhaps two decades down the line but tends to mask the destruction of the historic and urban infrastructure and the depletion of indigenous cultural traditions. This is why the utilization of a Japanese colonial period elementary school in a traditional neighbourhood of Taipei for MOCA and the maintenance of the 1927 façade of the former Japanese Supreme Court in Seoul for its art museum is encouraging.

The same belated sensitivity for the built heritage has not been shown by China, which has throughout the 1990ss and early years of this century set about wrecking what remains of the once great city plan of Beijing and the eclectic architectural mix of Shanghai. The city-state of Hong Kong, by contrast, while boasting far fewer cultural institutions has evolved, architecturally, in an organic way, so that the new complements rather than fights tradition. This is, in large part, a consequence of its colonial government and its humble architectural origins. In all cases the super-imposition of such Western and East Asian authoritarian government conventions as public sculptures – the turd in the piazza – has overlooked some of the great cultural Chinese traditions: stele inscribed with calligraphic poems, city gateways, natural rocks and formal gardens. The appropriate use of material and colour in architecture is perhaps most conspicuous by its absence in East Asia where 50 years ago it was an integral part of the cultural fabric.

Levels of cultural education

China's new urban élite is beginning to be serviced culturally by new lifestyle magazines and is being kept informed of cultural developments in East Asia and the West via the internet. Taiwan, with its premier collection of Chinese

art in the National Palace Museum, and its frequent loan exhibitions of Western art from Europe has perhaps the highest levels of cultural awareness in East Asia outside Japan. South Korea's modest cultural remains are pale imitations of China's and the absence of a permanent Seoul home for its imperial treasures further reduces the educational effectiveness of its institutions. The newly opened Samsung-owned Leeum Museum in Seoul goes some way towards improving this situation. Hong Kong, deprived of a great public cultural archive, also suffers from a lack of cultural awareness. The Asia Art Archive is, however, beginning the task of recording and collating information on contemporary Asian art. None of the cities have significant collections of Western Old Master, modern or contemporary art, although first-generation indigenous Western style artists are represented in their respective national collections. (See Figure 8.1.)

The East Asian art commodity

Chinese contemporary art is an international art market term used to describe works of art made by mainland Chinese-born artists. It ceases to be Chinese, to my mind, when the artist chooses to reside overseas. The work of American emigré, Gu Wenda, for example is now mainstream contemporary. By the same token, the works of Hong Kong resident, Wucius Wong, or Taiwanese citizen, Ju Min, are Hong Kongese and Taiwanese contemporary art respectively. The great *guohua* artist, Chiang Dai chen (1899–1983)[3] who emigrated to Taiwan with another great Classical master, Pu Hsin-yu, might be seen to have an ambivalent status, so closely was their inspiration drawn from Chinese culture. That is unless one accepts that Chinese culture was salvaged and nurtured on the island as fervently as it was destroyed on the mainland – so they became, in my view, Taiwanese artists.

The market likes to differentiate between the use of materials in particular, but also the degree to which work is imbued with a native spirit, and that usually means calligraphy or pen and ink work. The reality is that today's East Asian artists are either traditionalists or avant-gardists in the Western tradition. It may be the case that they play to certain perceived cultural strengths such as calligraphy for the Chinese, craft for the Koreans and naivity for the Taiwanese, but the commodities are best described as Western art with East Asian characteristics or, when made outside the region, as Western art.

The political dimension

Political and economic conditions of East Asia excluding Japan

An art market, as we have seen, does not exist in a vacuum. Systematic risk (see Warwick, 2000, p. 165), the risk inherent in the market place (Beta), cannot be diversified away, and art markets are as susceptible to Beta as any

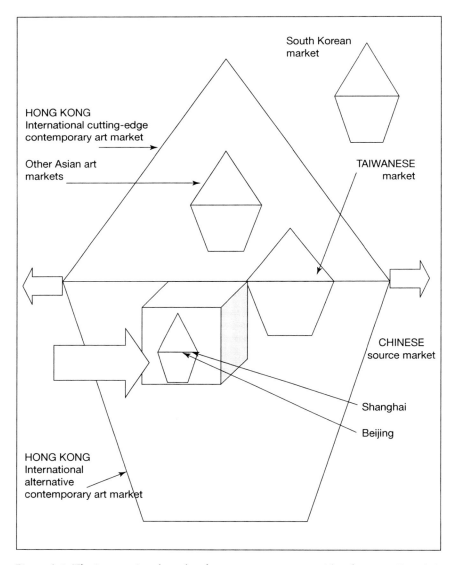

Figure 8.1 The international market for contemporary art with a focus on East Asia

The diagram depicts Hong Kong as the international clearing-house for East Asian contemporary art. It could be argued that a similar model with different participants has formed in Southeast Asia inside Singapore. There is, nevertheless, some representation of other, ethnically Chinese, Asian art in Hong Kong. Taiwan is a regional player without international reach and China as yet a local market, sourced by regional and international players. South Korea is stranded outside the Chinese world and remains a local market. Chinese contemporary art is disseminated by Hong Kong onto the international market for contemporary art, and sold on the art exchanges of Paris, London and New York. Increasingly, Hong Kong's intermediary position is side-stepped by international dealers who go straight to the source in China.

others. If the economy is underperforming, people have less money, they save rather than spend and businesses close. Regional security and national politics play a crucial role in the economic welfare of this region in particular and the consequences of instability have the effect of depressing consumer sentiment and consequently the perceived value of the region's contemporary works of art.

In 1996 I was one of many foreign nationals making hasty plans to leave Taiwan in the advent of a Chinese missile assault on Taiwan, until President Clinton mobilized the largest US force in Asia since the Vietnam War and defused the situation. America remains Taiwan's only ally, with the EU and France in particular taking a pro China stance as much to profit from that country's market as to cock a snook at America (Hille and Mallet, 2004). In August 2002 I was on my way to a small Yellow Sea Korean island when it was announced that North Korean marines had just killed a number of their South Korean counterparts in a maritime firestorm close to the island – reminding the world of an uneasy peninsular truce.

East Asia is a volatile political region. The revelations that Yongbyon, North Korea's main nuclear plant, had the capability to make plutonium and uranium grade bombs alerted Washington to the rogue state's threat to global peace. It led George Bush to declare North Korea a part of the 'axis of evil', thereby negating Kim Dae-jung's 'sunshine policy'. The recent impeachment of the current President, Roh Moo-hyun, has prompted Brian Coulton, Director of Asian sovereign ratings, to say, 'South Korea has become a political basket case' (Ward, 2003). If the country faces, as the Federation of Korean Industries fears, 'unpredictable economic and political uncertainties' (Ward, 2003), then consumer confidence will be affected. Uncertainties at home are also noticeable in the country's foreign relations. It is clear that Asia's fourth largest economy sees China as an (economic) threat as much as an opportunity and while its economy stalls, China's marches inexorably forwards. South Korea's relationship with the USA has also deteriorated in recent years and the uneasy (corrupt) partnership of its chaebols and political parties continues, prompting Andrew Ward to comment:

> While its newly industrialised economy gives the impression that South Korea is an advanced nation, a deeper exploration of its volatile democracy and corruption-scarred society show it to be a work in progress.
>
> (Ward, 2004)

The simmering dispute between the Republic of China on Taiwan, a de facto state, which China claims as its own, and the People's Republic, continues. The introduction of a new passport stating the island's name, and Taipei's aborted referendum for a new constitution, has added fuel to the fire (Hille, 2003). Following the botched 19 March 2004 assassination attempt on Chen and his subsequent re-election, the President plans to draft a new constitution

for a 2006 referendum to be enacted in 2008 when Beijing is due to hold the Summer Olympics. This, China believes, is a declaration of independence (Pan and Hoffman, 2004). Chen's confidence is backed by a rising tide of support for his party. Back in 2000 the DPP garnered just under 40 per cent of the votes. In 2004 Chen has the support of half the electorate (Chiang, 2004). The issue of Taiwan separatism is tied closely to China's perception that the USA is containing Chinese influence, a view that is reinforced by America's pledge to defend Taiwan against a Chinese attack. 'With the US navy already dominating the Pacific and with US troops still in Japan and South Korea; China does not wish to see a US encircling move into Central or South Asia that could ultimately result in China having to fight a two-front war' (Economist Intelligence Unit, 2003a p. 2). The Economist's report concludes that China would be very unlikely to attempt an assault on the island.[4] The effect of this political tension nevertheless infected investor sentiment and the TAIEX and NT$ both suffered significant falls. Seoul's composite index also dropped, fuelled as much by Taiwan's political insecurity as its own (Jopson et al., 2004) On the other hand, the events of 11 September 2001 resulted in the USA dropping its objections to China's WTO accession and a closer working relationship between the two powers over the fight against global terrorism. China fears 'splittism', which threatens the Communist nation state above all else, and the ethnic sympathy of the Uighurs in Xinjiang with the Turkic and Muslim peoples is considered a serious threat to this stability (Economist Intelligence Unit, 2003a). China's Han ethnic 'settlement' of the Western provinces is not perceived necessarily in a wholly negative light by the indigenous Muslim populations who are benefiting economically. In fact, neighbouring states like Kazakhstan view China as a friend and economic partner in what is becoming a benign Chinese regional economic hegemony (Bradsher, 2004).

Hong Kong, meanwhile, has struggled to retain its independence from Beijing, in the wake of new anti-subversion legislation (Mackay and Kynge, 2003). The Economist (Economist Intelligence Unit, 2003a) believes that Mr Tung, the territory's Chief Executive, has shown weak leadership since taking over the reins of power in 1997, undermining the former colony's economy. China's desire for a free trade area embracing China, Hong Kong and Macao, the Report explains, might threaten Hong Kong's free port status, unless Beijing drops China's tariffs. And while Beijing has allowed Hong Kong companies to buy stakes in Chinese banks and ports, China holds the power over controversial legal cases.

Art markets do not flourish under dictatorships, one-party states or command economies, which is why the erosion of the powers of Hong Kong's independent executive and legislature is so significant, as is the survival of Taiwan's and South Korea's fledgling democracies.

Economic position

As early as 2002, Richard MacGregor highlighted the advantages of a multi-national relocating its headquarters from Hong Kong and Singapore to Shanghai, making it easier for it to access Chinese import and export licences. Hong Kong's position as Asia's financial centre and conduit between East and West, has been further undermined since then by its structural fiscal deficits. On the other hand, Hong Kong has fared better than the information-dependent economies of Singapore and Taiwan and is sheltered by its growing integration with the mainland, no more clearly demonstrated than by the purchase of apartments in Hong Kong by mainland businessmen (Harney, 2003). With 70 per cent of Chinese exports to the USA passing through Hong Kong, the territory is still prospering in its role as China's window onto the world. The precious peg by which the HK$ is fixed to the US$ has not been challenged and the currency is therefore unlikely to depreciate. Hong Kong has also a very narrow tax base, which encourages foreign and local enterprise. The territory does not tax investment income or income earned outside, nor does it impose significant import duties.

Despite headline annual growth of between 7 and 8 per cent year on year since 1998, China's wealth is confined to Beijing, Shanghai and the eastern seaboard cities although there are signs that the hinterland is about to enjoy more of the coastal wealth.[5] Jiang Zemin's departing call for an expansion of the middle income groups[6] as part of a drive to quadruple the country's GDP by 2020, is the bedrock of a new policy which protects by law private property and legitimate non-work income.

The extent to which this new philosophy counteracts a technically insolvent banking system, chronic oversupply of goods, over-crowded cities and the spread of the HIV virus through a migrant work force lies at the heart of China's ascendancy, or not, to economic superpower (*Financial Times*, 12 December 2002). China's growing domestic economy may force the RMB to be re-pegged against a basket of currencies with a widening of the trading bands (Peyman, 2003) which may in turn negatively affect Chinese exports. China's reliance on fixed investment and the distribution of the majority of the country's assets to a small, well-connected political minority at the expense of the vast majority will, argues Andy Xie, chief economist for Asia Pacific at Morgan Stanley (2002), prevent a consumption boom. The new, alienated rich class are as likely to abscond with their assets if the economy contracts leaving behind an under-protected majority reliant on their meagre savings. It should also be borne in mind, according to James Kynge (2004), that China is rapidly denuding its natural resources, particularly water, and is consequently suffering environmental damage, which is affecting its industrial production. Cities like Shanghai are actually sinking under the weight of its buildings because of the overuse of underground water.

Two of the most important economic policy decisions in Taiwan were the easing of caps on Taiwanese investment in China and a softening of the rules

governing the repatriation of profits, resulting in growing economic integration between the two territories. Taiwan's accession to the WTO will, *The Economist* (Economist Intelligence Unit, 2003a, p. 18) believes, 'serve as a catalyst for closer economic links across the Strait'. At home, record levels of unemployment, a severely contracted stock market and falling earnings have dampened consumer demand. As a result the NT$ will remain weak to maintain export competitiveness, broadly tracking the yen.

Japan is the economic giant of Asia and the world's second largest economy and there are signs that it is pulling out of recession on the back of a global economic upturn. The yen showed a marked appreciation against the dollar in 2003/04. On the other hand consumer demand is depressed, the size of the economy has contracted by nearly 5.5 per cent since 1997, unemployment is at a post-war high of over 5 per cent and real wages have remained stagnant. There are also signs that despite a deep distrust and even hatred by the Chinese for their island neighbours, caused by China's perception that Japan has not apologized fulsomely for its war-time 'crimes', both are enjoying buoyant intra-trade relations. This situation is helped by the fact that the countries only compete in 20 per cent of third markets (Pilling and MacGregor, 2004). Lower interest rates in the USA and ultra-low rates in Japan are benefiting the heavily indebted Korean companies by lightening their debt-servicing burdens (Economist Intelligence Unit, 2003b, p. 4).

The strength of the Japanese economy and the other export-orientated markets of East Asia is strongly affected by US demand and economic performance (Economist Intelligence Unit, 2003b). Intra-regional trade is also important, and here, it could be argued, that China has an advantage over its non-Chinese neighbours with its satellite Chinese communities scattered throughout Asia. The ethnically Chinese-dominated city-states of Hong Kong and Singapore and the de facto country, Taiwan, act as natural trading partners and inward investors for the mainland. The flexible business-led nature of Taiwan make its democratic future and prosperity perhaps more certain than any of its East Asian neighbours, barring Japan.

Investments in the emerging stock markets of East Asia performed well in 2003 with China's vast consumer market and low manufacturing cost-base making it one of the world's most dynamic economies (Wyllie, 2003). Greater protectionism in the USA, a re-occurence of the SARS virus or a 1998 style banking collapse could undermine this buoyant situation. Memories of the bursting of Thailand's property bubble in late 1997, which sparked an Asian financial meltdown (although China and Taiwan were relatively unaffected), infecting the Russian economy as well, are foremost in the minds of most Asians.

The sheer speed of China's development (in the 1980s and 1990s it twice doubled its GDP – a feat which took Britain 60 and America 50 years, see World Bank, 1997) must raise questions about the strength of the economic models and their sustainability. Even a country such as South Korea, which has spent 50 years developing, has experienced economic trauma and more

recently political instability, so what of a megalith like China? East Asia (Japan aside) remains an exciting prospect for new art markets but one that suits the adventurous rather than the cautious.

Historical and critical dimension

East Asian contemporary art, and Chinese in particular, has suffered from a steady lowering of Western perceptions and has, as a consequence, steadily Westernized since the early days of the China Trade in the seventeenth century.[7] Even earlier (late sixteenth century) the scholar and missionary, Matteo Ricci, had commented rather condescendingly of Chinese art that it lacked the range and vitality and 'the superior quality of the foreign product' (Sullivan, 1973, p. 48). Chinese *Guohua*, until comparatively recently, was ignored by the West (Sullivan, 1973, p. 89) and the merits of Chinese art were firmly judged by Western consumers according to the ability of artists to, in great part, excel technically (see porcelain) and mimic Western proxies.

The Dutch merchants, through the *Verenigde Oostindische Comapagnie* (VOC), were governed by profit margins and consumer preferences. In the beginning (early seventeenth century) both were satisfied by high quality, sensitively decorated blue and white porcelain, known as *Kraakporselein*. The material, which was sold at auction in the Netherlands, appears in highly valued Dutch still-lifes by artists like Willem Claesz Heda and was set out on racks or set within glass-fronted cabinets in Dutch middle-class households. It was, in short, expensive and held in high regard. By the end of the seventeenth century and the beginning of the next, Chinese porcelain appeared in Dutch paintings as daily ware (Beurdley and Raindre, 1987; Haak, 1984). The change in status of Chinese porcelain in Dutch households was reflected in the market in two ways. First, in the specific nature of what was called 'the requirements' which by the 1740s took the form of European engravings with standard borders – the beginnings of standardization (Howard and Ayers, 1978) – which the Chinese were asked to copy onto porcelain. Second, in the vastly greater quantities of the commodity imported into Europe from the second third to the end of the eighteenth century. From 1602 to 1682 over 3.2 million pieces were shipped from China to Europe and from 1730 to 1789 this had grown to 42.5 million items.

The China trade continued into the nineteenth century but had already, by the eighteenth century, started to include a range of other products, such as oil paintings, but not the indigenous ink painting favoured by the literati. Reverse glass painting had been introduced into the trade in the 1750s and consisted mainly of landscapes and portraits. Decorative objects were created specifically for Western tourists throughout the nineteenth century until the United States Centennial exhibition in 1876 (Crossman, 1997, p. 19). Skilled Chinese painters, such as Spoilum, painted the portraits of Westerners or port scenes based on engravings for about $12 a piece (Crossman, 1997). One of the most famous, Lamqua, charged as much as $26.50 for a canvas

(Crossman, 1997), which was incredibly cheap in comparison to the prices charged for paintings by nineteenth-century Victorian artists. William Fane Salis's observation that Lamqua was 'the Millais or Ouless of South China' (Crossman, 1997, p. 89) was, therefore, faintly ridiculous. The greatest irony is surely that Western physical expansion into China during the high point of the treaty ports should be captured in the form of a six-set of the Western enclaves in oil on glass and in ceramic form by Chinese artists painting to order for Western buyers.

The Shanghai School, the international art market centre for China in the nineteenth century, and the art academies of the Republican period tilted the balance in favour of Western traditions in art by making art for Westerners and teaching Western oil painting techniques to a new generation of Chinese students.

It is interesting to note, therefore, how closely today's contemporary East Asian art criticism mirrors that of its Western counterparts. Open any catalogue of a cutting-edge East Asian artist and one is immediately aware of the shared ambitions and conscience (albeit acquired) of East Asian and Western critics. Criticism divides neatly into two forms, as in the West, the aesthetic complacency of the alternative market and the aesthetic vitality of the cutting-edge. The latter seeks to be a part of the international cutting-edge and national critics waste no time in asserting the global relevance of their artistic discoveries. Take this agenda-setting piece of commentary on one of China's premier 'Political Pop' artists, Wang Guangyi, from the well-known Chinese critic Li Xianting:

> The reaction of many was to turn against the heroism, idealism and yearning for metaphysical transcendence that characterised the 80s art movements, and to turn instead to their antithesis: an immersion in popular culture and a deconstructionist approach that, for several of these artist, resolved itself into Political Pop style.
>
> (Li, 1994, p. 5)

Sometimes the criticism reads like a desperate polemic, as in Hou Hanru's plea in MOMA's 1993 exhibition 'A Chinese Energy Plan, Silent Energy', for Chinese artists to be included among the international cutting-edge: 'The urgent need to construct a new critical framework in which it [the artworks] can be viewed: in this, the contributions of Chinese artists are as necessary as those from other cultures.' Contrast these pieces of prose with Lin Mu's description of alternative artist Huang Shan's 'Young Metropolitan girls' (1998): 'beautiful, fashionable and full of vitality and a youthful spirit. They have modern T-shirts, smart blouses and suits, small and exquisite shoes as well as fashionable hairstyles'. The same style of criticism for both types of art is replicated in Taiwanese, Hongkongese (see Robertson, 2000) and South Korean art catalogues.

The East Asian contemporary work of art asks the marketplace to consider it alongside Western equivalents but emphasizes regional characteristics that

are, it contends, uniquely its own. In China's case, much is made of the traumas of the cultural revolution and the rapid modernization of an ancient civilization. Chinese calligraphy is, in response, abstracted beyond intelligibility and traditional forms given a dose of colour or put through a technological blender to make the art appear contemporary. Taiwan's art is loaded with allusions to its unique (Nativist) history and politics, and South Korean devoted to the manipulation of natural materials. Hong Kong's art lacks specific characteristics. These artistic concerns, in the broadest sense, are a product of the political and economic regional realities and manufacture value for each territory's contemporary art.

Current price differentials between East Asian art and Western equivalents

The recent prices achieved by leading East Asian artists demonstrate, therefore, that the work may be over-valued, buoyed on a series of economic bubbles, favourable economic reports and a gold-rush mentality. There are still serious problems in China, of the oversupply of art onto the primary market, an under-stocked secondary market and limited international appeal for the product.[8] The Western cultural institutions have accepted a fraction of East Asia's cutting-edge art, with the Museum of Modern Art, Oxford, Fruitmarket, Edinburgh and Serpentine and ICA in London, for example, organizing exhibitions for the rising stars. But very little work has been accessioned into the bastions of contemporary international taste.

There are, I believe, opportunities for arbitrage or at least capital gains, because while contemporary Chinese art is at present more expensive on the international market than in Asia, other East Asian art has been resold at a profit in the country of origin. This suggests that the acquisition of contemporary Chinese art today in China from Alpha category galleries might, over a ten-year holding period, be resaleable in either Shanghai or Beijing on the secondary market. It also suggests that now is the time to buy South Korean and Taiwanese art before it is unaffordable. The developing art markets of Taipei and Seoul are more likely to add future value to their indigenous art, than those of Shanghai and Beijing are to theirs. So, there are as many reasons to wait and see what will happen to Chinese art in particular as there are motivations to consider a proportional investment in the commodity. (See Table 8.3.)

The process of arriving at an average price for an artist's work in Table 8.3 is complicated by the fact that each work is unique, and maybe of different size and material. The samples are also wildly different, which creates further imbalances. The fact that there are multiple sales outlets for East Asian art and that, apart from a very unsuccessful auction at Christie's London in 1998, and a much more successful one at Sotheby's Hong Kong at the end of 2004, much of the trading takes place outside the international art market – in local galleries and auction houses – making an accurate

Table 8.3 List of top prices for artists from Korea, China, Hong Kong, Taiwan, Japan, Europe, the UK and the USA (in US dollars)

Artist	Sample	Highest price		Lowest price	Average price
KOREAN ARTISTS					
Paik Nam-june (1932) (CE)	18	70,557	(91)	972	27,101
Chang Uc-chin (1918–90) (CE)	5	104,170	(SS02)	30,000	63,390
Kim Whan-ki (1913–74) (CE)	8	300,000	(SS00)	32,500	136,872
Park Soo-Keun (1914–65) (CE)	10	420,840	(SS02)	161,540	268,075
Chun Kyung-ja (1924) (AAM)	4	125,000	(SS02)	30,000	60,002

(Based on the results of three sales at the Seoul Auction House in 2000/01/02 except for Nam-june Paik whose auction price record was drawn from Cummings (2001, p. 191) Cummings draws average prices from Jan 1999–Dec 2000)

Artist	Sample	Highest price		Lowest price	Average price
CHINESE ARTISTS					
Zao Wou-ki (1921) (CE)	35	252,084	(TC98)	1,121	126,602
Wu Guanzhong (1919) (AAM)	41	210,386	(TC98)	6,396	108,391
Chen Yifei (1946) (AAM)	19	503,100	(HKS97)	41,630	272,365
Zeng Shanqing (AAM)	6	28,000	(Private Treaty)	3,000	17,458
Luo Zhongli (1912) (AAM)	6	41,860	(HKS97)	10,602	25,681
Wu Hao (1931) (CE)	11	25,781	(TS 92)	3,850	14,815
Liu Kuosung (1932) (CE)	9	31,204	(TC97)	7,059	19,131
Zhang Xiaogang (1958) (CE)	5	40,259	(Hanart 98)	3,048	21,477
Liu Wei (1965) (CE)	7	50,324	(Hanart 99)	3,321	21,428
Zhou Chunya (CE)	7	18,072	(Private Treaty99)	4,251	11,161
Yu Youhan (1943) (CE)	5	40,259	(Hanart 98)	12,077	26,168
Zhu Dequn (1920) (CE)	11	41,704	(TC98)	5,092	23,398

(Based on the results of auctions held between 1993 and 1999 at Sotheby's and Christie's Taipei, China Guardian, Beijing 1996–99 and Hanart TZ and Taipei 1993–99)

Table 8.3 continued

Artist	Sample	Highest price		Lowest price	Average price
HONGKONGESE ARTISTS					
Wucius Wong (CE)	4	19,178	(Hanart 94)	7,123	12,080
Luis Chang (CE)	4	16,986	(Hanart 98)	7,534	11,344
Diao, David (1943) (CE)	4	31,506	(TC98)	4,080	16,315

(Based on results of auctions held between 1993 and 1999 at Christie's and Sotheby's Taipei and Hanart TZ 1993–99)

Artist	Sample	Highest price		Lowest price	Average price
TAIWANESE ARTISTS					
Ju Min (1938) (CE)	11	83,280	(Caves99)	9,740	46,510
Chen Yin-hui (1931) (AAM)	3	85,937	(TS92)	12,489	39,469
Hwang Ming-chang (1952) (AAM)	8	75,815	(TS93)	15,819	45,817
Chen Tsai-tung (CE) (1953) (CE)	8	13,750	(TS93)	974	4,454
Yu Peng (1955) (CE)	5	4,285	(Hanart 98)	389	2,885

(Based on results of auctions held between 1993 and 1999 at Christie's and Sotheby's Taipei, Hanart TZ and Taipei and Caves between 1993–99; based on the results of Sotheby's and Christie's in Taiwan/Hong Kong 1993–1999 as well as the dealer sales of Caves and Hanart TZ and Taipei)

Artist	Sample	Highest price		Lowest price	Average price
JAPANESE ARTISTS					
Mori, Mariko (1967) (CE)	11	101,500		2,600	52,050
FRENCH ARTISTS					
Klein,Yves (1928–62) (CE)	86	6,100,000	(00)	514	3,050,257
SPANISH ARTISTS					
Picasso, Pablo (1881–1973) (CE)	1,370	104,000,000	(NYS04)	559	52,000,280
GERMAN ARTISTS					
Baselitz,Georg (1938) (CE)	43	1,000,000	(91)	1,149	500,574
Immendorf, Georg (1945) (CE)	24	193,993	(90)	526	97,259
Kiefer, Anselm (1945) (CE)	25	699,600	(95)	17,000	358,300
Schuette, Thomas (1954) (CE)	12	210,000		1,771	105,885

(continued)

Table 8.3 continued

Artist	Sample	Highest price		Lowest price	Average price
ITALIAN ARTISTS					
Clemente, Francesco (1952) (CE)	41	310,000	(94)	3,000	156,500
Paladino, Mimmo (1948) (CE)	38	225,000		371	112,685
Kounellis Jannis (1936) (CE)	30	1,058,940		1,548	530,244
BRITISH ARTISTS					
Auerbach, Frank (1931) (CE)	20	600,000	(90)	567	268,600
Gormley, Anthony (1950) (CE)	16	79,000	(99)	736	39,868
Kapoor, Anish (1954) (CE)	3	75,500	(00)	20,000	47,750
Hirst, Damien* (1965) (CE)	52	750,000	(00)	1,208	375,604
Hockney, David (1937) (CE)	155	2,000,000	(89)	576	1,000,288
Hodgkin, Sir Howard (1932) (CE)	23	584,600	(99)	3,200	293,900
Vettriano, Jack (1952) (AAM)	9	744,800	(04SScot)	15,500 (hammer)	188,595
AMERICAN ARTISTS					
Dine, Jim (1935) (CE)	63	600,000	(96)	850	300,425
Johns, Jasper (1930) (CE)	110	15,500,000	(88)	2,346	7,751,173
Kelly, Ellsworth (1923) (CE)	31	975,000	(00)	2,214	488,607
Nauman, Bruce (1941) (CE)	23	2,000,000	(97)	2,730	1,001,365
Serrano, Andres (1950) (CE)	37	162,000	(99)	3,017	82,508
Stella, Frank (1936) (CE)	77	4,600,000	(89)	3,000	2,301,500
Twombly, Cy (1928) (CE)	36	5,000,000	(90)	1,975	2,500,987
Koons, Jeff (1955) (CE)	29	1,650,000	(99)	792	825,396

Notes

* Hirst's prices do not include the $2 million paid to Gagosian gallery by C. I. Kim for 'Hymn' in 2001 or the 'reputed' $1.5 million paid for 'Charity' by the same collector.

AAM = alternative art market; CE = cutting-edge; HKS = Hong Kong, Sotheby's; NYS = New York, Sotheby's; SS = Seoul Seoul auction house; SScot = Sotheby's, Scotland; TC = Taipei, Christie's; TS = Taipei, Sotheby's.

assessment difficult. I have chosen recently deceased Korean artists because otherwise the sample of Korean contemporary art would have been practically non-existent. I selected Picasso (the most consistently expensive artist over the past decade) as a benchmark for all contemporary artists.

A selection of artists from both markets, alternative (AAM) and cutting-edge (CE), reveals that for East Asian art the prices are similar. Cutting-edge Taiwanese art tends to do less well at auction than alternative and there is a strong market for Chinese alternative art in Taiwan. Hong Kong and South Korean artists are the least successful at auction. The top end of both markets is dominated by Chinese artists.

When a pricing comparison is made between East Asian artists and the Western equivalents it appears that little has changed since the days of Lamqua and Spoilum. Deceased, first-generation Chinese oil painters like Chang Yu (1900–66) command high prices even by Western standards, but they are the exception rather than the rule. Taiwanese artists, overall, score higher than other East Asian artists particularly in the alternative market, but the only East Asian artists who approach the prices attained by leading Western (notably American) contemporaries are Wu Guanzhong, Chen Yifei and Zhou Wou-ki. This does not take account of major public commissions by Ju Min and Paik Nam-june, but does nevertheless show how great is the price gap between artists from the West and East.

The future of contemporary Chinese art depends on the development of a regulated indigenous national market, which is only possible once dramatic political reforms have taken place. Hong Kong's position as the region's only international art centre depends, in the interim, on China's genuine desire to make the one country, two systems policy work. Hong Kong artists, drawn from a small critical mass, are likely to remain in the shadow of their Taiwanese and Chinese equivalents. Taiwanese contemporary art would receive a boost if the island became a nation, able to represent its indigenous culture overseas, and it is difficult to see how else it might progress except within the strictures of its national market. South Korean art has perhaps the greatest opportunities for development, dependent on the desire of the government to improve the cultural infrastructure. It lacks the regional reach of Chinese art, with its extended and quasi-independent trading arms, but it might yet prove to be the region's star performer. For the time being, and over the short-term, Chinese contemporary art will grow in value at a faster rate than its regional competitors. Thereafter (post 2008), the East Asian regional art theatre might see dramatic changes.

Notes

1 Hanart Taipei has ceased street front trading and Galerie Pierre operates solely out of Taichung. Both are Alpha businesses.
2 According to the DTI's 'UK Trade and Investment', Beijing had 278 culture halls and 110 museums in 2001, although the quality is not commented on.
3 This, rather than Pinyin, was the artist's preferred transliteration of his name.

4 James Kelly's (Assistant Secretary of East Asian and Pacific Affairs) comment that the USA would do all that it could to help Taiwan defend herself against a Chinese attack differs significantly from an unconditional US willingness to defend Taiwan at all costs (*Financial Times*, 22 April 2004).
5 The 31 million strong city of Chongqing is expanding economically at a dizzy rate developing its river and road communications to the Yangtze River delta region (MacGregor, 2003).
6 China's middle classes are estimated to number about 200 million or 18 per cent of the population, a figure which could rise to 38 per cent by 2020. Home-ownership in Shanghai is now over 70 per cent (*Financial Times*, 12 Dec 2002).
7 Sullivan notes that a typical Chinese artist's studio in 1900 would have borne little resemblance to his Western counterpart's. A Chinese artist would have expressed surprise at the idea that his painting was not true to life and been scornful of the West's artistic obsession with scientific accuracy (Sullivan, 1998 p. xxvii). The Western influence on Chinese art was perhaps more immediately felt in the work of professional artists. China had an active art market from the Ming Dynasty (Clunas, 1997) and with the decline in court patronage and stagnation of Chinese art in the nineteenth century (Tregear, 1997), the Western influence began to assert itself.
8 I was surprised to see a number of galleries at the local Bologna Art Fair (2004) hold work by contemporary Chinese artists, suggesting that the international market is deeper than I say here. Work by these artists was not on display at premiere art Fair 'Frieze' (2003) in London, which may indicate a Beta dealer dimension to work that is considered Alpha in East Asia.

Bibliography

Barmé, G. R. (1999). *In the Red: contemporary Chinese culture*. Princeton, NJ: Columbia University.
Beurdley, M. and Raindre, G. (1987). *Qing Porcelain, Famille Verte, Famille Rose*. London: Thames & Hudson.
Bradsher, K. (2004). *New York Times*, 28 March.
Campbell, W. M. (1903, republished 1992). *Formosa Under the Dutch* (Originally, London: Kegan Paul Trench, Trubner & Co. Ltd), Taipei: SMC Publishing Inc.
Chang T.-Z. (1993). *Shedding the Burden of History, New Art from China: post 1989*. Oxford: MOMA Oxford.
Chang T.-Z. (1996). *Reckoning with the Past*. Edinburgh: Edinburgh Fruitmarket Gallery.
Chang T.-Z. and Decrop, J. M. (2002). *Paris Pekin*. Hong Kong: Asia Art Archive.
Chang T.-Z. and Navarra, E. (2001). *Made by Chinese*. Hong Kong: Hanart and Galerie Enrico Navarra.
Chiang, J. (2004). *Financial Times (USA)*, 26 March.
China Guardian (1994–2000) Auction house catalogues.
Clunas, C. (1997). *Art in China*. Oxford: Oxford University Press.
Crossman, L. C. (1997). *The China Trade*. Woodbridge, Suffolk: Antique Collectors Club.
Economist Intelligence Unit (2003a). *Country Report, China, Political Outlook for 2002–03*. London: Economist Intelligence Unit.
Economist Intelligence Unit (2003b). *Country Report, Japan, Economic Forecast for 2002–03*. London: Economist Intelligence Unit.

Haak, B. (1984). *The Golden Age: Dutch painters of the seventeenth century*. London: Thames & Hudson.

Harney, A. (2003). *Financial Times*, 2 September.

Hille, K. (2003). *Financial Times*, 28 June and 2 September.

Hille, K. and Mallet, V. (2004). *Financial Times*, 20–21 March.

Howard, D. and Ayres, J. (1978). *China for the West*. London & New York: Sotheby, Parke Bernet.

Jopson, B., Shellock, D., Mallet, V. and Hille, K. (2004). *Financial Times*, 23 March.

Jörg, C. J. A. (1982). *Porcelain and the Dutch China Trade*. The Hague: Martinus Nijhoff.

Krahl, R. and Harrison-Hall, J. (1994). *Ancient Chinese Trade Ceramics from the British Museum*. London: The British Museum.

Kynge, J. (2004). *Financial Times*, 26 March.

Li, Xianting (1994). 'Wang Guanyi, picture calendars', 22nd International Biennale of Sao Paolo, p. 5.

Lu, V. (1999). *Visions of Pluralism: contemporary art in Taiwan, 1988–1999*. Taipei: Council for Cultural Affairs and Mainland Affairs Council.

MacGregor, R. (2002). *Financial Times*, 29 November.

MacGregor, R. (2003). *Financial Times*, 23/24 Analyst.

Mackay, A. and Kynge, J. (2003). *Financial Times*, 8 July.

Pan, P. and Hoffman, D. (2004). *Washington Post*, 30 March.

Peyman, H. (2003). *Financial Times*, 2 September.

Pilling, D. and MacGregor, R. (2004). *Financial Times*, 30 March.

Robertson, I. A. (1993–2004). *Art Newspaper*, selected articles on Asian art markets.

Robertson, I. A. (2000). 'The emerging art markets of Greater China 1990–1999', unpublished PhD thesis, City University, London.

Sotheby's/Christie's Taipei Auction House catalogues 1992–99.

Sullivan, M. (1973). *The Meeting of Eastern and Western Art*. London: Thames & Hudson.

Sullivan, M. (1998). *Art and Artists of Twentieth Century China*. Berkeley: University of California Press.

Tregear, M. (1997). *Chinese Art*. London: Thames & Hudson.

Ward, A. (2003). *Financial Times*, 13–14 March.

Ward, A. (2004). *Financial Times*, 15 March.

Warwick, B. (2000). *Searching for Alpha. The Quest for Exceptional Investment Performance*. Chichester: John Wiley & Sons.

World Bank (1997). *The World Economic Analysis*, September. Washington, DC: World Bank.

Wyllie, A. (2003). *Sunday Times*, 28 December.

Xie, A. (2002). *Financial Times*, 26 March.

9 World taste in Chinese art

James Spencer

There are only in reality two nations, the West and the East.
(Napoleon in Thibaudeau, 1802)

Background and fundamentals

China looms large in the world of art, and ever larger. This should be no surprise to anyone. The reasons are fundamental. China not only represents around a quarter of the world's population today, it has always been a sizeable fraction of the total. China occupies some of the world's best and most fertile land and has cultivated much of it densely since early times. There are also great natural and positional disadvantages. Parts of China are prone to devastating earthquakes. Large-scale droughts are not uncommon. Most serious are the great floods that can inundate huge areas of the country. Chinese civilization first developed in and around the Huanghe River basin in the north. This river and its tributaries have caused massive floods. It has even changed course twice and entered the sea in a different place. Apart from great internal political upheavals, China has, until recent centuries, also been highly vulnerable to land attack by 'barbarians' on its long northern border.

This type of rich, or potentially rich, yet often insecure environment has played a part in moulding the character and habits of the Chinese people. Fundamentally, Chinese people were and are aware of the need to prepare for an uncertain future, to save, to store and to accumulate. From early times the need and the urge to organize, to work and to produce led to the Chinese becoming a highly skilful and industrious people. They learned how to exploit the natural resources of the country. For example, they became masters at casting bronze in the second millennium BCE and in the following millennium they also applied the same skill and dexterity to the technique and art of making lacquer.

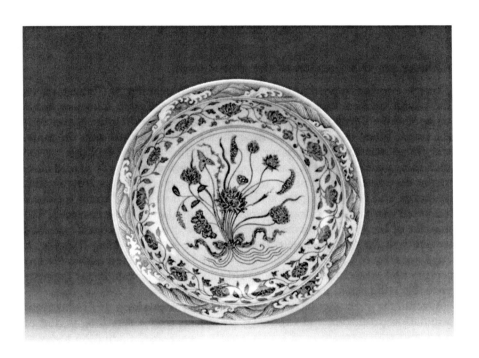

Plate 9.1 *Ming* dynasty blue and white porcelain dish of the Yongle reign, 1403–24
(Courtesy of the Chang Foundation, Taipei)

China's long monopoly in porcelain

Where the Chinese stand out most visibly from the rest of the world is in the field of ceramics. After more than a millennium of development, true porcelain (as distinct from pottery) was made in China by about the sixth century CE. It was not achieved in Japan until the seventeenth century, and not in Europe until the early eighteenth century. China was the only world source of porcelain for more than a millennium. In English the very name 'china' is another word for porcelain. Moreover, China has exported porcelain to other countries on a very large scale over a long period of time. It is therefore porcelain, along with earlier pottery, that has long been the leading category in the global market for Chinese art and remains so today.

Chinese art as a fraction of the global total

There is another important reason for the large quantity of Chinese art on the world markets today. In China, as in Ancient Egypt, a society based on agriculture developed in which the rulers came to hold great power over the ruled. When the rulers died, their tombs were furnished with the material things considered necessary in the afterlife. In the Neolithic period such things were limited in size and range. They were generally placed close to the deceased if not actually worn on the body. As China grew in size, resources and population, the scale, volume and variety of tomb furniture increased vastly. Tombs became 'underground palaces' of the deceased. The practice of burying the important dead with objects for the afterlife reached its zenith in the sixth and seventh centuries CE under the *Tang* Dynasty. A huge quantity of Chinese burial objects have been unearthed within the last century and now circulate on the world market, but an even larger quantity probably still remain underground.

Overall the phenomenon of a vast rich country with a large and industrious population producing and exporting art objects over a very long period of time, and with a tradition of lavish burials, has created a situation today in which Chinese objects of all kinds form a substantial part of the total number of non-modern 'works of art' on the world market. A crude estimate might be 10 per cent upwards.

Before examining the taste for Chinese art in different parts of the world, it is necessary to put it in a broad historical context, since it is by no means merely a modern phenomenon. We shall first look at the taste in Chinese art in the West, Japan, Korea, the Muslim world and Southeast Asia, then turn to what is perhaps the most important question for the future of the market, namely what is Chinese taste in Chinese art?

China's interaction with the West

In the Middle Ages Europe had no direct contact with China and only the vaguest notions about the country. Travellers' tales by Marco Polo and others only added to the glamour and mystique of 'Cathay'. However, a few examples of Chinese porcelain had reached Europe via the Middle East. They were regarded with wonder and highly treasured.

The Portuguese, foremost global navigators of the time, were the first Europeans to establish trade contacts with China. The earliest Chinese porcelain brought to Europe on Portuguese ships dates from about 1520. Trade expanded in the sixteenth century, especially after the establishment of the Portuguese settlement of Macao in 1557.[1]

Kraak porselein

Knowing little of the exact origins of the porcelain within China, the Dutch gave it the name *kraak porselein* (*kraak* being the Dutch version of the name of the type of Portuguese ship that transported Chinese porcelain). This name has remained to this day and is borrowed from Dutch for use in English too. It describes the blue and white porcelain, mostly dishes and bowls, that was produced in a very similar style from about the 1560s to the 1640s. Large quantities were produced, first for Portugal, then also for the Netherlands and other countries. When Chinese porcelain appears in Dutch seventeenth-century paintings, as it does not too infrequently, that porcelain is typically of the *kraak* variety. Quantities of this type of porcelain survive and it appears regularly in auctions in Britain and Europe.

Kraak porselein is an early and excellent example of the difference between Western and Chinese taste. The underglaze cobalt-blue designs on this type of porcelain are freely and often sketchily painted. The borders comprise petal-shaped panels. To Chinese eyes, then and now, *kraak porselein* is very ordinary. In the eyes of Europeans at that time the exact quality of the painting was less important than the fact that it was fine white-bodied porcelain, a precious commodity that could be acquired from nowhere but China. Many Western collectors would now agree with the Chinese opinion of *kraak porselein*, but at that time Europe knew little or nothing of the much finer Chinese porcelain that existed. In Europe *kraak porselein* was sometimes mounted in silver. Where they survive, early silver mounts are now more interesting and valuable than the porcelain they enhance.

The Dutch were the dominant players in the trade between Europe and East Asia throughout most of the seventeenth century, but they were joined by other European powers, most notably the English, who became the clear leaders in the eighteenth century. It should be remembered that the European trade with East Asia at this time was predominantly in tea, silk, spices, hardwoods and other commodities that were consumed or used and of which little physical evidence remains today. What does remain from this period of

trade between Europe and Asia is a great volume of Chinese export porcelain and a lesser but still significant volume of other Chinese export material, such as lacquer furniture, ivory carvings, tortoiseshell carvings, fans, silverware and paintings on glass and paper.

Transitional blue and white porcelain

In one respect the Dutch were far more fortunate than the Portuguese. Their period of dominance of the China trade coincided with the terminal decline in the power of the *Ming* Dynasty (1368–1644) in China. By the 1630s and early 1640s little or no porcelain was produced for the Ming imperial court. The best talents in China were employed in making porcelain for the domestic market and for export to the Netherlands and Japan. At this time a type of blue and white porcelain was made that we now call 'Transitional', because its style is between those of the *Ming* and succeeding *Qing* (1644–1911) dynasties. At its best, Transitional porcelain is far finer than *kraak porselein*. The subject matter is much more varied. It includes plants, animals, birds and human figures, typically in scenes from novels copied from woodblock prints.

Some of the fine Transitional blue and white porcelain exported to the Netherlands was in shapes specifically made to the Dutch taste, such as tankards and cylindrical vases. Some also had specific Dutch decoration in the form of tulips. However, much of the Transitional porcelain exported to the Netherlands was also broadly in the Chinese taste, or close enough to it to be acceptable in Chinese eyes. So, the situation now is that among the many types of exported porcelain, Transitional blue and white ware is one of the few categories that Chinese collectors might consider having in their cabinets.

Kangxi blue and white porcelain

In the late seventeenth century and early eighteenth century, as other European nations, especially England, joined in the China trade, the volume of trade increased and the variety of types of porcelain expanded greatly. A shipwrecked cargo, the *Vung Tau*, illustrates the European taste in Chinese porcelain of about 1690. It was an Asian ship, again probably bound for Batavia. It sank off the coast of Vietnam. From Batavia, the cargo would have been transferred to a Dutch ship and transported to the Netherlands. Among the cargo were quantities of Chinese blue and white porcelain vases, beakers, teapots, mustard pots and other forms of a distinctly European taste. There were even some porcelain wine cups in shapes that were obviously copied from European wine glasses. This cargo perfectly reflects the 'mania' for Chinese blue and white porcelain in Holland and England at that time, a time when the Dutch leader, William of Orange, also ruled as King of England.

This type of porcelain, still plentiful on the world market, is known as '*Kangxi* blue and white', after the name of the Chinese emperor who ruled from 1662 to 1722, the longest reign in Chinese history. It was exported to Europe in great quantities in the late seventeenth century and early eighteenth century. However, it subsequently went somewhat out of fashion. In the late eighteenth century and early nineteenth century, some of this blue and white porcelain was even over-decorated in Europe (especially in England and Holland) with other colours to 'cheer it up'. This practice is called 'clobbering'. However, the late nineteenth century saw a revival in Western taste for *Kangxi* blue and white porcelain. Artists and aesthetes, notably James A. M. Whistler, praised it highly and created a new demand for it. That demand was greater than could be met by existing 'antique' blue and white porcelain, so imitations of it were exported by China, especially to supply the rapidly growing American market. Fortunately for collectors today, most nineteenth-century imitations of earlier porcelain are easy to distinguish from the originals. Unfortunately the same cannot always be said of modern imitations, as we shall see later.

Famille verte *porcelain*

Until the late seventeenth century, blue and white porcelain formed by far the greatest part of the total of Chinese porcelain to exported to Europe. At about that time another type of decoration gained in popularity with European buyers. This type is called *wucai*, meaning 'five colours' in Chinese. Typical colours are green, red, yellow, blue and aubergine (non-vivid purple). In the nineteenth century French connoisseurs gave the name *famille verte* (green family) to the type, since green is generally the most dominant colour. *Famille verte* porcelain went out of fashion in the West in the 1720s, but enjoyed a revival in the late nineteenth and early twentieth centuries, when, as with blue and white porcelain, the original styles were copied in China. Significant quantities of *famille verte* export porcelain survive and circulate on the world market today.

Famille rose *porcelain*

In the 1720s *famille verte* decoration on porcelain was rapidly superceded by a more advanced type, called *fencai* (powder colours) in Chinese and *famille rose* (pink family) in French and English. On *famille rose* porcelain the colours and tones can be far more varied. What distinguishes it most easily from the earlier *famille verte* type is the presence of pink in the colour scheme, hence its name. Great quantities of *famille rose* porcelain circulate on the world market. In volume it is second only to the blue and white variety.

The period from the 1720s to the 1750s can be considered as the golden age of Chinese export porcelain. Increasingly affluent Europeans, especially

English, bought quantities of porcelain from China, including *famille rose* and other types of the highest quality. By this time the Chinese were adept at meeting the specific requirements of Western customers. European paintings and engravings were copied on Chinese porcelain, including most notably the works of Cornelius Pronk. Other Western requirements were dinner services painted with family coats-of-arms. The shapes of the soup tureens, sauceboats, salt cellars, and so on, of the dinner services were copied from contemporary European silverware or ceramics and were completely alien to Chinese taste. The Chinese potters simply copied them from models without necessarily understanding their use.

European coats-of-arms were also unknown in Chinese culture, so coloured drawings were sent to be copied. On one occasion the customer sent an uncoloured drawing with the English names of the colours written in the relevant spaces. What he got back was exactly what he sent, names of the colours painted his porcelain dinner service, not the colours themselves. This all emphasizes the point that the great Chinese export trade of this period was Chinese technology catering to the demands of Western taste. It had nothing to do with Chinese taste. Such Western taste was little understood and easily misunderstood by the Chinese.

Competition in porcelain from Europe and Japan

The great export trade in Chinese porcelain to Europe continued throughout the eighteenth century and into the nineteenth century, but it met increasing competition. Porcelain was first made in Europe by Johannes Böttger at Meissen, Saxony in about 1709, but it took several decades for the emerging European porcelain factories to compete with the Chinese in terms of quality and price, in spite of the great distance that separated the Chinese producers from their European customers. By the second half of the eighteenth century, however, European factories were becoming more competitive and as time went by some of them began to reap the benefits of the economies of scale that the Chinese had enjoyed all along. In the late eighteenth century the overall quality of Chinese export porcelain to Europe declined and this trend accelerated in the nineteenth century. Civil wars, especially the *Taiping* rebellion (1851–64), made conditions in China unstable. Furthermore, a serious new competitor appeared.

Following the *Meiji* restoration in 1868, Japan opened up to the West and quickly began to modernize. It soon produced porcelain for the Western market that was competitive in price and of higher quality than the Chinese. By the 1880s a typical 'oriental porcelain vase' sold in a European shop would be Japanese, not Chinese.

The nascent American market

The United States of America, having declared independence in 1776, developed direct trading links with China in the mid-1780s. The earliest Chinese export porcelain with specific decoration for the American market dates from this decade (Mudge, 1981). In the following half-century America soon grew to be a serious rival to Britain in the China trade. Although the export trade in Chinese porcelain was in long-term decline, it was still substantial. Moreover, other categories of Chinese objects were in demand in America, including lacquer, silverware, ivory carvings, fans and paintings (Crossman, 1991).

Overall influence of the Chinese export trade

Western perceptions of China changed during the long period of the export trade. In the eighteenth century China was often viewed idealistically as a peaceful well-organized country of skilful, industrious and polite people. Its styles were admired and copied, sometimes superficially, as *chinoiserie* in Western furniture, lacquer, ceramics and other media. In the nineteenth century more mixed views of China emerged. Album paintings of Chinese subjects on paper and 'rice paper' were produced in Canton to satisfy the curiosity of Western people about the country. The subjects include exotic birds, butterflies, insects, ships, scenes of manufacturing and selling porcelain, silk and tea, also different types of Chinese people, especially the mandarins of the nine ranks and their wives in their formal robes. In the later albums another subject often appears, tortures and punishments in various degrees of cruelty, according to the crime. By this time Western admiration of China's special qualities was also mixed with revulsion yet fascination with its darker side.

Overall the great export trade from China to Europe from the sixteenth to nineteenth centuries has left its influence on the current market in two ways. First, a high proportion of the Chinese objects that circulate in the markets of Europe and America are export objects of this type. Second, these numerous export objects have aroused the curiosity of Westerners about China in general and helped to maintain a taste for things Chinese. Many people in Europe and America have over time become accustomed to having Chinese objects in their homes, mainly but not exclusively in the form of china (porcelain). They have often developed a taste for certain types of Chinese porcelain, be it blue and white, monochrome or multi-coloured. Furthermore, an appreciation of the quality of Chinese export porcelain has sometimes aroused Westerners to go further and to collect seriously 'mainstream' Chinese ceramics and Chinese art in general.

China's interaction with Japan

Much of Japan's culture is native and unique, especially the *Shinto* religion at its core. Even so, the influence of Chinese culture on Japan has been profound. The Japanese adopted Chinese characters, which they call *kanji*, for writing their very different spoken language. The two countries, and Korea, all share Confucian values. Buddhism came to Japan via China. For centuries China was the only significant foreign influence on Japan, though part of that influence came through Korea and took on some Korean characteristics.

The Japanese are very conscious of the huge Chinese influence on their culture. As in the West, Japanese taste in Chinese art is expressed in, and now heavily influenced by, what was imported in earlier times. Early Chinese Buddhist art is popular in Japan. For example, the Japanese have played a leading role in studying and collecting Chinese Buddhist images of the fifth to eighth century CE. There are many such images in Japan, mostly in gilt bronze.

In some areas the Japanese have preserved elements of Chinese culture long after they have disappeared in the home country. This is most conspicuously true of women's dress. Styles of the *Tang* Dynasty (CE 618–907) are essentially still preserved in some traditional Japanese costume, a millennium after they have gone out of fashion in China.

Similarly, in the Japanese tea ceremony, tea is still prepared and served in the same basic way as it was in China about a millennium ago. Moreover, the Japanese imported quantities of Chinese ceramic tea bowls for the tea ceremony in the *Song* Dynasty (960–1279). Black-glazed bowls were especially popular, but celadon-green examples were also highly regarded. In Japan such *Song* Dynasty tea ceremony ceramics have been carefully preserved in their original Japanese wood boxes and handed down as treasures through the generations. Over time such boxes have been inscribed by successive tea masters. This gives the tea bowls far greater significance and importance in Japanese eyes. An original box with appropriate inscriptions can increase the monetary value of a bowl 20 to 50 times. For obvious aesthetic and commercial reasons, few if any such tea bowls with original boxes leave Japan. If they change hands at all, they do so within Japan.

Most of the Chinese ceramics imported by Japan in the *Song* Dynasty, including bowls for the tea ceremony, were similar to those used in China itself and reflect no basic divergence of taste. In the late *Ming* period, from about the mid-sixteenth century to the mid-seventeenth century, a new trend emerged. Porcelain was made in China specifically to the Japanese taste. An example of this is the mid-sixteenth-century *kinrande* group of bowls, vases and other vessels with gilt decoration over a coloured background, red, green or aubergine. In the early seventeenth-century there was a large export of porcelain, especially in sets of five dishes with blue and white or multi-coloured decoration. In the reign of the weak *Tianqi* emperor in China

(1621–27), a time when court eunuchs held effective power, little porcelain was produced for the emperor. Most of the porcelain of this period that has an imperial *Tianqi* reign mark was made for Japan and is in the Japanese taste.

Under the *Qing* Dynasty (1644–1911), Chinese taste began to diverge very markedly from Japanese. This is very obvious in the field of ceramics. Chinese ceramic technology developed to a climactic level in the late seventeenth and early eighteenth centuries. New and more sophisticated colours appeared, including pink, partly as a consequence of trying to achieve the same result as on European enamelled metalwork. In general there was an increasing perfection and formality. These trends did not appeal to Japanese taste. Under the *Tokugawa* Shogunate, Japan pursued a policy of isolationism from the rest of the world. Internally, Japanese taste was for more rustic and technically imperfect tea wares. Traditionally the Japanese have therefore shown very limited interest in Chinese porcelain produced after 1644. Another important factor in this was the rise of Japan's own porcelain industry in the seventeenth century, centred at Arita on Kyushu island. This eliminated the need to import the commodity.

In certain other fields Japan developed a Chinese art form to a more advanced level than was ever achieved in the home country. Lacquer and wood-block prints are good examples of this, but the most striking example is metalwork. In the *Samurai* military culture of Japan, up until 1868, great importance was attached to the quality of swords and sword fittings, especially *inro* (sword guards). In the pre-industrial era Japanese swordsmiths were the world leaders in making steel and they understood other metals too. The world market today reflects a huge divergence between China and Japan with respect to weapons and indeed anything to do with war. Many Japanese swords and sword fittings circulate on the market. A limited number of Chinese examples do too, but the majority of them date no later than the *Han* Dynasty (206 BCE–CE 220). While Japan developed a military culture, China, while recognizing the need for armies and a military hierarchy, essentially developed a culture in which things military had a low status. This is clearly reflected in the art, and taste in art, of the two countries.

As we have seen, Japan imported Chinese art objects, especially ceramics, from a much earlier time than did the West. Japan is therefore an important repository of Chinese art. Furthermore, Japan occupied large areas of China in the Sino-Japanese war of 1931–45, including Shanghai, then the commercial centre of the Chinese art market. This led to more Chinese art going to Japan, including important early bronze ritual vessels and funerary pottery. It also gave Japanese scholars better access to archaeological and other material in China. Their contributions in the field of Chinese art are considerable, especially in those areas where Chinese influence is most relevant to Japan, including Buddhist art, ceramics and lacquer.

In the 1970s and 1980s the Japanese were strong buyers of Chinese art on the world market. Their purchases well reflect Japanese taste. They ranged

over a wide area, including the categories we have already mentioned, namely tea ceremony ceramics, lacquer and Buddhist images. Japanese buying was characterized by an obvious focus on quality and a willingness to pay a premium for it. In ceramics, predictably, they bought little *Qing* Dynasty (1644–1911) material. However, they acquired some of the best *Tang* Dynasty (618–907) pottery vessels, especially those types that clearly influenced Japan's own art.

The current Japanese economic malaise that began in the early 1990s has severely reduced, but not eliminated, Japanese buying of Chinese art. However, it has caused some significant Chinese art, notably ceramics, lacquer and Buddhist sculpture, to come out of Japan on to the world market. Indeed, for the last decade Japan appears to have been a net seller of Chinese art, although much of that selling has been very discreet. There is little doubt that future Japanese interest in Chinese art will remain broad, with special focus on the traditional areas. Whether that interest and taste translates into buying more vigorously again will depend on the relative strengths of the Japanese and Chinese economies. Today, everything seems to favour the Chinese.

China's interaction with Korea

The influence of China on the adjoining Korean peninsular has been even stronger than on the islands that comprise Japan. For long periods Korea was even regarded as a tributary of China. In the early fifteenth century, for example, Korea was requested to send numbers of young girls and accompanying eunuchs to the court of the *Ming* Dynasty emperor *Yongle*, who had a taste for pale-skinned Korean women. Obeying that order put considerable strain on Korean society.

From China to Korea came Confucianism and Buddhism. Both became core elements in Korean society. Korean Buddhist images followed Chinese styles, but developed their own distinctive characteristics. The same can be said of other Korean art forms. In ceramics, Korea developed a very fine celadon (iron-green) ware in the twelfth and thirteenth centuries. Unlike its Chinese forerunners, it came to include inlaid decoration, usually in black and white. From the sixteenth century Korea made porcelain with underglaze cobalt-blue decoration in the Chinese tradition. In the early seventeenth century, Korean potters took the technology to Japan and initiated the Japanese porcelain industry.

It is only in the last two decades or so that the Korean economy has reached a level at which Korean buyers have been much evident in the world market, but their buying has been a clear reflection of their taste. Unlike the Japanese, they do not appear to have competed significantly at the upper end of the Chinese art market. Instead they have focused strongly on Korean art itself. The best Korean art is far more limited in quantity than Chinese or Japanese. When it has appeared on the market in optimum economic times, results have

astonished some outside observers. Some Chinese observers have been amazed at the high prices paid for the best seventeenth and eighteenth century Korean porcelain, because by traditional Chinese criteria it appears provincial, strange and technically imperfect.

China's interaction with Islam

Islam originated in Arabia in the seventh century CE and spread rapidly thereafter. In Central Asia it came into contact with Chinese civilization. Much of the Muslim influence on Chinese art can be traced back to the era of Mongol rule, the *Yuan* Dynasty (1280–1368). At this time the Mongols controlled much of Asia. Sea trade between China and Western Asia expanded. Muslim Western Asiatic merchants came and settled in China.

One result of this was a transformation in the Chinese porcelain industry. Cobalt was imported from Persia and used to create underglaze-blue decoration on fine Chinese white porcelain. The result was a product, 'Chinese blue and white porcelain', that is both beautiful and practical. It is beautiful because cobalt decoration under the glaze creates a sense of depth. It is practical because decoration *under* the glaze does not rub off. Moreover, unlike overglaze decoration, underglaze decoration requires no second firing of the porcelain so it is less expensive to make.

In Chinese culture blue is not an especially popular colour; red and gold are. The new product, blue and white porcelain, was at first considered vulgar, especially by the scholar elite. In the late fourteenth century attempts were made, using copper instead of cobalt, to make red and white decoration as attractive as blue and white. Copper, however, is far more difficult to control than cobalt, so for technical reasons it never really succeeded. The superiority of blue and white porcelain was clearly recognized in the early fifteenth century. It became the chief type of porcelain product made for the court and remained an important component in imperial ceramics until 1911, a good example of indirect Muslim influence on Chinese taste.

In certain Muslim societies another type of Chinese ceramics was especially valued, namely celadon ware, a stoneware with a soft green glaze derived from iron. There was a belief that the green colour underwent a subtle change when it came into contact with poison, hence the popularity of this type. The collection at the Topkapi Saray Museum in Istanbul is the best overall example of traditional Islamic taste in Chinese ceramics (Krahl, 1986).

Chinese influence in Southeast Asia

Chinese influence on taste in Southeast Asia is considerable. Porcelain was exported from China to the region in great quantities, especially from the thirteenth to the seventeenth centuries. This had a heavy influence on local ceramics, most notably in Vietnam and Thailand.

Many Chinese settled and prospered in Southeast Asia. They have come to play a very large role in the business of the region, even in those areas, such as parts of the Indonesian archipelago, where their numbers are proportionately few. In the former 'Straits Settlements' of Singapore, Penang and Malacca early Chinese immigrant men married local Malay women. Their mixed-race descendants are called *baba* (male) and *nonya* (female). From about the mid-nineteenth century to the early twentieth century China exported to them a type of porcelain specifically to their taste, a variant of the *famille rose* type, known as *nonya* ware, with highly colourful often crowded designs of plants, birds, butterflies and animals, typically with bright coloured backgrounds including turquoise, green, pink, yellow and brown.

In the Muslim parts of Southeast Asia, taste in Chinese art can be seen as part of the wider Muslim taste that we have already mentioned. In general, Southeast Asian taste in Chinese art reflects the ethnic and cultural mix of the region. However, the Southeast Asian collectors who are most active in the Chinese art market today are themselves predominantly Chinese in origin, so the following passages on Chinese taste in Chinese art also apply to them.

Chinese taste in Chinese art

Up until now we have looked at foreign taste in Chinese art, a taste that has been heavily influenced by China's main art export, namely porcelain. We now turn to the Chinese world itself, not just the People's Republic of China, important though that is, but to the whole realm of Chinese culture that includes Taiwan, Hong Kong and the great global Chinese diaspora, mainly in Southeast Asia, America and Europe. If foreign taste in Chinese art is rooted in history, the same is even more true of Chinese taste in Chinese art.

The influence of the literati (scholars and scholar-officials)

Until the fall of the last imperial dynasty in 1911, China was for centuries governed, under the emperor, by scholar-officials, chosen by competitive examinations. This elite group dominated the taste of the country. The ideal scholar-gentleman had certain 'accomplishments'. He painted, wrote poetry, play the zither (*qin*) and played 'go' (Chinese chess). In Chinese culture, the highest physical art forms are painting and calligraphy. These are called *meishu* (fine arts), as distinct from all other art forms, which are known as *yishu* (arts).

Chinese painting, and taste in painting, was not always dominated by scholars. Up until about a millennium ago, it was largely a separate activity, performed by artists and artisans who were outside the elite scholar circle. At that time Chinese painting was often highly colourful. After scholars took the lead in Chinese painting, they took it on a distinctive course. They

emphasized the essential quality of a work as an expression of the artist's inner feeling and eschewed unnecessary decoration, including unnecessary colour. They felt that the artist expressed himself in the way he used his brush, just as he did in writing Chinese characters. The quality of the brushwork is therefore critically important in a Chinese painting.

Traditional Chinese painting is normally on paper or silk. Black ink is the main medium of decoration. Quite often there is no other colour. When there is additional colour, it is typically limited and restrained. Landscape is the most important category, followed by bird and flower compositions, then various human, animal, insect and other plant subjects, including bamboo. In landscape painting, humans are relatively small and their buildings are modest. They are not allowed too great a part in the total. Nature must dominate, not man.

The traditional Chinese scholar-gentleman had a studio where he practised his accomplishments and received like-minded friends. The furniture of the studio, not least the furniture on his desk, was directly related to his activities. It included brushes (for painting and calligraphy), brush rests, brush pots, ink cakes (solid cakes of black ink), ink stones (natural stones for grinding ink), water droppers (vessels for adding water to make liquid ink), small boxes for red seal paste, and, most significantly, seals.

To this day seals are an important and distinctive part of Chinese culture. Where Western people use signatures, Chinese use seals carved with the name of the user. They are considered more reliable guarantors of authenticity, not only on paintings and calligraphy, but on everyday documents in business transactions. The Chinese scholar-gentleman had seals that were typically carved from a soft stone. Two of the most precious types are *tianhuang* (field yellow) stone from Fujian province and *jixue* (chicken blood) stone from Zhejiang province.

Another typical feature of a scholar's studio was a natural rock or stone, placed there for contemplation. 'Scholars' rocks' were chosen for their natural beauty and interest. Often they were given names, depending on their shape and character, such as 'cloud', 'dragon', 'pile of books', and so on. One especially favoured source of 'scholars' rocks' was Lingbi in Anhui province.

Within recent decades, there has been increased Western interest in Chinese 'scholars' art'. Even so, it is still predominantly the realm of Chinese collectors, especially in the case of seals. Their dominance is likely to grow as mainland Chinese collectors increase in numbers and purchasing power.

The influence of the imperial court

Until the founding of the Republic of China in 1911/12, the country was ruled by a succession of dynasties. Their imperial courts were huge, even by the standards of the largest Western courts, such as France or Russia. Requirements of the artisans in the Chinese imperial factories and workshops

were great. For example, in the year 1433, 443,500 items of porcelain are recorded as being ordered by the court, a colossal amount by any Western standards (Liu Xinyuan, 1989).

The result is that today a large quantity of Chinese imperially commissioned art still circulates on the world markets. Porcelain forms the largest category, but bronze, jade, cloisonné, lacquer and textiles were also produced in considerable numbers. Reign marks were first written regularly on imperially-commissioned items in the early fifteenth century. The practice continued, with some interruptions, through the *Ming* and *Qing* dynasties until 1911.

For Chinese collectors especially, an imperial item is generally more desirable than a non-imperial one. Moreover, an imperial item with a correct imperial reign mark is the most desirable. There are categories in which similar imperial items exist, some with and some without reign marks. Typically the items with reign marks are worth two to five times more than those without.

The Summer Palace

In the eighteenth century the Summer Palace, a great complex of imperial buildings, was constructed on the outskirts of Beijing. Among the many buildings were some in the European architectural styles of the period. They were lavishly furnished with objects, including porcelain, made in the imperial factories and workshops. The Summer Palace was sacked and looted twice, first in 1860 by the British and French, then again in 1900 by the 'Eight Allied Armies', the same countries together with Japan, Russia, the United States, Germany, Austria and Italy. Some of the contents of the Summer Palace survived destruction and went home with the victorious armies.

In Chinese eyes this cultural desecration was one of the worst examples of Western imperialism, but many Chinese people have a highly exaggerated view of the quantity of objects that were stolen rather than destroyed. Moreover, they often assume that the greatest loss occurred in 1900. In fact, among the limited quantity of imperial Summer Palace objects that reached the West, the majority are from the sacking of 1860. When they have appeared on the market, the great majority have been 'bought back' by Chinese buyers from Hong Kong, Taiwan and more recently mainland China. For Chinese people generally, a Summer Palace provenance invokes a patriotic urge to recover what has been painfully lost.

Jade

Jade is category that has traditionally been more highly regarded by Chinese than Western collectors. It is more than just a very hard type of mineral in Chinese culture. Jade is said to display and represent the 'upright qualities

of a gentleman'. The presence of jade in Chinese culture stretches far back into the Neolithic period, when jade was placed in the tombs of the important deceased, on or near their bodies. The use of jade as tomb material reached a climax in the Western *Han* period (206 BCE–CE 8), when the bodies of rulers were totally encased in suits of jade. Even the apertures into the bodies, the nose, ears, eyes, and so on were 'plugged' with jade. This was believed to preserve the spirit of the deceased and even to prevent the body from decaying physically. A jade cicada was placed in the mouth for rebirth and renewal.

Many Chinese people, men and women, wear a piece of jade somewhere on their body. It is believed to be beneficial to the body and the spirit. Its colour is also believed to improve as a result of close contact with human perspiration over a long period. The semi-mystical properties of jade are one reason why it has always been more treasured by the Chinese than anyone else. Another reason perhaps is the overriding importance Western collectors attach to dating art and the problem of dating jade.

Jade is a mineral of geological age. Unlike man-made materials, such as bronze and ceramics, whose ingredients and methods of construction are determined by man and change with the developments in his technology, jade is only carved by man. This makes jade easier to fake than most other categories of Chinese art. Some periods of jade have long given rise to dating difficulties, especially the 'middle' period in general, the tenth to sixteenth centuries or thereabouts. Archaeology in recent decades has thrown more light on this period, but the quality of fakes of these and earlier jades, including the Neolithic period, has increased markedly in recent years, to the point that even some of the most enthusiastic Chinese collectors admit that there is a general problem in this area. It is worth noting that major Western auction houses tend to avoid including early Chinese jade in their catalogues, unless there is a clear old provenance.

In the eighteenth century a type of jadeite was found in Burma that had a more brilliant green colour than anything previously discovered. It belongs to the jadeite category of jade, as distinct from the more common nephrite variety. This is the type now used in jade jewellery. It reflects a general divergence between Western and Chinese taste. For most Western people emerald (green beryl) is the most precious green stone. For Chinese, it cannot match the finest Burmese green jadeite for subtlety, 'depth' and 'warmth'.

Buddhist sculpture

Buddhist sculpture is admired and collected by both Western and Asian collectors, but there is often a different emphasis. Western collectors typically see a Buddhist sculpture as a work of art and value it according to its quality as such. They are more readily prepared to accept parts of a sculpture if they are beautiful, such as heads and headless torsos. For many Chinese collectors, Buddhist sculpture is more than just art. It is very important who the Buddhist deity is. Some deities are much more popular than others.

Guanyin, Bodhissatva of Compassion, is for religious reasons one of the most popular. Originally male, *Guanyin* has been portrayed mainly as female in Chinese Buddhism for the last millennium or so. In contrast, the ferocious deities of Lamaist Buddhism are avoided by many Chinese collectors. They also prefer images that are essentially complete. Missing details are acceptable, but headless torsos are not popular. Buddhist heads without bodies also have limited appeal to many Chinese.

Funerary items

Of all the Chinese items on the world market today, this author's estimate is that more than 98 per cent of those dating before CE 1000, and a diminishing proportion of later items, have survived by being buried. They have been unearthed much later, usually within the last century. Not all unearthed items were in tombs. Some were underground as a result of floods. However, it is reasonable to assume that the majority of early items that we see today do come from tombs. Moreover, the sole purpose of the early human and animal pottery figures that we see on the market today was to furnish a tomb. They were never intended to be seen again above ground. In fact the pottery from which they are made is not especially suited to everyday use. Lead-fluxed glazes are typically splashed on. Typically they run down the bodies and drip on to the bases of *Tang* Dynasty figures, such as horses and camels.

Funerary pottery has been a problem for many Chinese collectors. There is a strong tradition of not wanting anything at home that has come from a tomb. As a result, most of the best funerary items on the Shanghai market, up to 1949, were sold to Westerners and Japanese, including fine pottery horses, camels, human figures and vessels of the *Tang* Dynasty (CE 618–907). Although Chinese collectors are becoming far less traditional in their thinking about tomb items, there is still a preference for more pristine-looking material compared with what has unmistakable signs of burial.

Among Chinese collectors, there is still a greater aversion to items that have been buried more recently. Numbers of *Ming* Dynasty (1368–1644) funerary pottery human figures have appeared on the world market. Buyers have been mainly non-Chinese and mostly Western.

Notwithstanding traditional reservations about funerary material, Chinese collectors, including emperors, have long been fascinated by ancient bronze ritual vessels of the *Shang* Dynasty (circa sixteenth to eleventh century BCE) and *Zhou* Dynasty (eleventh century–776 BC). Indeed Chinese antiquarianism in this field stretches as far back as the *Song* Dynasty (960–1279), when copies of ancient bronzes were first made.

From a Chinese collector's point of view, ancient bronze vessels have the advantage that in general, unlike pottery figures, they were not made solely and specifically for a tomb. Typically they were used in the rituals of the living before being placed in the tombs of the dead. It should be remembered that

at this earlier time the practice of making quantities of human and animal images for tombs was still in the future. It was the actual servants, concubines and animals that went into the tomb with their master, not models of them.

For Chinese and non-Chinese collectors alike, there is one underlying uncertainty to be borne in mind when collecting funerary items, namely the great number of them that still remain under the ground in China. If in future such objects were to come on to the market in quantities, it could have a great impact on prices. This has already happened. In the 1980s quantities of funerary items, including Neolithic pottery, came out of China into Macao and Hong Kong. Prices of certain types fell by 50 per cent to 90 per cent.

Auspicious symbols

Irrespective of the category of art, there is one single factor that most clearly distinguishes Chinese from Western taste. It is the importance that Chinese people attach to symbolism. That is why so much Chinese art includes a relatively limited range of auspicious subjects. Symbols of longevity are the most numerous. They include cranes, deer, peaches, pine trees and the *lingzhi* fungus. Deer also represent official emolument. Fish, symbols of wealth, are abundant. Pomegranates symbolize numerous offspring, as do gourds, which represent the proliferation of descendants and of wealth.

The combination of magpies and plum blossom symbolizes happiness. It is a popular wedding subject. Pairs of fish represent husband and wife, with a connotation of wealth. Faithfulness and constancy in marriage are represented by a pair of Mandarin ducks. These ducks keep the same partners throughout life and the partners show every sign of mutual affection in their daily lives.

The combination of pine, bamboo and plum blossom is called 'the three friends of winter'. These three species retain or grow leaves in the cold season when other plants lose theirs, so they represent the friends that stay loyal in hard times when others do not.

Plum blossom represents winter generally and is one of the 'flowers of the four seasons'. Peony symbolizes spring, and also wealth and involvement in worldly affairs. As a beautiful flower coming out of a muddy pond, lotus in Buddhism is a symbol of purity in the midst of impurity. It also represents the summer season. Chrysanthemum denotes autumn, retirement and withdrawal from worldly affairs, so in some respects it can be considered the opposite of peony. These 'flowers of the four seasons' are often depicted together.

Certain creatures have somewhat opposite meanings in Chinese and Western culture. Bats are not considered auspicious in the West. If anything they are the reverse, but in China they symbolize blessings. Owls, symbols of wisdom in the West, are inauspicious in Chinese culture. They are generally associated with the dead. Few owls appear in Chinese art after the funerary material of the *Han* Dynasty (206 BCE–CE 220).

At our present time in history, perhaps the clearest example of opposite meaning is the swastika. In the West in general the swastika has taken on a very negative meaning since Hitler rose to power in the 1930s. In Asia, however, the swastika (or *svastika*) retains its ancient and positive meaning. It is a symbol of eternity. Many Chinese Buddhist images have a swastika at the breast. One difference is that unlike the Nazi symbols, Chinese swastikas can have their 'arms' pointing either clockwise or anti-clockwise. If there are two swastikas together, the arms may point in opposite directions.

In Western art dragons are monsters to be fought and killed by heroes, notably St George. In China the dragon is a symbol of great power, including the power to communicate between the earth and the sky, thus to bring rain and fertility. It was adopted as the symbol of the emperor and is therefore often seen on imperial porcelain, textiles, lacquer, furniture, and so on. Sometimes a phoenix, representing the empress, is shown with the dragon. From the fourteenth century onwards, imperial dragons were distinguished from all others by having five claws on each foot. Until 1911, no one other than the emperor was allowed more than four claws, on pain of death. It is not unusual to find objects, especially lacquer, with one claw cut off each foot of the dragon. Such objects passed out of imperial ownership before 1911 and their new owners were obliged to reduce the claws to four per foot.

Some of the auspicious symbols in Chinese culture are derived directly from the character and behaviour of the creature. The Mandarin duck is a perfect example of this. Many, however, are symbols only because in spoken Chinese the word for them sounds similar to the word for the thing they symbolize. Bats, for example, are *fu* in spoken Chinese. *Fu* can also mean 'blessings', so bats represent blessings. Chinese is a language of very limited sounds, so many ambiguities occur. Often a single spoken word can only be recognized in the context of the sentence in which it occurs. In written Chinese such ambiguities are overcome by using different characters. The characters for bats and blessings, for example, are not the same.

Ambiguity in spoken Chinese extends beyond single words and this gives rise to many auspicious combinations of various creatures and plants. The words for 'eagle' and 'bear' spoken together sound like 'hero', so the combination of an eagle and bear has that auspicious meaning. For a similar reason the combination of a monkey, horse and honeycomb means 'May you have rapid promotion'. There are many other examples.

The aforementioned auspicious Chinese symbols are only some of many, but they probably encompass more than half of all traditional decoration in Chinese art. This is because Chinese decoration is so heavily focused on what is auspicious. To the uninitiated Western observer, such focus may seem narrow and even boring, but there is no doubt that auspicious symbolism, correctly portrayed, greatly increases the desirability of any work of art in traditional Chinese eyes, and thus raises its commercial value. Conversely, if an attempt to depict an auspicious symbol is considered unsuccessful, it can have the opposite effect. For example, if fish, symbols of wealth, swimming

among water plants, appear to be dead or listless, when they are supposed to be alive and thriving, then an auspicious meaning can turn into an inauspicious one, namely that existing wealth is endangered.

Chinese taste in non-Chinese art

It is interesting and revealing to compare world taste in Chinese art with Chinese taste in world art. The Chinese name for China is *Zhongguo*. It means 'Middle Kingdom'. For centuries China considered itself just that, the centre of the world and of culture. All other people were considered to be peripheral and culturally inferior. China had no equal relations with other countries; they sent tribute to China. When foreign envoys were granted an audience with the emperor, they were obliged to kowtow to him.

This sino-centric view of the world has been under pressure since China's unhappy experience with the Western powers in the nineteenth century. Since the end of the empire and the founding of the Republic of China in 1911/12, China has treated foreign countries on the basis of equality. Nevertheless, sino-centricity is still evident in Chinese taste in other Asian art. Generally speaking, Chinese collectors have little interest in it. If they do take an interest in foreign art, it is more typically in Western art, especially the famous Impressionist and post-Impressionist painters. This contrasts with Japanese taste in art, which extends not only to China and Korea, but to Asia generally, especially the Buddhist and formerly Buddhist parts of Asia, in addition to Western art.

Fakes and forgeries today

Art world-wide has been copied and forged for centuries. Nowhere is this more true than in China. In recent years the problem has become more serious. Modern technology has enabled objects to be copied with far greater accuracy. Since the early 1990s especially, copies of various art forms have appeared from China of a quality that was previously unknown. This is particularly true of porcelain. The makers of these serious copies have been aided by having access to shards (broken fragments of the original porcelain) that have been dug up in quantities at the kiln sites.

The appearance of superb copies has raised serious concerns amongst Eastern and Western collectors alike. Provenance, especially tracing ownership back to the 1980s or earlier, has become all the more important in terms of the saleability of certain categories of Chinese art that are known to be forged to a very high standard. Fortunately there are still areas of Chinese art that appear to be unaffected by serious forgery.

Chinese art in the global auction market

The current auction markets in Europe, America, Hong Kong and China reflect the differences between Chinese and Western taste in Chinese art. More fundamentally, taken as a whole, they clearly indicate great differences in the quantities of types of art produced in China and the West. Whole categories of Western art are represented in Chinese art largely by very early or comparatively recent examples. Oil paintings appear in China only after its contact with the West. Silver, a significant category in Western art, is only numerically significant in China in the *Tang* Dynasty (CE 618–970). Chinese weaponry, as we have already seen, is not often seen dating from later than the *Han* Dynasty (206 BCE–CE 220). Medals and coins, as an art form, barely exist in China until relatively recent times. In contrast there are, as we have seen, large categories of art that are far more numerically significant in China than in the West, such as jade, calligraphy and 'scholar-related' articles in general.

The two main international auction houses, Christie's and Sotheby's, both hold regular auctions of Chinese art in Hong Kong, New York and London. The content of those auctions reflects the different tastes, and the purchasing power, of collectors and dealers in those places.

Hong Kong is now the leading auction market for Chinese art in general, including twentieth-century paintings. The best jade, including the finest jade jewellery, is normally sold there. So too are the best imperially commissioned items with imperial reign marks, including porcelain.

New York is the main centre for classical Chinese furniture (sixteenth to early eighteenth century) and for the largest and finest pottery tomb figures, especially those of the *Tang* Dynasty (CE 618–907). Interior decoration plays a role in this. Many Americans buy art to display in their homes, not to keep in a box, so it is important to them that the art fits well with their overall décor. Chinese classical paintings are also sold in New York. This has always been a difficult subject, as there are good old copies, sometimes nearly contemporary with the originals. It is one area of Chinese art where America is generally ahead of Europe, in part because it has attracted more of the affluent and educated Chinese emigrés since the communist revolution of 1949.

London was the leading global market for Chinese art, and art in general, until the 1970s. It is still important and is the leading auction centre for Chinese art sourced in Europe generally, including export art, especially porcelain. There is a general level of expertise in Chinese art, notably in ceramics, built up in London over decades, that does not yet appear to be matched in New York. This helps to preserve London's role.

Paris was the centre of the European art auction market up until the First World War of 1914–18 and it retained an important role for decades afterwards. However, its antiquated system of regulations and restrictions rendered it uncompetitive in the international art market that Sotheby's and

Christie's developed from around the 1960s onwards. Until that system was reformed recently, most of the Chinese art offered in Paris came from within France itself. It was limited in quantity and quality, but still significant. The Japanese auction market has traditionally been dominated by dealers and thus generally less accessible to outsiders.

Until recently the strongest Chinese buyers of Chinese art in the global market were Taiwanese, Hongkongese and others outside the People's Republic of China (PRC). Up to 2002 PRC buying had been growing in strength and range. In 2003 it took a leap forward as PRC bidders competed for many of the best and most expensive 'Chinese taste' objects in international auctions and won a good proportion of what they bid on. Moreover, PRC bidders did not confine themselves to major international auctions. They competed strongly in smaller European auctions, such as Amsterdam and Stuttgart.

For Chinese art the most interesting international auction development of recent years has been the rise of auction houses in the PRC itself, most prominently in Beijing, but also in Shanghai and elsewhere. The leading Beijing auction houses are China Guardian and Beijing Hanhai. Objects are already sent to PRC auctions from Hong Kong and elsewhere, because the prices for certain things are now higher there. The contents of these auctions are a clear indication of Chinese taste in Chinese art. They are similar to typical Hong Kong auctions in their focus on twentieth-century and contemporary paintings, jade, scholars' objects and imperially marked objects, especially porcelain. However, there is also more emphasis on classical paintings and on books. Laws prevent excavated objects from being offered in PRC auctions, but in any event those are the types of objects that would probably be offered in New York or London rather than Hong Kong if they were outside the PRC.

From an outsider's standpoint, the most serious drawback in PRC auctions is the restriction on the export of most of the better lots. Where export is prohibited, the lot is marked with an asterisk in the catalogue. This restriction only applies to lots that have come to the auction from within the PRC. It does not apply to lots that have come from outside the PRC and have undergone the correct import procedures. Export restrictions on lots are a serious but diminishing problem for PRC auction houses as local buyers become more and more competitive and some overseas Chinese buyers are prepared to buy and keep in the PRC. There is another much rarer category of lots in PRC auctions that is restricted to sale to museums within the PRC or to buyers on their behalf. This further restriction is announced by the auction house. It does of course severely limit the marketability of the lot.

Conclusion

Chinese taste seems set to play an ever larger role in the international market for Chinese art. Moreover, that taste is not static. It is becoming broader.

There are areas of the market that were once dominated by Western buyers in which Chinese buying is now stronger, such as funerary pottery and cloisonné enamel. That leaves Chinese export art, far removed from Chinese taste, as the main area in which western collectors seem least likely to be challenged in the foreseeable future.

Notes

1 Portugal monopolized this trade until about 1602/3 after which the newly created Dutch East India Company, *Verenidge Oost-Indische Compagnie* (VOC) rapidly came to dominate the business.

Bibliography

Carswell, J. (2002). *Blue and White Chinese Porcelain around the World*. London: British Museum Press.

Crossman, C. L. (1991). *The Decorative Arts of the China Trade*. Woodbridge, Suffolk: Antique Collectors' Club.

David, Sir Percival (1971). *Chinese Connoisseurship*, translation of the *Ko Ku Yao Lun*. New York: Praeger.

Garner, Sir Harry (1970). *Oriental Blue and White*, 3rd edn. London: Faber & Faber.

Howard, D. S. (1974). *Chinese Armorial Porcelain*. London: Faber & Faber.

Howard, D. S. (2003). *Chinese Armorial Porcelain*. Chippenham: Heirloom & Howard Ltd.

Jenyns, R. Soame (1965). *Later Chinese Porcelain. The Ch'ing Dynasty 1644–1912*, 3rd edn. London: Faber & Faber.

Krahl, R. (1986). *Chinese Ceramics in the Topkapi Saray Museum, Istanbul*, 3 vols. London: Sotheby Parke Bernet Publications.

Lee, S. E. (1994). *A History of Far Eastern Art*, 5th edn. New York: Harry N. Abrams Inc.

Liu Xinyuan (1989). *Imperial Porcelain of the Yongle and Xuande Periods Excavated from the Site of the Ming Imperial Factory at Jingdezhen*. Hong Kong: Urban Council of Hong Kong and Hong Kong Museum of Art.

Mudge, J. McClune (1981). *Chinese Export Porcelain for the American Market 1785–1835*. Newark, DE: University of Delaware Press.

Phillips, J. G. (1956). *China Trade Porcelain*. London: Harvard University Press.

Pope, J. A. (1956). *Chinese Porcelain from the Ardebil Shrine*. Washington DC: Smithsonian Institution.

Setterwall, A. *et al*. (1974). *The Chinese Pavilion at Drottningholm*. Malmo: Allhem Publishers.

Sheaf, C. and Kilburn, R. (1988). *The Hatcher Porcelain Cargoes. The Complete Record*. Oxford: Phaidon, Christie's.

Sickman, L. and Alexander, S. (1968). *The Art and Architecture of China*, 3rd edn. London: Yale University Press.

Strober, E. (1988). *La Maladie de Porcelaine: Ostasiatisches Porzellan aus der Sammlung Augusts des Starken [East Asian Porcelain from the Collection of Augustus the Strong*. Oxford: Phaidon, Christie's.

Sullivan, M. (1984). *The Arts of China*, 3rd edn. Berkeley: University of California Press.

10 The nature of supply and demand in the Old Master picture market

Alexander Hope

> It is clearly seen that the ravening maw of time has not only diminished by
> a great amount their own works and the honourable testimonies of others,
> but has also blotted out and destroyed the names of all those who have been
> kept alive by any other means than by the right vivacious and pious pens of
> writers.
>
> (Giorgio Vasari, *Vite*, 1568, revised edition 1996, p. 13)

Vasari's rather valedictory words on the masterpieces of the Renaissance,
taken from the preface to his *Vite*, still seem peculiarly relevant. It is after
all the truism most commonly observed of the Old Master picture market
that it is a finite field coming to the end of its fruitfulness. Observers have
repeatedly remarked on the decline in numbers of great masterpieces coming
to the marketplace, just two examples from newspaper reports of the sum-
mer 2003 auction season reading: 'With supplies drying up fast, [Old
Masters] remains the only major area of Western art in which newly dis-
covered works are seen in every important sale' (Melikian, 2003) and 'a field
where supply is ever dwindling and freshness to the market counts for every-
thing' (Moncrieff, 2000). Given this apparent fact, one might reasonably
expect from the laws of supply and demand that Old Masters would repre-
sent one of the most sought-after fields of the art world, characterized by
dramatic headlines and startling prices.

In reality, of course, this hardly seems to be the case. The range of prices
achieved for Old Masters in recent years is remarkably wide, extending from
a few hundred pounds to tens of millions, but the frequency of multi-million
pound valuations on individual pictures seems far lower than in the more
voguish fields of Impressionist and post-Impressionist art. One might,
therefore, be justified in wondering what it is that causes the finest European
works of art of half a millennium to be apparently overshadowed by the
oeuvres of a handful of artists from a (perhaps less than) hundred-year period
concentrated on France and its neighbours. There are few art historians who
would argue that that latter period surpassed *quattrocento* Florence or the
United Provinces in their Golden Age; many would contest the superiority

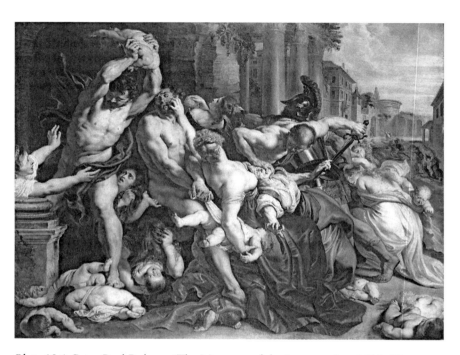

Plate 10.1 Peter Paul Rubens, 'The Massacre of the Innocents', *c.* 1611–12
(© Sotheby's, London)

of Degas, Monet and Picasso over their fellow-countrymen Watteau, Boucher and Goya. In the end, there is no objective answer, nor could there ever be, but it is still remarkable that the international art market should seem so decisively in favour of one period over the other.

A question of supply

The crux of the matter lies perhaps most of all in the above-mentioned supply problem. The general perception of that is, however, far too simplistic: a flaw that is hardly surprising when one considers the number of paintings produced throughout Western Europe from 1300 to 1800 (roughly the period considered by most art historians and professionals to represent that of the Old Masters). There is no known number even of artists within that period (indeed most remain anonymous, but Thieme-Becker's 1925 *Künstler-lexikon*, of which proportionally the greatest part was taken by Old Masters, consisted of 37 volumes), let alone paintings. However, every year some 5,000 such works appear at auction in the three largest houses alone, leaving aside the numerous regional companies as well as the unquantifiable number that pass anonymously through the hands of the art trade.

On the face of it, that statistic should strongly refute a pure supply problem. What it conceals, however, is the lack of works by the very finest artists from the field. When such a picture does appear, prices can reach parity with those achieved by the finest works of any period. So, for example, recent years have seen the sale at auction of such works as Rubens's 'Massacre of the Innocents' for £49.5 million, Rembrandt's 'Portrait of an Old Lady' for £19.8 million and Pontormo's 'Portrait of a Halberdier' for $32.5 million. Indeed, the first of those is, depending on the conversion rate, either the second- or the third-most expensive work of art ever sold at auction, after the $104.2 million achieved for Picasso's 'Garçon à la pipe' and the $82.5 million for Van Gogh's 'Portrait of Dr Gachet'; few, however, would number it among the very greatest of Rubens's works; it may be that equally few would regard Rubens, undoubted genius though he was, as the single finest of all the Old Masters – and certainly nobody would claim that he was the best by such a wide margin.

An equally popular candidate for that impossible election might be Raphael, the sale of works by whom presents a constructive example of the shortage of supply at the top end of the market. Very few pictures by the artists remain in private hands – no more than a handful of such are known – and in consequence the sale of one is a notable rarity. In 2003 a bid by the J. Paul Getty Museum was announced for his 'Madonna of the Pinks', then belonging to the Duke of Northumberland, for the sum of £32 million. Nor would many people necessarily rate that painting (whose prime status had been restored in 1991 after over a century of being regarded as a contemporary version) the very finest – or, at 29 × 23 cm, the largest – by the master. That price remains, however, the only public guide to the value of significant paintings

by Raphael; prior to 2003, the only realistic inference that could be drawn for such a calculation was the £5.2 million achieved for a single-sheet drawing by the artist: his 'Study for the head and hand of an Apostle', from 1516.

That such a price could be achieved for a drawing – even for one of such extraordinary sensitivity – can only be the result of a real shortage of supply of finished works. Such a situation is not uncommon: the world auction records for pictures by Leonardo and Michelangelo are also for drawings – £8.1 million each for the former's 'Study for a Horse and Rider' and the latter's 'Study for the Risen Christ'. In the case of the latter two artists, indeed, no paintings by either have been sold for over a generation: Leonardo's 'Ginevra de' Benci' to the National Gallery, Washington, DC, in 1967; Michelangelo not in living memory, if, indeed, ever (only two panel paintings by him are recorded, of which only one is known today). For Raphael, however, two paintings have also been sold relatively recently at auction (a 'Saint Catherine of Alexandria' in 1991 for $1.65 million and a 'Saint Mary' of Egypt' in 2000 for $600,000), both of which prices seem bewilderingly far from that of the 'Madonna of the Pinks'; neither, however, was in prime condition and – being early works (of *circa* 1503) – these are not prime examples of the artist's oeuvre.

That the condition of an object should so materially affect its value only exacerbates the problem of supply. Today's emphasis on condition is also relatively new, and has therefore arguably been one of the major contributing factors to the perceived drop in supply over the last two decades. The celebrated dealer Sir Joseph Duveen would have paintings restored to the point of the original surface hardly being visible, and his clients were not put off by a tendency to alter the appearance of a painting to suit prevailing taste.[1] By contrast, condition is nowadays a prevailing factor in the balance of supply and demand throughout the field: both restricting the supply of good quality works and reducing the demand for damaged pieces. The possibility that any object of between 200 and 700 years of age might be in poor condition is inevitably great. That said, pictures are hardier than is often supposed and can on occasion be astonishingly well-preserved; such a situation is, nonetheless, the exception rather than the rule and, where it is the case, the increase in value can be marked – for example with Rubens's 'Massacre of the Innocents' mentioned above, the sale price of which exceeded the previous record by more than 900 per cent.

It is impossible to gauge the proportion of works that remain in good condition, especially as that factor can realistically only be judged subjectively. However, the most common problems facing an Old Master, including pigment deterioration, flattening (normally caused by a poor re-lining of a canvas support), paint loss (whether from actual damage or natural flaking of paint from the support) and over-cleaning, are neither new nor rare. On the contrary, over time it is rare that a painting has not been imperilled by one such threat, and where these exceptions occur, it is often because the

support was a wooden or copper panel. Both were used by artists for the quality of the finish achieved; in addition, however, they – and in particular copper – are considerably more durable than canvas as a support, and in consequence, works painted on them tend to require less restoration. One may take it as a rule that the closer a painting is to its original condition, the greater its relative value, and, in particular, that of any work that has required minimal or no restoration.

Public collecting habits

Most of these factors should, however, apply more or less evenly to all Old Masters across the board. A further element, however, has over the last two centuries been exacerbating the shortage of top-quality works – the exponential growth in the proportion of great works of art in public collections. Museums frequently possess, or have access to, acquisition budgets greatly superior to those of private collectors; in addition, they have frequently been the beneficiaries of generous bequests. In recent years, these facts have only increased: so, for example, over the period 1990 to 2000, US museums experienced a 113 per cent growth in their endowments and, although the number of new acquisitions decreased by 16 per cent, the number of works of art received through donation increased by 50 per cent (Association of Art Museum Directors Survey, January 2002). The 16 per cent fall in acquisitions may seem contrary to the other figures, but, if taken as a reflection of the increasingly wide gap in cost between the finest works of art and the remainder – and the consequently fewer works that even a greatly expanded budget can cover – then the statistic becomes entirely logical. The inevitable concentration of these resources on the upper segment of the market has resulted in a further tightening of demand on that already pressured section.

Such institutional buying patterns would not necessarily further unbalance the market but for the permanence of their acquisitions. Largely until the twentieth century, the eventual re-appearance onto the market of great works of art could be more or less relied on. Certainly this might take a century or more, but the volume of works of art was large enough to accommodate the more permanent collections, even the greatest of which might one day be sold: one might for example cite the sale of such collections as those of King Charles I of England, the Dukes of Orleans, King William II of the Netherlands, the Spanish Gallery of King Louis Philippe, and the collection of the Dukes of Hamilton. Furthermore, within Europe the number of such collections was rarely as high as the sum of museums today; even more importantly, however, the contents of the collections was to a large degree considerably more patchy.

A case in point might be the collection of Cardinal Joseph Fesch (1763–1839), the uncle of Napoleon I and a collector of almost industrial proportions. In the entry on the Cardinal in the Grove *Dictionary of Art*, is written:

> According to the inventory drawn up at his death (Rome, Archv Cent. Stato), Fesch's collection then comprised nearly 16,000 works; the high proportion of copies and mediocre works. However, there were also many masterpieces, including Giotto's 'Dormition of the Virgin', Fra Angelico's 'Last Judgement' and Rembrandt's 'Preaching of John the Baptist' (all Berlin, Gemäldegalerie); Gabriel Metsu's 'Sleeping Hunter' and Nicolas Poussin's 'Dance to the Music of Time' (both London, Wallace Collection); and Mantegna's 'Agony in the Garden' and a Raphael 'Crucifixion' (both London, National Gallery) . . . The Grande Galerie, consisting of about 3,300 of the finest paintings in Fesch's collection, was sold at auction in Rome between 1843 and 1845.
>
> (Thiébault, 1996, p. 32)

This, then, was one of the largest collections of the nineteenth century; yet not only was a considerable proportion of it of little artistic merit, but also the greatest pictures within it were eventually put back onto the market, only for the majority of them to end up (including the examples given) in museums.

As the supply becomes ever tighter, so have prices become increasingly divergent. The figures by Art Market Research (see Figure 10.1) suggest a 136.4 per cent rise in value for the bottom 10 per cent of the sector compared to a 1,120.8 per cent rise for the top 10 per cent. Although these figures are hard to chart with complete accuracy, they demonstrate within reasonable parameters the remarkable divergence within the market. As time progresses, one would expect the trend to continue, tempered only by the relative nature of the market sections. If one were able to isolate those works that might reasonably be described as masterpieces of international stature, and then to chart the prices of such a finite list, then one might expect even greater polarization.

Figure 10.1 Old Masters 100 Index – nominal terms

Laws affecting the flow of Old Masters onto the market

A further consequence on the open market for Old Master pictures is the effect on sales of export restrictions from many of the most significant markets within the field. Most European countries retain some degree of control over cross-border movements of works of art, and these vary in extent from the lightest – for example Belgium and the Netherlands – to the most draconian, including among the latter group the majority of East European nations, which in effect entirely prohibit the export of antiques. For Old Masters, perhaps the most significant controls are those imposed by Italy and Spain: the former country was, of course, home to many of the most important schools of painting in history and which therefore, despite extensive foreign buying in the eighteenth and nineteenth centuries, still retains an extraordinarily important and extensive artistic patrimony. The latter, by contrast, realistically fostered no school of comparable quality, but instead raised many individual artists of outstanding personal genius, the relatively low popularity of whose works (and in particular of the more severely Counter-Reformation artists) among international collectors for long resulted in a remarkable proportion of their works remaining in Spain by the time export restrictions were introduced.

Due to the regulations of those two nations, it is extremely rare for owners of high-value works of art to be able to take such objects out of either country. There is no specific financial level but in Italy, for example, any work of art of more than 50 years of age requires an export licence in order to leave the country. Strictly speaking, the government can refuse such a licence, and thereby stop a work of art going overseas only if it is of national importance. In practice, however, many such applications for even works of relatively minor artistic significance, particularly if of Italian origin, are refused; for works of greater importance, refusal is almost inevitable. This clearly has a greatly detrimental effect on such a work of art's value, effectively restricting its sale to residents of that country who have no desire ever to move it abroad. It is not possible precisely to quantify the financial loss, as each case is individual to itself; it is, however, interesting to note that the highest price for an Old Master achieved at auction in Italy in 2003 was €835,550 ($976,000) for a painting of 'A Sibyl' by Guercino, whereas the most expensive sold internationally was $28.6 million for 'The Descent into Limbo' by Mantegna. The two paintings may not in themselves be comparable, but nonetheless the Guercino price, paid for a work of extremely high quality by the artist, would represent a medium-level sale rather than a top of the range one on the international market: the overall auction record for a painting by Guercino is almost double, at £1.22 million ($1.86 million), indicating the price level to which major works by the artist can rise.

Those export restrictions were introduced in 1933 by Mussolini. Since then, most significant works of art to have entered the country have done so on temporary import licences, thereby avoiding the ability of the government

in question to impose any control over any subsequent export. There remains, however, an extraordinary quantity of privately owned art in Italy under these controls. This has inevitably resulted in a degree of preservation of the art markets within those countries, particularly in private sale areas, be it through art dealers or auction houses. This has come, however, at the cost of the size of that market – in comparison, for example, with London, New York or even Paris. So, for example, when the Florence Biennale Art Fair was first established in the 1960s, it was a considerable event on the international art market, attracting large numbers of international dealers, 120,000 paying visitors and another 40,000 guests – this in comparison with the largest such art fair in Europe nowadays, in Maastricht, which attracts in the region of 70,000 visitors. By 2003 its importance in the art market calendar hardly compares with the numerous more international fairs, Italian dealers comprising 71 of the 85 exhibitors and disadvantaged in comparison with their international competitors bringing their stock in from abroad on temporary import licences.

National concerns over the export of art, and the implementation of measures to control them, are not new, nor are they in themselves unjustifiable. The collections of art in the UK at the end of the nineteenth century, for the most part the result of patterns of collecting among the British aristocracy during the eighteenth and nineteenth centuries, were perhaps the greatest overall accumulation of Western art ever known. By the end of that period, however, falling agricultural incomes and rising taxes threatened the great estates and houses to the degree that contemporaries began to fear for the nation's accumulated heritage. This potential reversal of the flow of art treasures from the country was noted by *The Times* as early as 1884, urging the purchase by the National Gallery of twenty-three pictures being sold by the Duke of Marlborough for the remarkable sum of £400,000: 'the tide has set in a contrary direction, but not as yet in overwhelming force. The nation must make up its mind to buy the treasures or see them lost forever.' Although a great deal has subsequently been sold abroad from the UK since that call, the fact that so much of its artistic heritage remains within the country, while at the same time it is home to the second largest domestic art market in the world, suggests that some degree of balance between heritage and economics is achievable.

That balance is the result of some of the most sophisticated structures in the world yet established for the regulation and acquisition of works of art, and an examination of the main elements gives an insight into the variety of controls that can affect the otherwise free working of the art market. Export licence applications for any Old Master (or any work of art of more than 50 years of age) worth in excess of £91,200 (for export beyond the EU; for export within the EU, £180,000) must be referred to Expert Advisers, who consider the applications against three criteria (the 'Waverley Criteria'):

1 Is the item so closely connected with our history and national life that its departure would be a misfortune?

2 Is it of outstanding aesthetic importance?
3 Is it of outstanding significance for the study of some particular branch of art, learning or history?

If an Expert Adviser believes an item to meet any of those criteria, they refer the export licence application to the Reviewing Committee on the Export of Works of Art, which may recommend that ministers defer the decision on granting the export licence (such recommendations are in practice always followed). The deferral of the licence is designed to allow an offer to be made by the nation, at or above the recommended price, and provides UK institutions and private individuals with an opportunity to raise the money to support such an offer. The deferral period can be extended where there is a serious intention to raise funds with a view to making an offer to purchase. If the vendor rejects an offer at the fair market value of the item, the export licence will be refused. If no such offer is forthcoming, the licence will be granted at the end of the deferral period.

In addition to these export restrictions, however, there are fiscal measures that have been established in order more effectively to enable the British government both to restrict the frequency of appearance on the market of works of art judged to be of national interest as well as, when such an event does occur, to maximize the possibility that the nation might acquire it. The main such structures are the systems of Acceptance in Lieu, Conditional Exemption and tax exemption for private treaty sales, which are defined by the government as follows.

Acceptance in Lieu

The Acceptance in Lieu scheme enables taxpayers to transfer works of art and other heritage objects into public ownership in the place of inheritance tax. The Inland Revenue may, with the approval of the appropriate minister, accept such works in payment of tax. These items must be 'pre-eminent', which in practical terms is taken to mean of particular historical, artistic, scientific or local significance, either individually or collectively, or associated with a building in public ownership, which will be expected to have public access for at least 100 days each year.

Conditional Exemption

Conditional Exemption from inheritance tax and capital gains tax is available where qualifying heritage assets are given public access. Conditional Exemption may be claimed for heritage assets that are judged to be pre-eminent, provided undertakings are given by the owner to:

1 preserve them and keep them in the UK;
2 secure reasonable public access to them (some measure of which must be 'open access' – without prior appointment);

3 publicize the availability of such access and the terms of the undertakings.

Tax exemption for private treaty sales

Sales by private treaty of works of art that qualify for Conditional Exemption are exempt from inheritance and capital gains tax. It is a longstanding policy that the price paid by the purchasing institution should not be reduced by the full amount of this tax saving but should instead be adjusted to leave part of the benefit (known as a '*douceur*') in the hands of the seller. This division usually allows them 25 per cent of the tax saving, with the remaining 75 per cent going to the public institution in the form of a price lower than would have been paid on a fully taxable sale. So, for example, if in order to settle an inheritance tax liability, an estate sells a painting valued at £100,000 on the open market, it generally has to pay further inheritance tax at a rate of 40 per cent on the proceeds of the sale (i.e. £40,000) and thus receives a net sum of £60,000 with which to settle its original tax liability. If, however, the painting is offered in lieu, 25 per cent of the tax that would have been payable on the sale (i.e. £10,000, being 25 per cent of the £40,000 tax payable) is credited to the estate. The vendor, therefore, would receive £70,000 rather than £60,000 after inheritance tax, an improvement of 17 per cent.

There are, in addition, provisions established for tax relief for both individuals and businesses for gifts of money, shares and land or buildings to charities. In practice, however, this third structure rarely has a noticeable effect on artistic institutions.

Resource's Acceptance in Lieu (AIL) Report 2002/03 describes a remarkable array of heritage items that were acquired by the nation in the year ended 31 March 2003. £15.8 million of inheritance tax was written off during the year to acquire works of art that were valued at almost £40 million. The range of items acquired is immense: Titian's celebrated 'Venus Anadyomene' (although there was a very substantial 'hybrid' element in that case, as the value of the painting was considerably higher than the amount of tax payable and other parties contributed to make up the difference), a Van der Ast still life (the first painting by the artist to enter the National Gallery in London), a still life by Roelant Savery, watercolours by Edward Lear, a sculpture by Barbara Hepworth, a sculpture of a ram from Ancient Egypt, Ancient Egyptian and Roman sculptures from Imperial Rome, and Chinese ceramics from the sixteenth century onwards. It is normally the case, however, that the financially most important among such acquisitions are paintings.

Successful though such policies have been for preserving national heritages, for the art market, their inevitable result is further to reduce the supply of high quality works. Historic sales such as those of, for example, Hamilton Palace, Stowe or Fonthill would now seem impossible given such carefully

designed fiscal policies; formerly, however, it was precisely such sales that provided the recurrent inputs of the highest quality works on the market during the eighteenth and nineteenth centuries that were largely to establish the secondary market in the structures that exist today.

Scholarly opinion

One area that has changed considerably since those days – and even in comparison with relatively recently – is the accuracy of attributions. This, of course, is one of the most significant recurrent complications in the field, and – as scholarship progresses and continually refines its conclusions – one that becomes ever more prominent in defining the nature of the market. There is no question that one of the primary factors in the apparently boundless supply of great Old Masters in past centuries was the fact that many of the attributions were highly optimistic: so, for example, Sir Joshua Reynolds's executors believed his estate to include a truly prodigious group of 44 Michelangelos, 24 Raphaels and 12 Leonardos. Perhaps the most celebrated case in recent years has been the field of Rembrandt studies. Although itself not without controversy, a panel was established in 1968 entitled the Rembrandt Research Project, whose object was to examine Rembrandt's painted oeuvre and to compile a critical catalogue of his paintings. There was a need for such an undertaking since the image of Rembrandt's work had been distorted by numerous over-ambitious attributions, a process that had already begun during Rembrandt's lifetime. Of a planned five volumes, three have been published, covering the years 1625 to 1642; the artist's output in his later years to 1669 remain uncovered, and yet in spite of that, of the approximately 1,000 paintings covered, some 750-odd works have been rejected.

The Research Project aimed at analysing Rembrandt's work through a variety of methods, including stylistic, technical and archival analysis (although the team involved were experts in the former field only). Paintings were examined by members of the team operating in pairs, initially by eye only (and in many cases it was never possible subsequently to examine the work more methodically), and subsequently where possible by scientific analysis, including through the use of X-ray, infrared and ultraviolet examination, dendrochronological analysis of the support (where relevant), canvas analysis, and physical and chemical analysis of the ground and paint layers. The difficulty of attribution, however, is noted by the fact that ultimately scientific analysis can only assist in that process, the final judgement still having to be made on the basis of connoisseurship. As noted by the Research Project, even if all Rembrandts were to be subjected to thorough scientific investigation, a decision on their authenticity would rest mainly on considerations of a very different kind (Stichting Foundation RRP, 1982). The frequent impossibility of certainty in those considerations is reflected in the division of the works considered into three categories: A, defined as 'Paintings by Rembrandt'; B, defined as 'Paintings Rembrandt's authorship of which

cannot be positively either accepted or rejected'; and C, defined as 'Paintings Rembrandt's authorship of which cannot be accepted'.

Yet even under this exhaustively careful system there have been disagreements and subsequent revisions: perhaps most notably the 'Portrait of Rembrandt as a young man with a gorget' in the Mauritshuis, The Hague. This picture, traditionally regarded as a masterpiece by the artist and accepted by the Research Project under their no. A21, was described as:

> a well preserved painting . . . that to some extent stands alone among the works from around 1629; there can be no doubt as to attribution and dating in that year, on the grounds of various detail features and of its overall high quality.
>
> (Stichting Foundation RRP, 1982, p. xiv)

Under copies of that work was listed a work in the Germanisches National-museum, Nuremberg, described as:

> a very faithful copy, datable in the seventeenth century . . . this is of relatively high quality yet has unmistakable weaknesses, most evident in the neck area.
>
> (Stichting Foundation RRP, 1982, p. xiv)

However, the 1999 exhibition 'Rembrandt by himself' at the National Gallery, London, and the Mauritshuis, enabled the two paintings to be placed side by side and thereby confirmed, as was subsequently supported by technical evidence, a controversial view first voiced in 1991 (Grimm, 1991, p. 208) that the Nuremberg painting was actually the original and The Hague picture the copy. The fact that such a revision could occur today even to what was supposedly one of Rembrandt's most famous works amply reveals the pitfalls of attributional work.

Not every one of those works rejected by the Research Project has in the past been sold, or offered for sale, as an autograph work by Rembrandt, but the great majority have been so regarded. That this is so is not particularly surprising when the artistic training and thought of the period is considered. It is a relatively modern phenomenon to believe it unworthy of a great artist to paint in the style of another; the majority of Old Masters, taught and trained through apprenticeship and in workshop practices, did precisely that throughout their careers, with only nuances of style and technique to distinguish them from their peers. When on occasion a figure of artistic genius appeared on the scene, it was not uncommon for him so overwhelmingly to influence his contemporaries as to create a school whose output can be relied on to be confused with that of the master for centuries to come. Indeed it is not just the Caravaggios or Rembrandts who have had such an effect, comparatively minor figures have also: one might, for example, consider the Haarlem school of landscape painting, where a whole generation of painters

were so enormously influenced by the work of Jan van Goyen and, to a lesser degree, Pieter Molijn – both highly able landscapists but not necessarily regarded as geniuses – as to make their combined oeuvres at times virtually indistinguishable from one another.

When one considers that the majority of the oeuvres of the greatest masters have been so conflated with those of their pupils and followers, and that it is for the most part only since the twentieth century – and in some cases the later twentieth century – that they have begun to be separated, it is hardly surprising that there are fewer masterpieces available. This is, however, further compounded by the rather obscurantist past practice of cataloguing peripheral works not, for example, as from the 'Circle of Sir Peter Paul Rubens' or by a 'Follower of Sir Peter Paul Rubens', but as simply 'Rubens' rather than the fully autograph 'Sir Peter Paul Rubens'. This omission of the forename was to distinguish between autograph works and those of a follower.[2]

That art scholarship should have been so greatly furthered during the twentieth century is not surprising when one considers the resources available to the scholar: in particular the ability to travel extensively and quickly, and the availability of photographic records of works of art have enabled vastly more people to accumulate a familiarity with the oeuvres of individual artists and schools than would ever formerly have been possible. With the greater numbers of such scholars comes also greater examination of each other's views and, at least in theory, ultimately the greater overall accuracy of opinion. For the art trade, such advances in scholarship have been a mixed blessing; attributional accuracy is the goal of any honest dealer and auctioneer, and thus knowledge is universally welcomed and supported. At the same time the need to consult academic opinion, and the consequently greater reliance on that, does not make a complicated business any easier, can lead to greater costs and, in the worst cases, can lead to corruption.

This continuing trend – besides the potential conflicts of interest deriving therefrom – has developed concurrently with that of art scholarship. Duveen is often credited with introducing authenticating experts after the model of Von Bode, and his professional relationship with Bernard Berenson is one of the most celebrated in the history of the art market. But Berenson soon demanded 25 per cent of the profits whether he was helping to buy or sell, or merely giving his all-powerful opinion; indeed René Gimpel, Duveen's brother-in-law, told of Berenson saying to Bauer: 'A man as scholarly as yourself shouldn't be a dealer, it's horrible to be a dealer', to which Bauer replied: 'Between you and me there's no great difference; I'm an intellectual dealer and you're a dealing intellectual' (Gimpel, 1996, p. 248). Gimpel also recalled a dealer complaining: 'The incorruptible Friedlaender now has a mistress at Berlin and for her he acknowledges all the pictures he had previously condemned.'

Both anecdotes are revealing, for Berenson and Friedlaender were, and remain, two of the most respected authorities of twentieth-century art history;

the fact that their impartiality and integrity could be attacked, whether justly or not, tellingly displays the potential complications introduced by money mixing with art history.

The question of reliability of expertise is crucial for the success of the market, and, in the field of Old Masters, this is compounded by the very difficulty of attribution. It is, therefore, one of the main arguments often put forward in favour of acquisition from auction houses rather than the trade: the very public nature of an auction exposes the house's attributions to the full glare of academic (and competitors') opinions, thereby preventing the sale of works of art under false descriptions. In actual fact, of course, the situation is not so one-sided: the time available to art dealers to research their pictures, and the comparatively fewer works on which they are working at any one time, often enable the trade to establish more fully – even if not necessarily any more correctly – a work's identity and history; and, as noted before, both such factors can have important implications for a work's value.

The benefits of buying and selling through auction or by private treaty

In reality, the question of whether to buy or sell through auction or trade comes mainly down to personal preference. Theoretically, it should be possible at auction to sell for more and buy for less than from a dealer, as the total commissions charged by the former – typically between 10 per cent and 20 per cent – are often smaller than the mark-up of a dealer buying from a private client and selling to another. At its simplest, were a dealer to acquire a painting privately for £100, he might then sell it for £200; were the original owner to offer it at auction, he might hope to realize instead a net £140, while the eventual purchaser might acquire it for a net £160. In reality, of course, chance and occasion mean that it is more realistic to suggest that the sale price at auction might fall anywhere between approximately £90 and £210, with the balance of probability resting somewhere closer to the original example. That a dealer might charge such a premium, however, is justified not only by the fact that he necessarily exposes himself to principal risk by acquiring a work of art for stock, but also by the additional possibility – indeed likelihood – of incurring significant costs, whether actual or implied, in holding stock for long periods of time.

In addition, an art dealer is able to provide a degree of convenience in the certainty of transaction that the nature of auction precludes: a collector cannot be certain that one will be able to buy a lot in an auction, while similarly a vendor can neither be sure that a work of art will sell, nor be sure of the final price; by buying from a dealer, one can be sure of exactly how much a work will cost. Additionally, that work will normally have been restored and can be hung on a wall immediately, whereas works bought at auction commonly require restoration: a process that in itself carries huge potential

risks and rewards. For many people, however, an alternative factor in the decision of whether or not to buy at auction is simply the excitement of a major auction process. The reaction displayed in 1887 when

> for a lumping sum there is a perfect uproar, just as the crowd roars its delight when the Derby is run, for the Christie audience revels in high prices simply for money's sake, though of course some of the applause is meant for the picture.
>
> (Faith, 1985, p. 9)

is hardly different from that today on the sale of a multi-million dollar work of art.

The two methods of sale therefore co-exist quite comfortably, the one offering financial advantage, the other convenience and security. Indeed, despite the comments of a few die-hards on both sides of the market, the relationship of the auction houses and the trade is symbiotic, both sides feeding the other and between them encouraging their mutual growth. With the international nature of today's art market, and the ease – export laws notwithstanding – of moving objects to the most attractive sale location, this is clearly seen in the dominance of those national art markets where the international auction houses operate, and the converse weakness of those where they do not. That presence is, of course, only one element in the relative strength of a national art market, and to a considerable degree it reflects the structures rather than causes them, but nonetheless the history of the French art market is a revealing example. In the first half of the twentieth century, France possessed one of the largest art markets in the world, rivalling those in the USA and the UK. However, anticompetitive legislation, including perhaps most importantly the protection of local auction houses, resulted, as the international market grew in competitiveness and mobility, in the steady decline of that market in France until by 2000 its share of the international art market was measured at 8.88 per cent compared to 26.39 per cent for the UK and 43.65 per cent for the US (Kusin & Co., n.d.).

Making sense of prices

One field within Old Master auctions that has been isolated is that of Dutch painting sales in the three largest single markets: the UK, the USA and France. The resulting numbers reflect a very similar situation within that field to the general figures mentioned above. In 1989, the average auction prices of Dutch Old Master paintings sold by those markets stood at just short of $75,000 per lot; from 1989 to 2001, French prices declined from almost $72,300 per lot to approximately $14,780, one-fifth of their former level. By contrast in the UK and USA average auction prices for Dutch Old Masters tripled. In terms of total sales, the UK saw an increase at an average yearly rate of 29.8 per cent and the USA of 22.2 per cent, while France recorded an average yearly decrease of 4.4 per cent. The success of the UK and USA in

the Dutch Old Master paintings market fully accounts for the French loss. More recently, with the opening of the French auction market, both major international houses have begun to reposition themselves within the field, selling in 2003 a combined total of €8.3 million that would previously have been offered in London or New York.

One often hears of the dominance of the USA in the art market, and single events are often taken to reflect hypothetical trends. Thus the *International Herald Tribune* reported in 2000 that:

> The Old Master market is exploding and New York is increasingly turning into the international art clearing house where the bangs are loudest. On Jan. 27 at Christie's and on Jan. 28 at Sotheby's, money spent on paintings exceeded $86 million.

The precise truth in any single sector is hard to ascertain, primarily due to the inherent difficulties of precisely calculating the figures for sales of Old Master pictures by art dealers, as the category distinction is to a large degree academic rather than commercial: too many galleries offer a variety of periods of works of art to be able accurately to distinguish between sales of any single period of object. Nonetheless the significance of Old Masters when generally calculated as a proportion of the market (in 2001 the sector was reckoned the largest generator of total sales at approximately €2.3 billion out of a global art sales total of approximately €24.6 billion (Kusin & Co., n.d.)) mean that general patterns for the market can, when seen with those evident for the sector at auction, give a reasonable idea of any such trends.

Between 1994 and 1999, the EU was a net exporter of paintings with net exports totalling €286 million in 1999. The USA is by far the major source and destination country for trade in paintings in the EU (Eurostat, 2000). It is clear that more sales of the highest priced fine arts are taking place in New York than in Europe. Globally, average fine art prices at auction have increased by 63 per cent from 1991/2 to 1999/2000, establishing an annual average increase of 6 per cent. During those years there were two exceptions to this pattern: in the period 1992/3 until 1993/4, the average price declined by 9 per cent; conversely, during the period 1998/9 through 1999/2000, the average global price increased by 21 per cent (these averages include all categories of fine art: paintings, works on paper, and sculpture). During the calendar period 1998 through 2001, Continental European sales ran counter to the worldwide trend. The average price for fine art sold in Europe actually declined by 36 per cent to €7,812. The pattern that emerges identifies the Continental European auction houses as constituting a (relatively) low-price marketplace for fine art where pricing, in economic terms, behaves more like a demand-driven retail market and less like the supply-driven nature of the higher end of the global art market. The UK has emerged as a (relatively) mid-priced marketplace for works of fine art, with certain exceptions, whereas the USA appears as the market leader in terms of fine art prices.

As recently as 20 years ago, the art market was predominantly regional in structure. Although the major UK auction houses had each established a presence in New York City by the late 1970s, their businesses operated until the mid-1980s on the basis of regional concerns with high levels of local autonomy. Trans-national cooperation among dealers on any measurable scale did not really begin until the late 1980s, and dealer trade associations were similarly focused chiefly on national concerns until the mid-1990s. Today, much of the art sector has developed a truly international organization. The major international auction houses now routinely transact business in whatever jurisdiction makes the most sense for their clients' particular needs; on the dealer side, EU–USA cooperation is now similarly routine. The stability and speed of rapidly evolving communication technologies underpin this transformation into an international business. As a result, in the international art economy, what has been referred to in other sectors for decades as 'regulatory arbitrage' has now emerged. Specific decisions and actions are being taken by auctioneers, dealers and their clients on both the buying and selling sides to achieve the highest efficiency for their capital and efforts. This frequently entails selecting transaction venues where various taxes are lower and regulatory strictures less onerous.

Perhaps one of the most significant factors in this is the harmonization of *droit de suite* ('DdS')[3] across EU member states from 1 January 2006. The inevitable and predictable result of that tax is the removal of the more valuable DdS-eligible works to sale venues where the tax is not payable. Auctioneers and dealers alike routinely exercise this option. The point at which this becomes feasible (the 'price of flight') – when the costs of insurance, packing, and then shipping a work of art to a point of neutral nexus are outweighed by the DdS payments – is currently just short of €60,000. However, this figure can be considerably less if the transfer is cheaper to execute (for example from Germany to Switzerland). To illustrate the potential loss of sales through the diversionary effect of DdS: in the UK in 1998, 1,090 lots of DdS-eligible art were sold at an average auction value of €291,468, substantially higher than the price of flight; together, these lots generated about €317 million. Given the nature of the UK marketplace for major works by contemporary and modernist artists, it is reasonable to say that most, if not all, of these lots would have been removed to a tax neutral place of sale if DdS had been instituted in the UK at the time. Furthermore, given the lower average value price for fine art in Switzerland, it is reasonable to assert that they would have been sold in New York City and not elsewhere in Europe.

Given this, one might have expected the scale of exports to the USA to be considerably greater than it is today, even allowing for those works sold in the USA for fiscal purposes and re-imported into Europe. The most obvious explanation for the fact that it isn't, is that the export is concentrated on the 'modern' sectors of the market, and is, to a degree, balanced by the more traditional sectors, of which, as noted above, Old Masters are the largest. That supposition is certainly supported by the evidence of headline auction

sales of Old Masters which remain overwhelmingly Europe- (and in particular London-) based: so, for the two main international auction houses over the period 1993–2003, the total sold in the USA stood at £281 million, and in the UK £780 million. Of those acquired in London, many might subsequently have been exported to the USA, but the discrepancy in size of the two markets is so great that it may nonetheless be taken as an indication of at least European demand compared to American. It is interesting to note that, in the case of Dutch Old Masters mentioned above, the UK rather than the USA was the principal winner of lost French business, whereas in a similar study of French Impressionist paintings, the French market lost a similar degree of market share, but the principal beneficiary was the USA. To a degree one might attribute the relative resilience of the European (including UK) Old Master market in comparison to that in the USA to fixed advantage. So, for example, the greatest concentrations of research resources and expertise remain in certain key cities – in particular London and Paris. But more importantly, it would appear that there is a greater propensity for buying Old Masters among Europeans than Americans. That is, of course, a gross generalization, and it applies increasingly less at the most expensive levels of the market, but nonetheless it appears at least for the time being to be true.

Concluding thoughts

Wherever the demand for Old Masters comes from, however, it undeniably exists, and in some quantity. This is not always the most accessible field, and at times may seem to require a knowledge base unattainable for the amateur collector. Fortunately, however, such is not the case, and the appeal that touched the sensibilities of the Medici and the Habsburgs still resonates with today's collectors. The market is, however, unbalanced by a variety factors that have in recent years reduced the supply of great works from a steady – but not overwhelming – flow to a steady – but not exhausted – trickle. This has, in turn, produced a two-tier market, where prices for masterpieces reach ever greater heights, while those achieved for other works remain subdued not only in comparison with their contemporaries, but also with later, more ostensibly fashionable periods. That problem of supply is in part insoluble (damaged or destroyed works cannot be brought back) but also partly created by artificial controls, and in particular those imposed by national governments. Were those ever to be relaxed, or even removed, in Europe then there remain enough works of the greatest quality in private ownership to reassure Vasari that, even 450 years after his lament, the great works of his contemporaries remain protected from his ravening maw of time.

Notes

1 An example of which practice is evident in the images in *Artful Parties: Bernard Berenson and Joseph Duveen* (C. Simpson, New York: Simon & Schuster, 1986) of the Sebastiano del Piombo 'Portrait of a lady' sold by Duveen to Andrew Mellon.
2 Debatable works were catalogued with the initial before the surname, for example P. Rubens was the standard practice in much of Europe until the twentieth century. It is little wonder that confusion was the frequent result.
3 *Droit de suite* is a royalty payable to an artist or the heirs for up to 70 years after the date of death. It is payable by the seller on each resale. Although *droit de suite* has existed in some countries since 1920, the final harmonization of the tax will apply equally across EU member states starting 1 Janaury 2006. Under the EU directive, the sliding scale begins at 4 per cent (with an option to charge 5 per cent) on a threshold of 3,000 euros and progresses through four additional increments ending at 0.25 per cent for the portion of the resale price exceeding 500,000 euros. The maximum tax payable for any work is 12,500 euros. See Chapter 6 for further information on this tax.

Bibliography

Brigstocke, H. (ed.) (1982). *William Buchanan and the Nineteenth Century Art Trade: 100 letters to his agents in London and Italy*. Guildford: Paul Mellon Centre for Studies in British Art.

Buchanan, W. (1982). *Memoirs of Painting*, vols I and II. London: R. Ackermann.

Eurostat (2000). Statistical Office of the European Communities.

Faith, N. (1985). *Sold. The Revolution in the Art Market*. London: Hamish Hamilton.

Fry, R. E. (1998). In C. D. Goodwin (ed.) *Art and the Market. Roger Fry on Commerce in Art*. Ann Arbor, MI: University of Michigan Press.

Gimpel, R. (1966). *Diary of an Art Dealer*, trans. J. Rosenberg. New York: Farrar, Straus & Giroux.

Goldstein, M. (2000). *Landscape with Figures, A History of Art Dealing in the United States*. Oxford: Oxford University Press.

Grimm, C. (1991). *Rembrandt selbst: Eine Neubewertung seiner Porträtkunst*. Stuttgart and Zurich: Belser, p. 208.

Heilbrun, J. and Gray, C. M. (1993). *The Economics of Art and Culture, An American Perspective*. New York: Cambridge University Press.

Kusin & Co. (n.d.) 'Art economy research data'. Dallas: Kusin & Co.

Melikan, S. (2003). *International Herald Tribune*, July.

Moncrieff, E. (2000). *The Art Newspaper*, July.

Stichting Foundation Rembrandt Research Project (1982). *A Corpus of Rembrandt Paintings*. The Hague, Boston and London: Nijhoff.

Taylor, J. R. and Brooke, B. (1969). *The Art Dealers*. London: Hodder and Stoughton.

Thiébault, D. (1996). 'Fesch, Joseph', in J. Turner (ed.) *The Dictionary of Art*: London: Macmillan, pp. xi, 32.

Vasari, G. (1568). *Le vite de' più eccellenti pittori, scultori, e architettori*, etc., Florence (1996). G. du C. de Vere trans. *Lives of the Most Eminent Painters, Sculptors and Architects*, 1912, revised edn. New York and Toronto, Macmillan & Co., p. 13.

11 Art crime

Patrick Boylan

> The French are all thieves, not all but Bonaparte.
> (Chamberlain, 1983, p. 123)

No aspect of the art world gets more media attention than art crime, whether thefts, burglaries and robberies, looting of museums, monuments and sites in times or armed conflict, or forgeries and fakes. Yet paradoxically while there is an almost overwhelming volume of information about individual crimes and events when these are 'hot news', there is little reliable information or statistics about art crime as a whole. Owners, public and private institutions, insurers and law enforcement agencies are all too often reluctant to give any details of events, even when these have already been widely reported in the press.

However, art thefts in the UK alone are estimated at £300 million ($500 million) a year (of which barely 10 per cent is recovered), while the leading French insurance group Argos estimates that currently around £7 billion ($10 billion) worth of works of art are stolen and traded around the world each year – an amount that is at least equal to the total legitimate international trade as reported in United Nations annual trade statistics.[1] In fact, any figure based on reported occurrences is certain to be a big underestimate, since this is based largely on the statistics of insured collections and objects. A high proportion of the most important collections and works are not insured, either as a matter of policy as in the case of government-owned collections and works, or because the owners cannot, or will not, pay the necessary insurance premium, especially at the present typical valuation levels, following the almost exponential increases in the price of so much art and antiquities over the past few decades.

Also, such estimates can only cover legitimate, known and recorded art. They do not take into account the huge amount of unrecorded works of art, antiquities and other cultural objects that is illegally acquired in the first place, for example from clandestine and other illegal excavations of monuments and sites, and important architectural and decorative features illegally removed from protected historic buildings.

Plate 11.1 The most wanted works of art (Courtesy of Interpol)

The great majority of police services around the world continue to classify crime for the purposes of their national statistics (and hence international statistical returns, such as those to Interpol) only by type of incident or the aspect of the criminal law or code that has been broken rather than by the type of material involved in the crime. Consequently, art crimes will typically be grouped within the much greater global totals for crimes such as theft, burglary, robbery, forgery or obtaining funds or advantage by deception.

Nevertheless, the world international crime coordinating body for national police services, Interpol, has for many years regarded international art crime as among the largest of its categories, and probably third in importance in value after the drugs and illegal arms trades. Though it now suggests that art and antiquities crime may have been overtaken in annual value by financial crime such as money-laundering, in so far as this can be separated from the drugs, arms and the illicit art and antiquities trades with which money-laundering is believed to be intimately connected in many cases.

Interpol gives high priority to measures intended to restrict art crime. This work is now supported by a special Interpol Experts Group on Stolen Cultural Property, which works closely with other international intergovernmental organizations such as the United Nations Educational, Cultural and Scientific Organisation (UNESCO), under a formal Cooperation Agreement signed in 1999 and updated in 2003, as well as with the (non-governmental) International Council of Museums (ICOM), and the International Customs Union, whose members have, of course, a key role in controlling the movement of stolen art and other cultural property across national frontiers. Among other services, Interpol runs international on-line illustrated databases of stolen art and other cultural property as reported by national police authorities, and of items of unknown ownership recovered by the police from apprehended criminals and illicit sources.

One of the most formidable problems in controlling the international trade in stolen or otherwise illicitly acquired cultural property (such as material from illegal excavations), and in recovering stolen or illegally exported property is that under most legal systems these are regarded as property crimes which are in principle criminal only in the territory where the crime was committed. Similarly, crimes relating to smuggling and illicit export are basically regarded as administrative or perhaps fiscal crimes, and again should be prosecuted in the country of export. These very longstanding legal doctrines severely limited the possibility of enforcement, recovery and return once an object had crossed the nearest international frontier. At the same time the relative impunity enjoyed once the work of art or antiquity was abroad was felt to greatly encourage and facilitate such crime, particularly where the origin was a relatively poor country with limited cultural protection resources, while the destination country or region was wealthy, with a thriving art market and many wealthy collectors and museums keen to acquire such material.

Over recent decades there have been very significant changes with the adoption of bi- and multilateral treaties intended to assist in the protection of the national heritage of countries party to them, most notably the Protocol (now First Protocol) relating to cultural property in zones of armed conflict under the 1954 Hague Convention on the protection of Cultural Property in the Event of Armed Conflict, the 1970 UNESCO Convention on the Means of Prohibiting and Preventing the Illicit Import, Export and Transfer of Ownership of Cultural Property, the 1995 *Unidroit* Convention on Stolen and Illegally Exported Cultural Objects, and most recently the 1999 Second Protocol to the 1954 Hague Convention. In each of these the relevant party of each state undertakes to regulate their own art and antiquities trade, and all persons, nationals or non-nationals within their territories, and to cooperate in and facilitate the return and restitution of cultural property illegally or illicitly removed from the territory of another party to the particular international treaty.

In this respect, the adoption of the 1970 UNESCO Convention by the USA in 1983, supported soon afterwards by national legislation, and subsequently by a number of bilateral agreements, was a major landmark since the USA was, and still is, one of the two top countries within the international art trade and much the most important importer of such cultural material by or on behalf of its museums, private collectors and art and antiquities trade. The other top art and antiquities trading country, the UK, finally ratified the UNESCO Convention in 2002, and in 2003 adopted the necessary national legislation to make the dealing in or handling of such illicit material acquired or transferred in contravention of another country's national laws a criminal offence in Britain through the Dealing in Cultural Objects (Offences) Act 2003. Under this, a new UK-wide offence of 'dealing in tainted objects' was established, carrying a maximum penalty of seven years imprisonment and an unlimited fine.

Theft and related crimes

The most common art crimes are thefts (generally defined as removal of objects from premises with the intention to permanently deprive the lawful owner or possessor of them, but without a forced entry) and burglaries (thefts in which force is used to break into or otherwise unlawfully enter the premises). However, recently there seems to be a very significant increase in the number of cases of robbery; that is, thefts or burglaries in which violence is used or threatened, typically accompanied by the use of weapons, up to and including firearms and explosives. The cynic would point out that the escalating seriousness of such crimes is the criminals' response to the marked improvements in many places to the security of museums, galleries, dealers' premises, the private dwellings of collectors, and other locations, as a result of a greater awareness of the need for enhanced physical and electronic security systems.

At one time in many parts of the world a sneak-thief could walk into premises with significant art collections on display posing as a legitimate visitor, remove a painting from the hook or light screws fixing the frame to the wall, and walk out with it in a bag or under a coat. With modern security arrangements and much greater surveillance, whether by security attendants or closed-circuit television (or probably both), it is more likely that there will be a carefully planned out-of-hours burglary of an unoccupied building, either using sophisticated equipment (or insider-knowledge and assistance) to try to bypass alarm systems or else in the form of a kind of night-time high speed smash-and-grab raid, ignoring the alarms and relying on the fact that even the fastest police response is likely to be two or three minutes.

Times when normal surveillance and security are be disrupted in some way may well present the opportunity the criminals need. For example, a very valuable collection of diamonds was stolen from the Mineral Gallery at the Natural History Museum, London, while the outside of the building was scaffolded so that the exterior could be cleaned prior to its centenary in 1981. Just before midnight on the night of 31 December 1999 a gang took advantage of the celebrations and firework displays. for the Millennium to break into Oxford University's Ashmolean Museum through the roof.

Alternatively, if it is known or suspected that there will be staff on the premises the raid may be further escalated to the level of an armed robbery, with or without the taking of hostages. In what is still, by value, the world's biggest every robbery, the 1990 raid on the Isabella Stewart Gardner Museum in Boston, USA, the thieves gained entry by posing as police armed officers and got away with twelve world-class works of art valued at over $100 million, including the only known Rembrandt seascape and a Vermeer.

The Art Loss Register is a London-based international company funded by the insurance industry and art trade to record and publicize missing works of art and other cultural property. It checks all major auction catalogues and proposed purchases by a very large number of subscribing dealers and individuals against its database, which now stretches back to include a large number of works of art still missing from the Second World War. Since its establishment the Art Loss Register has been instrumental in recovering over 1,000 works of art with an insured value totalling over £75 million ($100 million), just over half (51 per cent) of these being pictures, and silver and furniture at 10 per cent each, with auction catalogues providing the lead to over half of the successful recoveries. It has analysed the very large number of crimes reported to it since it started work documenting stolen and otherwise missing works of art and antiques in 1991, and finds that the location from which the thefts have been reported breaks down into the percentages shown in Box 11.1.

These figures are, however, based on the crimes reported to the Art Loss Register, and therefore largely reflect the position in the perhaps dozen or so countries within which the Register's institutional or commercial members are concentrated, and things may be markedly different in other countries

> **Box 11.1 Percentage of reported thefts by location**
>
> | Domestic dwellings | 54 |
> | Commercial galleries | 12 |
> | Museums | 12 |
> | Churches | 10 |
> | Commercial premises | 4 |
> | Public institutions | 3 |
> | Warehousing/storage | 2 |
> | Other | 3 |

and regions. Interpol statistics for 2002, for example (though based on returns from only 37 countries), suggest that in many of these countries churches and other places of worship were the worst hit. Six hundred and sixty items were stolen, for example, from religious buildings in Italy, 437 in France, 282 in Poland, 194 in the Russian Federation, 168 in the Czech Republic, and 99 in Turkey. Also, thefts and burglaries from the premises of art dealers can also be serious. There were 2,411 such losses from German galleries and dealers in 2002, compared with just 33 from museums and 56 from places of worship.

Thefts from private properties, including dwellings are a major problem in France (7,994 losses reported to Interpol in 2002), and in Russia (894) and Italy (807). However, the Interpol figures should be regarded with some caution. On the one hand a number of the most important art collecting and art dealing countries did not report any occurrences, though they were certainly not crime-free (e.g. Switzerland, the UK, the USA) while France may well be reporting most or all of its annual losses since the headquarters of Interpol and its cultural property unit are conveniently located in France itself. On the other hand losses from monuments, archaeological sites, and site museums predominate in some other regions, including Central America, the eastern Mediterranean and Southeast Asia.

Deception crimes

In addition to theft (in the narrow sense), burglary or robbery, the art sector also experiences a fourth significant group of theft crimes, which are usually much more difficult to detect. There are in fact a wide range of ways in which the criminal can obtain property or, more usually, financial advantage by means of deception.

At the simplest level, forged documents or identification, or forged or invalid financial instruments may be used to collect or divert works of art or other cultural objects without proper authority or the required payment.

For example, false transportation or customs clearance documents may be used to collect art in transit, or to redirect it to another destination. Purchases may be paid for with stolen credit cards, cheques, banker's drafts or other documents, or with legitimate ones drawn against accounts with insufficient funds. In the latter case, that is, where payment is offered but there are insufficient funds to pay for the goods, in many legal jurisdictions it may be difficult to prove criminal intent, and the police and prosecuting authorities may well decide that there has been a willing handing-over of the item or items bought, so the matter is essentially one of civil debt rather than a crime, and advise the losing party to pursue the matter in the civil courts. Typically, in Britain and many other countries the police may require evidence of a pattern of deceit extending over several dishonest credit card or similar transactions before considering a fraud investigation, though in some countries it is criminal offence to 'bounce' even a single cheque. It is therefore very important that adequate steps are taken by the vendor to verify the identity of the purchaser and to ensure that a proper payment has been made, and cleared through the bank in the case of a cheque or banker's draft, before releasing the items purchased.

As previously noted, there is a strong suspicion that works of art, particularly stolen or smuggled items, can be used in money laundering: when a stolen, illicit or otherwise dubious item is sold to a reputable dealer or through a public auction the vendor received an entirely reputable cheque or bank transfer from a 'clean' source. Consequently, under international money-laundering agreements and national art and antiquities trade regulation laws in many countries, all businesses including art dealers are required by law to take all reasonably necessary steps to determine and record the true identify of all vendors, and of anyone making significant transactions in cash, and notify the proper authorities of all larger cash transactions. In the European Union, for example, anything over €15,000 (or any series of related transactions totalling this) must be reported to the appropriate national fiscal authorities, and there may well be an obligation to report smaller transactions than this if they appear suspicious. It need hardly be added that providing details of the provenance of an item and evidence of legal title to it is becoming almost indispensable should the buyer want to sell on the item at some time in the future.

Another serious group of deception crimes are those relating to the identification, authentication, provenance of, and legal title to, cultural property. It goes without saying that a firm identification of a work of art as that of a major artist rather than a perhaps highly competent contemporary associate or follower can easily increase the market value by a factor of many hundreds, perhaps even more. With hundreds of thousands, perhaps even millions, at stake there is therefore a very real temptation to exaggerate attributions which are perhaps less than certain. There are also very real problems with the works of many major artists from the Renaissance to at least the mid-nineteenth century because of the extensive use by many of the major Masters

of a variety of studio assistants, including pupils, some of whom went on to greatness in their own right, as did Van Dyck in the studio of Rubens and Joshua Reynolds, the pupil of the fashionable and modestly competent Thomas Hudson in mid-eighteenth-century London.

Indeed, it is well known that many leading eighteenth-century portrait painters personally concentrated on the overall composition together with the face and perhaps hands, leaving the greater part of the canvas to be filled in by the assistant, pupils or perhaps even specialist painters of costume or backgrounds, of whom little is known today. It is equally well known that when a particular composition proved especially successful or popular many leading artists were more than happy to create and sell additional versions within the studio, probably with even less personal involvement than before (though there are examples where a subsequent version, though substantially the same, may be regarded as the superior version). All of these possibilities present significant art historical and ethical problems in terms of identification and attribution, but perhaps raise important legal issues as well. It may not be at all easy to define exactly the boundaries between a perhaps mistaken opinion made in good faith, reckless and unsupported exaggeration of an identification or attribution (either of which might be open to legal challenge in the civil courts for compensation), and a deliberate deception which is clearly criminal. It is clear, however, that the law of deception becomes a potential issue at a relatively early stage along this continuum.

Similarly, there are many problems arising from deliberate fakes, forgeries and later copies, of which there are certainly an enormous number in circulation. While it is not illegal to make copies or works 'in the manner of' a noted artist (providing the original work is out of copyright, of course), it goes without saying that creating a deliberate forgery for sale or attempting to pass off a fake or copy as an original is deception, and a criminal offence in most if not all countries.

Finally, within the area of deception, there is growing evidence of forgery and serious misrepresentation in relation not necessarily to the works of art themselves, but in respect of the related documentation. Again, there is considerable reluctance to publicize, let alone give exact details, of such crime, but in the late 1990s a regular visitor to the unique research and reference collections on twentieth-century British art and exhibitions in the library of the Tate Gallery was prosecuted after it was discovered that he had been systematically altering the records and catalogues of dealers' and other exhibitions in order to create false provenance for copies and other fakes that associates were planning to put on the market.

In a case involving so-called Holocaust Art, a leading international dealer claimed that two unique multi-million value items had been in the company's ownership and possession continuously since the 1920s. The company has continued to persist in this assertion even when modern catalogue or inventory numbers found on them matched unambiguously the numbers and descriptions of two items in the detailed catalogue of the works that passed

through the Nazi art collection point in the Orangerie, Paris, managed by Alfred Rosenberg between 1941 and 1944. The original *Einsatzstab Reichsleiter* Rosenberg catalogue, now in Washington with a copy in Paris, proves that the two items were among hundreds of works of art, manuscripts and items of furniture confiscated by the Nazis from one of the two most important Jewish collections in Paris at the start of the war, that of the Kan family. In the light of this there must be very serious doubt about the provenance of the items, particularly the claimed continuity of ownership since the 1920s.

It is understood that currently (May 2004) Holocaust survivors' groups in America who in 1998 successfully claimed over $1 billion from Swiss banks in the so called 'Nazi Gold' claim, are now preparing group actions in the courts against some leading international auctioneers and dealers, alleging that very large numbers 'Holocaust art' works were systematically 'laundered' through the legitimate art trade to museums and collectors by means of concealed or falsely created 'histories' of ownership. Recent research by collections through bodies such as the Art Loss Register, partly funded by the leading international auctioneers, has identified confiscated or looted works that have certainly passed through the legitimate art market since the Second World War, and which are now the subject of claims or negotiations for restitution. However, it remains to be seem whether the claimants can present any evidence in support of their grave allegation that such sales involved deliberate fabrication or concealment of evidence of previous ownership rather than a lack of sufficient 'due diligence' in enquiring into evidence of the legal title of the vendor.

Forged export licences are also found accompanying works of art and antiquities. One fairly recent high profile case involved the so-called Sevso Treasure of quite outstanding pieces of Roman silver, apparently discovered in recent times, presumably in a clandestine excavation or as an unreported archaeological discovery. This was originally offered for sale at Sotheby's in the mid-1990s, accompanied by what was later proved to be a forged Lebanese export licence. (The silver was withdrawn from the sale when the legality of ownership was challenged in the New York Courts by the State Attorney-General, and the ownership was contested by Lebanon, Croatia and Hungary, though the verdict of the court was inconclusive as to the place of discovery and hence ownership.)

Illicit and smuggled art and antiquities

The great majority of countries now have some sort of legal provision aimed at protecting and preserving the national heritage in terms of movable objects, such as archaeological finds, dismembered or fragmentary monuments, historical and other cultural objects, and works of art considered to be of national significance (in many cases there are similar provisions in respect of scientific and natural history items and collections of national significance

as well as archives). Typically these national measures will include the regu-
lation of archaeological excavations, a declaration of ownership over both
systematic and chance archaeological discoveries, with provisions for the
notification and registration of finds from these, and export controls on
material of national cultural significance.

Despite such measures, the present high market value of many kinds of
cultural property, coupled with serious economic problems in many of the
less developed countries of the world (plus indeed quite a number of very
important Western countries) has led to an explosive growth in recent years
of clandestine excavation, destructive dismantling of artistic and historic
detailing on buildings and monuments, and smuggling.

In its current 'information kit', *Promote the Return or Restitution of
Cultural Property*, UNESCO argues:

> The increase in pillaging, theft and illicit export of cultural property is
> proof that the legislation of the originating States in this area, no matter
> how detailed and well thought-out, is not sufficient in itself to stop this
> traffic.
>
> In addition, once the object has left the national territory, this inter-
> national movement, often combined with the purchase of the object
> in another country, or the fact that the object remains in the importing
> country for a considerable time, multiplies the obstacles to restitution of
> these objects. These include legal obstacles, depending on the content
> of the applicable laws, and even sometimes political obstacles, depending
> on the nature of the object and the interest the States concerned have
> with regard to the object. Once the object has been identified and found
> outside its country of origin, international co-operation is indispensable.
> This is why the international community has set up an entire legal and
> ethical arsenal to fight illicit traffic in cultural property both through pre-
> vention (adequate legislation and updated inventories with photographs
> of the objects) and solutions, by facilitating restitution.

In addition to national governments, UNESCO and the International Council
of Museums (ICOM) are both very actively involved in promoting the pro-
tection of the national cultural heritage, and in seeking the return and
restitution of items that have been smuggled or otherwise illicitly removed
from the country of origin and ownership. A key legal instrument in this
is the UNESCO Convention on the Means of Prohibiting and Preventing
the Illicit Import, Export and Transfer of Ownership of Cultural Property
(1970), which is now supported by an Intergovernmental Committee for
Promoting the Return of Cultural Property to its Countries of Origin or its
Restitution in Case of Illicit Appropriation and the Fund of the Inter-
governmental Committee for Promoting the Return of Cultural Property
to its Countries of Origin or its Restitution in case of Illicit Appropriation.
This Fund, maintained by voluntary contributions from states and private

partners, aims to support member states in their efforts to pursue the return or restitution of cultural property.

There are also provisions in the First Protocol (1954) and Second Protocol (1999) of the 1954 Hague Convention on the Protection of Cultural Property in the event of Armed Conflict, which aim to assist in the protection of both movable and immovable cultural property during wartime. The protocols, among other things, declare void any transfers of ownership as a result of, or during, armed conflicts, including non-international conflicts. They insist on the return and restitution of any temporarily displaced, or illegally looted, material at the end of the conflict.

UNESCO has assisted in the successful restitution to the country of origin in quite a number of high profile cases. Examples over the past two decades or so recorded by UNESCO have included the following:

- In September 1982, two portraits painted by Albrecht Dürer were returned to the German Democratic Republic by the USA following a court ruling.
- In January 1983, after a ruling by the Court of Turin, Italy returned a major collection of pre-Colombian ceramics to Ecuador that had been illegally exported in 1974. The UNESCO Intergovernmental Committee had provided moral support for the legal action engaged by the Ecuadorian authorities.
- In October and November 1987, due to the intervention of the UNESCO Intergovernmental Committee, 7,332 cuneiform tablets were returned to Turkey by the German Democratic Republic.
- In 1994, ancient textiles from Coroma were returned to Bolivia after a court ruling in Canada.
- On 27 March 1996, the Court of the First Instance of Genoa (Italy), ordered the restitution to Ecuador of 87 archaeological pieces dating back to the pre-Colombian era.
- On 23 April 1998, four pre-Colombian statues, which had been stolen during the 1980s from the Archaeological Park of San Agustin (Colombia), were returned during a ceremony that took place in Nantes (France). Two of them were listed in a stolen objects notice published by UNESCO, and in the ICOM publication (prepared with the support of UNESCO) entitled *One Hundred Missing Objects. Looting in Latin America*, distributed in 1997.
- In May 1999, Cambodia was able to recover 67 pieces of the ancient Khmer Rouge fortress of Anlong Veng, which were in the hands of Ta Mok, a former Khmer Rouge chief.
- On 10 April 2000, 59 pre-Colombian objects, in particular ceramic pottery dating from between 1800 and 1400 BC were returned to Peru by Canada.
- On 3 April 2001, a sculpture of St Mark the Evangelist, dating from the seventeenth century, was returned to the Czech Republic by the Austrian

auction house Dorotheum. This sculpture was included in the ICOM publication (prepared with the support of UNESCO), entitled *One Hundred Missing Objects. Looting in Europe*, distributed in 2000.
* On 26 April 2002, a head of Bayon style from the twelfth century and one from the Angkor Wat period in the eleventh century were returned to Cambodia by the Honolulu Academy of Arts. These two pieces were included in the list in the ICOM publication (prepared with the support of UNESCO) entitled *One Hundred Missing Objects. Looting in Angkor*, distributed in 1993.

In 1999, following widespread consultations, not least with the arts and antiquities trades internationally, the UNESCO General Conference adopted, and recommended to all countries and all trade organizations an International Code of Ethics on dealing in cultural property. The Code was prepared by UNESCO's Intergovernmental Committee for Promoting the Return of Cultural Property. It complements very well the 1970 ICOM Declaration on the Ethics of Collecting and the 1986 ICOM International Code of Professional Ethics, which have transformed the attitudes and behaviour of a great many museums and many thousands of museum professionals around the world in relation to respect for the cultural heritage interests of others. The Code of Ethics for dealers provides as follows:

The International Code of Ethics for Dealers in Cultural Property

Members of the trade in cultural property recognise the key role that trade has traditionally played in the dissemination of culture and in the distribution to museums and private collectors of foreign cultural property for the education and inspiration of all peoples.

They acknowledge the world wide concern over the traffic in stolen, illegally alienated, clandestinely excavated and illegally exported cultural property and accept as binding the following principles of professional practice intended to distinguish cultural property being illicitly traded from that in licit trade and they will seek to eliminate the former from their professional activities.

ARTICLE 1. Professional traders in cultural property will not import, export or transfer the ownership of this property when they have reasonable cause to believe it has been stolen, illegally alienated, clandestinely excavated or illegally exported.

ARTICLE 2. A trader who is acting as agent for the seller is not deemed to guarantee title to the property, provided that he makes known to the buyer the full name and address of the seller. A trader who is himself the seller is deemed to guarantee to the buyer the title to the goods.

ARTICLE 3. A trader who has reasonable cause to believe that an object has been the product of a clandestine excavation, or has been acquired

illegally or dishonestly from an official excavation site or monument will not assist in any further transaction with that object, except with the agreement of the country where the site or monument exists. A trader who is in possession of the object, where that country seeks its return within a reasonable period of time, will take all legally permissible steps to co-operate in the return of that object to the country of origin.

ARTICLE 4. A trader who has reasonable cause to believe that an item of cultural property has been illegally exported will not assist in any further transaction with that item, except with the agreement of the country of export. A trader who is in possession of the item, where the country of export seeks its return within a reasonable period of time, will take all legally permissible steps to co-operate in the return of that object to the country of export.

ARTICLE 5. Traders in cultural property will not exhibit, describe, attribute, appraise or retain any item of cultural property with the intention of promoting or failing to prevent its illicit transfer or export. Traders will not refer the seller or other person offering the item to those who may perform such services.

ARTICLE 6. Traders in cultural property will not dismember or sell separately parts of one complete item of cultural property.

ARTICLE 7. Traders in cultural property undertake to the best of their ability to keep together items of cultural heritage that were originally meant to be kept together.

ARTICLE 8. Violations of this Code of Ethics will be rigorously investigated by [a body to be nominated by participating dealers]. A person aggrieved by the failure of a trader to adhere to the principles of this Code of Ethics may lay a complaint before that body, which shall investigate that complaint before that body. Results of the complaint and the principles applied will be made public.

Already this has been widely welcomed by art, antiques and antiquities trade organizations and representatives in many parts of the world. This is perhaps the most encouraging development of recent years from the point of view of both the art trade and the too often embattled cultural heritage of the world. If the dealers, auctioneers or other players in the art market act at all times with integrity and ethically they will rarely have anything to fear from the national and international legal measures that have become necessary in the face of the unacceptable behaviour of what have always probably been just a minority of dealers, auctioneers, museums and collectors.

Note

1 The turnover of the international art market was estimated to be over $20 billion in 1998 and is now probably nearer $25 billion.

Bibliography

Boylan, P. (1995). 'Illicit trafficking in antiquities and museum ethics', in K. M. Tubb (ed.) *Antiquities: trade of betrayed, legal, ethical and conservation issues.* London: Archetype Publications & UKIC, pp. 94–104.

Briat, M. and Freedberg, J. A. (1996). *Legal Aspects of the International Trade in Art.* The Hague: Kluwer Law International.

Brodie, N. and Tubb, K. M. (2002). *Illicit Antiquities. The theft of culture and the extinction of archaeology.* London and New York: Routledge.

Chamberlain, R. (1983). *Loot! The Heritage of Plunder.* London: Thames & Hudson.

Conklin, J. E. (1994). *Art Crime.* Westport, CT and London: Praeger.

Doole, J., Brodie, N. and Watson, P. (2000). *Stealing History: the illicit trade in cultural material.* Cambridge: McDonald Institute for Archaeological Research.

Institute of Art and Law (1997). *Art, Antiquity and the Criminal Law*, Proceedings of a seminar held on 27 March 1996 at the British Museum. Leicester: Institute of Art and Law.

Kouroupas, M. P. (1995). 'United States efforts to protect cultural property: implementation of the UNESCO Convention', in K. M. Tubb (ed.) *Antiquities: trade of betrayed, legal, ethical and conservation issues.* London: Archetype Publications & UKIC, pp. 83–93.

Kowalski, W. W. (1998). *Art Treasures and War: a study on restitution of looted cultural property, pursuant to public international law.* Leicester: Institute of Art and Law.

Meyer, K. (1973). *The Plundered Past: the traffic in art treasures.* New York: Atheneum; republished London: Hamish Hamilton (1974); Harmondsworth: Penguin (1977).

O'Keefe, P. J. (1997). *Trade in Antiquities: reducing destruction and theft.* Paris: UNESCO; London: Archetype Publications.

Palmer, N. (ed.) (1988). *The Recovery of Stolen Art.* London: Kluwer.

Palmer, N. (1995). 'Recovering stolen art', in K. M. Tubb (ed.) *Antiquities: trade of betrayed, legal, ethical and conservation issues.* London: Archetype Publications & UKIC, pp. 1–37.

Renfrew, C. (2000). *Loot, Legitimacy and Ownership.* London: Duckworth.

Tubb, K. M. (ed.) (1995). *Antiquities: trade of betrayed, legal, ethical and conservation issues.* London: Archetype Publications & UKIC.

UNESCO (1997). *Preventing the Illicit Traffic in Cultural Property.* Paris: UNESCO.

Watson, P. (1997). *Sotheby's: the inside story.* London: Bloomsbury.

12 The current and future value of art

Iain Robertson

For I do nothing but go about persuading you all, old and young alike . . .
that virtue is not given by money, but that from virtue comes money and every
other good of man.

(Socrates, quoted by Plato, *The Death of Socrates*)

Almost 400 years ago, tulip mania took hold of the Netherlands, and land
and houses were exchanged for single bulbs that, it was hoped, would
produce new, highly prized varieties.[1] Today, the NovaCap Florales Future
fund, has successfully convinced Dutch speculators to repeat the experience,
with similar boom and bust results (Bickerton, 2003).

Galbraith explains our desire for euphoria by pointing to the 'extreme
brevity of the financial memory' and 'the specious association of money
and intelligence' (Galbraith, 1994, p. 13). Speculation and investment are
attracted to anything which promises returns above the market average,
be it tulip bulbs or art, but we shall see that speculation is not the same as
investment and picking out market highs and lows is an inexact science. So
is art any different or just another asset ready for a punt?

It is clearly possible to put a price to art, to price the priceless, as Grampp
(1989) neatly describes it; dealers and auction houses do it every day. It is
another matter to predict future art prices. This, however, is what today's
art market analysts are working towards. The marshalling of art market sales
data into indices and the correlation of those indices against those of the
financial markets marks the beginnings of this process. The two big questions
are, therefore, does art have a fundamental value, and what are the elements
that give it this value? An important subsidiary question is, can we analyse
art accurately enough in a portfolio of assets in order to achieve optimum
risk and returns for investors?

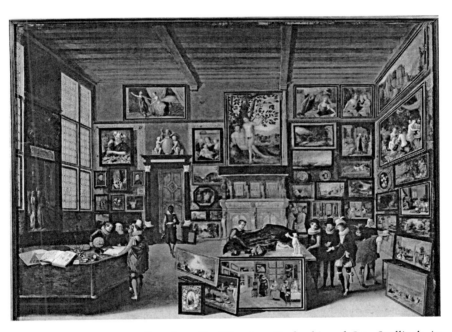

Plate 12.1 Hieronymus Francken II, 'The Art Dealership of Jan Snellinck in Antwerp', 1621 (Courtesy of Musées Royaux des Beaux-Arts de Belgique, Brussels, Belgium)

What are investment and speculation and how can they be applied to art?

Sixty years ago the financial analyst Ben Graham explained that the speculator tried to anticipate and profit from price changes and the investor to acquire companies at a reasonable price. He went on to say that investors tended to be calm, patient and rational, and speculators, anxious, impatient and irrational.

Risk/return trade-off or fear versus greed

Fear and greed fight for pole position in the investor's mind and we shall see how great art auctioneers are able to get that little bit more by raising feelings of desire and lowering levels of caution among bidders. The greater the risks the greater the returns and vice versa. Asset managers are significant entities in the capital investment world. Their aim is to obtain superior returns on their client's capital at the lowest risk by investing in a group as opposed to individual assets (see Markowitz, 1952, 'Modern Portfolio Theory' in Hughes, 2002 p. 20[2] and Bodie et al., 2002[3]), but increased transparency, generated by enhanced technology, has cut their margins dramatically.[4]

The importance of diversification or 'Don't put all your eggs into one basket'

Today's cautious investment climate is driven by cautious fund managers who seek short-term profits over long-term investments. The 'less is more' portfolio approach in which the investor chooses between five to ten companies[5] with low correlation, highly likely to perform well over the long term has worked for the most astute investors, but is today untypical investment practice.

The role of art in diversifying the portfolio risk

Art, says Bryan (Louargand and McDaniel, 1991) is a superior investment on a risk-adjusted basis – in other words as part of a large portfolio of assets. The precise proportion of an investor's portfolio that should be given over to this commodity is very difficult to estimate because the categories of art, the various types, sectors and commodities themselves perform differently from each other. Art is, in short, heterogeneous. It could almost be said that art and antiques offer too much diversification.

The balance of the art holding is difficult to measure. How many Old Master drawings and Chinese T'ang Dynasty pots should investors hold to maximize their utility and what is the covariance[6] between the two? It is an impossible question to answer without a great deal of accurate information on past prices and other variables. Perhaps a focus on investing in art might

offer a solution to the first part of the question, but any attempt to establish how one art asset might perform in relation to another is hampered by poor quality and partial information.

Liquidity

Art and antiques are very illiquid commodities – it takes a long time to sell them. Today's trade is particularly 'thin' because of certain 'artificial' constraints on supply that we will address later in this chapter. This illiquidity means the commodity should be expected to earn a premium above the risk premium, namely a liquidity premium. This sum compensates the vendor for the exceptionally high transaction costs. A way to measure the return of an illiquid asset such as art is to compare it to one offering similar risk.[7] Unfortunately, it is difficult to imagine a proxy asset for art.[8]

Putting fear before greed

The great success of certain long-term investors could be attributed to the effective use of the Kelly Optimization Model that advises investors, once they know the probability of success, to bet the fraction of their capital that maximizes the growth rate, expressed in the formula:

$2p - 1 = x$ (where 2 times the probability of winning (p) minus 1 equals the percentage of the total that should be bet (x)).

So if, for example, I am 75 per cent sure that my Jackson Pollock painting will go up in value in five years time I will bet on it 50 per cent of my expendable wealth:

$2 \times 0.75 - 1 = 50\%$

If I was only half confident then I would not invest, but I might speculate, and we shall see later how a speculative act is impounded into the price paid for art.

Of course I am not able to say, with any degree of accuracy, that my Jackson Pollock will go up in value in five years time and certainly not by what amount. In normal circumstances, however, investors using this method are shielded somewhat from short-term horizons, using leverage or overestimating the probability of success ('gambler's ruin'). Basically, sensible investment advises you to wait for a good product to arrive at an inviting price before committing a proportionate amount of your funds. If impetuosity is an active part of your nature, then divide your investment strategy between 'action' (speculative) bets and 'prime' (investment) bets. Finding the optimum percentage of this expendable income to commit to art would entail running a regression on an accurate benchmark All Art Index, something that

does not exist. Few, if any, non-industry investors in these circumstances would commit half their spare savings to one painting, but a collector might, and that is where art differs from other financial products.

Risk and return are inextricably linked (see Marowitz, 1952, 'Modern Portfolio Theory' in Hagstrom, 2001, p. 149) and all securities have a common relationship with some underlying base factor such as a stock market index or GDP. The volatility of the portfolio can be determined by the weighted average of the individual securities (see Sharpe, 1964 in Hughes, 2002, p. 20). Sharpe's volatility measure is called the beta factor:

> Beta is described as the degree of correlation between two separate price movements: the market as a whole and the individual stock. Stocks that rise and fall in value exactly in line with the market are assigned a beta of 1.0.
>
> (Hagstrom, 2001, p. 152)

Sharpe (1964) went on to develop the Capital Asset Pricing Model (CAPM) in which he identified systematic risk (beta) and unsystematic risk (a risk specific to a company's position that can be diversified away by adding different stocks). The model, however, only captures one factor, the market, and the firm's relationship to it. The value of art, in common with other assets, is dependent on multi-factors. Arbitrage pricing theory (APT)[9] says that rationally minded traders will buy the cheap and sell the dear until both are the same, but is this an accurate representation of art market player behaviour? It is not.

Behavioural finance believes that human nature interferes with the supposedly rational marketplace and fear and greed inform all our investment decisions to a greater or lesser extent. So, a satisfactory return on an investment differs in the mind of each investor, but the pain of loss is far greater than the enjoyment of gain in all cases. Most investors are prone to overconfidence and uncontrolled optimism can lead to mania, a condition most prevalent among young men who take the greatest risks and can fashion investment into speculation. There is much that a bidder at auction, an art buyer at a fair or a tipsy client at a private view will recognize in these descriptions of buyer behaviour, the rush of blood to the head and the surge of adrenaline that result in an over-payment or unwanted purchase.

An inefficient market

The art market does not conform to the Efficient Market Hypothesis (EMH). It is an imperfect and asymmetrical place in which prices certainly do not reflect all published and unpublished data. The assumption that the irrational trades of art market players are cancelled out by rational arbitrageurs (Shleifer, 1999), that prices instantaneously adjust to available information (Hagstrom, 2001) and that indices capture all economic activity (Coggan,

2003) cannot be applied to the art market. Even the weak form of EMH[10] fails to represent art market activity. Purchase prices for art are rarely quoted when 'bargains' are resold on the organized market, and high information costs deter non-price competition (Coffman, 1991) so individuals with a lot of knowledge are able to profit handsomely on a regular basis with a relatively low exposure to risk. Art professionals are, therefore, in an excellent position to 'rip off' even astute collectors because of their commodity and market information advantage. The fact that buyers return to the same dealers indicates either that dealers do not rip buyers off, that they do so only some of the time to some clients, or that the commodity, being unique, is uniquely attractive to buyers. The fact that art buyers enjoy great personal liquidity but are quality sensitive makes a final price all the harder to predict.

Institutional investment would lead to a more buoyant, liquid and efficient market, unless it performed in the same way as museum purchases – withholding works and depriving the market of resales. The attitude of museum and non-museum institutions in the future towards art will have a great impact on its value.

Alternative investments

Art and antiques is just one alternative product that the investor has to consider.[11] There are others that are all international, easily transportable, easily stored and sterile (not producing a dividend) (Duthy, 1978; see Figure 12.1).

The valuation of art

Non-observable price characteristics

Like a firm, a work of art can be divided into a number of properties: support (materials used in creation, be it canvas, porcelain, silk thread, etc.), subject matter and signature (Sagot-Duvauroux in Towse, 2003). The value of a work of art is determined in great part by underlying internal and external forces. The internal characteristics are size, materials, date of creation, condition, provenance, subject matter, and name and reputation of creator. The external considerations are macroeconomic and political forces often reflected in the stock market. The degree to which each of these internal characteristics is impounded into the price depends on the market of origin. In France the *piece* or size of the work is very important, for example, and in Korea even more so. The price of a painting increases at a decreasing marginal rate with size, and drawings are cheaper than gouaches, which in turn are cheaper than oils or acrylic painting. A work on paper is cheaper than a work on board (Sagot-Duvauroux in Towse, 2003).

Precious stones

Diamonds

De Beers, a monopoly, controls through its Central Selling Organisation, 75% of the $6.2bn diamond market (4th March 1998 BBC Online) The determinants of value are: cut, clarity (flawless, internally flawless, Very, very small inclusions, small inclusions, pique), colour and carat. The diamond stockpile is large, but its supply and price are controlled by De Beers. The price of diamonds has risen considerably since the second world war. Most rough diamonds arrive uncut in London where they are sold in £1million or above parcels at 'sights' to about 300 hundred dealers at fixed prices. The gem quality diamonds then pass onto diamond cutting specialists in Antwerp or Tel Aviv. Finally they reach the 50,000 or so retail outlets. A parcel will have risen 500–1000% at this stage and then is frequently marked up a further 200% by the jeweller. Investors are, therefore, best advised to buy from the 'sight' dealers. The investor is ill-advised to buy from a retailer who would offer to buy back at perhaps 20% of the purchase price. Perhaps only 0.5% of all gem quality diamonds sold are appropriate for investment, and even then a 20 year holding period is normal. Coloured stones are even more hazardous investments as the Japanese found to their cost in the 1970s. One area of potential higher returns is in the stones set by the great 'houses' of Tiffany, Cartier and Chaumet. Perhaps its greatest function is as a portable asset. Cut Diamonds are valued as follows: flawless (F.L.), internally flawless (I.F.), very, very small inclusions (V.V.S), very small inclusions (V.S.I), small inclusions (S.I.) and piqué (P.) The size of carat is another determinant of value (Duthy, 1978).

Art & antiques

Precious metals

Gold

The value of gold increases as the US$ weakens, As such, it is a safe haven. Gold held its value during the 1930s depression because of its official status. Gold's value fluctuated in the 1960s when investors used the 'gold window' to exchange their dollars for gold. The situation stabilised when Nixon closed the window in 1971.

Official coins:

Bullion with various percentages of premium, e.g. S.A. krugerrand, British sovereign and US dollar.

Bar hoarding (common in Middle and Far East and South America).

Carat jewellery (retail price over 300% above the value of gold. 20–30% mark up in Middle and Far East).

Medals, medallions and fake coins (100–400%) premium for artistry.

Silver

Bullion, bars, coins

Platinum, Palladium, Rhodium

Other alternatives:

Angels (investors in theatre plays and musicals)

Highly volatile asset with the possibility of total loss or extraordinary gain. The variables are: people involved, technical, feasibility, audience appeal, a suitability venue. A well known producer can reduce the risk of failure, although once again, it is advisable to back a number of projects over a five year period to be more certain of returns (Wullschlager, 1989)

Forestry

Bareland planting is a long (50-year cycle) and you are unlikely to see profits until year 20. It is also akin to buying in the Futures market. Thinning is unlikely to produce any income, although you can always sell off your wood at a profit. An established wood is ready to produce, but there are costs, i.e. the infrastructure to support plantation. It is an illiquid market but the fringe (non-pecuniary) benefits include buying into an alternative lifestyle (Wullschläger, 1989)

Property

An unpredictable asset that produces a dividend/rent (buy to let) and offers capital growth. The market fluctuates in London from postal code to postal code, in Britain from region to region and in the eurozone from country to country. It is a global market, cyclical and dependent on local economic conditions. Like forestry it offers the investor utility. The market is, like the art and antiques market, fairly unregulated, with hundreds of property agencies, thousands of retail outlets, some international, but most domestic and local. Property has become a popular investment asset in the last 25 years.

Figure 12.1 Alternative investments

The supply and demand factors for the different markets

In the contemporary cutting-edge market the reputation of the artist greatly outweighs the size of the work or the materials used, whereas skill and sentiment are the most highly valued qualities in the alternative art market and both characteristics are reflected in the price. In the antiquities market, sound provenance is essential and in the antiques market, condition, stamp

and provenance are critical. In the market for Chinese art, jade, imperial porcelain and snuff-boxes fetch a premium price among Chinese buyers, whereas export and armorial porcelain and tomb sculptures are dependent on Western buyers. Chinese buyers are also keen to repatriate appropriated national treasures and their desires, preferences and recent wealth combine to produce high prices.

A number of writers (see Chapter 2; Becker, 1982; Moulin, 1987; Bongard, 1982; Bowness, 1989) have concluded that the price of a work of art is the outcome of the interaction between different art world actors. The supply side considerations for contemporary art revolve around the quality and frequency of an artist's exposure, the variety of media used and a price history.[12] Further considerations depend on the difference in the cost of producing an extra unit, gallery running costs, price expectation and the imminent death of an artist. The decision of the artist to stick with a commercially successful style or to do otherwise, strongly influences price. On the demand side, real per capita income, the rate of return against other investments, inflation and hedging all impact on price.

There are a number of techniques used to arrive at a price for a given work of art, but none capture all the value. The double sale method (comparing past prices), the average price method (weighing various artists in a sample) and the representative painting method (an index featuring close substitute works of art) are three of the most common.

The value of art exceeds, in some cases, its investment value. Art of the very highest quality or of particular emotional significance, contains attributes that cannot be captured by the marketplace. These attributes, let's call them the convenience-yield, are covered, at present, by the state's museums and galleries or by private foundations and museums. This gives the option value from which the public draws benefit without use. In this case the general public is just happy to know that they do own a share of the country's cultural capital even though they never intend to see it for themselves. Prestige value again reflects well on non-museum visitors who like the idea of a collection 'owned' by them. National identity is a benefit usually confined to impecunious cultural apparachiks whose voices are heard when a 'great' work of art is threatened with export. Spillover effects also concern the state, but mostly professional politicians, who equate art with economic and social regeneration. As much a public as a private incentive, the innovative effect allows for some value to be applied to the stimulation given to others by examples of creative excellence. Another shared public/private effect can be described as sunk-cost or the past efforts at building up a collection.

In the world of private foundations and museums, different values are captured over and above investment. Under the 'endowment' effect, individuals value a work, first and foremost, as a gift for subsequent (private or public) generations. The opportunity cost (or the cost of lost chances to make money elsewhere) the 'pyschic' returns (enjoyment) and the undervalued asset returns (a bargain) are all strong considerations for the prospective art buyer.

The econometric method of determining the value of art in the Old Master (drawing) market

Using weighted stock averages as a method of valuation for Old Master drawings, dividing a work of art into a number of non-observable price characteristics is common valuation practice. The quality weighting valuation method attributes different values to each non-observed characteristic and for each style of art within the Old Master drawing category. The non-observable price characteristics in this case are:

- *Technique* (pen and ink, black chalk, red chalk, wash, oil, pastel, water colour/gouache, white heightening)
- *Subject matter* (religious, one-person studies, landscapes, animals, flowers, historical/mythological, several person, heads and portraits)
- *Dimensions* (height, width, large or small)
- *Artist*
- *Year of sale*
- *Provenance* (number of collection stamps)
- *Other characteristics* (unsigned, signed, not reproduced, reproduced)
- *Saleroom* (Christie's, Sotheby's, etc.)
- *Signature*
- *Reproduced in the auction house catalogue*

(NB A portion of the price will remain unexplained, containing the variables of time, taste, place and random elements.)

Utilizing the qualitative method of valuation known as Hedonic Regression, Victor Ginsburgh and Nicholas Schwed of Brussels University (*Art Newspaper* July–Sept 1992)[13] created a price index based on these non-observable characteristics. They determined that French drawings had increased in value at a much faster rate than either Italian or Flemish in the period 1980–91. The use of oil paint in Old Master drawings during this period was found to be twice as attractive in French as in Italian drawings, but the size of drawing influenced the price of Italian and Flemish drawings to a much greater extent than French. A French landscape, they discovered, could not be compared to a Flemish or Italian landscape, which were significantly less important, but it could be compared to other French drawing subject matter. Old Master drawings escaped the 1991 art market collapse. Flemish drawings, however, did not increase in value from 1980 to 1987 and French and Flemish drawings fell in value in 1983 and Italian in 1981. An accurate All Old Master index would, bearing in mind the very different performances of Flemish, French and Italian drawings, be very difficult to imagine. Lastly, it is not sure whether this method can be used to forecast prices or whether it can just be fitted to a past model. An out of sample testing procedure would demonstrate this one way or the other.

Although subject to changes in taste, there are general investment characteristics for most art market sectors. (See Figure 12.2.)

Furniture
The design
Decorative features
Colour, patination and grain
Authenticity
Condition
Provenance
The catalogue

19th and 20th century English art
Subject matter
Melodrama
Sentimentality

Teddy bears
Condition
Maker's provenance
Sentiment

Firearms
Historical association
Unusual specimens
Decorative appeal
Constructional rarities

Silver (High art pieces)
Age
Rarity
Provenance
Quality
Sculptural form
Engraving
Manner of other decoration
Silversmith
Mark

Books
Rarity
Historical interest
Condition
Subject matter
With or without dust jackets
Language
Binding

Stamps
Country of origin (states with high philatelic reputation)
Method of production
Rarity
Condition
Unmounted mint
Mounted mint
Unused, part original gum
Unused, without gum
Fine used

Prints
Condition
State
Impression
Premium artists
Margins (full or trimmed)
Rarity
Quality
Richness
Detail of image
Condition
Impression
State of print
Limited according to historical fact
Limited by human intention

Wine
Vintage
Characteristics of the wine
Region of France

Motor cars
Body style
Coachwork
Famous ownership
Racing history
Rarity

Coins

Rarity
N Normal, S Scarce, R Rare, R2 Very rare, R3 Extremely rare, R4 11–20 in existence, R5 5–10 in existence, R6 3–4 in existence, R7 1–2 in existence.

Condition
Fleur-de-Coin (FDC) perfection
Uncirculated (UNC) newly issued, tiny imperfections
Extremely Fine (EF) under eye glass traces of wear
Very Fine (VF) Some rubbing and minor damage
Fine (F) Signs of wear, or badly centred, but inscription and date easily visible
Fair: serious wear but inscription and date just still visible
Poor: Badly worn or struck

NB A rare coin in FDC condition can be common in Poor condition

Figure 12.2 Determinants of value in other collecting categories

A premium is paid for medieval silver because most of it has been, over the years, melted down for bullion, and also for items from the golden age of English silver (1660–1830). A Royal connection and a superior maker (Paul de Lamerie, Paul Storr, Nicholas Sprimont and Philip Garden) will dramatically enhance value.

Furniture collecting is closely connected to lifestyle decisions, and English furniture (1550–1820) is thought to be more liveable than the extremely beautiful but impractical French equivalents. The furniture from both countries attracts a premium value.

The value of Old Master prints is determined by the stature of the artist. In descending order of importance: Dürer, Mantegna, Rembrandt, Callot, Canaletto, Goya, Ostade, Piranesi are the highest valued. The price is also affected dramatically downwards if the work is trimmed. In the modern print market the size of the edition, rarity of the work and involvement of the artist in the printmaking process are the governing factors in deciding value. An artist's proof (AP) is the most sought after of any run.

Rare books survived two economic depressions (1929 and 1987) unscathed, and colour plate and natural history books have performed particularly well. Rather like scientific instruments it is the evocation of long-since disappeared ideas that captures the imagination of many collectors. Among firearms, cased pairs of pistols are most desirable because they are easier to display and handle, but any guns made before the age of Colt's interchangeable parts in the 1830s are collectable.

Motor cars are perhaps the most international and understandable of collecting passions. The acquisition can be used and even produce a dividend if hired out for special occasions. A great premium is set on the love and attention lavished on a vehicle and its rarity, but only if the model is exclusive as opposed to inferior. The great marques like Bugatti, Rolls-Royce and Bentley followed by Hispana-Suiza, Ferrari, Porsche, Isotta Franchini, Mercedes, Alfa-Romeo and Jaguar are the 'exotics' which command the highest prices.

Some collecting is very irrational. Actrophiles (teddy bear lovers) are conditioned by sentiment and collect even in times of economic hardship. Philatelists collect because they are interested in history, geography and owning a small work of art, and at the extreme end (flyspeck philately) because of errors. Great wine, which is doubly sterile, offering no dividend or pleasure, despite its obvious consumption attributes, can now be purchased privately by an agent for as little as 10 per cent commission. It can also be acquired at a reasonable price at auction in 'options to buy parcels'.[14]

A work of art is subject to other pre-sale and point of sale actions, which impact on the price. It can take weeks, or even years, to sell a work of art and so the commission or bid–ask spread is often in the range 40–100+ per cent to compensate the seller for opportunity costs. If the work has extremely high unit value or is brokered, the percentage is considerably lower, but the principle of high commissions for single units characterizes sales in this market. Lower auction house commissions – typically 10 per cent for the buyer and 5–15 per cent for the seller – reflect the higher turnover (Ashentfelter in Towse, 2003). The execution price rarely if ever matches the posted prices, and in many cases prices are not even stipulated.

The business of auction

Jussi Pylkkanen (Deputy Chairman, Director nineteenth- and twentieth-century pictures at Christie's) speaks of the three learnt cardinal auctioneer virtues as pace, poise and preparation. A brisk but unhurried bidding rhythm

of 40–60 second intervals per lot is to be encouraged. Coolness under pressure is vital, as is research into potential and likely buyers. Two more cardinal virtues are God-given. They are panache and instinct. In combination all these virtues can elicit strong bids, where at first there were none (Pylkkanen, 2004).

Art auctions are conducted in the main according to the Anglo-Saxon system of open-cry ascending bids.[15] A 'reserve' is set and the 'ticks' agreed before the sale. The eventual owner is the last person to make a bid, at which point the work is 'hammered down'. This is known as the object's 'hammer price'. If a work fails to make its undisclosed reserve it is 'bought in',[16] and its 'reserve' is its hammer price. The work might then be sold at an undisclosed price below its reserve. A 'bought in' object is said to be 'burned' and is subsequently harder to sell. Ashenfelter (Towse, 2003, p. 32) maintains that this happens to a third of Impressionist works and to 5–10 per cent of goods in wine auctions. Other typical rates of 'buying in' fall somewhere between the two. To start the bidding an auctioneer may take 'chandelier' or 'off the wall' bids. Off the wall bids are placed by the seller but are unethical and even illegal if they are used after the reserve price has been exceeded. Sellers are forbidden by contract from bidding at auction in an attempt to bid up price. If the auctioneer thinks the seller may be good for another 'bump' he may generate a 'phantom higher bid' – this is also unethical and probably illegal (Ashenfelter in Towse, 2003, p. 34). Finally, in a Game Theory scenario, by not revealing the identity of the purchaser, the auctioneer encourages 'ring' members to bid privately out of self-interest.[17] Dealers may also encourage more than one of their clients to bid up the price of an object at auction, offering the successful bidder a *douceur* of another work of art.

Ashenfelter (Towse, 2003) talks of 'the declining price anomaly', which occurs when identical lots of wine appear in the same auction. To counteract this negative effect on price, auctioneers will put large quantities of wine at the end of the auction, reasoning that buyers see nothing wrong in paying less per unit for greater quantities and thereby avoiding the depressing of consumer sentiment. An auctioneer might also offer the successful bidder of the first lot following identical lots at the same price, capturing the business of the risk-averse. Most auctions in the art market are subject to the 'afternoon effect' when end of the day drowsiness and fewer bidders bring prices down. Auction houses combat this effect by spacing the most desirable objects throughout the day in a procedure known as the 'lot effect'. Skilled auctioneers will also 'work the room' and encourage a 'feeding frenzy' in an effort to counteract depressed prices. It is at the end of the day that a 'sleeper' or undiscovered, hidden masterpiece might appear, selling for a fraction of its potential worth.

As Ashenfelter and Sargot (Towse, 2003) explain, auctions produce a remarkably fair price and the international houses are able to achieve fundamental price through arbitrage, but the value of large and valuable collections is sometimes artificially enhanced when the auction house offers the seller a

minimum 'guaranteed' amount. Prices, as a result, more closely reflect the vendor's aspirations fuelled by a house anxious to secure the seller's business then a price between market clearing and the reserve. It is also likely (Goetzmann and Spiegel, 1995) that the private value component of art induces buyers to overpay for objects because a 'winner's curse' operates immediately after an auction sale following a decline in the potential number of bidders.[18] Once you have successfully bid in an Anglo-Saxon auction you have defined your position and you are known to be the person most willing to pay the highest price for a work of art. The winner's curse is to some extent off-set by 'greater fool theory': the knowledge that somewhere there is a greater fool than you willing to pay more for the same object. If you don't know who the fool is, then it is probably you.

In the dealer market, a less than rigorous approach to pricing is common. A 'feel for the market' (based on past prices), 'mark-up pricing' (based on a standard percentage increase) and an assessment of the buyers' 'subjective willingness to buy', which might have to be attained on the spot at an art fair, are three common techniques. Contemporary artists can also be 'burned'. If they are dropped by 'Alpha' dealers, lesser dealers will be reluctant to take them on. Sellers to secondary market dealers are unlikely to receive a fair price and should expect the dealer to mark up 100 per cent (Burgess, 2003).

All things being equal, art is cleared in the way shown in Figure 12.3 (Heilbrun and Gray, 1993).

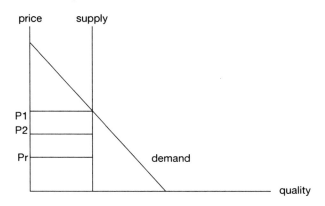

Figure 12.3 The clearance of art by private treaty

Note:
Market clearing or equilibrium price is P1. If no one is prepared to pay this price the seller will fix on P2 above the reserve Pr.

In the auction house where there is more than one bidder, the situation can be described in the way shown in Figure 12.4

Figure 12.4 The clearance of art through auction

Note:
In the stair-step method, the demand curve is discontinuous, which indicates a number of potential buyers. The keenest bidder (A) might be willing to pay Pa but need only offer P1a to top the bid of (B) at Pb. The price received by the seller still exceeds the reserve price, Pr, while the bidder preserves some consumer surplus.

Institutional intervention

Although difficult to prove, there is little doubt that the actions of the public sector museum and gallery world dramatically enhance the current value of art. Taste may be fickle, but public gallery curators and directors are perceived to be its monopolists. Even though they are drip-fed the new by the commercial world, they are seen to be disinterested selectors. Not just the public sector, but its constituent parts – collectors and critics – work together to create future price. As René Gimpel (2003) describes it:

> There is the object, the story of that object and, a subject of some delicacy, the price of that object. Dealer and client execute a quadrille and this new narrative becomes a supplementary commentary on the painting, another page of its history to be added to its provenance.

The fact that Rembrandt's 'Portrait of an Old Man' could sell for £100 (£4,063 today) in 1877, for 7,000 guineas (approx £228,000 today) in 1937 and £315,000 (£756,000 today) in 1969 tells us that that the system is deeply flawed. Rembrandt was a highly prized artist in his day, so what happened to taste and judgement? In the first sale in Palmeira Square, Hove, the work was sold as a Rembrandt painting, albeit of William Tell. The subsequent two sales were at Christie's, King Street. The 1870s and early 1970s were

both bear auction markets and so the only possible explanation is that respect for Rembrandt as an artist was rekindled by two major retrospectives of the painter at the Rijksmuseum in the 1950s and 1960s, allied to the actions of the great American collector Norton Simon who paid £798,000 ($2,234,000 today) for the artist's 'Portrait of Titus' in 1965.

When private collectors or dealers decide to lend a work for exhibition to a public institution, their works of art benefit from the resulting exposure, validation, and enhanced reputation. On occasion the owners may even receive an exhibition loan fee, which is a form of dividend. No clearer demonstration of the process of maximizing the total utility of art can be seen than in the Sigmar Polke exhibition at the Tate Modern (2003/4). Each work in the show had a caption indicating that the majority of the exhibits came from Polke's dealer, Michael Werner, and the rest, bar a few, from rarely anonymous private collectors. In the words of René Gimpel (2003):

> At the same time, the Tate Modern reincarnates Versailles. Like Versailles, the Modern is a spectacular building. Like Versailles, the Modern's appeal is to the First Estat. Like Versailles, the titular head of authority is not a commoner. Like Versailles, the Tate is a centralising authority. . . . Any contribution to the Tate enhances collectors and collection. Their named association with the Tate adds authority to their own activities in the art world, which is to increase the capital value of their collection. For American patrons, donations to the Tate are tax-deductible in their own country. . . . Art is discreet, portable, anonymous, surrounded by security and stealth. That is why it finds its way into the Tate.

Time, place and taste

The place of sale, time of sale and the taste of the day are all factors that are impounded into the price of art.

Time

If the world economy is depressed, art prices deflate, although in the case of a falling stock market, art prices usually respond positively for a short period afterwards before falling. Price is also dependent on the mood of the bidders and performance of the auctioneer on the day of the sale.

Even contemporaries are aware of when they are in a peak or trough. *The Times* newspaper of 25 April 1935 rightly identified the period 1927 to 1929 as boom art market years. It was subsequently right to assume that by 1935 the market had almost shaken off the bear.

Frank Herrmann, in Christie's *End of Year Report*, 1975, recalled another volatile period:

As the most dramatic for generations. It seemed to start reasonably well in the early autumn; then went into a short decline reminiscent of the worst pre-war doldrums on either side of Christmas; it staged a slow recovery in the Spring, and bounced back to near record-breaking form in June and July 1975.

In the 1988–89 season, the time when Jasper John's 'False Start' made $17.1 million and Sotheby's world-wide sales reached $2 billion, Alfred Taubman (1989) was able to write in the preface to *Art at Auction*: 'The 1988–89 season was the most successful in Sotheby's history'. Rather like property, it seems, art eventually succumbs to the general economic gloom, but, as we shall see, fares a great deal better and recovers much quicker.

Place

A work of art attains an international price in an art market capital and through international intermediaries, or in regional or local centres if it is of exceptional local interest and the local economy is expanding. In all other cases its price is flattened.

Most of the highest prices are achieved in New York and London, but there are occasions when top prices for works of art have been attained outside those two art market capitals. Hong Kong has achieved a record price for Chinese ceramics. China Guardian, Beijing recorded a top price for a work of Chinese contemporary art, and Sotheby's, Taipei for a Taiwanese oil painting. Arbitrage (strictly speaking, Capital Gains, since the transaction is never without risk) in the art world is, therefore, a common and lucrative activity and the price achieved at auction is closely linked to the number of bidders, present at any one time. Sotheby's and Christie's, who hold their sales at the same time to achieve a critical mass, are best equipped to attract the top bidders most of whom travel to New York and London auctions.

Taste

In his Prologue to Samuel Foote's comedy, 'Taste', published in 1752, the great actor, Garrick, disclaims:

> Before you buy, be sure to understand,
> Oh! Think on us what various ills will flow,
> When great Ones only purchase – what they know.
> Why laugh at TASTE? It is harmless fashion.

If you tell someone that they have a very poor understanding of black holes, they are unlikely to present a spirited defence. If you suggest that they have bad taste they are as likely to hit you. The 'I know what I like' school of aesthetics is a broad-based, inclusive and populous club that is dismissed by the

cognoscenti. It has expression in the alternative art market and is dominated by such sensations as nostalgia, sentimentality and a desire for narrative. Andrew Lloyd Webber's collection of Victorian art is a pictorial manifestation of this state. In the cautionary words of George Bernard Shaw, 'Do not do unto others as you would they should do unto you. Their tastes may not be the same' (in Hillier, 1974).

There is a paranoia in the art world about the onset of majority taste, and this is because a majority elects the most commonly acceptable, the average, not the most beautiful or the best. Cumming (2001) even feels that the re-attribution work of the five members of the Rembrandt Research Project is a, 'flawed enterprise: you cannot resolve disputed attributions by majority vote in a committee' (pp. 213–14). Yet, René Gimpel (2003) is able to say that: 'A bad, ugly painting which sells for a profit is useful' (p. 2).

This notion of art cleverly suggests, contra to Marxist thought, not only that exchange value has a use but also that art which is less than useful (bad) has a use value.[19] This view chimes with Galsworthy's in the *Forsyte Saga* when he explains that 'As every Forsyte knows, rubbish that sells is not rubbish at all – far from it' (in Hillier, 1974). The taste of the connoisseur exercises a disproportionate influence on the exchange-value of cutting-edge contemporary art and the art of the past in particular, although outsiders are unsure how these aesthetes arrive at their conclusions. Gimpel is wrong in one sense, because there is no such thing as bad, validated or authenticated art, just as there is no such thing as a connoisseur with bad taste. I am not trying to say that the more expensive an object, the nobler – *sub specie aeternitatis*, that would be a *reductio ad absurdum*, but I am saying that connoisseurs do not make errors in taste. Taste may change but the christened work of art is historically inviolate. Value may not always concur exactly with good taste, and this is a market fault, but the art historical process does help to redress this imbalance.

Risk-averse investors choose to collect in the cutting-edge, institutional market. If they are prepared to sublimate their taste to that of the cognoscenti then they can reduce their risk and costs by gaining access to privileged information. Leaked Alpha gallery information on the rising art market stars, supported by public sector shows, allows budding collectors to join the vanguard of 'good taste'. Many uninformed buyers according to Sagot-Duvauroux and Benhamou (Towse, 2003) offset uncertainty in the cutting-edge contemporary market by adopting copycat forms of behaviour, leading to price frenzies for 'hot' artists. This mimetic process or herding suggests that market forces alone do not necessarily select the most talented: 'Selected performers may be untalented, and inertia of consumers' behaviour leads them to dominate an increasing share of the market' (Benhamou in Towse, 2003, p. 73).

This, more importantly, leads one to conclude that the fundamental value of art must be incorrectly priced because particular emphasis is placed on the most recently available information. It is also worth considering that information on art is revealed more slowly than other investment vehicles

and as Hong, Stein and Lim demonstrated (Warwick, 2000, p. 140), low information stocks react more sluggishly to bad than to good news. This throws great doubt on the use of art as a hedge.

Despite this, once Alpha galleries have selected their art, the risk of it bombing is lessened. Potential buyers, however, are no nearer selecting for themselves the jewel in the crown. They might be usefully advised to buy an artist's entire oeuvre in the manner of Charles Saatchi, thereby negating the most elusive part of taste, a good eye. But their purchases are still based on fancy and taste, which suffer future market correction. The timing of a player's entry and exit into and out of taste determines how profitable is the experience.

Art as an investment and speculative vehicle

Although there are many similarities between the art and financial markets, there are crucial differences, which make pricing art and accounting for risk in the art market much less accurate and effective than in the stock market.

The measurement of art returns is subject to unacceptable levels of misinformation, and profits and losses are often shrouded in mystery. Most art businesses are privately owned, illiquid small enterprises jealously guarding price information. Client identity is confidential and the buyers prices have paid outside auction are hard to verify. Finally, there is no obvious benchmark[20] for art, which makes risk assessment very difficult. It has been suggested (Gérard-Varet, 1995) that investors in art are capable of 'rational bubbles' with the short-run prospect of gains compensating for the risk that the bubble may burst, but there is slight hard evidence to this effect.

An art index

The construction of an art index is hampered by a number of unique factors: art only sells occasionally, no two works of art are identical, there are only a small number of bidders per work, and works include a private value component (Goetzmann and Spiegel, 1995). An added problem with six of the most interesting art market indices is that they offer only partial price information. All six are relatively strong on tertiary market results, although most developing market tertiary activity is ignored, and private treaty sales remain unrecorded. Yet, today, serious attempts are being made to bring transparency to the art market and to create indices against which international, not just industry, investors and speculators can bet. The American Mei/Moses Index correlates the All Art Index (AAI) to the Standard & Poor 500 (S&P 500). The British Art Market Research (AMR) plots the progress of a number of categories, sectors and types of art and with Mei/Moses is an industry standard. The Art Sales Index (ASI) (also British based) and French Art Price Index (API) do not appear to use any benchmark index, but plot the financial vicissitudes of individual artists, movements and national

markets. The Italian Art Index Gabrius (AIG) operates an investment tool, Artexpand, which purports to offer investment guidance to collectors. The news that Bloomberg are to supply data to the Gabrius index certainly opens the art market up to the wider investor community. Nomisma, an index based in Bologna, has set about aligning expert art historical appraisal with independent economic valuation for Italian Old Master paintings (interview, 26 January 2004). It has also attempted a Mei/Moses style comparison between the AMI top 500, European real estate, and international and Italian government bonds (Sassoli de Binachi, 2001). A small bespoke London-based agency, Arttactic, gives advice to subscribers on the investment potential of contemporary artists, based on past prices (interview, 2 February 2004).

Using a financial tool, the capital asset pricing model (CAPM), Pesando and Shum (1999), attempted to correlate the S&P 500 against a part of an index, Picasso prints. The danger of taking the performance of an artist in isolation is similar to that of evaluating a component of a work of art – say its condition – and arriving at a final price. The problem with taking an index, say the Old Master, and measuring its solitary progress is the same as looking at the price of Ford motor cars and not at those of its competitors and concluding that Fords offer good value for money. The Old Master index may be shown to have gone up, but it may also have under-performed relative to other art market indices and to financial commodities.

In theory, a benchmarked index should make it easier for an investor to borrow money from a bank to buy a work of art. In practice, it is difficult to operate because information on art prices is so limited.

An art market index needs an equivalent benchmark index in order to give sense to its performance. Is the answer, therefore, to use a default investment strategy and measure it against a blue chip Equities index like the S&P 500, FTSE100, FTSE Eurotop 300 or Nikkei 225 Average? It is not at all sure that investors pile out of equities into art at the first signs of a crisis in the equities market and there is little else to recommend volatile equities as a proxy. The only risk-free asset would appear to be government backed bonds, and then again not the bonds backed by all governments. The UK government's gilt-edged securities and the US, Japanese and (soon) European bond markets are all safe havens.

All these benchmarks are, however, incorrect proxies. They reflect only a part of global activity and, importantly, pay no heed to taste. The consumption-based asset pricing model (CBAPM) developed by Breeden (1979) introduced per capita consumption, which is helpful but covers all goods and services and is therefore too general. A more interesting model is the arbitrage pricing theory (APT) which allows for such things as price to earnings ratio (P/E) and pre-specified economic factors (Chen *et al.*, 1986). Yet even this model fails to account for taste. We have applied financial descriptors to works of art and I think this is a useful way to look at the commodity, but there are major discrepancies between financial and art commodities. Sellers of contemporary art are not able to secure a future

position, fearing unfavourable changes in interest rates, stock indices or currencies, because LIFFE (London International Financial Futures Exchange) or a Chicago-style futures exchange for art does not exist. The problem remains that we are no nearer assisting investors measure their exposure to risk because we are no nearer predicting what an artist will create next, if anything.

In a small way, the dealer/client relationship does offer a degree of security. If a buyer, who sees the value of his purchase increase over the short term, wishes to secure that gain, he may agree with the dealer from whom he bought the work, to buy it back at the current price. If the dealer agrees then the buyer has, in effect, acquired a put option. But there is unlikely to be a written contract and the deal rests on a handshake.

It is probably true that at one level of the tertiary market – Alpha quality Old Masters, moderns and established cutting-edge contemporary – a fairly accurate index can be created, since most of these works circulate around the world's top auction houses and international cities. One has to assume that the private treaty sales for these works correspond to auction house prices, although this is a big assumption. It still does not account for 'sleepers', fakes, forgeries, misattribution or the illicit trade, but these top works could be correlated against a stock market equivalent. Perhaps the new index could be called the All Art 1000. All other work, after being cate-gorized, could be measured against specific commodities such as precious or industrial metals (GSCI Industrial Metals sub-Index). The real estate and wine markets would provide more accurate proxies, although arguably both commodities are too close to the art market. The search continues for a proxy index that will act as a benchmark against which the volatility of art can be measured.

Time lag

The time lag between a declining stock market and falling art market is one important element of the art market that the indices are able, retrospectively, to capture. Christie's former Chairman, appositely called, I. O. Chance, observed in 1974 that there was an 18-month gap between the stock market collapse of 1929 and a fall in art prices. Mei/Moses have gone on to record as saying that a significant fall in art prices occurred from the late 1870s until the early 1880s, lagging behind the economic depression of 1876–79. A less dramatic decline can be noted in late 1974 (approximately 18 months after the economic crisis of the early 1970s) (Mei and Moses, 2002). Probably the most dramatic collapse in art prices (across all major markets) occurred late in 1990, approximately three years after Black Monday (19 October 1987) (Mei and Moses, 2002; ASI, 2003). Recovery was uneven, with the US market returning to pre-crash highs by late 1997 and the UK not until the summer of 2000. France and Germany have still failed to achieve the high pre-crash values, but minor markets have fared much better (ASI, 2003). As

little as a year separates art from financial market performance according to Olivier Chanel (1995) and although stock exchanges may be considered advance indicators of art market performance, changes in fashion and taste make long-term forecasts difficult. Mei and Moses (2003) believe that the correlation between art and stock values is relatively weak, or in the case of the masterpiece index, negative:

> First, while there tends to be a flight to safety away from the art market, producing a decline in art prices, the impact of recessions tend to be short-term. While several recessions did cause large price declines, such as those of 1973–75 and 1990–91, the declines did not happen until the second year of the recession and they were followed by robust recovery after the recession. On average, art prices have decreased on average 0.7 per cent during the past 27 recessions over the 1875–2000 period. Second, art prices are unpredictable even in the midst of a recession. While art prices generally tend to fall during a recession, this is not always the case. For example, there were no decreases in the overall art price index in the recessions of 1960–61, 1980, and 1981–82. Third, the average appreciation of art prices was 7.7 per cent over the 1875–2000 period, outpacing inflation by 4.9 per cent compared to an inflation beating real return of 6.6 per cent by the S&P 500. Thus, art seems to be a good long-term store of value in addition to the aesthetic pleasure enjoyed by its collectors.
>
> (Mei and Moses, 2002)

It does seem that a managed art fund would do rather well during a downturn in the stock and bond markets. In that sense art would make a sensible addition to an alternative financial portfolio of futures and derivatives or even an asset within a hedge fund.

Holding period

Failure to observe the five- to ten-year 'interval of safety' for holding a work of art before resale was one reason, suggests Frank Herrmann (1974), for the topsy-turvey (Moulin, 1987) post-war market. The other, he goes on, was the unshakeable confidence in art as an object of (real) value. The optimum period for holding art is 20–30 years, because despite the extreme volatility, a focused collection should outperform the market. The profitability of long-term investment over short-term gain is supported by Goetzmann and Spiegel (1995) although they add that increasing numbers of global collectors and shifts in taste towards Western-style twentieth-century art have helped offset the 'winner's curse'.

The returns

The ever-resourceful Wemmick in Dickens's *Great Expectations* urges Pip to 'Get hold of portable property' (Ch. 24). Art and antiques are just that, but Wemmick might have been disappointed by their returns.

Art is not a particularly good pure financial investment, although it has consumption benefits that make it an attractive part of any financial portfolio. It is, at best, a floating rate commodity because unlike bonds the rate of interest and thus the return cannot be fixed. It is also illiquid and indivisible – or so it might appear. You cannot, Ginsburgh argues, buy a 1,000th share in a Picasso painting, yet this is exactly what the Fine Art Fund, a US Delaware registered limited partnership managed in the UK and chaired by Lord Gowrie, is seeking to do. The $100 million to $350 million fund aims to hold its art from ten to thirteen years, sell it and reward the pool of investors with a share of the profits.[21] Investors are asked to commit their capital for a minimum six-month to maximum 10-year period. The Fund's optimism is based on the dwindling supply of Alpha works (their market), which will continue to push prices high:

> The Fine Art Fund will create a diversified portfolio of works of art by some of the world's greatest artists, usually only accessible to the wealthiest individuals or largest corporations. . . . The Fine Art Fund will consider acquiring selected works of art from collectors in exchange for a participation in The Fine Art Fund. . . . The Fund may make opportunistic sales between years four and nine but would only do so where returns appear very attractive.
>
> (Fine Art Fund, 2003)

The Fund reserves the right to sell any of the work at auction or privately to either collectors or museums. Crucially, investors can 'enjoy' the Fund's works of art in their homes and offices, and works may be lent to third parties 'for the benefit of the Fund's investors'. The Fund suggests that there is a negative correlation between equities and it notes that the areas in which it is interested in investing have shown 8–12 per cent compound annual growth over 25 years:

> With the benefit of advice from world class experts, The Fund expects its portfolio of works of art to show an appreciation in value over the life of The Fund in excess of the art market average based on the Art Market Index (as published by Art Market Research).
>
> (Fine Art Fund, 2003)

There are a number of occasions when collections and investment funds have reaped significant rewards. The British Rail pension fund, established in 1974, invested £40 million into the art market across ten art categories,

approximately 2.9 per cent of its entire portfolio. It sold the bulk of its collection in the second half of the 1980s, achieving an overall return of 11.3 per cent compound to December 1999. In Impressionist art the return was 21.1 per cent compound. The Victor and Sally Ganz sale at Christie's, New York in 1997 achieved a similar return, 11.74 per cent compound, just under a per cent higher than stocks (10.85 per cent compound). Charles Saatchi sold 128 contemporary works in 1999 for £1.6 million, 60 per cent more than the estimate and, reputably, some 150 per cent more than he paid for them ten years previously. The Chicago collector Lew Manilow bought Jeff Koons's 'Michael Jackson and Bubbles' in 1991 by private treaty for $250,000 and sold it two years later for $5.6 million. These last two examples point to the recent rude health of the contemporary art market, which has grown exponentially since the 1990s. The art insurer Zurich (Zurich-Art Market Research Art & Antiques Index, 2003) explains that because it offered the opportunity for buyers to make a personal statement, build an image and '*blaze or support new trails*' contemporary art increased in value 126 per cent from 1995 to 2003 and 26 per cent from 2002 to 2003.

So, it could be argued, as Ginsburgh does, that given significant acuity and expert advice, the financial return on paintings for modest investors is roughly comparable to that of wealthy collectors. If managed well it could also be argued that art returns are comparable to those of stocks and shares. Ginsburgh's model portfolio for the modest collectors differs a little from the Art Fund's but is substantially the same:

> They [realized returns and variances for various indices] show that the risk for a portfolio of Impressionist, modern and contemporary masters is much smaller than for portfolios of other European and American painters. If only investment decisions were at stake, an optimal portfolio mixing both groups would therefore contain a much larger share of European masters. This is less so with prints, the returns and risk of which are not very different from those of paintings. However, if decisions are also based on liquidity considerations, choices may well impose paintings by less known artists and/or prints instead of paintings.
>
> (Towse, 2003, pp. 49–50)

The 1990s and the first few years of this century demonstrate that art has actually produced better returns than the stock market, enough to put a smile on the face of a latter-day Wemmick. In the year to June 2002, the FTSE 100 share index fell by 17.4 per cent compared to a 9.7 per cent fall in the UK art auction index. However, the Art Sales Index shows that over the last ten years the FTSE All-Share Index has risen by nearly 200 per cent and the UK art auction index by just 65 per cent. The main problem with art as an investment is the large sums you have to tie up for significant periods of time and the cyclical nature of some sectors of the market. Shifts in taste can

suddenly catapult value for certain types of art and leave other categories destitute.

The blue-chip banks such as Dresdner AG, UBS, Citi, Merrill Lynch, Unicredito, BNP Paribas, Deutsche, Coutts, Monte dei Paschi di Siena, Banca IntesaBci and Credito Italiano have all at some time offered, as part of their private banking service, art and antiques as an alternative investment to very high net worth individuals. These banks establish closed funds often in collaboration with an auction house or specialist consultancy and revel in the glow of positive publicity. *Premier*, the magazine for HSBC premier customers carried a section on alternative investments in its winter 2001 issue. They advised that starting your own collection should be driven by the heart but informed by 'focusing the eye'. The eye, the magazine suggests, is best honed by going through reputable dealers in London and New York, but also to Hong Kong and Beijing based dealers for Chinese contemporary art – according to the magazine, a hot new investment opportunity. Perversely, the magazine suggests that budding collectors restrict their collection to one genre or period in the sanguine expectation that one day that collector will be the new Samuel Courtauld or Dr Albert C. Barnes. Putting all your eggs into one basket is dangerous advice from one of the sponsors of the Art Fund.

Art is also expensive to acquire. There are substantial commissions to pay, because information costs are high and it needs to be insured by a specialist firm like Aon La Playa or Hiscox Syndicate 33. The high transaction costs in art also make it an unattractive investment commodity. According to Kate Burgess in the *Financial Times* (2003):

> sellers of small-ticket items can pay up to a quarter of the hammer price in commission and charges to auction houses. Successful bidders can pay one fifth in what is euphemistically called the 'buyer's premium'. This is added to the price the buyer pays, but it means that, in total, a sum equivalent to nearly half the hammer price can go in dealing charges and commissions.

There are other costs applied to art, such as VAT, transport, insurance, photography, restoration, advertising, shipping, packing, storage, customs duties, import tax, and now in many countries *droit de suite*. Buyers from dealers should bear in mind that the 20 per cent premium asked of them on the first £70,000 and 12 per cent thereafter asked of them by Sotheby's (Christies 19.5 per cent on first £70,000 and 12 per cent thereafter) is more likely to be 50 per cent and upwards in the secondary market. These high commissions are justified by the relative illiquidity of art and its high information costs. Sellers are penalized by a 15 per cent sales commission and 1.5 per cent insurance in the tertiary market.

High transaction costs contribute to long holding periods. If my costs, for example, are 25 per cent and the asset grows at 10 per cent per annum, I will

be showing a loss for the first two and half years of holding the asset. If I sell at the end of three years, the asset has risen by 30 per cent, but I have made only 5 per cent profit – less than 2 per cent per annum. I am better off, therefore, holding on to my art for ten years or more.

Achieving Alpha in art (making a superior return after adjustment for risk) is based most commonly on exploiting stale or incorrect information or through insider trading and access to privileged information. The limits on arbitrage in the art market given the absence of close substitutes make this a risky activity, which often results in substantial losses. Sholes's substitution hypothesis (Schleifer, 1999) states that if a seller unloads stocks, a number of investors gladly increase their holdings, reducing holdings in close substitutes, in exchange for a small price increment in order to achieve greater portfolio diversity. This works because of the perfect competition between the potential buyers. It would be very unlikely to occur in the art market because in common with broad classes of securities, there are no obvious substitutes and so there is no riskless hedge for the arbitrageur. Price inequalities, therefore, are slow to be corrected. If a major collection of Impressionist paintings came up for sale at Sotheby's in New York, bidding would be fierce, but the bidders would in all likelihood be interested in modern art. It would be highly unusual for a private individual interested in contemporary painting to buy at an Impressionist sale in order to spread risk. Institutional funds, such as the British Rail and Art Fund, would be the only takers. The Japanese institutional buyers of Impressionist and modern paintings of the late 1980s used a leveraged arbitrage strategy to acquire works of art by borrowing money from local banks who failed to realize that the fundamental value of this art had been vastly exceeded. Institutions, like individuals, get it wrong a lot of the time.

Art investors do not speculate against indices because art indices are partial and often inaccurate, and although categories of art fluctuate due to external pressures they do not react rapidly to critical comment, oral or written, in the manner of financial markets. They have little knowledge of price history (see fluctuations of price in pre-Colombian statuary), are susceptible to the framing of information (see Gigerenzer, 2002) especially from dealers in the primary and secondary markets, and they show a marked distaste for offloading or exchanging their purchases.[22] But, as was evident in 1990 with the collapse of the art market, the market is susceptible to 'noise traders' and a herd mentality, although it takes a long time to impound into a price change. One of the most unnerving things about art prices is that they react in the same manner to hype as to informed comment. In a limited arbitrage market with weak substitutability and slow price convergence to fundamental values, the investment and trading risks are high. Add mercurial investor sentiment to the equation and the picture is yet more uncertain.

Returns

Table 12.1 shows the percentage returns from art for various periods, with comparative figures from the stock market.

From 1961 to 1989 the rate of return from art was a medium of 1.5 per cent, with an average rate of return as a minimum of –19 per cent and as a maximum of 26 per cent.

Whatever one's reservations about using S&P as a passive benchmark index for art, the data in Table 12.2 clearly show that art outperforms stocks during war and recession. Mei and Moses (2002) point out that art is volatile in 'interesting' times, but performs well over the medium term (ten years) and provides good diversification. The partnership also established (2003) that the lowest third of objects by price performed the best outperforming the S&P 500 from 1950 to 2002. The middle and top thirds of the market performed the same and 'substantially under-performed the low price index' (2003). The low price index also outperforms the all art index and has higher returns and lower risk than the other two art indices, but the S&P 500 enjoys lower risk than any of the art valuation indices. Nevertheless the risk decreases as the art holding period increases without substantial changes in return. Mei and Moses (2003) conclude that:

> These findings support the general notion that art is an excellent long-term store of wealth but potentially inappropriate for investors who do not properly balance arts higher risk with other asset classes in their wealth portfolio.

A simple formula (Heilbrun and Gray, 1993) helps us to understand returns from assets. The formula is:

$$R = \frac{C + Pt + 1 - Pt + S}{Pt}$$

where R = return, C = dividend or coupon payment received, $Pt+1$ is the expected price in the next time period, Pt is the actual purchase price, and S is the convenience yield.

Table 12.1 The returns from art over various periods

Dates	Art return (%)	Stock return (%)
1810–1970	3.3	6.6
1946–1968	10.5	14.3
1652–1961	0.55	2.5
1715–1986	2.0	3.0 (Bank of England)
(cited in Frey, 2000)		
1875–2000	7.7	6.6 (S&P 500)
(Mei and Moses, 2002)		

Table 12.2 The performance of art in times of recession and economic unrest

Dates	Art	FTSE	S&P
1913–15	–34%		
1913–18		–25%	
1913–18			–18%
1937–40		–50%	
1937–38			–50%
1937–39	88%		
1920	125% of 1913 value		
1920		94% of 1913 value	
1920			94% of 1913 value
1946		104% of 1937 value	
1946			=1937 value
1946	130% of 1937 value		
1954			67% of 1949 value
1954	108% of 1949 value		
1975			–27% of 1966 value
1975	256% of 1966 value		

Source: Mei and Moses (2002).

Property

$$R = \frac{C\ \$12{,}000\ (\text{rent}) + Pt{+}1\ \$60{,}000\ (\text{expected sale price}) - Pt\ \$50{,}000\ (\text{purchase price})}{Pt\ \$50{,}000\ (\text{purchase price})}$$

Return is 0.44 (44 per cent) minus cost of ownership, inflation and opportunity cost. Here S is excluded because property to let is rarely if ever aesthetically appreciated.

Art

For a collector:

$$R = \frac{Pt{+}1\ \$6{,}000 - Pt\ \$5{,}000 + S\ \$1{,}000}{Pt\ \$5{,}000}$$

Return is 0.40 (40 per cent) minus costs of ownership, inflation and opportunity costs.

For a speculator:

$$R = \frac{Pt{+}1\ \$6{,}000 - Pt\ \$5{,}000}{Pt\ \$5{,}000}$$

Return is 0.20 (20 per cent) minus cost of ownership, inflation and opportunity costs.

The convenience yield (S), which is a major consideration for collectors, but not for speculators, is measured as the difference between the financial return and the returns achievable through alternative investments. Art is rarely rented (C). As Heilbrun and Gray (1993, p. 161) explain:

> For a work of art we would expect that C would equal zero, but it might be negative, when such things as insurance premiums, maintenance and other outlays are taken into account. Normally S would have some positive value. For a typical asset, on the other hand, S would be zero and C would have some positive value.

A collector, so the logic goes, should be willing to outbid a speculator when S (the convenience yield) is calculated into the formula. Speculators also tend to leave the market when price variations appear, attribution becomes uncertain and transaction costs increase. If financial assets produce say 15 per cent in the next time period, and the collector, speculator and dealer believe the value of the painting will increase by say 20 per cent, then this projected increase has to be offset against the performance of other assets. A collector will, however, always pay more to the power of his or her convenience yield. The opposite is likely to be true if, for example, an asset like property shows declining returns and a lower expected sale price. Art prices in this instance will probably rise. Sometimes, when a buyer has just successfully bid for a work of art, the under-bidder will approach the new owner privately with a higher offer. So shortly after the sale, the owner has probably not had time to enjoy the work and will refuse. This behaviour will, in theory, reduce real future price. All these scenarios are approximations of market behaviour, and there is never any precise agreement on the future price of art.

An investor buys a case of Château Lafite in order at some stage to realize a profit, to make the commodity, metaphorically, liquid. It is of no concern to this individual that the wine is on the way to becoming *vin aigre* (sour), that it is *bouchonné* (corked) or that it might be *usé* (worn). The investor is also indifferent to the wine's qualities, its *finesse*. A sommelier, on the other hand, is interested in the wine's physical properties, and it is the *goût* (taste) of the sommelier that allows the chateaux, wine merchant and investor to benefit financially. In much the same way, scholars, critics and public sector curators employ their connoisseurial expertise to authenticate and validate works of art and antiques for the benefit of dealers and collectors. Both markets require the services of the disinterested and informed who should, but don't, capitalize by commission on their expertise. Perhaps it is the inability of the connoisseur to price the newly attributed or freshly validated object that permits this injustice. They, on the other hand, are not subject to the risk of bankruptcy – a fate which befell certain investors in the Dutch Tulip mania who mistook onion for tulip bulbs and lost all.

Notes

1 Doubt has been cast on the level of speculation during the *Bloemenspeculatie*. Peter Garber argues in *Famous First Bubbles* (2001) that the reality has been wildly exaggerated some 200 years later by Charles Mackay in his chapter on 'Tulipmania' in his *Extraordinary Popular Delusions and the Madness of Crowds* (1841/1852).

2 'The basic idea behind MPT is that the set or "universe" of securities representing the investment choice faced by an individual behave differently to each other' (Hughes, 2002, p. 21).

3 MPT: 'Principles underlying analysis and evaluation of rational portfolio choices based on risk–return trade-offs and efficient diversification' (Bodie *et al.*, 2002, p. 984).

4 Fixed commissions ended on 1 May 1975 but electronic trading, which began in 1980, allowed for over the counter (OTC) sales and wide bid–offer spreads due to informal collusion. This came to an abrupt end after 1994 when the first antitrust law suits were filed against the NASDAQ.

5 Fund managers tend to hold a minimum of 15 stocks in their portfolio, but will hold more the bigger the fund. By the time 15 stocks have been included, 'a great proportion of specific risk (i.e. risk associated with the holding of individual securities) has been diversified away as a result of the differing behaviour of securities given different market conditions' (Hughes, 2002, p. 29).

6 'A measure of the degree to which returns on two risky assets move in tandem' (Bodie, 2002, p. 980).

7 According to Luehrman (1997), the return is then measured against the investor's patience and the risk-premium

8 Equities indices are used next to art indices because there is an assumption that equity investors abandon equities for art when returns on the financial markets are low or negative. This is not necessarily the case.

9 Arbitrage Pricing Theory 'describes the relationship between expected returns on securities, given that there are no opportunities to create wealth through risk-free arbitrage investments' (Bodie *et al.*, 2002, p. 978).

10 Weak efficiency states that prices fully reflect the information implied by all prior price movements (Keane, 1983, p. 10).

11 Within financial markets, Futures, Derivatives and Hedge Funds provide alternatives.

12 The art commentator, Willi Bongard constructed a remarkably accurate fame and fortune index for contemporary artists ('KunstKompass') in which he awarded and deducted points for different events in an artist's career. Points could be acquired for one-person shows and deducted if the artist chose not to reside in an art market capital, for example. In 1999 his table of actual and predicted prices showed that his fame and fortune barometer was extremely accurate. Sigmar Polke scored the highest number of points in 1989–99 and was the leading points scorer in the 1998–99 season. He was considered to be fairly priced. Third on the list, Bruce Nauman, was considered very good value. Douglas Gordon comes in at 18, and very good value and Paik Nam June at 21 but very expensive. Damien Hirst languishes at 97 and is considered very expensive, but this was before the artist's show at Gagosian in New York.

13 The results of Ginsburgh and Schwed's research was based on public auctions between 1980 and 1991 in almost all Christie's and Sotheby's sales (a total of 2,375 drawings – 707 Flemish, 513 French and 1,155 Italian).

14 'Options to buy' allows the buyer of the first Lot of wine the option to take further kits of similar bottle size at the same price (Wullschläger, 1989).

15 Fish and flower auctions are conducted according to the Dutch auction of descending bids. A Vickery auction is favoured in the second-hand car market, operating according to ascending bids but awarding the item to the last bidder at the second highest price. Both systems lend themselves to speedy transactions. The closed or sealed bid auction is used in the property market and greatly favours sellers over buyers.

16 Bonham's auction house retains the auctioneer's discretion to sell an object that fails to make its reserve at half the low estimate. The low estimate is often set just above the reserve.

17 See Gigerenzer, 'The Monty Hall Problem' and 'Three prisoners on death row' (2002, pp. 217–27).

18 The 'winner's curse', which can be described as the bid gap between bidder and under-bidder is also known as the 'liquidity premium' or 'bid–ask spread' (Goetzmann and Spiegel, 1995).

19 Finally, nothing can be a value without being an object of utility' (Marx, 1867/1999, p. 131).

20 The benchmark can be viewed as the manager's 'neutral position'. It is used by trustees with the intention of monitoring the level of risk taken by the fund manager, this being measured by his deviation from benchmark weights (Hughes, 2002, p. 45).

21 Dresdener Kleinwort Capital raised up to £200 million for a fine art fund in 2002/3, but required the investors to pay £175,000 over a six-year period.

22 René Gimpel has noticed (Dec. 2003) that fewer and fewer collectors retain their art throughout their lives, preferring to exercise options, swaps and futures: 'Capital, he asserts, in whatever form, is restless, encouraging collectors to shift, dispose, reassemble, repackage. But then people also change homes, cars, fashion, partners and countries. It's an unstable world.'

Bibliography

Altman, E. I. and Nammacher, S. A. (1987). *Investing in Junk Bonds: inside the high yield debt market*. New York: John Wiley & Sons.

ASI (Art Sales Index) (2003) Online at www.art-sales-index.com

Becker, H. S. (1982). *Art Worlds*. Berkeley: University of California Press.

Bickerton, I. (2003). *Financial Times*, 5 December.

Bodie, Z., Kane, A. and Marcus, A. (2002). *Investments*. London: McGraw-Hill Irwin.

Bowness, A. (1989). *The Conditions of Success*. London: Thames & Hudson.

Breedon, D. T. (1979). 'An intertemporal asset pricing model with stochastic consumption and investment opportunities', *Journal of Financial Economics*, 7, pp. 265–96.

Burgess, K. (2003). *Financial Times*, 13–14 December.

Chanel, O. (1995). 'Is art market behaviour predictable?', *European Economic Review* (Elsevier): 519–27.

Chen, N., Roll, R. and Ross, S. (1986). 'Economic forces and the stock market: testing the APT and alternative asset pricing theories', *Journal of Business*, 59, pp. 383–403.

Coffman, R. (1991). 'Art investment and asymmetrical information', *Journal of Cultural Economics*, 20, pp. 1–24.

Coggan, P. (1999). *The Money Machine: how the city works*. Harmondsworth: Penguin.

Coggan, P. (2003). *Financial Times*, 15 December.

Cumming, R. (2001). *A.R.T.: a no-nonsense guide to art and artists*. London: Everyman.

Duthy, R. (1978). *Alternative Investment*. London: Michael Joseph.

Ferguson, N. (2001). *The Cash Nexus: money and power in the modern world 1700–2000*. London: Allen Lane, The Penguin Press.

Fine Art Fund (2003). Brochure of Fine Art Fund LP, January. London: Fine Art Management Services Ltd.

Frey, B. S. (1997). *Not Just for the Money: an economic theory of personal motivation*. Cheltenham: Edward Elgar.

Frey, B. S. (2000). *Arts and Economics: analysis and cultural policy*. Berlin: Springer.

Galbraith, J. K. (1994). *A Short History of Financial Euphoria*. London: Whittle Books in association with Penguin Books.

Garber, P. (2001). *Famous First Bubbles: the fundamentals of early manias*. Cambridge, MA: MIT Press.

Gérard-Varet, L.-A. (1995). 'On pricing the priceless: comments on the economics of the visual arts', *European Economic Review* (Elsevier), 39, pp. 509–18.

Gigerenzer, G. (2002). *Reckoning With Risk: learning to live with uncertainty*. London: Allen Lane, The Penguin Press.

Gimpel, R. (2003) unpublished paper.

Goetzmann, W. and Spiegel, M. (1995). 'Private value components, and the winner's curse in an art index', *European Economic Review* (Elsevier), 39, pp. 549–55.

Grampp, W. D. (1989). *Pricing the Priceless: art, artists and economics* New York: Basic Books.

Hagstrom, R. G. (2001). *The Essential Buffett: timeless principles for the new economy*. New York: John Wiley & Sons.

Heilbrun, J. and Gray, C. M. (1993). *The Economics of Art and Culture*. New York: Cambridge University Press.

Hermann, F. (1974) *Sotheby's Art at Auction*, London: Sotheby's.

Hillier, B. (1974) 'Foreword', *Christie's Review of the Year*, London: Christie's.

Hughes, D. (2002). *In Theory and Practice: an introduction to modern portfolio theory*. Canterbury: Institute of Financial Services, Financial World Publishing.

Keane, S.M. (1983) *Stock Market Efficiency: theory, evidence and implications*, Oxford: Philip Allan.

Louargand, M. A. and McDaniel, J.R. (1991). 'Price efficiency in the auction market', *Journal of Cultural Economics*, 15, pp. 53–64.

Luehrman, T. A. (1997). *What's it Worth? A general manager's guide to valuation*. Cambridge, MA: Harvard Business Review.

Marx, K. (1867/1990). *Capital*, vol. 1. Harmondsworth: Penguin.

Mei, Jianping and Moses, M. (2002). *Art as an Investment and the Underperformance of Masterpieces*. New York: New York University Press, available at http://www. stern.nyu.edu/artgood.pdf

Mei, Jianping and Moses, M. (2003). 'Semi-annual index update and spring New York auction season review', http://www.stren.nyu.edu.artgood

Mould, P. (1997). *The Trial of Lot 163: in search of lost art treasures*. London: Fourth Estate.

Moulin, R. (1987). *The French Art Market: a sociological view*. New Brunswick, NJ: Rutgers University Press.

Pesando, J. and Shum, P. (1999). 'The returns to Picasso's prints and to traditional financial assets, 1977 to 1996', *Journal of Cultural Economics*, 23, pp. 183–92.

Pylkkanen, J. (2004). *Financial Times*, 29–30 May.

Sassoli de Bianchi, E. (2001). 'Art advisory services as a branch of private banking: the Italian case', unpublished MA dissertation, City University, London.

Schleifer, A. (1999). *Inefficient Markets: an introduction to behavioural finance*, Oxford: Clarendon Press.

Taubman, A. (1989). 'Introduction' *Art at Auction, 1988–1989*. London: Sotheby's.

Towse, R. (2003). *Handbook of Cultural Economics*. Cheltenham: Edward Elgar.

Valdez, S. (1997). *An Introduction to Global Financial Markets*. Basingstoke: Macmillan Press Ltd.

Warwick, B. (2000). *Searching for Alpha: the quest for exceptional investment performance*. New York: John Wiley & Sons.

Wullschläger, J. (1989). *Alternative Investments*. London: Financial Times Business Information.

Yates, J. F. and Stone, E. R. (1994). *Risk-taking Behaviour: the risk construct*. New York: John Wiley & Sons.

Part III
Conclusion

13 Endgame and beyond

Iain Robertson

> So you'll probably think it incredible, until you've actually seen it for
> yourselves. According to this system, plates and drinking vessels though
> beautifully designed, are made of quite cheap stuff like glass or earthenware.
> But silver and gold are the normal materials, in private houses as well as
> communal dining-halls, for the humblest items of domestic equipment, such
> as chamber-pots.
>
> (Sir Thomas More, *Utopia*, 1516)

It is June 2004. I am aware that in the months between the submission of
this manuscript and its publication, the stock and property markets may have
crashed. If, indeed, the financial and property markets have imploded, then
I am confident that the art market will be at the height of its boom. Within
a couple of years of this boom, slightly less or more, the art market will have
also crashed. This will be the case if not this year than the next or the next.
Rest assured, it will happen. So what are the signs that should alert us to the
approaching collapse or correction?

It is not the place of this book to seek economic outcomes to macro-
political events. Nevertheless, there is a sense that political anxieties in the
Middle East and the barely less tender inter-state tensions in East Asia will
affect future economic confidence. Whether oil prices are rising as a con-
sequence of political actions, and at a time when the needs for this commodity
in emerging economic states like China is increasing, is conjecture, but the
price of oil is high. Oil price hikes and rising interest rates will dampen
consumer demand in general. Worse still, these two events could bankrupt
heavily leveraged businesses and individuals. There is the flavour in 2004
of the 1973 depression and the 1974/75 art market crash. Will the burst asset
bubble of just over a decade ago re-occur? Will we be subjected to two-digit
interest rates? The high levels of personal debt are alarming and the re-
mortgaging of the consumer's largest asset, the house, to increase liquidity
is disturbing.

The art industry is showing greater restraint than in the heady late 1980s.
Auction houses are more circumspect about issuing 'guarantees' to major

Plate 13.1 Feng Mengbo, 'The Video Endgame Series: Taking Tiger Mountain by Strategy', 1992 (oil on canvas, 34 2/3 × 39 1/3 ins; 88 × 100cms)

vendors and are very reluctant to lend buyers the money to make the payment on a work of art. But the industry is powerless in the face of political uncertainty and economic meltdown.

The past actions of the art world in times of political and economic upheaval are a useful guide to future art market behaviour. The French Revolution ruptured France, but turned London into the world art market centre. The Second World War laid waste to Europe but within 20 years turned New York into *the* international art entrepôt. Still wealthy American buyers profited from the bear market of 1929–36 and fed off the spoils of the great Russian collectors forced to give up their collections to a cash starved Soviet state. Even in the early 1970s and again in the 1990s, the art market's delayed concussion was less severe than the knock out suffered by other markets.

There are, however, new and worrying developments in the art market that threaten its robustness. The first and most easily preventable is the refusal of museums (and governments) to accept the need to de-accession from public collections. No one has, to my knowledge, asked how much art the public has a 'right' to see. No one has asked how many works by a given artist or how many examples of an ashtray a public might need in order to understand the work of that artist or the stylistic development of ashtrays. The consequence of following, unquestioningly, a consensus that states that as much art as possible should be publicly owned, is that the market for 'dead' art is drying up.[1] Bacon's 'Study after Velasquez' valued at £10 million is the latest 'stunning rediscovered masterpiece', in the words of Britain's Minister for the Arts, to be awarded 'please save me for the nation' status.

There is another factor that is inhibiting the movement of the best 'dead' art onto the market. Today's collectors are buying without the intention of selling. Art has, it seems, become an asset that protects wealth against tax erosion. It allows tax avoidance in France, Switzerland and Italy and, if of exceptional quality, exempts collectors against capital tax in the UK. It may also be used in lieu of UK inheritance tax (IHT). Under the British Acceptance in Lieu Scheme, works of art of international or local importance are eligible for a *douceur* of 25 per cent of the 40 per cent capital gains tax (CGT) when they present their works to the nation. These tax sweeteners resulted in £25.6 million worth of works of art going from private estates to museums in 2001–02 (Thorncroft, 2002). In the USA and Canada such a donation can be put into trust for a lifetime plus 90 years and is deductible against income tax when given to museums, even if the not-for-profit-institution is owned by the donor (Barker, 2002). In America and East Asia, a rash of private museums and cultural foundations have appeared which might result in many works being lost to the market for good. In the UK, for example, Sir Peter Moores is to put his collection of Chinese bronzes, Neapolitan paintings and British folk art into a new £50 million gallery at Compton Verney. Frank Cohen is planning to house his collection of cutting-edge contemporary art in a converted nineteenth-century market hall or old mill in Manchester.

Sir Elton John, who owns moderns and contemporary art, is to build a gallery beside his Georgian mansion in Windsor (see Morrison, 2003; see also Waterfield, 2003).

If problems of under-supply are pushing up the prices of Old Masters and antiques in particular, then problems of over-supply are about to beset the fast growing 'living' artist market. There are now too many supply outlets and too little product differentiation for this commodity, and this is putting pressure on price. The parallels between today's market for contemporary art and that of the late seventeenth-century Dutch Republic, just before a surfeit of art brought about its collapse, are remarkable. Consumer interest in cutting-edge art has been raised to irresponsibly dizzying heights by the current Labour government keen to re-brand the UK as 'cool', and by its cultural advisers keen to grow the size of their industry. The going up in smoke of Saatchi's YBA collection might be a harbinger of this forthcoming economic catastrophe. If nothing else it has certainly preserved value for a complete *trousseau* of the emperor's new clothes prior to a sharp price correction. The contemporary art market's salvation lies in the middle market for alternative art. Art that serves a decorative function and shows evidence of technical ability should reinstate consumer confidence as well as appeal to a much broader genuine and sustainable collecting base. Much of the most accomplished work of this type is produced in the emerging art markets of East and Southeast Asia.

Today's art market is sustained by American buying and a relatively weak dollar has hindered growth. The dollar has lost value to both sterling and the euro in 2004 and if the dollar trend is downwards this could spell trouble for the art market. On the other hand, European buyers are almost on a par with their American cousins and they clearly favour a strong euro. Chinese buyers, we have seen, are becoming increasingly prominent on the international market. Their contribution to the art market's development would be all the greater if the RMB were to become a convertible international currency. There are already signs that Beijing is considering widening the band in which its currency is allowed to fluctuate. In addition, Beijing needs to drop its currency controls which at the moment prevent all but the indigenous auction houses from buying (legally) overseas.

Speculation is not new to the art market, but it is only a serious factor in the wake of a stock and property market crash. Since the high value, top end works of art are being 'withdrawn' from circulation there is less for the speculator to speculate on. The only market that might be vulnerable to financial interlopers today is the cutting-edge contemporary. If ever there was an inflated and overpriced market this is it. I believe that this market has peaked and because of low level information barriers is ripe for outside speculative intervention. Such incursions will push prices well beyond top estimates only for them to fall dramatically as the speculators withdraw, either licking their wounds or counting their profits. The consequences of these actions are a cull of new cutting-edge galleries, a reduction in the

number of art fairs world-wide and (I hope) an end to the art biennale phenomenon.

Perhaps the most exciting area of growth in the art market is within another industry. Private banking caters to an exclusive world of high net worth individuals (HNWI) with several million dollars worth of personal liquidity. Portfolio managers, and the exclusive banks for which they work, want to offer their clients exciting new products, especially if it can be demonstrated that those products have low levels of correlation to mainstream financial assets. Art is one of the most surprising and unpredictable of assets, but there is, the banks argue, enough evidence to suggest that it is not such a bad investment, and a good hedge against other products. Whether banks can accommodate the unpredictability of the art market and its hetero- geneous commodities remains to be seen, but at Alpha level it is not such a preposterous proposition. Then again, how does a portfolio manager deal with re-attribution, discovery, forgery and, most dangerous of all, uncer- tainty in the art market? By playing safe, private banking can add steam to the market. By allotting say 5–10 per cent of a client's investable income for art, the risks are minimized. All this is difficult to measure accurately, however, in the absence of a financial model. If, for example, it can be demonstrated that art outperforms other financial assets during one of two economic cycles; that is, in times of economic expansion or contraction, then art trading at one level would become more regulated. This is one of the most important questions to be answered today. The banks' biggest com- petitors should be the two international auction houses, Sotheby's and Christie's, who should have set up their own investment banks years ago or at the very least made themselves the first choice consultants for the banking world.

Despite my pessimistic observations on the dearth of Alpha quality 'dead' art traded today, the volume of art sales is still very substantial. Japan imported a staggering $4,232.4 million worth of art in 1990, representing almost 30 per cent of total world imports. The UK exported $2,602 million of art in 1998 and the USA $4,742.7 million of art and antiques in the same year.[2] Art is now factored into fund and wealth managers calculations, especially since it offers lower levels of correlation than other financial assets and, consequently, represents a hedging option. It is also a comparatively virginal market, appealing to the frontier spirit of risk-takers. As a result of these two tendencies, art speculation is likely to increase rather than diminish in the future.

There are corners of the art market that will always remain outside the control of any model or index. The 'sleeping' Old Master drawing tucked between the pages of a book. The 'undiscovered' Ming vase set among bric a brac on a market stall and the re-attributed painting, which yesterday was 'School of' and today is by the master's hand cannot be captured by any index. Technology has its limitations, and the Internet has singularly failed to replace traditional modes of selling art. It is highly debatable whether an

index is the best way to measure the progress of the art commodity. In many ways, informed commentary and a written analysis present a much clearer picture.

The market's inefficiency lends itself to eccentric trading habits, a situation that encourages grey and outright illegal areas of exchange. The art market's often covert and secretive buying and selling practices do encourage or at least permit high levels of criminal behaviour. Unethical behaviour even occurs in the mainstream markets, and this merely hints at the huge underground trade in illegally excavated antiquities and stolen works of art. Social, political and economic upheaval attracts the trade almost as much as a buoyant economy, political and social stability. It is also sadly true that art is often used as security or a medium of exchange in illegal drug and gun transactions.

All this is bad news for the market and good copy for newspapers. Nothing is more likely to make the pages of the dailies than the top price set at auction for a work of art, or the theft of the Duke's Rembrandt and its discovery in a downtown lock-up. But, as we have seen, the art market is much more than its headline prices and stolen masterpieces. It is a Tower of Babel that touches the highest reaches of consumer sentiment and a deep well that unleashes the basest instincts for acquisition. It is, in short, the most aspirational market in the world and as a result encourages the transgression of society's mores and laws. Unethical in parts, the art market may be but no more or less unethical than its consumers, who may be equally unethical in other aspects of their life.

The market has been dominated for decades by New York and London, but since the deregulation of the French market, Paris is set fair to expand at the greatest rate. Both Christie's and Sotheby's will, in future, be holding major auctions in the French capital. The auctions at Drouot and regional French sales are buoyant and Parisian galleries, the most numerous of any city in the world, sense a new dawn. Some of the new French business will be taken from London and New York, but a great deal will simply be transferred from Monaco. Basically, the French market has internationalized and will now compete with London on a level playing field, especially with respect to art taxation. London has responded with a concerted effort to promote itself through the Art Fortnight in June – an event that sees co-operation between the city's museums, auctions, galleries and art fairs. Cross-channel competition promises to be as fierce as transatlantic in the future. How long will it be before a fourth front is opened up in East Asia? Perhaps we are entering a period when the national and regional inconsistencies between markets are being eroded. It will be a long time, however, before New York, Switzerland, Hong Kong and the offshore havens share the same trading conditions as the EU states. How much of the French regulation bleeds into the de-regulated international market is one of the most intriguing questions of the next decade.

The *dystopian* art market

In book two of *Utopia* (1516) Thomas More teaches us that cultural equality is a good thing. Order and regulation are worthy aspirations and the community comes first. The fact that a man who has a passion for jewels requires written assurances that a stone is 'genuine' is, he insists, ludicrous:

> But my dear sir, why shouldn't a fake give you just as much pleasure, if you can't, with your own eyes, distinguish it from the real one? It makes no difference to you whether it's genuine or not – any more than it would to a blind man.

A man's reason and intelligence, More writes, raises him above the animals. But not, we have learnt, when those humans are acting in the art market. A more useful analogy for art market behaviour is made earlier, when the satirist declares that when we buy a horse we take every possible precaution before parting with our money but when we choose a wife we are unbelievably careless (*caveat emptor*).

There is no room for the art market in *Utopia*. Equality destroys competition, and true feeling and appreciation oust profit and gain.

I have, however, a dystopian vision that might work.

In this world, museums would husband the world's entire supply of art and antiques, and receive international indemnity from a supra-national cultural agency. The same agency would operate a gigantic art fund, the interest from which would pay for the building, maintenance and upkeep of these museums and their staff of dedicated curators. This money would cover the convenience yield of art, since original works would no longer reside in private hands. Non-industry financial institutions would own all the world's art, acquiring it at major auctions throughout the year (dealers and brokers and all other outlets for art and antiques would be criminalized). Art would be placed for loan periods ranging from three months to 25 years in the aforementioned museums. Particular national and regional cultural requirements would be taken into account in the placement of these works, a decision that would be made by museum directors. Anyone who stole art or attempted to trade outside the official auctions would be executed. The beauty of this system would be that everyone would be playing to their strengths, the market would be absolutely transparent and we might finally have some idea about the value of art.

Notes

1 Sotheby's sold 200,000 lots in 1989, 188,000 in 1990 and 110,000 in 2000. Christie's sold 282,000 in 1989, 245,000 in 1990 and 177,000 in 2000.
2 The UK imported $3,272.9 million and Switzerland and Liechtenstein, $1,259 million in 1998.

Bibliography

Barker, G. (2002). *The Times*, 28 August.
More, Sir Thomas (1516/1965) *Utopia*. Harmondsworth: Penguin.
Morrison, J. (2003). 'Arts', *The Independent*, 13 July.
Thorncroft, A. (2002). *Financial Times*, 20–21 July.
Waterfield, G. (2003) 'The Modern Medicis', *Museums Journal*, July, pp. 28–33.

Index

CPSIA information can be obtained at www.ICGtesting.com
Printed in the USA
LVOW071852090413

328397LV00002B/45/P

9 780415 339575